ELIOT PORTER

OCTOBER 1987

ELIOT PORTER

OCTOBER 1987

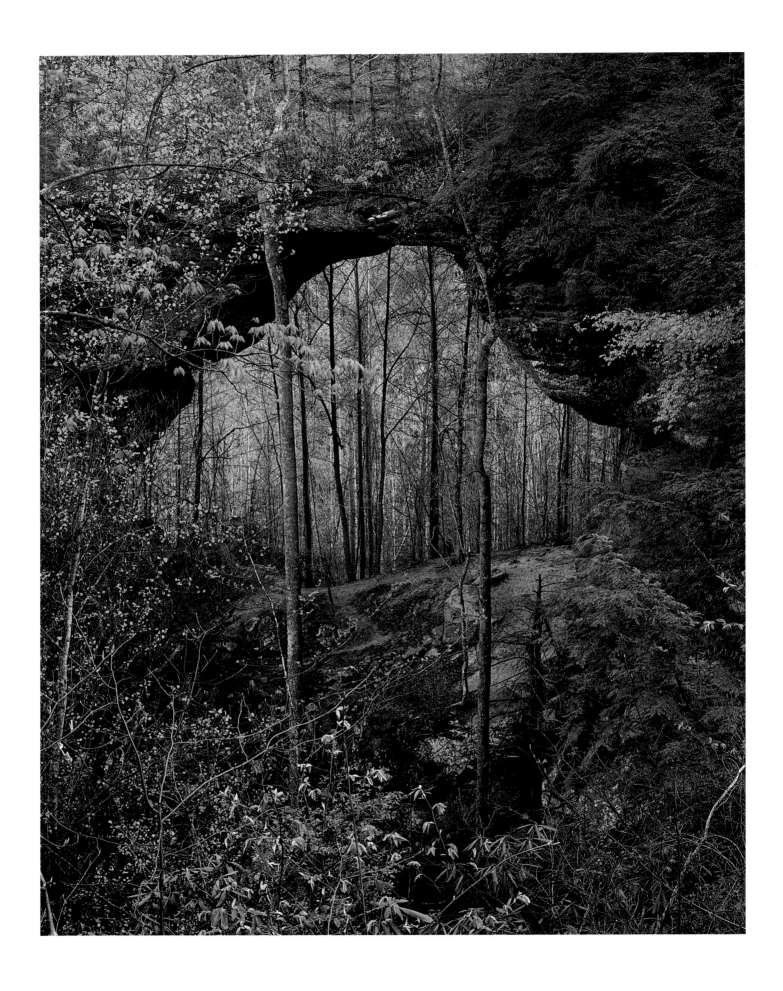

FRONTISPIECE: GRAY'S ARCH, RED RIVER GORGE, KENTUCKY, APRIL 16, 1968

ELIOT PORTER

Photographs and text by Eliot Porter

Foreword by Martha A. Sandweiss

Published by New York Graphic Society Books

Little, Brown and Company, Boston

In association with the Amon Carter Museum

I WISH TO EXPRESS my appreciation to Eleanor Caponigro and Martha Sandweiss for the many hours they spent in the selection of the photographs from all my work reproduced in this book. And I want to thank Terry Hackford and especially Ann Mason for their patient inestimable assistance in the organization and editing of the account of my career as a photographer.

I wish also to acknowledge the lifelong support and encouragement I received from all members of my family: my wife Aline and my sons who provided devoted assistance on many expeditions both near home and to distant lands.

Eliot Porter

THIS BOOK WAS PRODUCED in conjunction with *Eliot Porter*, an exhibition organized by the Amon Carter Museum and shown at the Amon Carter Museum, Fort Worth, Texas, October 31, 1987 – January 3, 1988; the Bowdoin College Museum of Art, Brunswick, Maine, April 15 – June 5, 1988; the Huntsville Museum of Art, Huntsville, Alabama, July 3 – August 21, 1988; and other locations to be determined.

MANY OF THE PHOTOGRAPHS in this book were previously published. Substantial portions of the text previously appeared in *Galapagos: The Flow of Wildness* (Sierra Club, 1968), *Harvard Medical Alumni Bulletin* (March – April 1970), *Birds of North America* (E. P. Dutton and Company, 1972), and *Antarctica* (E. P. Dutton and Company, 1978). Please see the bibliography at the back of this book for a complete listing of Eliot Porter's publications.

FIRST EDITION
PRINTED IN THE UNITED STATES OF AMERICA

LIBRARY OF CONGRESS CATALOGING-IN-PUBLICATION DATA
Porter, Eliot, 1901 –
 Eliot Porter.

 Bibliography: p.
 Includes index.
 1. Porter, Eliot, 1901 – — Exhibitions. 2. Nature photography – Exhibitions. I. Amon Carter Museum of Western Art. II. Title.
TR721.P66 1987 779'.3 87–12413
ISBN 0 – 8212 – 1675 – 9
ISBN 0 – 8212 – 1676 – 7 (pbk.)

NEW YORK GRAPHIC SOCIETY books are published by Little, Brown and Company (Inc.)

Published simultaneously in Canada by Little, Brown & Company (Canada) Limited

CONTENTS

FOREWORD

"It has come to this," Henry David Thoreau wrote in his journal in 1857, "that the lover of art is one, and the lover of nature another, though true art is but the expression of our love of nature. It is monstrous when one cares but little about trees and much about Corinthian columns, and yet this is exceedingly common." Eliot Porter, an observer and photographer of the natural world for more than half a century, is that rare artist who belies Thoreau's fears. A true work of art, Porter says, "is the creation of love, love for the subject first and for the medium second." Throughout his long career, the subject Porter has loved above all others is nature; the medium color photography.

Porter first discovered what Thoreau called "the tonic of wildness" as a young boy exploring his family's island in Maine. At eighty-five, he retains his boyish enthusiasm for adventure and an ability to see the world with childlike wonder and curiosity, but age has tempered this with self-discipline and patience. It is fortunate, he writes, that he achieved photographic success relatively late in life — after a brief career as a medical researcher — thereby avoiding "the disappointment and anguish that too often result from an inability to sustain a creative drive developed too fast and too early in life." Since making the decision to pursue photography in 1939, he has steered his own course, freed by family money to pursue his youthful interests in nature and his later interests in fine photography without regard for fashion or fad or the demands of the marketplace. "It appears highly desirable," he writes, "to order one's life in accord with inner yearnings no matter how impractical they may seem, and not be bound to a false start by common considerations."

There is an essential conservatism to Porter's work; it can be difficult if not impossible to distinguish a photograph he made thirty years ago from one made last month. Though he has photographed street life in such diverse places as Manhattan, Macao, and Mexico, the natural world remains his central interest, and he continues to work in a style uninfluenced by changing photographic fashions. In this regard he is similar to his brother, the painter Fairfield Porter, who continued to make representational paintings in an age of abstract expressionism, resisting novelty for novelty's sake.

What characterizes Porter's pictures is the carefully observed detail — the narrow segment of sea, the fragment of rotting bark, the tangle of bare branches — rendered with an unexpected and startling clarity of color. A detail, writes Porter, "is quite capable of eliciting a greater intensity of emotion than the whole scene evoked in the first place . . . because the whole of nature is too vast and complex to grasp quickly, but a fragment of it is comprehensible and allows the imagination scope to fill in the excluded setting." Porter intends for each of his pictures to be absolutely convincing and so each is a straight shot, exposed and printed without recourse to such manipulative techniques as double exposures or solarization. Yet the convincing quality of Porter's work does not rely on the viewer's prior knowledge of what the natural world really looks like. Indeed, in Porter's photographs, grass is as likely to be black or yellow as green, shadows might be blue rather than

black, filtered sunlight on leaves might be white or blue or warm orange. There is no assumed, habitual meaning to his colors. They are rendered as they are observed, not as they are recalled, for Porter is an artist who reveals rather than invents. Thus part of the pleasure of looking at the pictures comes from seeing the world anew, and more carefully, through Porter's eyes. This pleasure is like looking at an Impressionist painting and realizing that our assumptions about the proper color of things are limiting and wrong.

Porter's pictures are generally composed without a single eye-catching focus. Each is carefully laid out from edge to edge, and the picture frame feels full. There is no extraneous information or empty space to flush out or detract from the overall composition. And though the photographs are always convincing renderings of an observed scene they can be full of contradictions. The colors may be unexpectedly brilliant and saturated, but the composition itself may have the understated simplicity, elegance, and flat austerity of a Japanese print. The picture may be a straightforward shot of an observed phenomenon such as lichen growing on a rock, but Porter's closeup treatment and attention to color may render it as abstract as a nonrepresentational painting. The literalism of his work should not be confused with a lack of interest in design or abstraction.

One searches in vain through Porter's writings for an account of the influences on his photographic style. While acknowledging that Ansel Adams and Alfred Stieglitz impelled him to make better pictures, he says little about other artists — either photographers or painters — who have had an impact on his work. One is left to wonder about the influence of his brother Fairfield's brightly lit landscapes of the family island in Maine, or of his wife Aline's freely painted floral still lifes and carefully constructed boxes incorporating found natural objects. One is left with the impression that this scientist cum artist is simply an expert and alert observer gifted with a deeply intuitive — and

hence indescribable — feeling for beauty. He is very good at describing the place where he made a picture; less good at accounting for just why a picture looks the way it does. In any case, he notes, "an account of the influence and inspiration that go into the creation of a work of art is not necessary for its justification, which rests on its inherent accepted merit."

In light of Porter's photographic conservatism, his stalwart championing of color photography for more than forty years seems ironic. Even today, color is regarded warily by many fine art photographers and resisted by collectors and even museums. There is a misguided sense that it is somehow too literal and not artistic enough, that it does not reveal the artist's creative potential, that it is a stepchild of the grand black and white photographic tradition pioneered by such masters as Ansel Adams or Walker Evans. But in the hands of a master like Eliot Porter who works in the laborious three-color dye-transfer process, color photography is clearly a creative enterprise that reflects the artist's technical skill as well as imagination. With this process, color can be controlled just as tonal values can in a black and white print to enhance the photographer's interpretation. To say that color photography is not a creative medium because it is too literal is as foolish as saying that photography itself is not a creative medium because it depends on a mechanical device.

There are at least four ways to look at Porter's photographs. One can look at them as formal constructions and pay attention to the understated elegance of composition, the relationships between colors, the way in which the significant detail suggests the whole, the manner in which the seemingly abstract represents a realistic portrayal of a particular scene. Or one can view the pictures as material equivalents of emotions or feelings, an approach Porter himself invited with his first book, *"In Wildness Is the Preservation of the World"* (1962), where he paired his photographs with selected quotes from the philosopher and naturalist Henry David Thoreau. "I hoped to be able to complement in

feeling and spirit Thoreau's thinking one hundred years ago," Porter wrote in his preface. Alfred Stieglitz experimented with using photographs as material representations of his inner feelings in the "Equivalents" series of cloud pictures he made in the 1920s. But where Stieglitz's pictures seem deliberately obscure and private, Porter's photographs are more accessible, for he means to share his private experiences with his viewers. The intention of the artist-photographer, he writes, is "to elicit if possible the same response or association in his audience that the original object or place aroused in him." Porter is adept not only at discovering the awesome in the familiar, but at evoking this same sense of wonder from his audience.

Yet a third way to regard Porter's photographs is as literal descriptions. Porter is at heart a naturalist and scientist, and even as he is drawn to the color or evocative spiritual quality of a particular scene, he is also a describer who wants to show us what a particular bird looks like or how a glacier reflects and refracts light. This descriptive quality of his work must be considered along with the pictures' formal and spiritual attributes, for Porter has never distinguished between the pictures he has made for scientific illustration and those made for more personal purposes. The artist in him does not quarrel with the scientist. Anything worth photographing, he says, is worth photographing beautifully.

Finally, one can regard Porter's photographs as propaganda, persuasive bits of evidence presented in support of the conservation causes he has long championed through his books and political activities. But one must be careful to note that there is nothing inherently propagandistic in the pictures themselves. They take on this added meaning only when placed in a particular context, usually in juxtaposition to words. Just as

Porter avoids the obvious landscape shot — the grand view with the requisite mountain, lake, and reflection carefully framed between misty grasses — so he steers away from the cheap conservation shot that exudes didactic moralism. He does not make pictures of despoiled landscapes littered with beer cans or crisscrossed by utility wires in order to suggest that man should leave nature alone. Rather, he continues to focus on the wild, unspoiled landscape, hoping to suggest the merits of conservation through a positive, persuasive illustration of nature's inherent beauties.

This book accompanies a major retrospective exhibition organized by the Amon Carter Museum, the designated repository for Porter's photographs, and is the first publication to present the complete range of Porter's work and to focus on the pictures themselves rather than a particular subject. The photographs seem a kind of celebration of light and color, of natural growth and decay, of the small things unseen or forgotten in the rush of everyday life. They offer convincing proof that photographs can be at once persuasive and beautiful, descriptive and aesthetic. And they demonstrate that color can be used by a creative photographer much as pigments can be used by a painter to enhance the artist's perceptions of the material world. But the book itself is a celebration of another sort, as it celebrates the energy and tenacity of a tireless photographer who after fifty years of work still observes the natural world with unchanging pleasure and pursues his work with great delight.

Martha A. Sandweiss
Adjunct Curator of Photographs
Amon Carter Museum

EARLY YEARS

OUR EARLIEST INTERESTS are directed by adult relations and the circumstances of our early lives. In my case I am sure that the parental influence of a humanist mother and a scientifically oriented father were strong. I have no recollection of having spent any time drawing imaginary pictures, but very early I did get real pleasure from making things out of wood with my first tool, a pocketknife. I was also, while still quite young, attracted to the natural world — to the first growing things of spring, and to birds, a fascination that in my adult life became a passionate preoccupation for many years. All these interests were treated with sympathy and encouragement by my parents, especially by father, who would take us for Sunday walks on Lake Michigan's shore and tell us about the geological history of the Great Lakes, about the significance of fossil crinoids that could occasionally be found in the gravels of the beaches, and about how it all was tied together by evolutionary change.

We were raised in Winnetka, Illinois, near Chicago, where our family extends back to about 1850. My father was the second child of a widowed mother, Julia Foster, who was always simply "grandmother" to us children. On the death of her husband she assumed lifelong mourning, dressing always in long, full black shirtwaists that buttoned closely around her neck. A costume of such formality, together with an inherent reserve, inhibited spontaneous expressions of affection by her grandchildren. Land purchased by my great-grandfather Foster near Fort Dearborn, which later was given the Indian name "Chicago" (skunk cab-

bage) — an epithet for the swampy environment surrounding the area — was passed down to Julia and her sisters. Not foreseeing the growth of Chicago and the enormous appreciation of the land they inherited from their father, Julia's sisters, preferring more civilized society, sold their shares to Julia and moved to Peterborough, New Hampshire. Julia married an Episcopalian minister, Maurice Porter, and lived for several years in Racine, Wisconsin, where he had a parish; but he died of appendicitis when my father was only five, after which the family moved back to Chicago. My grandmother was a deeply religious person. To help alleviate the sufferings of others and to make her own sorrow more bearable, she established with the aid of women friends a hospital for children of the poor. At first a simple project in a rented house, where the sick would receive constant care, it soon expanded, with male financial and administrative assistance, to a professional institution. Dedicated to the memory of my grandmother's eldest son, who had died in childhood, it was named the Maurice Memorial Children's Hospital.

My father, James Foster Porter, received his early schooling in Chicago. When he was a young man of pre-college age, in the late 1880s, Darwin's revolutionary theories on biological succession attracted great interest among American students. With a group of contemporaries — young men and women of Chicago who were similarly interested — he helped found the Agassiz Association, a discussion group that met frequently to exchange ideas on current scientific theories in biology, geology, and evolution. My father became

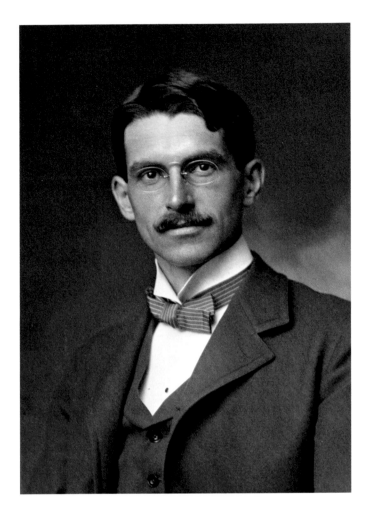

James Foster Porter, c. 1898. Photographer unknown.

a dedicated protagonist of the scientific interpretation of natural phenomena, with an unshakable belief in causality and a fierce rejection of purpose as a driving force in the universe. Under the influence of Darwin's writings, my father professed agnosticism; in later years he went beyond such qualified skepticism and pronounced his disbelief in a god or the need for a supernatural explanation of existence. But perhaps because he had been brought up under the strict guidance of the Episcopalian faith, he retained, if not the religion, certainly its moral precepts. He held to very high standards of conduct. Truth, honesty, and fulfillment of all promises were his guiding principles. He did not lecture us on these ethical matters; it was by example that we learned to honor and live by them.

Although he seldom talked about religion, it is not surprising that I absorbed my father's point of view and grew to share his beliefs in causality, agnosticism, and evolution. My father's other influences also had a profound and positive effect on me. He took us camping and on Sunday walks and talked to us at length about geology, paleontology, astronomy, and marine biology during our summers in Maine. My father, at heart a naturalist, instilled in his children, perhaps most profoundly in me, a fascination with the natural world.

Father went to Harvard, where his principal studies were in biology, and he graduated in 1896. Soon after graduation he married my mother, Ruth Wadsworth Furness, also a Chicagoan who had graduated from Bryn Mawr College in 1895. Mother was brought up as a Unitarian, the daughter of William Eliot Furness (for whom I was named) and Lucy Wadsworth, whom I remember as a sweet and affectionate grandmother who died when I was still very young. Motivated perhaps by a spirit of adventure spurred by the westward drive of civilization in America, they had settled in Chicago after the Civil War. My mother belonged to the small group of women of her time who had attained a college education, and in her years at Bryn Mawr she developed cultivated literary tastes, became an omnivorous reader, and made several lifelong friends who became associated with Jane Addams' Hull House in Chicago. I suspect that it was not only family tradition but also these friendships that encouraged her emotional bias towards a liberal point of view. She supported women's rights, the suffragist movement, racial equality, and other progressive political movements.

It was through my mother's influence that I learned racial and religious tolerance, or more correctly, was not exposed to social prejudices. Not until I was sixteen and away at boarding school did I learn about ethnic distinctions and how they subvert personal and social judgments. The term "Christian" being uncommon in my family, I did not place myself in any particular religious category, nor did I know the distinction between

Jews and non-Jews. Very few Negroes lived in the suburban community in which I grew up and went to school. Because my mother's father had commanded a Negro regiment during the Civil War (though it never saw action), we thought of them as the "freed people."

Because we were exposed to a variety of political views we learned political tolerance. My father was Republican throughout his life, whereas mother, when women attained the franchise, voted Democratic or for third-party candidates, which encouraged in her children a tolerance for unorthodox political views. And so I grew up in the liberal tradition, to which, in the absence of convincing arguments to the contrary, I still subscribe. That a government, any government, but particularly a democratic government dependent on popular sanction for its existence, should be responsible for the general welfare of the governed is to my mind a foregone conclusion that does not seem to be universally accepted today. Excessive militarism defeats its intended purpose in a constitutional democracy when the rights, liberties, and economic welfare of the people are made secondary to their defense. I have come to regard my political liberalism as a precious legacy from both my parents.

After their marriage my parents took up residence in New York City so that father could attend the Columbia Architecture School. Architecture was my father's second major interest after biology, which he gave up shortly after graduating from college because he felt his eyesight was too poor for work with a microscope. In order to manage his mother's real estate interests, he and mother moved back to Chicago in 1898 after the death of his grandfather Foster. Father then immediately began to plan houses for his family and for his mother in Lakeside, a northern suburb of Chicago on Lake Michigan. For our family he planned a large brick Greek revival house with Ionic pilasters at its corners, an entrance portico and facade featuring Corinthian columns, and Doric-columned porches on each side of the house. The porch on the east side over-

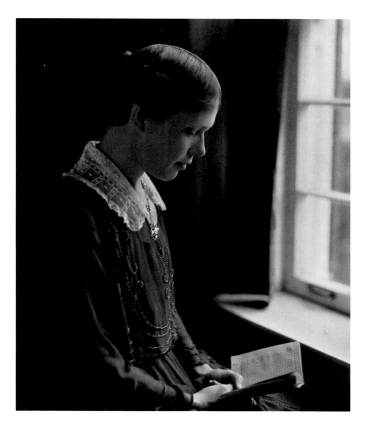

Ruth Wadsworth Porter, c. 1900. Photographer unknown.

looking the lake was screened as a sitting room for summer use. The west porch was glassed in to serve as a conservatory and greenhouse, where father raised flowers and exotic plants. His admiration of classical architecture was based on its purity of function and design expressed by the mathematical precision of Greek temple construction, which he meticulously maintained in the features he incorporated in his house. The house he designed for his mother was half-timbered Tudor style. The two houses were sited about two hundred feet apart on a bluff overlooking Lake Michigan. Construction was started before the turn of the century and before completion my sister, Nancy Foster, was born in Chicago. I, however, was born in the new house in December 1901 soon after my parents and my two-year-old sister moved in. The house overlooking Lake Michigan was our year-round home until, when I was eleven, the whole family started going to

Maine each year for the summer. I was the second child in a growing family, with my older sister Nancy and three younger brothers — Edward, Fairfield, and John.

We had a devoted mother who read tirelessly to all her children. The first stories I can remember were the classics of Beatrix Potter; my favorite was the frightening *The Roly-Poly Pudding*, in which Tom Kitten was captured by rats and about to be made into a dumpling when he was rescued by the Scotch terrier, John the Joiner. She also read the King Arthur stories, *Treasure Island*, and others by Stevenson and Mark Twain. Later during our summers in Maine, mother would read to the whole family gathered of an evening in the high-ceilinged living room around the fireplace in which four-foot logs burned.

Father had become an enthusiastic camper during his college years, when he went camping twice with friends in the Canadian Rockies. His fascination with geological phenomena, stimulated by the western scenery of the Grand Canyon, Yellowstone, and the dramatic mountain ranges of the Canadian Rockies, drew him repeatedly westward; it was to the Canadian Rockies that he returned most often. In the first decade of this century father and mother went on many camping trips in the West with friends and relatives, and a few times with their eldest children, returning to my father's favorite haunts. As a family we also traveled to Peterborough, New Hampshire, to visit grandmother's sisters; our July 1905 trip was my first exposure to New England. In March 1909 father and mother took me to Florida. I never understood why I was singled out for this excursion, unless it was to speed my recovery from appendicitis. I remember we visited St. Augustine, where I had my first experience with seasickness in a powerboat cruise, and in my misery I lay down on a bench wet with green paint. Farther south in the Keys (on Long Key) I learned by sad experience about the trailing filamentous nettles that arm the Portuguese man-of-war and fiercely sting the unwary.

It was probably early in 1911 that the three of us — Nancy, Edward, and I (Fairfield, only four, was left at home) — were taken on a short camping trip to the Grand Canyon and then on to Santa Barbara. One day in the Grand Canyon our parents went off on a walk by themselves leaving us in the care of the guide. While playing in a shallow cave near camp we found a cache of dynamite left by a prospector, which, in our innocence, we thought to be candles. Father was horrified when we showed him later what we had found. Of Santa Barbara I remember little more than the wooden sidewalks, red with squashed mulberries, finding a moonstone on the beach, which father admired so much I gave it to him for his mineral collection, and being driven at fifty miles per hour in a Pierce Arrow by Mr. Walling, one of our Winnetka neighbors. These early family trips fostered the love of travel that has persisted throughout my life; our trip to the Grand Canyon oriented me for the first time towards the West.

In 1910 father bought an island on the coast of Maine in Penobscot Bay as a summer home for his family. The large two-story shingle house he had built had separate rooms for each of the children and for guests as well. Our summer home on Great Spruce Head Island was to become an important source of inspiration in my life. And it was there that I developed my love of the sea. Our lives there, my brothers' and sister's and mine, were from the first determined by the sea. High tide was the time to swim, and low tide the time to explore the shore. We set our clocks ahead before daylight-saving time had been devised in order to enjoy the daylight hours more fully. We gathered shells along the high-tide wrack: powder blue and purple mussels in all sizes that nested together in compact families; pale green sea urchins washed clean of their spines; and the perfectly preserved, brilliant orange carapaces shed by the small, brown-green crabs that live in the rock weed of the littoral zone. We collected starfish, sunstars, and sand dollars, and dried them under the kitchen stove. From the shallow edge of the sea we dredged up

anemones, sea cucumbers, limpets, and coral-like calcareous algae. Our father explained the names and relationships of all these creatures to us, and took an even greater interest than we in this ever-present museum of marine biology. So it was that we began to live by lunar time. A deep feeling for nature began to grow in me, a feeling that was to affect the whole future course of my life.

Our summers there, which began in 1912, have continued, with the next generation, to the present time, except for those few years when various family members pursued their own adventures or traveled abroad. In my book *Summer Island: Penobscot Country* I explored my childhood experiences there.

My early interest in woodworking, which had been first expressed by whittling with a pocketknife, received strong support one Christmas around 1911 when I was given a workbench with a vice and a chest of tools. It was a day I can still vividly remember: my surprise and overwhelming excitement when the doors to the formal parlor were finally opened — an event always delayed until after Christmas dinner so that our grandparents could participate — the lighted Christmas tree in all its glittering splendor was revealed, and the gift that was to have such a profound and lasting effect in broadening my childhood activities was presented.

The carpenter's bench was installed in my bedroom, where it soon became the source of much litter and shavings, seldom, however, causing complaints from higher up. Eventually the hand tools were supplemented by an electric scroll saw and, from basswood purchased at the local lumberyard, I made nest boxes for house wrens and toy boats, some with propellers driven by rubber bands. From this impressionable period of my life I cannot now place new experiences and knowledge in strictly chronological order. They flash into consciousness in kaleidoscopic disarray; one thought supersedes another in no logical sequence, mysteriously recalled from hidden recesses of the mind. Visions of my tool bench tucked in a corner of

my bedroom, disorder all about, are suddenly veiled by thoughts of Halloween pranks — of the time my friends planned to raid my father's fruit cellar, which I had to circumvent — or by a vision of the first aeroplane I saw, a red biplane flying low over Lake Michigan.

A favorite game we played was the game of tag, which we played on the roof of our barn. The barn, built at the beginning of the century like the house, was planned for horses and carriages. It was a brick building with second-floor living quarters for a coachman and his family. A one-story ell for the horse stalls extended at right angles from the main carriage area and opened onto a paddock enclosed with a high brick wall, which could be entered from the outside through a double-door gate wide enough for carriages. Within a few years of my birth the carriage period was superseded by the motor age, the barn was converted into a garage, and the horse stalls became obsolete and vacant. The cedar-shingled pitched roofs of this complex building ended at four-inch-high raised gutters, beyond which from the main building a shed roof of lesser pitch extended into the paddock. A large dormer window projected from the main roof above the shed. With our school friends, my brother Edward and I could chase one another around the dormer window, slide down onto the gutter, and run around on the top of the paddock wall without ever having to come to the ground. Our game of tag was finally brought to an end one day when Edward slid over the gutter on the horse stall ell and landed feet first in a trash barrel. He went howling into the house, more frightened than hurt, and when father came home that evening and was told about it he ordered us in no unmistakable terms never again to play on the roof because we would damage the shingles.

Backed against the wing of the barn was a clay tennis court that father, a dedicated player, had constructed soon after his house was built. When as little boys we had become adventurous enough, Edward and I would climb up and watch tennis games from the

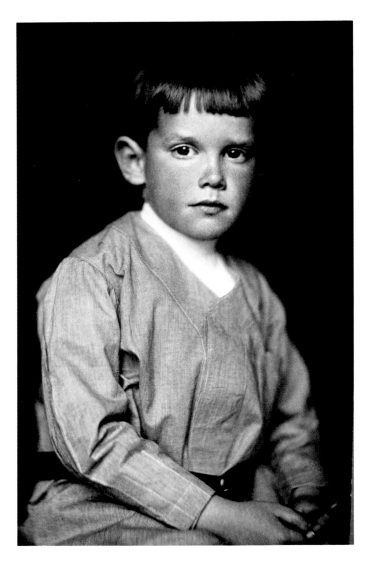

Eliot Furness Porter, c. 1907. Photographer unknown.

top of the roof. One day when Aunt Frances, father's adopted sister, was playing with Arthur Fisher (an older boy from the neighborhood), Edward and I, being in a mischievous mood, began throwing trash — an old broom and other objects — down on the court. We expected a reaction, but not the one we elicited. Arthur, much to our surprise, put an end to our harassment by direct action, climbing up on the roof. I fled in panic down the roof to the tennis court backstop and, according to Frances (I have no recollection of how I escaped), ran cat-like along the top board of the backstop and jumped off at the end. This was quite a feat, as

the board was not more than two inches wide and the drop was ten feet.

One day I saw an advertisement for a small wood-turning lathe operated by a treadle similar to the first Singer sewing machines. I was determined to have it, but the price was beyond what my modest allowance could finance — even with most rigid restraint on all other spending — so I persuaded a playmate, Curtis Nelson, who I knew was a soft touch, to go in with me for it. When it arrived I installed it in my room, where Curtis' opportunity to use it was very limited. Eventually his parents found out about the deal and insisted that the lathe be more equitably shared, half time with Curtis. This would obviously be difficult to arrange, and greatly to my disadvantage, without being of benefit to him, and I also knew I had persuaded him to join me in a deal which was foreign to his inclinations. The predicament was ultimately resolved when my shocked parents learned how I had taken advantage of a friend, scolded me for my greed, reimbursed Curtis, and reduced my allowance.

A series of events that had implications for the future occurred in my second year of high school. I chose the chemistry course taught by Mr. Boyle, an inspiring teacher who opened doors to a whole new world of science. As supplemental reading to satisfy my eagerness for more information, he recommended Slosson's *Creative Chemistry*, a popular new book that I read repeatedly from cover to cover. That year as a birthday present I was given a chemistry set, with which I could perform simple demonstrations of elementary chemical phenomena. To supplement the chemicals in the set I purchased more effective reagents at a chemical supply store in Chicago: concentrated nitric and sulphuric acids, along with other chemicals that react energetically. Stimulated by Fourth of July fireworks, to which all boys are compulsively attracted, I made a variety of gunpowder-like explosives from potassium nitrate, carbon, and sulphur but failed, fortunately, to make nitroglycerine.

Nancy, Fairfield, Edward and Eliot Porter, c. 1909.
Photograph by James Foster Porter.

Experiments with chemicals, to discover what would happen if two substances were mixed together, to see if what was supposed to happen actually did, to satisfy such curiosity, became a compelling impulse for me. Reactions of the most vigorous kind were, of course, the most challenging and irresistible to try. I experimented with potassium perchlorate, permanganate, and with metallic sodium, which violently reacts with water to produce hydrogen. I discovered that perchlorates mixed with sugar are explosive. Remarkably I never had a mishap.

One of the phenomena I played with was the differential affinity for oxygen of metals: thus aluminum can capture the oxygen from iron oxide or rust under proper conditions. The phenomenon was used in the thermit process for welding railroad rails. A mixture of powdered aluminum and iron oxide in a graphite crucible can be ignited with magnesium ribbon and the reaction will proceed rapidly to completion (at several thousand degrees Fahrenheit with a fountain of incandescent sparks), when the aluminum has combined with the oxygen of the iron oxide, leaving a puddle of molten iron in the bottom of the crucible. The display in my room was spectacular; it burned holes in my rug

and charred spots on the painted floor, but I never actually set anything on fire, and I am sure my parents knew nothing about these pyrotechnics.

My activities were not confined to solitary pursuits in my room; I did have friends who participated in some of the more spectacular experiments and with whom I played outdoors. The community of Hubbard Woods, originally called Lakeside (renamed for Gordon Saltonstall Hubbard, an early Chicago settler), was the northern part of the village of Winnetka; although not politically independent, it did rate its own station on the Northwestern Railroad, on which my father commuted to Chicago. The part of Hubbard Woods where my friends and I lived was on the lakefront east of the tracks. West of the tracks was the business district with its stores, public buildings, and schools; further west was the great Skokie, the Indian name for marsh, where we bicycled to hunt for marsh birds' nests. A wooded knoll within the marsh called Crow Island, mysterious for its isolation in a sea of grass, was a haunt for a band of crows, frequented occasionally by owls (anathema to the crows) and a pair of red-shouldered hawks. To enter the dense stand of oak and hickory in summertime from the openness of the marsh was to become enveloped, by contrast, in stygian gloom, where unfocused, muted sounds produced an atmosphere in which one felt like an intruder in a forbidden sanctuary.

Hubbard Woods east of the tracks was divided into several sections by a branching ravine, which had been the course of a stream (subsequently diverted into a storm sewer) that flowed into Lake Michigan before the area was settled. The ravine became the route for Sheridan Road, the principal northern highway out of Chicago, until it was superseded by a less winding route west of the tracks. The point at which Sheridan Road entered the ravine was the only hill within the entire northern suburban area of Chicago, and in winter it became a popular coasting hill for both children and adults. The house my father built was east of the ravine on a bluff overlooking the lake, whereas most of

Eliot Furness Porter, Shushu, and Fairbank Carpenter,
c. 1910. Photographer unknown.

duced when iron sulfide is mixed with hydrochloric acid. On the friendly pretext of inviting Willoughby to play, but as a cover for our conspiratorial mission, we went to see him one afternoon. I had brought with me a small bottle of diluted hydrochloric acid and some lumps of ferric sulfide. As we were leaving his room, I managed undetected to secret the hydrogen sulfide generator above the door inside Willoughby's closet. Not until the next day did we find out how successful our prank had been. Because of the smell, Willoughby eventually caught on to what we had been up to, but it took him a long time before be located its source, which was revealed by the brown-stained plaster above the door. No parental wrath ensued from this escapade, probably because the amount of gas produced was small and it was taken good-naturedly by the victim. Innocent and gullible though Willoughby was as a young boy, he grew up to be the most adventurous of us all. Probably disillusioned by the standards of success in conventional society, he dropped out of Cornell to seek adventure in the West; he became a migratory laborer, rode freights, and worked in lumber camps, but eventually returned to Cornell, where he obtained a degree in forestry. Willoughby became the inspiration for exploits I undertook years later.

Fairbank Carpenter was just my age and became my very best friend until college days. I no longer remember how I became a friend of his but we soon became inseparable, and I spent more time with him than with any of my other playmates. He derived as much pleasure as I did from the untamed wild world. We explored the woods and the Skokie swamps and hunted for birds' nests together. It was with him that I discovered that witch hazel blooms in the fall after the leaves have dropped. The inconspicuous flowers that grow on the bare branches would go unnoticed were it not for the four, narrow yellow petals that give each blossom a spidery appearance.

The east porch of our house was enclosed in winter with plate-glass panels, replaced by screens in the sum-

my friends lived on the west side. The Wallings and Fishers were directly across and the Nelsons farther west on a side branch of the ravine, the only part without a road, and for that reason the place where we played more than anywhere else. South of where the ravine cut through the bluff onto the shore of Lake Michigan were three homes, including that of the Carpenters.

Willoughby Walling, who was my brother Edward's age, younger than most of my other friends, often went tagging along with us, and in trying to keep up would make a nuisance of himself; we older boys reacted by teasing him, sometimes unmercifully. He was especially eager to participate in our experiments with chemicals, so one day I proposed that we play a trick on him with the reagents in my chemistry set. Hydrogen sulfide gas that smells like rotten eggs is pro-

mer. Plate glass was a death trap for birds, to whom the porch appeared to be an open space through which they could fly. As a warning that there was an invisible barrier we taped pieces of paper to the middle of each panel, but in spite of this precaution a bird would occasionally break its neck against the glass. Sometimes we had the most colorful of these birds mounted by a taxidermist in Chicago, and sometimes father prepared skin specimens for me. Other specimens came less innocently. Guns have a lethal fascination for boys, because the temptation to take a shot at anything that moves is almost irresistible. Fairbank owned a beebee gun; almost the first day after it was given to him we went hunting to try it out. It proved miraculously and shockingly efficient when Fairbank shot a sapsucker in his front yard. There we were with a dead bird, still warm, proof of callous wantonness that we could not haphazardly discard, so we decided to ask my father to skin it, telling him we had found it. During the skinning he found the lead pellet and, not suspecting us of being the killers, said that the bird had been shot. I remember my uncomfortable feeling of guilt, not only for killing the bird but for the deception we had practiced.

That experience did not, however, end our hunting exploits until we were shamed permanently into giving them up some days later. I had found a blue jay's nest in a bush at the foot of our drive on Sheridan Road. The female bird incubating her eggs was so fearless one could almost touch her. For some inexplicable reason, Fairbank and I had the macabre urge to shoot her on her nest at close range. While we were taking aim, a car came by and the driver, seeing what we were up to, stopped and gave us a terrific bawling out, saying that shooting birds was wrong and to shoot a bird on her nest utterly disgraceful, that we should be reported to our parents. That episode was the ray of truth that struck home; it shamed us and, much to our unacknowledged relief, saved the bird's life. From then on shooting ceased to be an attractive sport for me except for sporadic target practice.

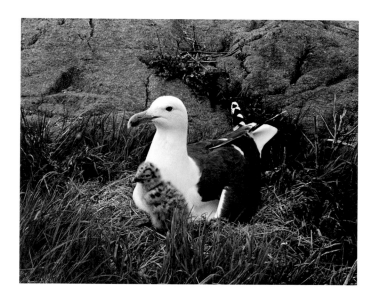

Great black-backed gull with young, Sloop Island, Maine, May 31, 1939.

In 1912, when we began to spend summers on our Maine island, the Carpenters had a summer place at Northeast Harbor on Mt. Desert Island. I was the oldest boy in my family with three younger brothers, with whom I had less in common than with boys my own age; this resulted in my brothers developing a rapport in their play that excluded me. In recognition of this situation and of my need for a summer companion, my parents encouraged me to invite Fairbank to the island for a month. After that first year he was invited every summer and became very much a member of the family.

Fairbank and I did everything and went everywhere together. One activity that we pursued seriously and enthusiastically for several years was collecting butterflies and moths. From an amateurish beginning we became more and more professional in our judgments and methods, and with adult advice and support gradually acquired the best equipment, including nets, cyanide bottles, drying and preserving paraphernalia, as well as the standard books on lepidoptera identification and life histories. We each had Brownie cameras with which we photographed the most approachable birds — gulls and terns on grass-covered islets, where they nested

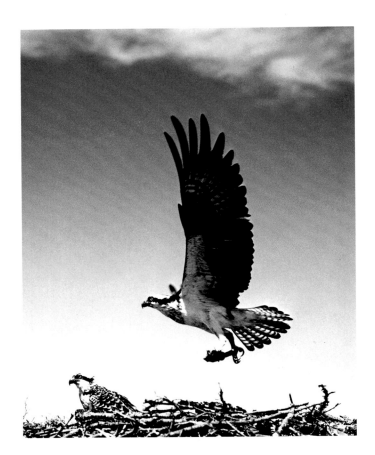

American osprey, Great Spruce Head Island, Maine,
July 22, 1949.

in dense species-segregated colonies. At first we were
taken to these places on expeditions organized by
adults, and our subjects were nests of speckled eggs or
the mottled gray, downy young wedged in crevices for
concealment and safety. Gradually we acquired more
sophisticated equipment, first Kodaks, which had
faster shutter speeds, and ultimately, as we became
more proficient, Graflex cameras — the sine qua non
for the naturalist. With these we spent hours at a time
crowded into a tiny canvas blind that I had designed
and mother had sewed together, photographing gulls in
their crowded colonies as well as the most appealing
and exciting of all avian subjects, ospreys or fish hawks.

In those years of our youth ospreys were very abun-
dant along the coast of Maine. They built bulky stick
nests, sometimes in trees but mostly on the ground on
rocky ledges and treeless headlands. On Great Spruce

Head Island only one of seven osprey nests was built in
a tree; all the others were located around the periphery
of the island on tidal islets or barren points of rock.
At these places we would set up our blind ten feet from
the nest after the eggs had hatched and crawl in with
camera, sandwiches, and a thermos of water. We never
had to wait long for the birds to accept the blind as an
inanimate addition to the environment and to return
to brood and feed their young. One adult would keep
watch at the nests, staring at the blind, while its mate
was off fishing. Its return with a fish was always an
exciting moment, both for us in the blind and for the
birds outside, and was always accompanied by enthusi-
astic piercing whistles by the mate on the nest.

During those first years on the island Fairbank and
I were not attracted by the passerines, the song birds of
the Maine coast. They were a mysterious and difficult
group to identify, unlike the birds of the woodlands
and prairies of the Midwest with which we were more
familiar. We knew a few songs, those of the hermit
thrush, the song sparrow, and the whitethroat, but the
wood warblers were a confusing group whose songs
and plumages were too difficult for us to distinguish
without prolonged observation — something we did
not have the patience to do. We found a few nests of
these species and marveled at the complexity and deli-
cacy of their construction and the beauty of the tiny
speckled eggs nestled within them. With our bulky
equipment, however, it was impossible to photograph
the nests and eggs, and least of all their creators. Not
until years later, following an abortive period of re-
search in science, when I had equipment especially
adapted to the purpose, did I return to photograph the
passerines, and then it was to the wood warblers in
particular that I devoted all my time in the spring of the
year.

My experience in public school up through eighth
grade was not very stimulating; not until I took Mr.
Boyle's chemistry course in high school did I enjoy for-
mal education. No doubt this had something to do with

the quality of teaching in Winnetka schools, before the educational system was made more progressive. It must have been because of an early awareness by my parents of this deficiency that I had been sent to a private school in the next suburb, called The College School, where the discipline was strict, and from which I was rescued by an attack of appendicitis. After that I was sent back to public school, where the eighth-grade athletic director, Mr. Clark, failed in his attempt to make an athlete of me, and the music teacher despaired of my lack of musical talent and kept me after school because I could not sing in tune. I was punished for being what she called tone-deaf, unable to sing the notes she struck on the piano. On this occasion my mother, who was also tone-deaf, intervened on my behalf.

I subsequently entered New Trier High School where the only courses I liked were chemistry and geometry. Latin was my bête noire, and I failed English because I could not spell, an inability that threatened my education until I was admitted to Harvard. After two years in high school my friend Fairbank was sent to Morristown School, a boarding school in New Jersey, for more intensive preparation for the college entrance exams than was provided at New Trier, and of course I wanted to go there, too, and begged my father to send me. I had already passed my college exams in chemistry and mathematics, but because of my difficulty with English and a foreign language — German was the language I was most familiar with because my youngest brothers had a German governess — my parents finally agreed to enroll me in Morristown. They probably realized that my chances for passing the other exams would be enhanced by the special training provided by a boarding school. The English teacher at Morristown, an elderly bearded gentleman always dressed in a dark suit, and nicknamed "the whistling deacon" in mockery of his sibilant manner of speech, dourly predicted I would never pass the English exam unless I learned to spell. But I did pass.

The first year I lived in the upper school dormitory, but the second year, as a prerogative of our senior status, I shared a room with Fairbank and another boy, Piran Edgerton, in a faculty house across the road from the school. Chapel was compulsory but bowing our heads during prayer was not, and I was among a group of students that used this opening to demonstrate our religious independence. Fairbank and I were able to pursue our photographic hobby at athletic events, for which we were granted special privileges during interscholastic games.

World War I was drawing to a close in the autumn of 1918, my first year at Morristown. At the same time there was an influenza epidemic that had little effect on the students, who were isolated from the outside world and restricted to the school grounds. Interscholastic athletic contests were also cancelled. Nevertheless early in November, on the first announcement of peace in Europe, the upperclassmen were allowed to go into New York to participate in the celebration. (As it turned out, the rumor of peace was premature; the armistice was not signed until a week later on November 11, when a less spontaneous celebration took place, which we were not permitted to witness.) Times Square was so jammed with civilians and soldiers and sailors on leave, aimlessly milling about, that motor traffic was completely immobilized. My wallet was stolen. We had been instructed to be back in school early and returned by ferry to Hoboken, taking the Lackawanna Railroad to Morristown.

About this time, after the Russian Revolution had deposed the Czar, a young teacher of history and government described to his class the workings of the Kerenski government. Word got around that he was subverting his students by promoting Bolshevism, and he was summarily dismissed. The chairman of the school board, an old man in his dotage, was called upon to address a school assembly to explain what had happened to the popular teacher. The teacher was fired, he told us, because our minds were being poisoned by

the "dragon of Bolshevism." This example of political intolerance had a lasting effect on me.

I was admitted to Harvard in the fall of 1920 with a condition in English for bad spelling and the requirement to take freshman English. Since I had registered in the Engineering School with the intention of majoring in chemical engineering, all my other courses were in sciences and mathematics. Elementary facility in a foreign language was required for graduation, which I fulfilled by passing the German reading-knowledge exam. As elective courses I took history and astronomy, the latter a great disappointment since I expected to learn about the latest discoveries regarding spiral nebulae and the formations of the moon — subjects on which father had talked at length. My father had both proposed and published what he called the "boloid theory" of the formation of the moon. The craters of the moon, he maintained, were not of volcanic origin, as generally assumed at that time, but were caused by the impact of meteors and asteroids, which were gradually swept up by the planets and satellites during the formation of the solar system. According to father's theory, all the planets should show evidence of this accretion process if only they could be seen at close range, as has now become possible through unmanned space probes that support his conjecture. Instead of addressing these issues, however, the course was devoted to a description of the planetary orbits of our solar system.

By the end of my junior year I realized that chemical engineering was not the field of science for which I had originally held such high hopes: that it was the chemistry of living organisms, biochemistry, not sterile industrial processes, that attracted me. My introduction to Slosson's *Creative Chemistry* had come at a time when the boundaries between the sciences were beginning to be blurred due to overlapping areas of activity. The most exciting advances in chemistry during my undergraduate years were, it seemed, being made, not in pure organic chemistry as suggested by Slosson, but in the chemistry of biological functions. To enter this bur-

geoning field a knowledge of biology and physiology was essential, and so I decided that I must go to medical school.

Medicine was thus a science that I came into indirectly from a primary interest in another field. I did not choose to study it, as many students did, out of a professed dedication to humanitarian ideals, but as a logical consequence of an interest in chemistry — not to alleviate human suffering, but in order to better pursue truth through science. Nonetheless, I was conditioned enough by idealism to be shocked during my first year by some of my classmates' frank admissions that their reason for choosing medicine was to make money.

I entered Harvard Medical School in the fall of 1924. Entering medical school is an exciting experience. Suddenly you are confronted with an entirely new point of view towards biological phenomena. Biology deals with life and living processes towards which the student is expected to be objective. Thereby he escapes personal involvement, and, in proportion to his avoidance of identification, tries to become a detached observer. A plant, a protozoan, an insect, an amphibian, and even a mammal are creatures towards which there is little difficulty in assuming a completely detached attitude. But as soon as he begins to study the human body, whether grossly or histologically, he finds himself no longer looking through an opened window onto a newly discovered world outside but, instead, into a mirror where he sees himself. To arrive at objectivity towards oneself requires for most of us a lifelong effort — if it is ever possible. The seemingly hard-boiled first-year medical student is only protecting himself with a not-too-impervious shell constructed precisely of his vulnerability. For not only is he suddenly confronted face to face with his physical self, he is subjected to a view of all its malfunctions and of the disease processes that may wholly corrupt it. This can be quite a shock but is also high adventure.

About this time I developed a capacity for observation that has lasted all my life: a capacity operative in

the natural world but not in other areas, such as in regard to people and cities or the interiors of houses. To this day my wife, Aline, can change the decoration in our living room and I might not notice it for weeks. But outdoors I saw a great deal and, without effort, became engrossed in nature. Very soon my attention was drawn to birds, a common enough interest, but in my case one which has been sharpened through the years, becoming directed away from youthful collecting to photography and more sophisticated knowledge of them. Butterflies were also a preoccupation, which at first took the form of collecting and later became channeled into photography. But I never considered making a career in natural history; these interests remained only in the background until years later when they became the focus of my attention.

As my second year in medical school drew to a close, I began to realize that I was not obtaining the quality of instruction that I had anticipated, and that medical school was, after all, primarily concerned with clinical education. Since my original purpose in going to medical school was to obtain an education in biological sciences in preparation for a career in biochemical research, I began to have serious doubts about continuing on for two more years. To help resolve this predicament I sought the advice of Dr. Hans Zinsser, head of the bacteriology department, who was by far the most charismatic teacher in the medical school at this time, and whose lectures were always the best attended. Through his humor and enthusiasm, his elucidation of the body's defenses against infection, and his dramatization of the search for the cause and cure of disease, he endowed the science of bacteriology with an aura of romance and adventure that captivated his audience. I was not immune to this influence. With sympathy and understanding he gave me his whole-hearted support and suggested that I take a year off to do graduate work in biochemical sciences in Cambridge, England, where he could arrange to have me admitted with the help of a professional acquaintance.

In June 1926 I went abroad on the Dutch Line steamer Volendam, disembarked briefly in Plymouth in order to register in Cambridge for the fall term, and then went to Paris and on to Vienna by the Orient Express. In Vienna I went to a summer school for foreigners to improve my German. There I met other American, Danish, Polish, and Indian students, and I lived with a Viennese family on Sievering Strasse. Life in Vienna was so very relaxed and easygoing that I was not a very conscientious student, neglecting the assignments that had to be done by those working for credits and becoming a frequent patron of the Viennese coffee shops, where I acquired a taste for *Kaffeschlag*, coffee with whipped cream. On weekends I went on *Ausflüge* (excursions) with some of the students; I took a Polish girl named Tamara to the opera and fell in love with her, but she had so many admirers that the competition was intense. One Sunday I invited Trude, the younger daughter in the family with which I was living, to go with me on an *Ausflug* to the Wienerwald, the forest near Vienna that is a popular place for outings. And on another occasion I accompanied Trude, along with her sister and brother, to a *Heurige* for an evening of revelry; a *Heurige* is an outdoor restaurant where *Neujahr* (new year) wine is served and where there is music and dancing. We all got very high, and I climbed onto a garden wall where flowers were growing to pick one for Trude. I think she wanted to marry me and go to America.

At Cambridge I was entered as an undergraduate again, enrolled in lectures in biochemistry and biology and assigned to a tutor, who gave me reading supplementary to the lectures. There was no laboratory work in connection with the courses, which would be available under the guidance of a lecturer only after I had established an aptitude for, and sufficient mastery of, the subject. The many regulations to which undergraduates were subject, as well as the curriculum, made me feel that I was being put back in school, and I began to think that this English interlude in my medical school education was a mistake. However, my extracurricular

association with some of the students was enlightening. I joined a discussion group in which the contradictions of the British Empire and Commonwealth and relations with America were discussed.

By the time of the long Christmas recess I had decided to return home and finish medical school. Before leaving, however, I went to Warsaw to see Tamara Morosovitch, the Polish university student with whom I had carried on a desultory correspondence. I stayed only two days, during which I saw her twice and was convinced that she was embarrassed by my attentions.

After Christmas I was back in the United States and went home to Hubbard Woods for a short visit before entering medical school again following the mid-year recess. While I was at home my sister and brother-in-law gave a party in their apartment in Chicago, and there I met Marian Brown, a Hinsdale girl home from Bryn Mawr College for the Christmas vacation. We met several times in New York after that first meeting, and I went to see her in Bryn Mawr. We became engaged and were married in her brother's house in Wilmett, a suburb of Chicago, in the spring of 1928. We lived in Boston during my last year of medical school and my first years of teaching and research following graduation. Our first child was a girl, Meredith, named for a sister of Marian's, who died of meningitis at the age of two. We had two more children, both boys; the first was named for me and the second, Charles Anthony, for Marian's father. We first lived in an apartment on Lime Street in Boston and later in a house on Charles River Square. In summer we would go to Great Spruce Head Island in Maine for four to six weeks and lived in the big house that father had built in 1911 for his large family; often my sister came, too, with her first child.

Although the house was large enough to accommodate us all, my parents recognized that in-law relationships were not always the easiest and that as a permanent arrangement married children needed their own domiciles. For this reason father purchased a Hodgson portable house for us that could be assembled in a

month. Hodgson houses are designed around six-by-twelve-foot modules that can be put together in many different styles. The house father ordered had three bedrooms, a bathroom, living room, and kitchen, with adequate closets. Plans were provided for the foundation, which I constructed during our second summer. The house arrived on a cargo schooner that was beached at high tide near the boathouse and unloaded at low tide. The modules were hauled up to the site by tractor and the outer shell of the house was assembled in two days with the help of everyone on the island. Interior construction, painting, electric wiring, and plumbing kept me occupied for the remainder of that summer and much of the next.

After the first four years our marriage began to deteriorate, and following a very trying period of unresolvable differences we were divorced in 1934. Marian obtained custody of the children, and I was allowed to have them on the island for two weeks during the summer.

I moved into an apartment not far from where we had been living. Since my ex-wife obtained most of our possessions I had to furnish the apartment from scratch, which led to my friendship with Peter Kilham, who had a workshop nearby. Peter was a very creative individual, an artist and inventor of great talent; he invented a tool for bending metal, built sporty automobile bodies, and designed modern furniture. For me he made very original and utilitarian objects for my apartment. He lived a few blocks away in his family's house on West Cedar Street with his father, Walter Kilham, a widower and famous architect, a younger sister, Aline, and younger brother, Lawrence. An older brother and two older sisters lived in New York. Aline was acting as housekeeper for her father and Lawrence, who was a law student at Harvard.

At the time of my introduction to the Kilham family Aline was a well-known painter in Boston, where her works had been exhibited twice. Her mother had been a painter of considerable talent, a faculty inherited by

Aline (who was also a gifted musician with a guitar and violin). When Aline was eleven her mother took the whole family to Paris for the winter, with the exception of Peter, who had done poorly in school and was left at home with his father. On graduation from the Winsor School in 1928, Aline received a scholarship to study painting abroad, which she did in Paris under Andre Lhôte. This experience determined her dedication to painting and the arts. Her main interest was flower painting, but not the literary style of still life — arranged vases of flowers in a conventional interior setting. Her style was freer and more abstract, a more personal and creative depiction of the essential qualities of her subjects — an entirely original approach to flower painting. She had also done some portrait painting in a style that was influenced, perhaps, by her mother and Andre Lhôte.

The Kilhams had a summer house in Tamworth, New Hampshire, where I was invited to go with Peter in the spring of 1935. We drove up there in an antique car he had remodeled with an aluminum body. It was an adventurous trip during which several breakdowns occurred, but Peter was not at all dismayed; an automobile trip without mechanical trouble was very dull to him. From past experience Aline and Lawrence had wisely decided to go ahead. Lawrence was off in the woods most of the time looking for birds, and Peter was involved with his car, leaving Aline and me together most of the time. She showed me around the house and large barn at the end of a dirt road surrounded by woods, not far from a woodland brook and isolated from the nearest neighbors. The wood frame house was a rambling structure with great charm that had been frequently enlarged. A small one-room house nearby was a favorite place for Aline and her sisters to stay. From that time on I began to see more of Aline in Boston and was often invited to supper. Frequently we would have cocktails with her father, and sometimes Lawrence, in the library on the second floor and then go down to the dining room on the first floor. Aline did

Aline Kilham Porter, c. 1938. Photograph by Ellen Auerbach.

the cooking for her father, which was often a baked dish, and I remember that on one occasion while we were sitting alone over drinks I heard a faint pop from below, whereupon Aline announced that supper was ready. She had put a whole eggplant in the oven to bake, and it had burst open — a signal that it was well cooked. In the fall I invited Aline to spend a weekend with me at my cousin Margaret Clement's farm in Peterborough, New Hampshire. One afternoon we went for a walk in the woods, stopping to rest on a sloping rock beside a brook, and I told Aline I loved her and asked her to marry me. She said she would. We were married the following May, went to Tamworth for our

honeymoon, and to Great Spruce Head Island for the summer.

After graduating from medical school I had been appointed to a minor teaching position in Dr. Zinsser's bacteriology department at Harvard and subsequently became a tutor with research opportunities in biophysics under Jeffries Wyman. I was employed in these positions from 1929 to 1939. The subject that interested me most at the time was the phenomenon of bacteriophagy, a process by which a virus-like factor destroys bacteria. The mechanism of the action was not well understood at that time and has only been superficially elucidated since then as techniques for genetic manipulation have become possible.

In two years I got to know Dr. Zinsser very well. I was persona grata in his house on Beacon Hill and at his farm in Dover. I was welcome at any time of the day or night as one of his family, and in fact he later told me that he loved me like a son. I could go to him for advice on any problem that beset me — emotional or intellectual — and he would give unstintingly of his attention and time. Although I returned his love with great affection and the greatest admiration, it was nevertheless a responsibility that weighed heavily on me at times. A facet of Dr. Zinsser's romanticism was a belief that a dedicated researcher could lose himself in his work to such an extent that he would sooner or later have to be rescued by his colleagues from starvation or nervous collapse. I never attained that state of immersion, for which I felt the guilt that comes from failing to live up to the expectation of another. I had started with the conviction, which became a hope but finally a despair, that I would make discoveries. I did not clearly understand that research mostly involves a slow, painstaking gathering of information, and my unrealistic views on scientific research at last resulted in disillusionment. I discovered that perhaps I was not cut out for this kind of a career. And the truth began to dawn on me — that you cannot succeed solely because of the pressure or hopes for you of one you admire.

Painful as the process eventually became, Dr. Zinsser brought to focus within my mind a better appraisal of my potentialities and aspirations. This was a by-product of his hopes for me, and because it led me in another direction it was difficult for him to accept; but it was a gift for me, for which I shall forever be grateful. I am grateful to him also for the greatly expanded outlook he made possible for me, for the advice that I did not always follow, for his understanding, and for his friendship. Indeed without his influence I might well have gone into medical practice. I might have prospered well enough in it, but I do feel that whatever creative potential I have — though one can never know the end of the untried road — would not have found the fertile ground it needed in medicine. I do not regret the years of scientific research he steered me into, for who could renounce an association that encouraged self-examination during the impressionable years of youthful enthusiasm and idealism? Hans Zinsser opened my eyes to my own inner capabilities through his inspiration, by his expectations of me, and through his personal dedication, honesty, and zest for life.

Probably partly as solace for my failure at research I began, after a lapse of several years, to take photographs and observe nature again; and although in a last attempt at research I transferred to another laboratory, where I worked conscientiously on a biophysical problem under another man, the seeds of my interest in nature and photography had by now taken root too deeply and were beginning to put forth their own fruit.

A contemporary in the Bacteriology Department, Victor Seastone, who had also recently obtained his M.D., was an amateur musician and photographer. He used the Leica camera, the 35mm German invention that revolutionized photojournalism and many other fields of photography. I was so intrigued by his ingenuity in adapting the camera to innumerable purposes that were impossible with more bulky equipment that I bought one and immediately began experimenting with it. Because of the Leica's top shutter speed of

1/1000 second, one of the first things I tried was to photograph the splash pattern produced by dripping water. The pictures were remarkably successful in so far as they dramatically recorded the sequence of invisible events in a common phenomenon, but otherwise were no more than curiosities. I soon began to photograph more conventional structural subjects — bridges and buildings around Boston and details of trees, flowering plants, and barnacled rock on the coast of Maine during my short vacations. One of the subjects I was especially proud of was a close-up of blueberries enlarged to the size of tennis balls.

My return to photography as a hobby became known to friends of the family, one of whom was Curtis Nelson's older sister Lois Wheelwright, who lived in Cohasset, Massachusetts. She invited me to dinner one day and suggested that I bring some of my photographs because another photographer would be there. The other photographer turned out to be Ansel Adams, of whom I had never heard, an acquaintance of Lois' husband. After dinner I was asked to show my pictures, which I did with a certain amount of self-satisfaction. Ansel Adams looked at them but said nothing, and then showed his. That was a traumatic and embarrassing experience; I saw immediately how vastly superior his photographs were to mine, and how little I knew about photography technically, or what its potential was for creative expression. The photograph that made the greatest impression on me and that I still remember from that day — I can recall none of the others — was his famous photograph of a frozen lake in the Sierra Nevada. Sensing my embarrassment, Ansel Adams tried to encourage me, suggesting that my photography could be improved by using a larger format camera and recommending the much-publicized new Eastman camera that used 2¼ x 3¼ inch film. Soon after that revelation I purchased a 9 x 12 centimeter Linhof.

Shortly after this experience, about 1930, I was introduced to Alfred Stieglitz by my brother Fairfield, who had settled in New York to pursue a career in painting. Stieglitz had introduced America to the works of several modern French artists and was first to exhibit painting by Americans now recognized as preeminent, in his gallery An American Place. Among those who influenced Fairfield most profoundly were Marin and Dove, whose paintings he saw for the first time at An American Place.

It became apparent quite early in Fairfield's life, before he went to college, that he was destined for a career in the arts, either as a writer or as a painter; he had considerable talent in both of these pursuits. In spite of his own artistic inclinations, father never completely understood Fairfield's aspirations or his first immature attempts to express them. Mother, however, was more sympathetic, albeit not informed about the prevailing vogue in painting. After graduating from Harvard, Fairfield attended the Arts Students League in New York, where he studied under Boardman Robinson. Mother paid for a trip abroad during which he toured Italy for several months, visiting all the museums and palaces in order to gain firsthand knowledge of the famous works of the Italian Renaissance painters.

After marriage he first settled in New York City, where he was living when he introduced me to Alfred Stieglitz, but after several years he moved permanently to Southampton on Long Island, and it was there and in Maine that he developed his inimitable style of representational painting. His circle of friends included writers and poets of distinction and many abstract expressionist painters, among whom was De Kooning, an immigrant from Holland whom Fairfield greatly admired even before he became famous. The French painters Fairfield especially admired and whom, more than any others, he sought to emulate, were Bonnard and Vuillard. Fairfield's dedication to realist painting was criticized by Clement Greenberg, who said of his work, "You can't paint like that and be successful"— to which Fairfield replied that that was precisely the way he would continue to paint. Fairfield was also a critic of recognized perspicacity and wrote reviews for *Art*

News. He once said that he considered himself a better
critic than painter.

Fairfield's probable motive behind introducing me
to Alfred Stieglitz was his hope that Stieglitz would be
willing to look at and constructively criticize my photo-
graphs. In his gallery An American Place Stieglitz also
exhibited his own photographs and those of a select
group of others. Soon after Fairfield's introduction
Stieglitz did agree to look at a group of my photographs.
He treated me kindly, contrary to what I had been led
to expect, but his comments were far from encourag-
ing. He said they were all "woolly," but that it was not
a matter of sharpness — a description I never under-
stood, as woolliness implied only one thing to me, and
that was lack of sharpness. Photography, he added,
requires a lot of hard work. I had the audacity to return
a year later with more photographs, when his remarks
were again noncommittal and his advice again was
to work harder. In the meantime I bought the small
Linhof view camera and photographed with it in Maine
for several summers and in Austria.

At Harvard, while I was a tutor in biochemistry,
I met Wolfgang Stolper, a Jewish Austrian graduate
student in economics. We became friends, and he pro-
posed that during the summer of 1935 we spend several
weeks in the Austrian Tyrol with members of his
Viennese family. This was before the Anschluss.
Wolfgang went first to see his fiancee in Zurich, where
I stopped briefly en route to Munich as part of a photo-
graphic journey through Switzerland and Austria.

While in Munich I was accosted by a seedy SA
trooper as I was coming out of the famous Deutsches
Museum; he asked in sputtery German for a light, and
when I offered him a match he asked for a cigarette,
which I was also able to provide. Recognizing me as an
American, he started questioning me about my visit to
Germany and invited me home, where we sat briefly
in the kitchen with an ample, silent, and suspicious
woman, who offered us nothing in the way of refresh-
ment. After leaving he asked if I would like to meet Der

*Berwang, Austrian Tyrol, 1935. Exhibited by Alfred
Stieglitz at An American Place, 1938 – 39.*

Führer. On noting my surprised, incredulous reply, he
assured me that Hitler always liked to meet Americans,
and so with some trepidation off we went to Hitler's
headquarters, where we were met by a black-uni-
formed guard, who politely informed us that unfor-
tunately Der Führer was away attending the Wagner
Festival. My feelings were a mixture of disappoint-
ment and relief.

I continued my photographic journey, traveling by
train to Innsbruck and from there to the little village of
Berwang, where I rejoined Wolfgang, his fiancee, and
his relatives from Vienna. During two weeks in the
Tyrol I photographed Tyrolian houses, churches,
graveyards, and the gentle landscape.

From time to time during this period I continued to
show work to Stieglitz, who gave me encouragement
but never once suggested that I contemplate giving up

Song sparrow's nest in blueberry bush, Great Spruce Head Island, Maine, June 15, 1938. Exhibited by Alfred Stieglitz at An American Place, 1938 – 39.

science. Finally, in 1938, I went to him with my most recent photographs, among them some of the pictures I had taken in the Austrian Tyrol. He looked at all the prints I had brought to An American Place, one by one, slowly replacing them in the box, and then went through them a second time, closing the box. After a pause he said to me, "You have arrived, I want to show these." These few words completely changed the course of my life. His was the most sought-after art gallery in New York — indeed in the whole western hemi-

sphere — for he was the first to bring the great modern French painters to this country. To have work exhibited at An American Place was an honor that overwhelmed me. Under the stimulus of this recognition I realized at last that I must make the break with science.

My decision to make a career in photography was received by my family, associates, and friends with the greatest skepticism. Dr. Zinsser was especially disappointed because he still had confidence in my research ability; if I would only stick to it, he said, I would make that "breakthrough"— his expression for a significant discovery. But I feared instead that I would have years of frustration working under the guidance of others for originality and inspiration. Members of my family were less concerned about my productivity, which they were not in a position to judge, than what they perceived as the wasted years of specialized education in chemistry, biology, and medical sciences. To give all that up was to renounce an expensive education and ten years of dedication to science. Yet I did not consider those years wasted; they were my past, the foundation on which my future was based. Without those experiences it would be impossible to predict what course my life would have taken, least of all that it would be in photography. In retrospect, from my experience it appears highly desirable to order one's life in accord with inner yearnings no matter how impractical they may seem and not to be bound to an unfitting vocation by practical considerations. Nevertheless I would not have been able to make the change, regardless of how urgent the need, had I not had the support of a sympathetic wife, who, being an artist herself, understood my concerns.

SANTA FE
AND THE WEST

STIEGLITZ'S OFFER TO EXHIBIT my photographs took me very much by surprise, and it was some time before I understood its potential significance. But what I did immediately realize was that I was being offered recognition for my contribution to photography, an avocation in which I had been engaged for several years. Success had come here before I had made any significant progress in scientific research. I could now unpretentiously regard myself as a serious photographer of recognized achievement, something I had never been able to consider before. This showing of my work vindicated the time I had spent, sometimes guiltily, making pictures with a camera on an island in Maine, while my conscience told me, according to others' expectations, that I should have been pursuing a career in science in a laboratory. I knew now that photography was legitimate for me; and that truth in the arts has a different dimension from truth in science. Here for the first time was something I could do with complete self-confidence.

The exhibition of my work at Stieglitz's An American Place was scheduled for three weeks in December 1938 and January 1939. The show consisted of twenty-nine black and white photographs of a variety of subjects: several landscapes of the Austrian Tyrol, which I had taken while in Europe in 1935, a baby portrait of my infant son Jonathan (born 1938), a picture taken on Bonaventure Island, Quebec, several landscapes of Maine, and a selection of birds' nests and birds. Although Stieglitz did not view his gallery as a commercial venture, a number of my prints sold during the show. David McAlpin, who was then on the board of the Museum of Modern Art in New York, bought seven prints; later he was responsible for organizing a show of my color photographs — *Intimate Landscapes* — at the Metropolitan Museum of Art. In all, I received four hundred dollars from print sales at the show, money I used to purchase an 8 x 10 view camera and a Protar lens. During the show I corresponded with Stieglitz, who wrote: "Crowninshield [Secretary of the Museum of Modern Art] was in and I showed them to him. He had asked me what it was in the young generation … that was so cold — so unfeeling. I showed him your prints as my reply. 'He has your kind of feeling,' he said, as he saw the first. He looked at all and said: 'very, very beautiful.'" And a review of the show in *The New York Sun*, December 31, 1938, read: "Mr. Porter is unquestionably an artist who looks upon nature with the appreciative eye of a painter yet gets his effects through straight photography. He indulges in no tricks and shuns sensational viewpoints. He is equally successful in simple landscape into which, somehow, he imbues a poetic feeling, and with tapestry-like details of grasses and materials which verge at times almost into the abstract. Mr. Porter gains a rank at once among our serious photographers."

During the weeks that followed the show at An American Place, I decided not to seek renewal of my appointment as a tutor in biochemistry and to terminate all research work at the end of the academic year in June. Giving up my job was not too much of a financial sacrifice, because I received a modest income from a

Jonathan Porter, 1938. Exhibited by Alfred Stieglitz at An American Place, 1938 – 39.

family trust. I went to Maine for the summer with Aline and our baby son, Jonathan, and, since there was no compelling reason for living in Cambridge now that I was an independent agent, I felt free to practice photography anywhere.

Aline's brother, Peter, had recently moved to Santa Fe and urged us to go there for the winter. Santa Fe, an attractive small town, the oldest European settlement in the United States and the capital of New Mexico, was favored with a very pleasant climate. Since I had become romantically oriented towards the West, first as a child on camping trips with my family and later on adventures with college classmates, I was especially eager to try living there. Aline, more conditioned to New England, was less enthusiastic but willing to try it for a winter.

In the fall of 1939 Aline and I drove west and, after

we were settled in a small apartment in Santa Fe, Jonathan was brought out on the train by a dear elderly Maine woman, who had previously worked for other members of the family and was willing to spend the winter with us to help with domestic responsibilities.

That first winter in Santa Fe was a very productive time for me due to the stimulation of a different environment, a dramatic landscape, and a foreign culture. As a photographer I was interested in its Spanish-Indian culture, surviving here in a less diluted form than anywhere else in the United States, characterized by adobe architecture, Indian pueblos, fiestas and Indian dances to celebrate the passage of the seasons or propitiate adversities of weather, and a devout Catholic society, unified by many unique adobe churches (each with its bell tower or cupola), which are found in every community, large or small, no matter how remote. Here there is semi-arid landscape, dominated by the valley of the Rio Grande and mountain ranges to the east and west that rise to over 10,000 feet and generate towering thunderheads in summer. The most famous mountains are the Sangre de Cristos, rising directly east of Santa Fe and named for the red light in which the last rays of the setting sun envelop them. But it was the Mexican-Spanish churches in the mountain villages that attracted me most by their flawless proportions, as they did other photographers who had come to northern New Mexico before me. With a new group of friends introduced by Peter, which included the poets Spud Johnson and Witter (Hal) Binner, the pace of life was less rigid than it had been in the academic atmosphere of Cambridge. We explored the countryside, the mountain villages, and Indian pueblos, where we saw Indian dances for the first time. We visited new friends in Taos, which was a nucleus for artists in the Southwest — among them Mabel Dodge Luhan and Frieda Lawrence — who were attracted by common interests and a congenial society. In the spring, Aline and I went on an automobile trip to Tucson and northern Arizona and later joined two friends in an expedi-

tion to Havasupai, the Indian reservation in Havasu Canyon, an offshoot of the Grand Canyon.

We stayed in Santa Fe only that one winter, returning in May to Winnetka, where my grandmother's house, which had been occupied by my brother, Fairfield, who had since moved back to New York, was now vacant. Aline's affinities were more with Boston and Europe and mine more with the Southwest; New Mexico was more alien to her than to me, harder for her to adjust to, and if we were eventually to live in the West permanently, she preferred to make the move in stages. But the most immediately compelling reason for returning was that she wanted to have another baby and felt more confident about the hospitals in Illinois than in Santa Fe. Our second son, Stephen, was born on July 24, 1941.

My primary interest during all this time was photographing birds. For two years before I decided to give up science for photography, I had been photographing passerine birds in Maine in black and white using artificial light — a special technique I had adopted in order to obtain much higher quality photographs than was possible with natural light. The bird photographs I had seen in publications, such as *Audubon Magazine*, were mostly of such poor quality that I was determined to raise the standards by which bird photographs are judged to those applicable to other fields of photography. Samuel Grimes of Jacksonville, Florida, and I developed independently a special technique for this purpose. We used large flashbulbs, which had to be synchronized with a shutter, devising means of adapting our equipment to this combination. Later, of course, entrepreneurs began to develop and produce such equipment. I was so encouraged by the results obtained with artificial light that I began to think about the possibility of a book of my bird photographs and showed them to a publisher, Paul Brooks, editor-in-chief at Houghton Mifflin. He complimented me on them but rejected the idea on the grounds that the birds could not be identified in black and white and, for pub-

lication, would have to be in color. I am sure he had no concept of the problems color photography of birds presented at that time, and perhaps not even whether the medium was available at all.

Eastman Kodak Company had recently developed Kodachrome film, which I immediately adopted for photographing birds in Maine in the summer of 1939. This made the process of bird photography more complicated. The early Kodachrome was a beautiful film but had a speed of only ASA 5; much larger apertures were necessary or more flash bulbs closer to the subject had to be used to get correct exposures. This made photographing a subject as elusive as birds more difficult, but the results were very satisfactory.

Because Kodachrome film produced a color transparency, another major problem was how to produce color prints from transparencies. The only photographic color printing techniques available at that time were the three-color carbro process and a method developed by the Eastman Kodak Company called washoff relief. They both involved making three negatives of the transparency with red, green, and blue filters — the three primary colors of the spectrum. The carbro process was the most permanent and beautiful but the most laborious, involving the bleaching of black and white prints of each of the separation negatives in contact with sensitized, pigmented tissues to produce three-color relief images, which were then combined manually in register. The process was not designed for duplicate printing. Washoff relief involved producing positive gelatin relief images on film base from each of the separation negatives, which were then dyed in colors complimentary to the primary colors recorded by the negatives. Thus the red negative positive is dyed cyan (blue-green), the green negative positive is dyed magenta (red-blue), and the blue negative positive is dyed yellow (red-green). The three dyed gelatin images are then consecutively pressed in contact with mordanted gelatin-coated paper. The dyes transfer completely from the dyed positives to the mordanted

gelatin on the paper, where they are chemically bound. The positive gelatin images, called matrices, are registered and punched before dyeing, and the transfer is done on a board with pins that match the punch holes. Many duplicate prints can be made simply by redyeing the matrices.

Since it was not possible to establish a photographic laboratory in my grandmother's house, I obtained space for a darkroom, with the help of my brother Edward, in a building in Chicago he managed in the family interest. Here in 1940 I began to experiment with color prints by the washoff-relief process from transparencies. I obtained all the theoretical and practical information I could find about color printing in photographic journals of the Optical Society of America and anything published by the Eastman Kodak Company with special reference to the washoff-relief process. The properties of the materials used in the method did not always seem to conform to expected standards, and thus it required a great deal of experimentation to obtain even moderately acceptable results. The matrix film was fragile and not very stable, dimensionally. The transfer paper had to be made either by coating paper with gelatin or by clearing the silver from unexposed enlarging paper. These papers often required more than half an hour to absorb each dye.

Since I sought to achieve prints as close as possible to the quality of the transparencies, I had to take into account the properties of the filters used to make the separation negatives. For the best results the separation filters should transmit a narrow band of light, but since they actually transmit wavelengths outside that band, the colors in the print are degraded. To overcome this effect the separation negatives must theoretically be made from transparencies masked with negatives made with filters complementary in color to the separation filters. This would be the solution if the spread of light transmitted by the three separation filters was equal, but it is not. The first prints I made on the basis of this theoretical assumption were posterized, that is, the colors were saturated but all intermediate hues were lost. The result was that I had to give up masking and accept prints in which the colors were more subdued and degraded but more realistic. Eventually Eastman Kodak published a masking technique that took into account these characteristics of the separation filters, was less complicated, and produced prints that were remarkably accurate replications of the original transparencies. By this time other improvements had been made, both in materials and equipment, and the process was renamed dye transfer.

In spring of 1940 in Santa Fe I applied for a Guggenheim Fellowship to photograph birds in color. Most of my friends were very pessimistic about a fellowship being granted for such a specialized project, so in the following February I was surprised and delighted when I received a letter informing me that my application had been granted with a stipend of $2500. When spring came and my Guggenheim Fellowship was announced, I drove west to Tucson to begin photographing birds, where the breeding season begins much earlier than in Maine, and I continued that project during the summer of 1941 in Illinois.

The Japanese attack on Pearl Harbor on December 7, 1941, changed everything. We heard the news on the radio Sunday morning, and in that one moment all my plans for the coming year became meaningless. I knew that photographing birds during wartime would be an impossible pursuit but thought that my knowledge of photography might be of some use in the war effort, and with this hope I tried to enlist in the Air Force as a photographer. I was rejected, ostensibly for minor physical reasons but more likely because of my age, and eventually obtained a war job scheduling work in the machine shops at the Radiation Laboratory at M.I.T., where military radar was being developed — a secret project described to the inquisitive as the development of radiators. We moved back to Cambridge for the duration.

My job was to expedite the production of experimental apparatus requested by physicists and engineers in the various departments, which involved assigning the work to those shops with the lowest work load. Also at times I was forced to make decisions as to the urgency of a request, which did not always please the person making it, but on the whole there were few complaints and the work got done satisfactorily. Sometimes when the job was small I could do it myself, since I had access to some of the machine tools. One day I discovered that in a shop with which I had a rather limited connection, several of the machinists had no work and were passing the time doing crossword puzzles. I assigned some work there, which displeased the foreman, who complained to the head supervisor of all the shops, Mr. Kohler, who, feeling that I was undermining his authority, complained in turn to Dr. Loomis, the physicist director of the Radiation Laboratory. Dr. Loomis summoned me to his office; Kohler was there. I was told that what I had been doing must not continue, and that all the work had to be scheduled through Kohler. I protested and defended my methods to no avail and then, becoming quite angry, I described the state of affairs, the waste, inefficiency, and uncooperative attitude I had found in the shop from which the complaint came; but bureaucratic rigidity prevailed and my responsibilities became much less direct.

As the war was drawing to a close in Europe with the invasion of Germany late in 1944, I resigned my position at the Radiation Laboratory, and we moved back to Illinois. Here I was able to resume my photography of birds, though only in a limited way because of gasoline rationing. We were in Maine in the summer of 1945 at the time of the Japanese surrender.

Aline had become reconciled to living in New Mexico or, perhaps more accurately, had given in to my wishes, so that fall I drove out to Santa Fe to find a house. Since it was soon after the end of the war many places were for sale, one of which belonged to friends from our first year in Sante Fe — Ernest and Gina

Knee, a photographer and a painter like Aline and myself. The house was in the rural community of Tesuque, a few miles north of Santa Fe, which appealed to me especially, though we found it meant driving our children to school would become a routine responsibility. It was in need of much repair but the price, which included some of the Knees' furniture, was very reasonable, and I was able to have the most critical repair work done during the next year.

By this time my family had been increased by our third son, Patrick, born in February 1946. We drove out to Santa Fe in July 1946 with Jonathan and Steve, leaving Patrick to be brought out by train as soon as we were settled in our new house; he was too young to be subjected to the long motor trip, which in those days before there were interstate highways took more than a week. (Patrick, who was then only four months old, has always felt cheated out of a western birthright.) The children were very excited at the prospect of going west; Jonathan probably remembers very little of his first winter in Santa Fe but to Stephen, who knew nothing about the wild West, it was a great adventure. Expectations were very high. When we crossed the border into New Mexico, we stopped by the roadside to let the boys release their pent-up excitement, and they ran about like colts first out to pasture. They romped and scampered all over the place with an exuberance that confirmed the wisdom of our decision to come west.

This summer was the continuation of a new lifestyle and occupation briefly attempted before the war in 1939, when my commitment to photography was unfocused and experimental. I resumed my bird photography project with renewed zeal. Not only did I have a definite goal, the pursuit of which would keep me occupied for the springtime of many years, but I had a new land — the wide open Southwest — to learn to know and understand, to incorporate into subconscious acceptance, to share and explore with my children.

Our new house was situated on the west side of a fourteen-acre plot of land, across which ran the Tesuque

village irrigation ditch not more than one hundred feet west of the house. Cottonwood trees and Chinese elms had been planted along the ditch to provide afternoon shade to the house in summer, and below the ditch in a two-acre orchard, cherry, apple, and pear trees had survived four years of neglect during the war. The house was roughly H-shaped with the living room in the middle, three bedrooms and two baths on the south side, and a large studio, hall, dining room, and kitchen on the north side. A storeroom and small darkroom opened off the east side of the kitchen and beyond that was a large workshop with only an outside entrance. It was a pueblo-style house with two-foot-thick adobe walls and a flat roof bordered by a parapet through which canales projected for the runoff of rain water. Portales (porches) surrounded much of the exterior to provide shade in summer to cool the house. Each room in the house, including the kitchen and a bathroom off the studio, had an Indian pueblo-type fireplace — eight in all. There was also a two-car garage, which was a separate building from the house.

In addition to being a noted photographer, Ernest Knee was a skilled craftsman and carpenter. He had done most of the carpentry for the house himself, including many beautifully paneled doors, mullioned windows, and corbeled vigas.

The Knees had no children, and we soon began to appreciate the difference between their requirements and ours. One of the first changes we made was to remove the partition between the storeroom and darkroom in order to make one large pantry and utility room. I needed to replace the darkroom, so I built a larger one more suitable to my purpose as a separate structure attached to the garage. Carpentry and furniture making were activities I had enjoyed since childhood, and over the years I had acquired an adequate supply of hand and power tools. The workshop was, therefore, a very useful feature of the house. Eventually, however, the workshop was converted into bedrooms and a bath for the children, with an entrance

through the utility room off the kitchen. For a workshop I then closed in the garage, added a concrete floor, and brought in electric power. A new garage was built later. At first I shared the studio with Aline, but that arrangement proved impractical for a painter and a photographer, a situation which was remedied by building a studio of my own attached to the darkroom. These building projects and renovations were not done all at once but were carried out over a period of years as the need for them became apparent.

There was one requirement of a different kind that had to be met very early — the matter of transportation. The station wagon in which we drove west had to be available to Aline at all times, and I needed a vehicle for photographic purposes. I learned that the Federal government was selling off army field ambulances, preferentially to veterans. My sister's brother-in-law, who was a veteran, obtained one for me at a reasonable price that was practically new. The standard ambulances were four-cylinder, four-wheel-drive Dodge trucks with rear doors. I repainted it an earth-color brown, and installed two folding bunks, a gas stove, sink, water tank, and storage cupboards so that I could live in it for an extended period. I also made it possible to use as a darkroom. I could go almost anywhere in this vehicle on photographic trips and live in it quite comfortably.

Aline had continued her painting after we were married until this activity was limited for a while by maternal responsibilities in a growing family, but she never stopped painting entirely. Another important facility of Aline's, which grew to a creative art in later years, was a fundamental concern with her immediate environment — the house in which we lived. This concern involved all the objects with which we were surrounded, the furniture and decor of our rooms. She was not a decorator in the traditional sense; the talent she had (and has) was the ability to make the place in which we lived exceptionally beautiful, pleasant, and convenient.

Another manifestation of this talent was the plea-

sure Aline got from constructing an elaborate doll's house in Winnetka after Steve was born. She first began model-building by creating miniature rooms in two orange crates, which in those days were partitioned wooden boxes. I took pity on her and built a two-story house out of plywood with a staircase to the second floor, double-hung windows, and paneled front and back doors. The front and the roof of the house were removable, and the proportions were odd, but at least it was better than orange crates. We took the house with us to Santa Fe, where it was stored in the garage and generally forgotten as Aline became more preoccupied with painting and the children; years later it was resurrected.

Gradually, under the influence of abstract expressionism and Betty Parsons, who had become an intimate friend, Aline's painting changed to a more geometrical style prevalent in New York in the fifties. Betty Parsons had a gallery on 57th Street in New York, where she showed Aline's flower paintings and her abstract work. (Her abstract paintings were also exhibited at Section Eleven Gallery.) About this time, as an outgrowth of her fascination with doll houses, Aline began to make constructions and arrangements in boxes of assorted, unrelated objects, which when placed together in original relationships became creative and sensitive works of art. Aline had been greatly influenced by Joseph Cornell, who originated this kind of creative construction. Her boxes were exhibited by Betty Parsons and have repeatedly been shown in Santa Fe; they have always been enthusiastically received and have been purchased by many patrons of the arts.

After several years of experimenting with abstract art, Aline returned to her first love, flower painting, which she pursued in both Maine and New Mexico. And with the children grown up and away from home she thought again about the doll's house that had been collecting dust and dirt in the garage, where it had suffered considerable damage when the boys had set off firecrackers in it. It was brought into her studio, where

I repaired the worst damage. For years Aline worked on it; she enlarged and refurnished it, put clapboard on the outside, and wired it for electricity. It was built and furnished in a New England style that became more elaborate and exquisitely detailed under Aline's loving and imaginative care. Before the New England doll's house was finished she began the construction of an adobe, pueblo-style house, which was a true model in every respect — proportions, architecture, and furnishings. It was a typical one-story, flat-roofed building constructed of vigas and latillas with fire walls and canales. The furniture was all handmade by a Santa Fe craftsman. When completed Aline gave it to the Folk Art Museum in Santa Fe, where it was on exhibit in the lobby for several years and greatly admired. The first doll's house was eventually given to the Albuquerque Museum. As with any artist, the pleasure Aline derived from these projects was largely in their making.

Following her abstract period Aline's paintings were not entirely of flowers. She also developed a style of dividing the canvas into panels — separated by black or another appropriate color — in which she painted various objects: a single blossom, a leaf, a shell, berries, or a bird's nest. These paintings were very popular and could be more readily sold than she was willing to part with them. Her other works were still life paintings of cups, pots, and other vessels reminiscent of the work of the Italian painter Giorgio Morandi.

During our first years in Santa Fe most of my time in spring was devoted to bird photography, a process that involved much time and effort learning birds' identities and habits and hunting for their nests — the prerequisite to photographing them; making the photographs was the least time consuming part. When I went off photographing, Aline did not always go with me, especially to the wild places, since for her it would have involved much patient waiting while I photographed. Bird photography, which usually involved many hours of searching for and watching birds and the operation of the photographic equipment, I always did alone. But

Graveyard, Tesuque Pueblo, New Mexico, 1939.

when I went to the Spanish and Indian villages, which attracted her the most, Aline minded the waiting less and often accompanied me. And we went together on visits to friends in Taos or to Georgia O'Keeffe's studio at Ghost Ranch or in Abiquiu. The cultural and human aspects of New Mexico appealed to Aline more than the natural surroundings. Also, she was more tied down by domestic responsibilities than I. She was able to get away occasionally to New York for more direct contact with the contemporary art world. She loved to go to New York, the dynamic center of art in America, to reestablish contact with her friends in the art world and to gain firsthand experience with the most recent art movements. And in those years our family trips to Maine for the summer were a welcome break from the routine of living in Santa Fe.

One experience that stands out in our early Santa

Fe years was a trip to Mexico that Aline and I undertook with Georgia O'Keeffe and our friend the poet Spud Johnson. Georgia O'Keeffe had moved to New Mexico in the late forties, taking up residence first in Taos but settling permanently soon thereafter in a house on the Ghost Ranch near Abiquiu, which she purchased from Arthur Pack. The artists' colony in Taos, under the aegis of Mabel Dodge Luhan, was not congenial to an individual with such a dominant personality as that of O'Keeffe, who needed complete control of her social relationships. She was attracted to New Mexico by its agreeable climate, adobe architecture, and the warm pastel colors of the desert landscapes that inspired so much of her painting. She became a friend of Spud Johnson, whom Aline and I had gotten to know during our first winter in New Mexico. Of the four of us, only Spud had been to Mexico, and on hearing him describe his trip there with D. H. Lawrence we cooked up a plan to drive together to Oaxaca in February of 1951.

We decided to go in two cars, Spud with Georgia and Aline with me. The route we chose was the Pan American Highway from Texas to Mexico City and on to Oaxaca, our southern destination. We had expected to depart from Santa Fe early in the morning, but as so often happens on group expeditions, delays caused by procrastination and inexperience occurred. Georgia had failed to provide herself with the required Mexican tourist papers. Eventually in the afternoon we departed, heading south towards Texas. South of Laredo our pace was more leisurely; we had picnics at noon on the excellent food that Georgia had brought, made frequent stops for photography, and stopped early at the best hotels for the night. Aline and I wanted to stop early at night so that we could have drinks before supper, but Georgia always wanted to eat immediately, complicating the routine, because Spud, who would have preferred a later supper, felt obliged to accommodate Georgia's wishes. The result was that we seldom dined together. In Mexico City we became separated in

our search for hotel accommodations and only got to-gether again briefly in Oaxaca at the Marqués del Valle Hotel. Our room looked out onto the plaza, where we were awakened at night by the haunting, dulcet music of a marimba band — a serenade for those from far away.

In Oaxaca I photographed the famous ceiling of the Santo Domingo church and several aspects of the clois-ter and convent. We drove to Mitla and Monte Albán to see and photograph the Zapotecan ruins, and in Mitla I was particularly intrigued by the juxtaposition of sixteenth-century Christian churches with pre-Columbian temples. We visited several villages in the neighborhood of Oaxaca, and I took several photo-graphs of the interior of an earthquake-damaged church in Maguile Xotchitle. I was discovering the fascination of church art, both in the exterior architecture and in the interior structure and decoration, especially the latter, which expressed a more sympathetic human acceptance of the teachings of Christianity than the formal sixteenth-century architecture of the building that enclosed it. Much of the decoration was the work of peasant Indians, a simple, often naive, expression of reverence for the saints and holy icons on display.

Some years later, in 1955, I returned to Mexico, in the company of photographer Ellen Auerbach, to do a major photographic survey of Mexican churches. We spent months traveling from San Miguel de Allende to the Yucatán and Chiapas, returning by way of Oaxaca. In addition to churches, we also photographed many other aspects of Mexico. Thus I satisfied the interest sparked during my first years in Santa Fe.

One other experience with Georgia O'Keeffe dur-ing my early years in Santa Fe stands out in my mem-ory. In 1961 I went on a river trip down the Colorado River through Glen Canyon with a small group that included my son Stephen, his fiancee Kathy, the pho-tographer Todd Webb, and Georgia. One night we camped on a gravel bar littered with rounded stones that had been shaped and smoothed by flood waters

loaded with sand. Since moving to New Mexico, Geor-gia had assembled quite a collection of natural objects she had found, including weathered bones, wood, and stones, which she frequently used as subjects for paint-ings. While supper was being prepared everyone searched the bar for attractive stones, and a contest developed to see who could find the most beautiful specimen. I spent most of my time, however, photo-graphing the stone collectors. By the time our guide announced supper by calling out, "Come and get it," Georgia had accumulated quite a hoard. I had picked up nothing but boastfully declared that I would find the most perfect stone. By chance on the way back to camp I found a polished, black, elliptical, hand-sized stone; and when I showed it to Georgia, she would not give it back until I said it was for Aline. It was the win-ner. I kept this stone in my pocket, and often during the rest of the trip Georgia would ask to see it. I would show it to her but would not let her hold it, for fear she would not return it.

The following Thanksgiving we had a party to which we invited Georgia. Steve came down from Col-orado College, and he suggested that we set a trap for Georgia with the black stone. We have a black slate coffee table in the living room on which he proposed we place the stone, saying nothing about it to Georgia. As we were talking we noticed that she had spotted the stone almost immediately but did not comment on it, and when she thought she was unobserved she picked it up and put it in her pocket. Later we confronted her with the theft, and she unabashedly returned it. I sus-pect she may have realized that we were playing a game with her.

Some time later Georgia invited Aline and me to a meal in her house in Abiquiu. We decided then, since she wanted the black stone so badly that she had tried to steal it, that we would give it to her. Ever after when we visited her, Georgia would show us the stone where she kept it on a shelf at the head of her bed. Years later a magazine photographer went to Abiquiu to do a story

on Georgia, and she showed him her favorite stone, given to her, she said, by a close friend. A photograph of her holding the stone in her hand was included in the magazine story.

My primary focus during my first years in Santa Fe, however, continued to be bird photography. During those years I regularly photographed birds in the spring and early summer, returning to Arizona as well as going to many other areas in search of local species. I went on birding expeditions to south Texas, the Midwest and mid-Atlantic states, Florida, and the Chiricahua mountains in southeastern Arizona, and also pursued the work on my many trips to Maine. The states of the Midwest that I visited most often were Michigan and Minnesota, states in which a greater number of species of a particular bird family are found than occur in most other parts of the country. They are the wood warblers, a group with which I had become enchanted and which attracts most ornithologists. They are small birds with colorful plumage and distinctive songs by which they are readily identified, and there are some fifty species in the United States.

Through friends in my field of interest I was introduced to bird people in southern Michigan, who welcomed me into their fraternity, took me with them on their photographic and bird-watching excursions, and led me to the best warbler habitats. We shared all our discoveries and photographic opportunities. I was taken to the nesting area of the Kirtland's (or jack-pine) warbler, the rarest of all its genus, found only in one Michigan county and nowhere else in the world. Its common name denotes its narrow adaptation to a habitat of young jack pines.

One of the first people I was introduced to was Edward M. Brigham of the Kingman Memorial Museum in Battle Creek. He was a director of the Michigan Audubon Society, which was independent of the national organization (a situation that many members made sure I was cognizant of), and an editor of the Society's bulletin, *The Jack-Pine Warbler.* Ed Brigham, a naturalist

in the traditional sense and an enthusiastic wildlife photographer, insisted that I stay with him and his family, a rare example of hospitality extended to a near-stranger in recognition of shared interests, but without the assurance of more than a dilettantish commitment. I visited the Brighams again the next year and met William Dyer, another Audubon director and Superintendent of Union City Schools, and Dr. Powell Cottrille of Jackson, Michigan. They both invited me to stay with them. Powell and his wife, Betty, were superb birders who took two months off from medical practice every year to photograph birds, both movies and stills. I became a regular guest of theirs, driving to Jackson at the end of May, from where we would set off together for different warbler habitats in Michigan, Minnesota, Ohio, and the Connecticut Lakes area of northern New Hampshire. Betty Cottrille knew all the warbler songs, and once a bird was located she had the patience to watch it for hours until it led her to its nest and mate. ("Patience" is the wrong term for this kind of activity, one which is usually used by non-bird people. Your attention is entirely focused on the events taking place around you, whether they are related or not to the activity of the principal subject of your search. Everything that is going on is important, because there is no way of knowing the significance of any event until you discover its connections with other events.) We were a very good team for finding the nests of many kinds of birds, not just warblers.

In bird photography I have usually sought to include enough of the characteristic habitats to which the various species have adapted to suggest environmental relationships, rather than simply to obtain close-up portraits in which the immediate surroundings are almost entirely eliminated. To me, photographs of birds in their environments are the more meaningful and aesthetically pleasing. When photographing birds in the breeding season, which is the easiest time in their life cycles to do it because their habits are then most predictable, a sampling of the habitat is included by

necessity, but the choice of what to include should be made with discrimination and an eye for the aesthetics of the situation. By this time I was using sophisticated equipment involving electronic flash, which had to be operated by power from a storage battery and included three flash lamps. Thus my equipment was quite bulky, and I often had to make four trips from the car to the bird locations in order to carry it all in.

My efforts to photograph birds led to fascinating moments of observing their behavior. I recall one occasion in New Mexico on which I was attempting to photograph long-tailed chats in a willow thicket on the flood banks of the Rio Grande. These birds, like the piñon jays, were so extremely timid that I had resorted to a blind, but even then they would not accept my equipment. I had removed most of it from near the nest and was beginning to set it up again piece by piece when the chats began a querulous complaint — those unmistakable despairing cries that always indicate the presence of a snake. I could see none, but the outcry that had begun some distance away drew slowly closer. From what direction the snake was approaching, whether along the ground or through the tops of the bushes as some varieties are quite capable of doing, I could not tell. I only hoped that it would pass by leaving the chats unmolested, but I did not appreciate the hunting acumen of snakes and this one I learned soon enough was zeroing in on the chat's nest. In spite of the fact that I was very much on the alert for its appearance, I was completely taken by surprise when I saw it poised over the nest. It had climbed up the willow in which the nest was built and was looking down at the young birds. How it got there so suddenly, unnoticed by me, I could not understand, which was a rather disquieting experience. Nevertheless the thought came to me of what a dramatic picture I could have gotten had only my equipment been operative: the copper-colored sinuous length of the snake twined through the willow stems that supported the nest and arching over above to reveal the pale yellow-pink belly scales, with

Stephen Porter with bull snake, Tesuque, New Mexico, 1948.

its insensate head aimed like the arrow of destiny at the young birds below. The snake was a five-foot Rio Grande red racer. I rushed out of the blind and drove it off. But I did not know how persistent snakes are, and in twenty minutes it was back. Three times I chased it from the nest, and three times it slithered off evasively over the branches of the willows without going to the ground and with a speed that did not belie its name. The fourth time I pursued it with a determination fed by anger, caught and killed it. Then I packed up my camera and equipment and left the chats, ashamed now for the travesty I had perpetrated against nature.

Another memorable experience with birds happened during a sojourn in south Texas, when I found a coot's nest in a cattail marsh at the edge of a small pond. Since the water was too deep for a blind but not for a tripod, I decided on a procedure that had worked well

Patrick Porter, Tesuque, New Mexico, 1950.

in a similar situation, years before, at a small Illinois prairie marsh inhabited by red-winged blackbirds. On that occasion while I moved through the cattails, counting the redwings, I flushed a marsh bird from a nest containing eight sparsely speckled, buffy eggs. Since she went off quickly through the reeds, I could not identify her; but from the eggs, which were smaller than a bittern's and not immaculate, I guessed her to be a Virginia rail. Because of the reputed timidity of rails, I surmised that an attempt at directly photographing the owner of the nest would not succeed, and decided on another strategy. This was to place a triggering device, concealed in a split section of dried cattail stalk, in the nest in such a way that the rail would press against it and release the shutter as she settled over her eggs. The scheme would undoubtedly be a one-time affair if it worked at all, since following the trauma of the first

exposure it was unlikely that the bird would return a second time so long as the camera and lamps remained in place. Nor was there any way to ensure that the bird would be in the most satisfactory position at the moment of exposure. Nevertheless, concluding that nothing risked meant nothing gained, the next day I set up my camera with the triggering device in the nest, and then walked to higher ground on the far side of the small marsh to watch what happened. I had not been there long when I saw the flash and knew that mechanically, at least, the device had worked. Later, the picture of a Virginia rail arranging her eggs proved that the effort was justified.

Such was the device I intended to try with the coot. Setting it up as I had before, I went away and waited several hours before returning to see whether a photograph had been taken in the meantime. No bird slipped away into the cattails as I waded out to the camera, and my first thought was that she had deserted. Then I saw that the nest was empty. Evidently a predator had come and eaten the eggs. Its identity was a mystery, since there were no broken eggs, fragments of shells, or signs of their contents to be seen: the nest was as tidy as though it had just been completed. In my bafflement it did not immediately occur to me that I might have a record of what had happened. And indeed the processed film revealed the predator: an indigo snake in the act of swallowing one of the eggs, all of which it had eaten whole.

Inspired by the New Mexico environment, I became interested in photographing other forms of biological life in addition to birds, in particular reptiles, spiders, and insects. Jonathan and Stephen were fascinated by the abundance of wildlife around our house and would capture lizards for me to photograph, of which fence lizards, race runners, and horned toads were the most common species. I photographed them in natural settings, but because they were always very active and hard to control I would cool them off in the ice box before placing them in an appropriate position,

and as they warmed up and again became alert I would photograph them before they dashed off. Snakes of a number of kinds were not uncommon where we lived; bull snakes were the most docile and could be easily handled because they liked the warmth of the human body. For several years Jonathan kept a bull snake, which he carried around with him under his shirt. Bull snakes had to be fed on mice, which were easier to raise than to trap — not the most pleasant aspect of keeping a pet snake. Although we never saw rattlesnakes at the 7,000-foot altitude of Santa Fe, they could be found in the Rio Grande canyon west of us.

The most favorable time to photograph spiders and insects was late summer when they were most abundant. The best way was to photograph captured individuals in my studio with controlled illumination and in natural environments brought in from outdoors, which was not difficult to do because of the small size of the subjects. My children brought me all the strange creatures they found — strange to them and some even strange to me — from grasshoppers, katydids, beetles, and wolf spiders to praying mantises. I particularly wanted to photograph tree crickets stridulating. They are the insects that produce the buzzing sounds at night, from whose frequency one can estimate the ambient temperature. Jonathan and Steve were able to capture tree crickets for me, and I sat up late into the night with a recalcitrant individual perched on an elm tree branch in front of my camera, with flash lamps set for the moment it should be inspired to do its stuff. After a long wait it raised its wings vertically above its back and began to rub them together, revealing its stridulation technique, which varies from species to species of the orthoptera.

From time to time I raised spiders in my studio in order to photograph them. One black widow I raised fabricated two egg sacs in quick succession. During the night the eggs in one of the cases hatched, and on entering my studio in the morning I discovered a sheet of fine silk fibers extending from the cage to the ceiling. Cling-ing to this veil of finest gossamer from top to bottom were hundreds, myriads it seemed, of minute, pale brown spiderlings. They were all in motion, creeping slowly along the nearly invisible fibers. How they had ballooned the silk to the ceiling in the still air of the studio remains a mystery, but true to instinct they had deserted the guardianship of their mother, who once they acquired an active independence might have eaten them. I had no idea how to cope with this multitude of newly born spiders, how to transfer them outdoors. The task was not complicated by risk of being bitten, since immature black widows are not venomous, but any means of intervention was made impossible by their sheer numbers and smallness. So I left my studio door open, and inadvertently the glass top of the cage, when I had to leave on other business. On returning in an hour or two I found to my great relief that all the young spiders had vanished, and with them, unfortunately, their mother.

When our children were older I took them on camping trips around the Four Corner states — to the Grand Canyon, to the national parks in southern Utah (Zion and Bryce), and to the San Juan Mountains in southern Colorado. The ghost towns of Silverton and Ouray, which were slowly being abandoned, had been the centers for extensive mining in the San Juans. The many deserted mines there were an attraction to me as a photographer and to the boys for souvenir collecting. We camped in some of the deserted mine buildings and drove on old mining roads to the most remote mines. Some of these appeared to have been abandoned on short notice, since the machinery was still in working condition. One of the longer camping trips I took with the boys was to Yellowstone National Park. The most spectacular phenomena of the park — the geysers, hot springs, and mud pots — did not excite the boys as much as the black bears, which we encountered everywhere begging for handouts and upsetting trash cans, fearless but not tame, and not to be trusted — a situation I had to impress on the boys. The bears often came

into the campsites at night foraging for food and would make a great racket knocking about a food container that had been inadvertently left out, trying to break it open. I always had the boys sleep in the truck while I slept in a tent beside our campfire. One night in a crowded camp site, when several bears were making a tremendous commotion with trash barrels while the campers were banging on tin pans to frighten them away, a lone bear stuck his nose in my face as I was lying with my head near the open flap of the tent. I hit him, shouting to drive him away, and was thankful that the boys were in the truck where they slept through it all.

A few years after moving to Santa Fe I realized that I needed a more maneuverable vehicle for bird photography to get me and my increasingly elaborate equipment into the roughest terrain. For this purpose I purchased a Universal Jeep with a canvas top, the civilian counterpart to the original military Jeep. The price was $1400 and in this vehicle I was able to drive across country and high into the mountains in search of the more uncommon and elusive birds. I also took the Jeep on some of the camping expeditions with my children and their friends by towing it behind the ambulance. On one such camping trip to the San Juan Mountains I drove the Jeep to the top of Engineer Mountain, a barren peak beyond the capability of a larger vehicle, and to Stony Pass between the Rio Grande and the San Juan River watersheds. On another of these expeditions, while I was photographing the abandoned Highland Mary Mine, Jonathan and his cousin, David, were searching the mine buildings for souvenirs and discovered a case of dynamite, which they carried out and put in the Jeep to use for some ill-conceived purpose. When I discovered it shortly thereafter I was horrified and made them put it back,

much to their chagrin and disappointment, since they considered the find a great treasure.

Some summers we went to Maine, to Great Spruce Head Island, which to our youngest child was the epitome of Maine. On one occasion Aline went by train with Pat and I drove east with Steve and Jonathan in the ambulance. With us we had a little black dog named Inky that we could not, of course, leave behind; in addition, we had an assortment of other pets, including Jonathan's bull snake Nosey as well as, I believe, a hamster or two. In the Midwest we saw many box turtles crossing the road as though on a mysterious migration, and we picked one up. The top speed of the ambulance was 45 mph so that we were constantly being passed by all passenger cars. The boys could ride in front with me but usually preferred to be in the back where they could play or lie on the bunks. I began to notice while driving through the Plains states that the people in the cars passing us were often laughing, and I wondered what was so amusing, thinking it might be the ambulance; then I discovered that as the cars approached, Jonathan and Steve were holding the pets up to the rear window one at a time to show the people in the passing cars.

Once in Maine we had barely settled in when Nosey, the bull snake, escaped. Jonathan was very distressed, but we knew he would not starve. On the day before we were to leave, Nosey was discovered under one of the apple trees, having grown considerably on a diet of voles, which are abundant on Maine islands. He was the first and only bull snake that had ever enjoyed such a salubrious summer on a Maine island, where his only relatives were the green and brown meadow snakes. Jonathan brought him back to his native land, where he would not have to contend with the hardships of a New England winter.

THE SIERRA CLUB AND CONSERVATION

BY NATURE is generally meant the environment of man that he has not had a hand in shaping. This definition is, however, so rough an approximation that there are almost more exceptions than examples that fit it. Consider only for a moment the extent to which the human race has been altering its surroundings over large areas of the earth for generations. Ever since men became what we call civilized they have been busy altering the face of the globe by cutting down forests, plowing up prairies, and damming up rivers — to mention only a few of their activities. As a result, even in New England, a relatively recently populated part of the world, there is hardly any original, untouched nature left. Nevertheless, those areas of the land that are not continuously exploited and occupied by people — second-growth forest, pasture land, hedgerows, etc. — are legitimately included within the domain of nature. (In one sense, of course, everything — man and all his works included — belongs to nature, but for convenience one may distinguish between man and the rest of nature.)

Let it be assumed, therefore, that by nature is meant all there is in the world that man has not had a controlling hand in molding. In this category one might include growing corn or domestic animals, over which he has certainly exerted a profound influence but which he has not actually created, whereas skyscrapers would definitely be excluded. I think within these broad limits, without further definition and without running the risk of significant misunderstanding or ambiguity, the photography of nature can be discussed.

It is the beauty of nature that I try to represent by photography. What this expression means to most people, I am quite sure, is such features as the flowers of spring, autumn foliage, mountain landscapes, and many other similar aspects about the aesthetic qualities of which no one would care to offer contradiction. That they are beautiful is indisputable, but they are not all that is beautiful about nature; in fact they are only the most obvious and superficial aspects of nature — which anyone may observe with half an eye. They are the peaks and summits of nature's greatest displays. There is no doubt about their importance; they could not be dispensed with. Underlying and supporting these brilliant displays are slow, quiet processes that pass almost unnoticed from season to season, unnoticed, that is, by those who think that the beauty in nature is all in its gaudy displays.

Much is missed if we have eyes only for the bright colors. Nature should be viewed without distinction. All her processes and evolutions are beautiful or ugly to the unbiased and undiscriminating observer. She makes no choice herself; everything that happens has equal significance. Nothing can be dispensed with. This is a common mistake that many people make: they think that half of nature can be destroyed — the uncomfortable half — while still retaining the acceptable and the pleasing side; their idea is of a paradise where nature stands still. Withering follows blooming, death follows growth, decay follows death, and life follows decay — in a wonderful, complicated, endless web the beauties of which are manifest to a point of view unattached to

vulgar, restricting concepts of what constitutes beauty in nature. Thoreau, who observed all aspects of nature throughout his life, repeatedly remarked on the beauty of the unaccepted. "How much beauty in decay!" he exclaimed on examining a worm-eaten oak leaf. To him the sere, brown leaves of winter were as beautiful as the fresh green of spring. This was a principle that has remained important for me throughout my career.

Ever since I had been told that photographs of birds must be in color to be publishable, I had been working with that goal in mind. Unfortunately, I had not been able to enlist the interest of any publisher, largely on account of cost. I had, however, taken close-up color photographs of other nature subjects, which my wife considered original, and to help alleviate my frustration with my bird photographs she suggested that I concentrate on a different theme. My photographs, she said, were evocative of Thoreau's commentary on nature. The idea was so remote from my involvement with photography that I was taken by surprise, but it did appeal to me. I started reading Thoreau, first *Walden*, which at first I found dull, followed by his other books, *A Week on the Concord and Merrimack Rivers*, *Cape Cod*, *The Maine Woods*, and eventually his journals. I carried some of Thoreau's works with me wherever I went on my birding trips, much to the amusement of my associates. I marked passages that appealed to me and with which I felt I could associate a photograph of comparable sensibility; and I took photographs of subjects for which I hoped to find a compatible description by Thoreau. Because I had learned to think in close-up terms, small objects and the details of nature first drew my attention. And so I photographed the little things of the woods and fields: dead leaves, mosses, decaying logs, wildflowers, and once in a while a tree trunk or the entire tree. Thus I pursued birds and Thoreau simultaneously for several years; and in the end I became more distracted from bird photography by Thoreau's wider perspective on nature.

I worked on the Thoreau project for twenty years

or more, from about 1939 to 1960, in the course of which time I produced a dummy that combined my photographs and Thoreau's words. I showed it to publishing houses in both Boston and New York. One editor after another considered the proposal, praised the photographs, admired the sentiments of Thoreau, and ultimately shied away from publication on the grounds of color reproduction costs and the parochialness of Thoreau's following. I was told the book would not sell outside of Massachusetts. The time was not ripe for such a focusing on nature. The environmental movement had not yet gained the momentum that was soon to sweep across the country and force government to take cognizance of the heedless destruction of natural beauty.

However, this situation changed significantly, and my career direction with it, when the Sierra Club accepted the Thoreau proposal. The breakthrough occurred in 1959 while I was showing a selection of the photographs at the George Eastman House in Rochester, New York — an exhibition entitled *The Seasons*, organized by Nancy Newhall. At a cocktail party given by Nancy and Beaumont Newhall for the opening of the show, I told Nancy that no publisher was interested in my Thoreau book, and she said she knew someone who might be — David Brower, the Executive Director of the Sierra Club. She telephoned him on the spot in San Francisco and described the kind of book I had in mind, and he expressed immediate interest, urging me to send him the dummy, which I promptly did. After considerable delay, which I interpreted as probably an indication of rejection, he wrote me that the Sierra Club wanted to publish the book provided they could raise $40,000. Two years later, while Aline and I were in Colorado Springs for the celebration of our son Stephen's wedding, Brower tracked me down with the news that the Sierra Club had received a gift of $20,000 and a loan of an equal amount for the publication of the Thoreau book. The loan, from Kenneth Bechtel (president of the Bechtel Corporation and a director of the

National Audubon Society), was to be repaid, provided the book was a financial success. The book was published in 1962 and printed by the Barnes Press on Spring Street in New York, where I spent many hours, mostly at night, observing and offering criticism during the press run.

The Thoreau book took its name from Thoreau's essay on walking: *In Wildness Is the Preservation of the World*. Joseph Wood Krutch contributed an introduction. My first encounter with Krutch was through his book on nature, *The Twelve Seasons*, written when he was living in Connecticut. He was a literary critic and contributor to *The Nation* and other national magazines, whose reputation was based on his critical biographies of Poe, Johnson, and Thoreau. Shortly after *The Twelve Seasons* was published he had moved to Tucson, Arizona, to devote himself almost exclusively to describing the phenomena and ecological dynamics of the natural environment. On one of my bird photography expeditions to southern Arizona I had gone to see him for his advice and opinion on my Thoreau book. I showed him examples of my photography, and I may have shown him the dummy for the book. He was interested and very helpful, suggesting several passages from Thoreau that I had not discovered, and when I asked him if he would write an introduction for the book, he agreed. In addition, we collaborated on an appeal to a Congressional committee concerning an environmental issue, he writing the statement and I supplying color prints to go with it. He was also interested in my bird project and spent a day with me in the field looking for the nest of a rufous-winged sparrow. Another of Joseph Wood Krutch's books, *The Forgotten Peninsula*, about Baja California, would inspire a later adventure of mine.

In Wildness was an immediate best seller in San Francisco — an indication that social awareness of environmental concerns was growing, contrary to what all other publishers had foreseen. Its publication led to an association with the Sierra Club that resulted in widening the purpose and scope of my photography. I saw that the camera could be a powerful instrument for persuasion for other than exclusively aesthetic and creative purposes, without diminishing in the slightest degree the artistic integrity of photography. Photography could be used, I began to realize, to open the eyes of people to the natural beauty of their surroundings, to the intricate relationships of plants and animals, to the continuing processes of change in the living world of growth and death and transformation, in other words to the ecology of the wild environment — although ecology was not then the fashionable word it is today. I became convinced, also, that photography's persuasiveness was greater the higher the aesthetic quality of the photograph, and greater still in color than in monochrome.

People were often startled by the relationships revealed in my color photographs; sometimes they were incredulous, other times delighted, but never indifferent. The disbelievers are most often those who have been preconditioned to a stereotype of nature, not blind but unreceptive to the portrayal of unusual and exotic aspects. Nature to them presents a bland and expressionless face except during her violent extremes; her subtle fleeting moods escape their notice. For me the stereotype is the least interesting aspect of nature, and the one I most often reject as a color subject. The wide blue sky, the big landscape, the mountain scene, the comprehensive views — these I believe are best portrayed in black and white.

The relationships that are all-important for me in nature photography are best illustrated in my close studies. Close is a relative term; it may refer to a spot of lichen or a reflecting pool in the sand, or more broadly in a larger connotation to a sheer cliff or a grove of trees. But in either case the photograph is an abstraction of nature — a fragment isolated from a greater implied whole, missed but imagined, a connection which assists in holding the viewer's attention. The comprehensive, explicit view lacks more often than not this compelling quality. The relationships that interest

me are both biological and aesthetic, ecological in the broadest sense: interactions between living things and the physical environment, which includes rock, water, and ambient light.

The recording of these interactions stimulates the most dispute in my photography. Depending on its quality, ambient light produces remarkable and not always readily appreciated effects on the subject. In certain situations this light will be heavily loaded with blue from the sky, which will be manifest in blue highlights on smooth reflective surfaces even though an overall blue cast to the shadows is neutralized by reflection of light from other parts of the environment. These blue highlights are especially noticeable in shaded locations on the upper shiny surfaces of leaves, on moving water, and on the oxides formed on smooth rock surfaces called desert varnish. The most severe criticism of my photographs has been directed at the recording of these phenomena, particularly at the portrayal of vegetation with a blue overcast. Blue rock reflections have also received a fair share of dogmatically expressed disbelief by people who claim to have been to the same places. By exploring these relationships in my photographs, I hoped that people would see beyond what they had been conditioned to see, to perceive the subtle and intricate interrelationships that shape the natural world. I have received many letters from people young and old about *In Wildness*, telling me how it has opened their eyes to nature.

But strangely my eyes, too, have been opened by this book and stimulated by its success, by those with whom it brought me in contact, and by the opportunities it created for other photographic projects concerned with preservation of our wilderness legacy. Two book ideas that had their origins way back at the beginning of my career as a photographer came to life again.

My second collaboration with the Sierra Club, *The Place No One Knew: Glen Canyon on the Colorado*, was about the travesty of the damming of Glen Canyon. To produce the photographs for this book I made eleven

raft and boat trips on the Colorado River through the canyon. This experience and my association with the Sierra Club and its many dedicated members transformed me from a theoretical and intellectual conservationist to an emotional and militant conservationist.

In the late summer of 1960 I was invited by Spud Johnson to join a group from Taos on a raft float down the Colorado River through Glen Canyon. I had hardly heard of Glen Canyon and knew nothing of its scenic wonders, but was eager to see this geological feature of the West which was new to me. I did not anticipate that this trip would lead to anything of special significance to my photographic career. We started off in two rubber rafts from Lee's Ferry, the only possible crossing of the Colorado between Moab and Navajo Bridge. This was an experience unlike any I had ever enjoyed before; here I was at the bottom of a narrow canyon looking up at vertical walls, rather than looking down from above — a more intimate perspective than a view from the top. I was part of the scenery, part of the convoluted sandstone cliffs and the brown river that had been undercutting and eroding them grain by grain for thousands of years. I had visited Canyon de Chelly, but there the dynamic forces at work were less apparent and less impressive, despite its magnificence. The flow of water in Canyon de Chelly is intermittent after rain; one can drive into that canyon and risk getting stuck in quicksand — a blind trap unlike the thoroughfare of Glen Canyon. (On one visit to Canyon de Chelly in my ambulance with my two children, Jonathan and Steve, we *did* get stuck in quicksand, but extricated ourselves by cutting willows to place under wheels.) Glen Canyon was difficult to comprehend on that first trip; it was so monumental and so complex that I could not focus on any of its features without experiencing a confusing sensation of losing contact with the whole canyon.

Every year until 1965, sometimes twice, I went back to Glen Canyon. A group of my early pictures were exhibited in the Sierra Club headquarters in San Francisco, where they attracted a good deal of attention and

led many to realize that this was a place that should have been high on the Sierra Club's list for preservation. The construction of Glen Canyon dam, which had begun at the time of my first visit, would, when completed in ten years, flood one hundred miles of the canyon under several hundred feet of water, burying for all time a unique geological wonderland and scenic treasure. From the time of my first introduction to Glen Canyon, I realized that the dam would be a scenic and aesthetic disaster for everyone who had ever floated the Colorado through there, as well as for all those who unknowingly would be deprived of that experience. I was especially affected by the circumstance that the Commissioner of Reclamation who was largely instrumental in obtaining the Congressional appropriation for the dam was my brother-in-law, Michael Strauss. He was a dam enthusiast, committed to a vast program of hydroelectric power development that would harness most of the rivers of America. He admitted, however, that even if all the rivers were maximally developed for power production, they would deliver only five percent of the foreseeable electric power needs. Why are you so concerned, he asked me, about a mere two hundred feet of water, when above that level there will still be a lot of natural scenery and besides it will make a very pretty lake. He did not appreciate the natural beauty that was to be lost, because to preserve it would have prevented a development to which he attached greater value. He believed that the usefulness to man of natural resources is measured by their material and economic value; for him, aesthetic considerations were of minor importance. In the late 1950s, without any knowledge of what would be sacrificed, the Sierra Club had proposed to the Bureau of Reclamation in the Department of the Interior that in place of the dam it was considering in Dinosaur Monument at the confluence of the Green and Yampa Rivers, it dam Glen Canyon, a suggestion that may have influenced its decision to do so. Despite this unfortunate turn of events, David Brower decided to publish my book of Glen

Canyon photographs, which he named *The Place No One Knew: Glen Canyon on the Colorado*; it came out in 1963. The title indicates a more universal ignorance than he should have wished to admit, thus, perhaps, deflecting criticism for a bad policy decision. In 1963 the dam had not yet been completed; at that point the Sierra Club, discovering its mistake, lobbied against the dam and attempted, unsuccessfully, to prevent it from being completed.

This was my second book in two years with a conservation message, and the bird book, which did not have such an ancillary purpose, was still not even on the horizon. The only success I had had with my bird project was the publication of a few pictures in *Life*, a contribution to *Land Birds of America*, published by McGraw-Hill, and some badly reproduced photographs in a National Geographic Society publication entitled *Song and Garden Birds of North America*.

I was still going to Maine for at least part of each summer, and, to educate Californians about the beauty of another part of the country, I invited David Brower and his family to visit me on Great Spruce Head Island in 1964. Aline had decided to stay in Santa Fe that summer. The Browers came for a two-week vacation of ease and relaxation, leaving the housekeeping and cooking largely to me. Their sons went off rowing and swimming every day, while I showed Dave and his wife Anne around the island. Brower was obviously very much impressed by the beauty of the landscape and by the way we had adapted to living on a Maine island for more than half a century. He asked if I had ever thought of writing about it, and I said I had long ago, before I became involved with bird photography, but that nothing ever came of it. You must write about your life in Maine, he said, and the Sierra Club will publish it with your early black and white and color photographs. I set about it enthusiastically, discovering how much I remembered once I got started, and how varied and active my childhood had been. The book was published in 1966 with the title *Summer Island: Penobscot Country*.

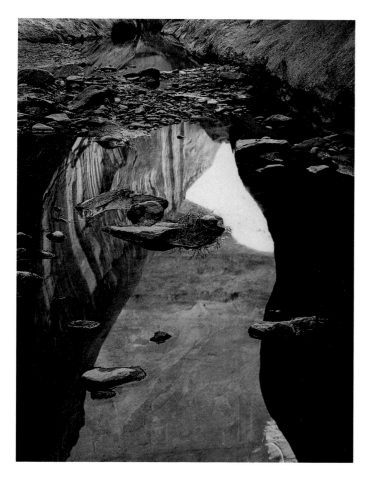

Hidden Passage, Glen Canyon, Utah, August 27, 1961.

In looking back I also recalled how much Fairfield's presence was a part of Great Spruce Head Island for me. Fairfield had started painting on the island, where his subjects were the landscapes of the Maine coast. My interests at that time were wholly in the realm of science; as a consequence we had little in common besides the usual family intercourse. This was the situation for many years, even when we were together in summer on the island. Not until I gave up science for photography did our interests begin to converge and finally become intimately interwoven. I was very affected by his paintings of the sea and sky and the spruce trees growing right down to the water's edge, which captured the very essence of relationships in the natural world. When I sent Fairfield a copy of *Summer Island*, along with my Adirondack book of the same year, he wrote

me: "Thank you for the Island book, which I love: it is your best collection of photographs, I think even better than *In Wildness*. In this book each photograph is better than the previous one, and there is never a let down. In the Adirondack book some that I very much like are the first wide landscapes with slopes of millions of leaves in the foreground and a mountain in the distance, and the ones of deserted orchards in which sight is carried beyond itself to a kind of total knowledge of the world as a whole."

During the last summers of his life, I often visited him in his studio on the back porch of the Big House, which had become his by right of occupancy. On these occasions he would show me what he was working on and the paintings he had completed; he would then ask for my opinions and listen reflectively to my comments, which, as an inexperienced critic, I expressed with hesitation. During one of these conversations he told me that he had been influenced by my photography, words of praise that I cherished. Fairfield was the brother to whom I grew closest in my later years. After his death in 1975 his wife, Anne, wrote me: "He really loved talking with you; so often he said at the Island, 'I think I'll go and see if Eliot is home.' The text of the book on Antarctica was such a joy to him I'm sure he told you. He kept saying, 'It's beautiful, beautifully written. It's a classic.'"

My Sierra Club books also led to another meeting with Ansel Adams. In 1961 Aline and I were in San Francisco to celebrate the Sierra Club decision to publish the Thoreau book; we were invited to Ansel's house to meet with David Brower and other members of the Sierra Club, and to reach a final agreement about various features of the book, including the dust-jacket photograph. I had brought a group of color photographs with me, which I was asked to show to the assembled group. When I unpacked them, Ansel Adams would not look at them and left the room. He had a strong aversion to color photography, maintaining that color had no legitimate place in the art of photog-

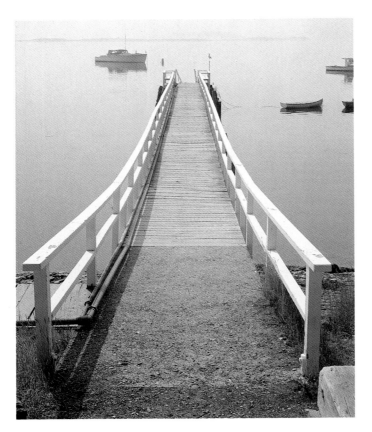

The wharf, Great Spruce Head Island, Maine, July 25, 1965.

raphy, and that it degraded the medium. Amplifying his views later, he explained that color photography was too literal to be an art form, that it was not possible to practice it interpretively, and therefore that it was not creative, whereas the interpretive possibilities of black and white were unlimited. Years later he was to disclaim color photography for its falsification of reality.

We became good friends in spite of our differences, which never affected my admiration for his photography that so profoundly influenced my own. I visited him several times in California, and he and his wife Virginia stayed with us more than once in Santa Fe. He started life as a pianist and became a photographer, the story goes, after seeing his father-in-law's photographs of Yosemite, certain he could do better. Ansel Adams was very good company socially and on photographic outings. He was a great showman and entertainer, and more often than not the life of the party. I remember

one hilarious evening at our house when he played the piano with a grapefruit. Ansel was impetuous, always on the go and at times painfully thoughtless, but when asked for help or advice in photography he was unsparingly generous. One time when he dropped in to see me unannounced, he stormed into my studio with scarcely a word of greeting, hastily inspected some cloud pictures that I had recently hung on the wall, and said, "You don't get good whites"— and dashed out again. I was very much taken aback by such abrupt, though probably perceptive, criticism.

It was hard to pin ulterior motives on Ansel. His remarks, which may have seemed at times to conceal devious motives, were actually frank expressions of considered judgments. Ansel was a dedicated conservationist who never hesitated to express his opinions on the environment to any official involved with the issues, including the President of the United States, so it was difficult to find fault with him even when his remarks carried a painful bite. On the publication of *Summer Island* Ansel was quoted as having remarked that my exposure was becoming too much, to which our fellow photographer Imogen Cunningham said with characteristic asperity, when I reported this remark to her: "Too much for him." (Imogen, too, could be quite blunt; at my first exhibition in New York of Mexican church photographs, she asked me rather pointedly what determined my choice of subjects; and when I explained that we photographed everything we could inside the churches, she said, scathingly: "It looks that way.")

Meanwhile I was working on another project independently of the Sierra Club. In 1962 I had been approached by Harold Hochschild, founder of the Adirondack Museum, at Blue Mountain Lake, New York, to take photographs for a book the Museum planned to publish on the Adirondacks, the wooded mountains west of Lake Champlain; the book would be a selection from the work of several photographers. Hochschild lived in Princeton, New Jersey, during

the winter and, in summer, on his large estate in
the Adirondacks. Mary, his wife, was a Marquand,
who had spent her childhood summers in Keene
Valley, New York, on the east side of the Adirondack
Park, which she loved and intimately identified with.
Probably she was largely responsible for determining
the Adirondack Museum's decision to finance the
Adirondack book. The proposal appealed to me, since
the Adirondacks were a part of the eastern Appalachian
mountains I had only superficially visited and this was
an opportunity to know them better.

In the fall of 1963 I put up at an inn at Blue Moun-
tain Lake and devoted the next several weeks to pho-
tographing around that area, both in the park and on
private estates, where, through Hochschild, I had
received permission to photograph. The Adirondack
Park had been established under a provision of the
New York State constitution, which stated that these
lands "shall be forever kept as wild forest lands"; the
provision had, however, recently come under attack by
private interest groups seeking to amend the consti-
tution to permit commercial developments. The
Hochschilds had expected me to give them not more
than a dozen photographs, but I found such an inex-
haustible wealth of subjects that I gave them more
than one hundred. They were hard pressed to make a
small selection. I was invited to their Princeton house
for a review of the pictures, and there Mary Hoch-
schild told me they could not decide which ones to
use; instead, they asked me if I would be willing to take
all the pictures for the book. I was delighted to accept,
of course, and explained that that would require many
trips back to the Adirondacks in all seasons. I returned
in the spring of 1964, in the winter of 1965, and again
in the spring and fall of that year.

In the course of this work I described the enterprise
to David Brower, who immediately attempted to cap-
ture publication of the book for the Sierra Club. "Cap-
ture" is the correct description for his action, which
offended Harold Hochschild's sense of propriety and

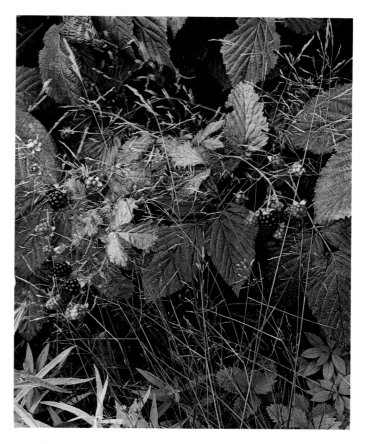

*Blackberries and grass, Great Spruce Head Island,
Maine, 1954.*

resulted in his angry rejection of Sierra Club partici-
pation. The Adirondack Museum negotiated a copubli-
cation arrangement with Harper & Row, a fortunate
choice for me, because it led to a long, happy, and
productive association with the executive editor, John
Macrae. Essayist and journalist William Chapman
White, a lover of the Adirondacks, was supposed to
contribute the text but died; however, Mary Hoch-
schild approached his widow, Ruth White, who chose
some of his writings to accompany the photographs.

I became fascinated by what I read about the origin
and geological history of the Adirondacks, which began
one billion years ago as towering snow-capped peaks.
These were reduced by the inexorable force of erosion
until only their roots remained; and in more recent
times the grinding and polishing weight of mile-thick
ice had rounded and smoothed them.

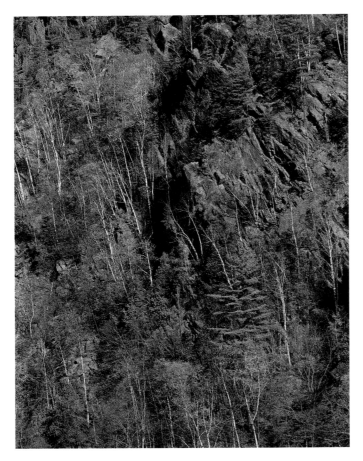

Trees in OK Slip Ravine, Adirondack Mountains, New York, October 6, 1963.

In the fall of the year the Adirondacks reach their time of greatest glory. Then the autumnal color-changes reveal the great variety of vegetation; where before all was green, and one leaf was scarcely distinguishable in the mass from another, now this uniformity is replaced by all shades of browns and russets, yellows and reds. The hillsides become patterns of contrasting vivid colors, which thousands of city people travel hundreds of miles to view. The undistinguished, bushy pastures change their character completely. In the tangles of weeds and coarse grasses, the leaves of blueberry bushes glow like the coals of burned-out fires in the slanting rays of the sun.

Lichens seem to be richer in hue at this time of year. When the fall of the leaf begins, the forest floor is strewn with discarded needles of the pines, scattered like jack straws among the red and yellow maple leaves and browning ferns — all except the evergreen ferns that retain their green under the snow. The quiet, flowing brooks are at their best now, littered with still-unfaded leaves revolving in the eddies and plastered on the wet rocks at each little cascade. The clear water reflects in blurred and swirling patterns all the colors of the fall mixed with the blue of the sky — kaleidoscopes of shifting hues. Along the marshy borders of the flows, cattails turn to russet-brown, and their full, ripe coffee-colored heads lose their plushy firmness as they begin to disintegrate and disperse their seeds.

There are few places on this continent where the land retains such an intimate relationship with its water system. Second to the mountains themselves, the rivers, streams, and lakes of the Adirondacks are the wildest areas. The Hudson River rises at the foot of Mt. Marcy, and to the north the Ausable flows into Lake Champlain. Water is everywhere abundant. In the southern part, an intricate network of interconnecting lakes and ponds offers some of the best canoe country in the United States. Ponds dot the countryside; every hollow in the hills holds one; some are the sources of brooks, whereas others are situated midway in the flow from high drainage basins to large streams.

This is not farming country, although there have been farms there, and still are. It is a land of wildness, a land where the forests belong, a land of the beaver and bear, of the deer and fox, a land where one can still see what the land once was, a land to go to and return from, a land where one can escape from his neighbor and enjoy the peace of solitude, which those who live in cities need. While very different from Glen Canyon, Baja California, and some other natural worlds I have traveled, the Adirondacks are like them in being a land where the human spirit can yet be free.

Having been stimulated by the Sierra Club's interest in *Summer Island* and *The Place No One Knew*, I began to think about other projects that would be compatible with the Sierra Club's conservation program.

About the time of the publication of *The Place No One Knew* I obtained a small book on the Galápagos Islands entitled *Galapagos: The Noah's Ark of the Pacific* by Irenaus Eibl-Eibesfeldt, an Austrian biologist. The book is an account of two expeditions to the islands. During the first, as a member of the Xarifa expedition, the author saw the ruthless slaughter of the unique fauna perpetrated by the crews of visiting ships, despite Ecuadorian laws protecting the wildlife. On returning to Europe he appealed to the International Union for Conservation of Nature and Natural Resources in Brussels for the establishment of a biological station with a permanent warden to enforce the laws. He was asked by the International Union and UNESCO to lead an expedition to the Galápagos, to conduct a survey on the wildlife and to select a site for the station. The second expedition was a much more thorough study of the indigenous fauna and flora of the islands, resulting in his book, in which he reported that seventy percent of the animal species and fifty percent of the plant types were found nowhere else in the world. It was a dramatic appeal to the conscience of civilized countries to assure the survival of this unique biological treasure, threatened by wanton and mindless destruction at the hands of increasing numbers of ignorant adventurers. The response to his appeal was immediate and favorable. With the cooperation of the Ecuadorian government, the Darwin Research Station, a permanent institution in the service of science and with a full-time director, was established on Santa Cruz Island. A sailing research ship, the *Beagle*, manned by a professional crew, was also provided.

Eibl-Eibesfeldt's book made a tremendous impression on me. The Galápagos Islands were in danger of losing their unique value as a natural museum and laboratory of evolution to thoughtless exploitation; such a fate for this wonderful place must not be allowed to happen and should be made a major conservation issue of the Sierra Club. I believed that a large-format photographic book about the Galápagos Islands could

have great influence for their preservation, so I proposed the idea to David Brower, who was immediately interested and took the suggestion up with the publication committee. There was a great deal of opposition to the proposal within the Board of Directors on the grounds that the islands were outside the continental United States, which, it was felt, put them outside the legitimate conservation concerns of the club; so the idea was rejected. However, David Brower was not about to give up and was determined to propose it again.

In the meantime, having no project in mind for the winter of 1964, I remembered an account by Willoughby Walling, a boyhood friend now living in Santa Fe, of a trip he had made down the desert peninsula of Baja California. For the whole thousand-mile length of the peninsula, few facilities were available; you had to be self-reliant, he told me, be prepared to make your own repairs and fix your tires, and you had to carry a plentiful supply of oil, water, and gasoline with you. He had taken fifty-five-gallon drums of water and gasoline in his pickup truck. It seemed to me that Baja California would be a good introduction to the similar desert environment of the Galápagos Islands, so I asked my son, Stephen, and his wife, Kathy, who had just graduated from Colorado College, to join me, along with two young men from Santa Fe. We set out in February 1964 with three vehicles — two Jeeps and a Jeep truck with a camper body equipped with two bunks, a gas stove, and an icebox without ice that served as a storage space for provisions. We carried a surplus of gasoline and water in military jerry cans, and a redundancy of tires and tools for every conceivable mechanical emergency. In fact, we did a valve job on one vehicle during the trip. A winch on the front bumper of the truck was a handy machine for extricating us from a difficult situation on several occasions. Tire repair was a frequent necessity, not caused especially by the rough tracks (called roads) that we followed, but by cactus spines that could penetrate the toughest treads and work their way through to the inner tube.

Shrine, Concepcion Bay, Baja California, March 6, 1964.

For camping we all had sleeping bags, and tents were brought along as insurance against weather that never — hardly ever — penetrates this desiccated environment. Meals were very simple affairs; any cooking required was done by Kathy without complaint and enhanced by Mexican beer, several cases of which we had purchased in Mexicali, where we crossed the border from California. Our progress was very slow; some days we made only twenty miles, since we had purposely decided against a time schedule and I insisted on stopping frequently to photograph. And then there were places in which we wished to linger to observe special features, as at Scammon's Lagoon to see the gray whales, or in San Ignacio to enjoy the comfort of a bed, the luxury of a shower, clean clothes, and good Mexican food.

The Baja California excursion had not been undertaken with the intent to produce a book, but my photographs reawakened the interest of David Brower in a region seldom visited and almost unknown to Americans. Baja California offered evidence of recent geological and volcanic activity, exotic xerophilic vegetation that had evolved in semi-isolation, and the abandoned remains of Hispanic colonial missions in remote locations along the peninsula, all of which contributed to

its mystery and attractiveness. Joseph Wood Krutch had written a book called *The Forgotten Peninsula*, published in 1961, on the history of Baja California from its discovery and the establishment of missions to its gradual desertion by western civilization, including a description of some very queer plants which, contrary to logical expectation, seemed to be growing upside down. Krutch journeyed to Baja California ten times by every available means of transportation, which exceeded the prediction that if you went once you would inevitably go again. Due to Brower's enthusiasm on seeing my photographs from the first trip, and with inspiration from Krutch, I determined to make a second visit, this time in the summer when the exotic plants — the cirios and the elephant trees — were in bloom, and with a book in mind. On this trip, in July and August of 1966, I spent more time exploring the northern part of the peninsula, which I had neglected the first time, and also the central area, where the exotic vegetation was most prolific. *Baja California and the Geography of Hope* was published in 1967 with a text by Krutch.

In the meantime, pressured by Brower's persistent persuasion, the publication committee of the Sierra Club had at last agreed to finance an expedition to the Galápagos Islands. Before it left, in early 1966, our party reached an almost unimaginable size. It did not include Loren Eiseley, whom I had met and invited to join the expedition; he declined the invitation to go but agreed to write an introduction to the proposed book. As my assistant, I requested that my son, Stephen, with his wife, Kathy, be included in the group. David Brower, who was making arrangements with the Ecuadorian government for our visit to the islands, was in correspondence with Cristóbal Bonifaz Jijón, an Ecuadorian conservationist, whose advice he sought on the expedition, but who did not accompany us. Brower also invited John Milton of the Conservation Foundation to come along as an expert on conservation policy. Then it was suggested that there ought to be a film-

maker included, to assure comprehensive coverage of Galápagos wildlife behavior. While photographing birds in Tucson before the war I had gotten to know Tad Nichols, who made wildlife movies and was famous for his extraordinary film of the eruption of the Mexican volcano Parícutin. I suggested that he and his wife, Mary Jane, an excellent amateur birder, be included in the roster. Then Brower, as a parallel factotum to my son, Steve, added his son, Kenneth.

We had no idea where we would stay when we got there. The Darwin Station on Santa Cruz, which provided accommodations for scientists and those with legitimate purposes for visiting the islands, could not put us all up; but fortunately Mary Jane, who in addition to being a wildlife enthusiast was a ham radio operator, had made contact with Forrest Nelson (a ham operator in the Galápagos Islands) before leaving Tucson. He had built a lodge for tourists, recently completed, near the Darwin Station and would be able to put us all up and feed us for the duration of our stay.

From the start I became the person responsible for organizing the expedition, but with the cooperation and advice of all the members. One of the first things that had to be done when we arrived in Quito was to get permission from the Ecuadorian navy to visit the Galápagos Islands; second, and more difficult due to government red tape, was to obtain release of our shipment of equipment from customs in Guayaquil. Eventually we boarded the *Cristóbal Carrier,* a converted wartime LST, and sailed west out into the Pacific Ocean. Our first port of call was Wreck Bay on San Cristóbal, the administrative center for the islands. From San Cristóbal the *Cristóbal Carrier* sailed for Academy Bay on Santa Cruz, which was to be our base of operation in the Galápagos.

One of the first matters that had to be settled was to arrange for inter-island transportation. Our request to the Darwin Station for use of the *Beagle,* the station's research vessel, was in vain; the *Beagle* had already been assigned to other groups. Instead we chartered

Giant opuntia cactus and palo santo tree, Albemarle Island, Galápagos Islands, 1966.

two sailboats from the Angermeyer brothers, Carl and Fritz, for the duration of our stay, and set out to explore the islands. All were volcanic; two of the large islands were actually active volcanoes, while the others were all silent but with many dead or flooded craters projecting above the sea. We planned to land on many to probe their secret recesses and to observe their unique living inhabitants. We would be living off the resources of land and sea: fruits and vegetables from the small interior farms, fish from the sea, and the meat of feral goats made into a delicious stew. They were escapees from domestic stocks or had been intentionally introduced by misguided individuals as a store for future cropping; but they were a menace to the indigenous vegetation on the smaller islands. Attempts had been made by Galápagos conservation groups to eliminate the goats from a

few of the islands where they had become especially numerous, and hunting them was encouraged everywhere. Fritz was also an expert fisherman and caught groupers when we were at anchor, a delicate fish that became a frequent element of our diet. But the greatest delicacy from the sea that we caught under sail on a troll was a dolphin. If one has never seen a dolphin, its edibility would be considered its greatest attribute. A dolphin is a fish at home in the surface of tropical seas, a fish of speed and grace and iridescent beauty. To catch a dolphin is to commit an act of ultimate disdain for the miracle of creation, and to ingest a dolphin is to perpetrate an ultimate indignity to the species. And yet we caught and ate a dolphin without suffering more than a moment of shame. Our dolphin was hauled on board, fighting desperately against the irresistible steel barb in his lips. His high blunt forehead would plow the waves no more; his dark green, azure-spangled back had glided unseen for the last time through the blue watery empyrean. His great yellow eyes stared hopelessly, as with a final desperate effort he sought, by convulsive flopping, to regain his native element. He soon was clubbed into insensibility, and as he poured his scarlet blood upon the deck his vibrant, living colors faded to the gray of death. The azure light along his sides became mere palish, lifeless streaks. His green and yellow belly, which was the color of a fresh lemon, and which served to make him invisible in the shining surface of the sea to the eyes of his enemies below, changed to dirty slime, slipping from his scales in stringy masses. No longer a dolphin, he had become a dead fish merely.

I had never had an experience that came close to the kind of life we had been transported to in these mysterious islands, where all creatures were unafraid of men and expected not to be molested — a paradise in which one sensed a harmony in nature and could feel secure from the surprise of danger. We wore a minimum of clothing, only shorts and sneakers, and we sailed the smooth, tropical sea in quiet when the motor was turned off, interrupted only by the faint sloshing of the bow wave. I liked to lie way out on the bow whenever a pod of porpoises came by to investigate; they would coast along in front close to the stem of the vessel, as though pushed by an invisible wave, and from time to time they would turn on their sides and look up at me to be sure I was still watching. On the few occasions when we sailed at night, a wonderful phenomenon of the sea was displayed; the bow waves sparkled with incandescent points of light from the phosphorescent plankton, which had been violently disturbed, and flowed away in our wake in a milky stream of greenish light, spinning and pulsing, spread out for fifty yards astern.

For four months we cruised among these "enchanted" islands, exploring them from cool lagoons to hot, parched interiors. We snorkeled in quiet bays, where young sea lions swam beside us, and on a moonlight night we attempted the ascent of Fernandina, one of the active volcanoes, but were driven back by tropical heat and dehydration. When we flew home I experienced mixed feelings — of regret at leaving this Eden, so isolated from all the responsibilities of civilization, and of eager anticipation to return to my family and society.

As a result of the publication of three of my books by the Sierra Club, all of which carried a conservation message, I was elected in 1966 to the Board of Directors of the club. During a board meeting at the Sierra Club camp in the Sierra Nevadas in 1968, Brower proudly presented me with the first copy off the press of *Galapagos: The Flow of Wildness*, which was in two volumes as I had requested. My initial delight was soon dampened, however, by the discovery that my name appeared nowhere on either volume other than as photographer, although later I discovered that Brower had credited me in his introduction with the idea for the books. The first volume contained, aside from the introduction by Loren Eiseley and a foreword by David Brower, fragments from the journals of buccaneers,

Tumbleweed and cliff, House Rock Canyon, Marble Canyon, Arizona, June 13, 1967.

explorers, and scientists. The second volume was introduced by Kenneth Brower's foreword, and a long introduction by John Milton was followed by my text and several short sketches by Kenneth Brower. When I asked Brower why my name was not on either volume, he said it was because there were so many contributors that no one could be named. I was so shaken and speechless I left the meeting.

One other book grew in an informal way out of my Sierra Club connections. Martin Litten, a director of the club, had become an enthusiastic river runner and had made several trips down the Colorado through the Grand Canyon — the most dramatic part of the Colorado canyons. He used a special class of wooden boats called Mackenzie dories, guided by oars rather than motors (which he felt were a travesty to true wilderness experience). At a Sierra Club board meeting he offered

to take me on his next run through the Grand Canyon, which was scheduled for June 1967. For me this was a return to the place I had been brought by my father as a child, and I was anxious to confirm my early impressions. Martin Litten's river trip in his three wooden dories started on June 13 at Navajo Bridge, the only road-crossing of the Colorado between Moab and Boulder Dam, and terminated 241 miles downriver seventeen days later. There were nine of us in the party in addition to Martin Litten, his son John Christopher, and Francois Leydet, the three experienced oarsmen who would guide the boats through the rapids. Among the others were photographer Philip Hyde, my son Patrick, and Ron Hayes, a Hollywood actor who had played minor parts in western movies. Because it was not a money-making venture, as most of the rubber raft trips are, each of us contributed his share of the expenses, and our progress was leisurely. We stopped often to explore side canyons and occasionally stayed two nights at a campsite. Martin knew all the collateral canyons and which ones were most interesting, and he was never in a hurry, because he had no schedule to adhere to. He always allowed us photographers plenty of time.

It was hot in the Grand Canyon in June so that, even in our scanty clothing, the wetting we received running a rapid offered welcome relief. We wore our life jackets constantly for safety in case of an upset, and frequently in search of more effective relief from the heat we would jump overboard and float through minor rapids. The sensation is quite unexpected; you suddenly find yourself quietly floating in the river, not buffeted about, just drifting along with the current as you bob up and down with the waves. There is no perception of speed until you look at the bank, which you are amazed to see is rushing past. Major rapids we approached with more caution and ran them with the boats well separated to avoid any possibility of collision. As the lead boat slid into the fast water where the rapid began, it would often appear from the following boats to drop

out of sight into a hollow in the river, only to reappear a few minutes later on the next crest of water. Steering the boat during that moment of fast action required considerable skill in order to avoid mishaps; one such mishap did unfortunately happen to John Litten when he lost his grip on an oar, which slammed against his shin, cutting it to the bone. Since I was the only member of the party who had a medical degree, although I had no practical surgical experience, it was up to me to sew up the wound. This I was able to do with the very adequate first aid equipment provided by Martin Litten's foresight, which included such essentials as surgeon's needles and hemostats. I had John bite on a stick during the suturing, and he never winced or complained of my clumsiness. The wound did not become infected. Ron, who was confident that he could do anything requiring physical skill, kept begging Martin to let him row. He knew less about rowing than I did from my summers in Maine, which Martin did not recognize as adequate training for handling a Mackenzie dory. Finally Martin weakened and gave the oars over to Ron at the top of some very mild rapids. I was standing in the bow pointing out obstacles when Ron, misunderstanding our wildest gesticulations, ran full onto a rock with such force that I was pitched overboard. Abandoning his oars, Ron leaped overboard to rescue me. By that time I had climbed out on the rock and Martin had taken command of the dory; and after some skillful maneuvering we were both able to get back on board. Ron was not the least fazed by this episode, nor did it deter Martin from letting him row again.

Tapeats Creek is a tributary we walked up for several miles to a fork where half the flow issues from a cave high in the side of a perpendicular wall. It is an underground river pouring forth in a spectacular flow, as though an enormous faucet had been opened. Near Tapeats is Deer Creek, revealed by a waterfall at the river's edge, behind which lies a narrow, sinuous gorge, beautiful and tantalizing to those who look down into it, but inhibiting to descend. We also explored Kanab

River edge and cat claw bush below Havasu Creek, Grand Canyon, Arizona, June 26, 1967.

and Matcatameba Canyons and Havasu Creek, which flows down from the Havasupai Indian Reservation that I had visited from above during my first winter in Santa Fe. Tuckup Canyon and Fern Glen were another two of the many places we visited during our seventeen-day expedition.

I made a second trip later that year. My photographs from these two journeys were published by Jack Macrae (now at E. P. Dutton) in the book *Down the Colorado*, with a text from the journals of John Wesley Powell, who had made the first river trip through the Grand Canyon one hundred years before in 1869.

As a member of the Sierra Club's Board of Directors I was involved in a policy conflict that arose between the supporters of a publication program and those who believed in a less indirect way of spending the club's money for the protection of natural resources — a conflict that was not resolved until after the publication of

the Galápagos Islands book in 1968. By 1969 the crisis came to a head. The club had been operating under an increasing deficit attributed by one faction to an extravagant publication program, which it insisted must be curtailed. The supporters of the program, led by Brower, maintained that Sierra Club books had been a tremendous asset for conservation and that the deficit was only temporary. As the disagreement became more intense and tempers were ruffled, Brower was accused of ignoring the advice of the club's officers, misleading the Board of Directors, and arrogating to himself the expenditure of funds at the risk of bankrupting the club. His supporters maintained that these accusations were grossly unfair, that to function effectively an executive director must be allowed a considerable degree of independence in decision-making, and that under his directorship the Sierra Club had become a powerful force for environmental protection. The division between his critics and supporters on the Board became sharper until, at a tense board meeting, a resolution was proposed limiting Brower's freedom in the management of club affairs. The vote was 10 to 5 for the resolution, on which I voted with the minority, whereupon Brower, interpreting it as a vote of no confidence, resigned as Executive Director.

Despite our differences over the Galápagos book, I have always appreciated David Brower's help and encouragement in numerous projects. With his resignation and the curtailment of Sierra Club publishing, my relationship with Sierra Club books came to an end, though not my commitment to the club's conservation objectives.

WIDENING
HORIZONS

My primary concern in traveling to unusual places was adventure — the opportunity to see new places, especially places that were dramatic. Though my purpose was not always to take photographs for publication, wherever I went I always took photographs because this was how I expressed the impressions these places made on me. And several of my adventures led to books.

Jack Macrae had taken up the idea of a book on East African wildlife (first proposed by the Sierra Club before its publication program was curtailed) and had been looking around for a possible collaborator for the text. He was familiar with Peter Matthiessen's accounts of his travels to remote parts of the earth and his recent journey up the Nile to Uganda and Kenya. I also had read and been very much impressed by several of his books, especially *The Cloud Forest* and *Under the Mountain Wall;* so when Jack suggested a collaboration with Peter on an East Africa book, I was enthusiastic. I met Peter in Jack's office at E. P. Dutton, and we agreed immediately to work together. Arrangements were made to start in February of 1970 on a preliminary trip, when Peter already planned to be in Kenya, and for us to return in June for a much more extended visit. In the Galápagos Islands I had met Allen Root, an adventurous film producer from Kenya who offered to arrange safaris for me with Root & Leakey (his safari business with Richard Leakey), if I should ever visit East Africa. I therefore wrote to him that I would be coming to Kenya on a photographic venture and requested his assistance in organizing safaris. Aline was also enthusi-

astic about going to East Africa to see the wild animals, and Jack Macrae, realizing that this was an opportunity for him to see Africa, too, decided to join us for part of the trip.

Aline and I flew by way of Athens to Nairobi and there, as the plane approached the airport, I had my first unbelievable glimpse of wild Africa — a group of giraffes browsing like domestic livestock almost within the city limits. We had a week before Jack would arrive, which I wanted to spend climbing Mt. Kenya, an extinct volcano on the Equator, to photograph the unique vegetation that occurs only at high altitudes on a few African mountains. Jock Anderson, the representative of Root & Leakey, made reservations for us at Naro Moru lodge at the foot of Mt. Kenya, from which we were driven up the mountain to the end of a road. From there we walked with Kikuyu porters, who carried our equipment, to a base camp in Teleki Valley at twelve thousand feet. This camp was a simple establishment for mountain climbers and other visitors to the mountain; it provided tents, canvas cots, bedding, primitive facilities, and meals. The camp was situated in a broad swale from which the peaks of Mt. Kenya, a serrated wall of black lava, rose for several thousand feet. The dominant vegetation was a variety of giant groundsel that looked like cabbages on woody stalks and a giant lobelia that at a distance suggested enormous, furry asparagus shoots. The temperature dropped every night below freezing, a condition to which the vegetation had adapted, as exemplified by a yellow, prostrate, daisy-like flower that froze solid at night and thawed

out undamaged in the sun. The camp was quite uncomfortable, especially for Aline, largely because of the altitude, and after three days of exploring Teleki Valley and visiting a tarn in a cirque formed by the wall of peaks, we returned to Naro Moru lodge at the foot of the mountain.

Jack Macrae joined us in Nairobi, and we set out on a safari to northern Tanzania with Jock Anderson as our guide. This was the part of the trip Aline had been looking forward to. Safaris, as Jock explained, can be very luxurious affairs with many special amenities, but our safari was comfortable without being luxurious, which gave us a taste of the way Africa was experienced between the wars. We did have a very expert cook and facilities for showering at the end of the day.

In Ngorongoro Crater we heard the low, menacing roar of a lion and were surprised by the unhorselike bark of the zebras. The most frightening sound, however, was produced by a small animal whose nearest relative is the elephant. It is the tree hyrax, which after sundown from his concealment in a thorn tree above your head lets go with a blood-curdling scream, which is answered by his companions until you are convinced that the chorus is a protest against some horrible disaster. In the plains of the Serengeti we saw the great herds of wildebeests, the clowns among the antelopes. With an exuberance of spirit they are perpetually leaping and jumping about, shaking their horn-crowned and bearded heads, as though life were just a game and they had not a worry in the world for the predators always alert for a kill. On a bare stretch of the plains devoid of all vegetation we came upon a cheetah with its disemboweled prey, a Thomson's gazelle, on which it was feasting. Standing nearby at a respectful distance, a group of vultures awaited their turn at the carcass and in their greedy eagerness slowly pressed forward until the cheetah, in apparent exasperation, charged to drive them back. They retreated with great flapping of wings to a safer distance from which they again slowly advanced. Eventually the cheetah, its appetite appeased,

Cheetah, Tanzania, 1970.

stood for a moment confronting the vultures and then, with what appeared to be utter disdain, turned and walked slowly away. Thereupon the vultures leaped upon the carcass, and in the combative turmoil that ensued the remains of the gazelle were quickly torn to pieces.

During these safaris I photographed the animals from Landrovers with roof hatches; it was necessary to photograph the animals from a vehicle, both for safety and in order to minimize the possibility of frightening them away. I had to direct the driver when to stop, and because of these circumstances I used various hand-held cameras for the animals.

Back in Nairobi we were invited by the Roots to spend our last nights in Kenya as guests in their house on Lake Naivasha. Allen and Joan Root always had a great many animals around their place that they had raised or that had been rescued or brought to them to be treated for injuries. A few were even house-broken and enjoyed the privileges of the house. When we arrived we were introduced to a young hippo on the lawn, where he came out of the lake to be fed when hungry. Like all tamed animals he recognized a good thing, accepting all handouts as a matter of right. We were shown into the guest room, and after only a

Dik-dik, Serengeti, Tanzania, 1970.

few minutes I began to experience itching eyes and difficulty in breathing, which I recognized as the allergic symptoms I suffered from contact with domestic cats. When I told Allen that I could not possibly sleep in that room, he said that he had kept a caracal — an African cat similar to the North American lynx — there recently and would put me in another room. That evening after supper a young female striped hyena came into the living room and jumped up on the sofa beside me. She had been raised from a pup, having been deserted by her mother, and was very much a pet, albeit rather rough in her behavior. She bit my hand when I stroked her, as a young dog might, not viciously. Her fur was very soft and silky and had a pleasant animal smell, not disagreeably odoriferous as hyenas are reputed to be.

This first trip was just a sampling of what was to come in the extended visit. Back in the United States I had to prepare for the more comprehensive trip to Africa, which was to begin in June. Two of my sons, Patrick and Stephen, and Stephen's second wife, Marcie, were going with me. All my photographic equipment — cameras in duplicate, spare parts in anticipation of loss or damage, and a plentiful supply of film — had to be shipped in advance by air freight to Nairobi.

Our flight via Athens was uneventful, and we were met as before by Jock Anderson. Our first obligation was to decide on our itinerary, for which the wishes of Peter Matthiessen, who had preceded us to Nairobi, were determinant. He proposed a safari into northern Kenya with Lake Turkana (formerly Lake Rudolf) as our ultimate goal and with intermediate visits to North Horr and Mt. Marsabit, a national park on a mountain oasis in the surrounding desert that includes most of northeastern Kenya. North Horr is a military outpost maintained as a protection against incursions by the Shifters, the wild tribes of northeastern Kenya and Somalia. I photographed the flag of Kenya and a group of camels in a corral adjacent to the army headquarters, whereupon I was immediately accosted by a guard, who told me it was illegal to photograph the flag or military equipment — meaning the camels. He wanted to confiscate my camera, which Jock saved by the compromise solution of removing the exposed half of the film and surrendering it to the commander of the station.

Our destination on Lake Turkana was Loiyengalani, a village of the Lo Molo tribe of the east shore. The tribesmen demonstrated spear fishing and fire-making by friction and put on a social dance for our entertainment. We explored the country around and drove north hoping to visit Richard Leakey's camp near the Ethiopian border, where he had made important anthropological discoveries. We lost our way and were running out of gasoline and water so we were forced to turn

back. We were reduced to drinking beer and cooking with it until we discovered a spring in a lava flow, which showed evidence of having recently been a Shifter campsite. We drank our fill, filled our water cans, bathed, and left. The gasoline held out until we reached the nearest source of supply. We stayed a few more days in Loiyengalani before starting back to Nairobi by way of Thomson's Falls, where we celebrated our return to civilization by staying in the Thomson's Falls Lodge. At supper that night we all became high over drinks and wine, and in the spirit of the moment Pat suddenly began to sing cowboy songs, much to the entertainment and amusement of everyone in the dining room.

Our next safaris took us into Tanzania, to the places I had already visited with Aline and Jack Macrae — Ngorongoro Crater, Lake Manyara, and the Serengeti — but also to Mt. Meru and the Momela lakes, Ngurdoto Crater, Engaruka, and Ol Doinyo Lengai, the most recently active volcano in East Africa; at one time we had thought of climbing it but were deterred by its formidable slopes. Nearby we were invited into a Masai manyata, a circle of mud huts surrounded by a thorn hedge, into which cattle are herded at night as security against lions. The center of a manyata is a heap of dried dung — an accumulation of many years — on which the Masai women sit to do their handiwork. Marcie indicated by signs an interest in their beaded collars, and amidst great hilarity they tried them on her, but they would not part with them, money having little meaning for them. On the way back to Engaruka we stopped at a Masai camp and were asked to share their repast of blood and milk, but did not have the courage to accept. In Kenya we spent several days in Tsavo East game preserve, following elephant family groups made up entirely of females and calves (the bulls remaining separate and solitary) and able to get close to them at watering holes, where they came frequently to drink.

Our longest and last safari took us into Uganda, first south to Queen Elizabeth Park that borders Rwan-

Gol Kopjas, Serengeti, Tanzania, September 1970.

da in a branch of the Great Rift Valley, where Africa is slowly drifting apart, and then north to Kidepo Valley in the land of the Karamojan just below the Sudanese border, which was some of the most beautiful country we had seen. Here a spectacular elephant migration crosses a steep escarpment that they descend by sliding down on their rumps — a spectacle I hoped to see, but it was the wrong time of year. The most overwhelmingly impressive natural phenomenon in Uganda was the Nile River, the source of which had been the goal of explorers during the early years of the last century. The river had been followed to Lake Albert and south to Lake Edward in Queen Elizabeth Park, but a doubt persisted that this was the principal source because of another river that flowed into Lake Albert close to the emergence of the Nile. By following this river Murchison came upon a tremendous falls, now bearing his

name. Beyond that the river continues for more than two hundred miles to its ultimate source in Lake Victoria; this is the Victoria Nile. During all this time I was photographing a great variety of subjects — landscape, animals, and vegetation. Although my original intention had been to concentrate on animal life, I became intrigued by all kinds of subjects.

We took a boat ride on the Victoria Nile below the falls to see the riparian life of the river — crocodiles basking on sand bars, hippopotamuses grazing on the banks, and snowy-headed fish eagles (larger than American bald eagles) perched in the trees on both sides of the river. We drove up to Murchison Falls, to overlooks from which one could look into the gorge. The river was divided by an island that diverted most of the water to the left bank, from which the most spectacular views were obtained. The river was funneled into a black, narrow pit into which it disappeared to emerge beyond in an enormous plume of turbulent water. In the river below were the bloated bodies of hippos that had been carried over the falls.

This was the last safari for Steve and Marcie because Steve had to return home to a teaching job at Cornell. Pat stayed on with me for another two weeks until he, too, had to return to continue his education. I stayed on into November. On our Serengeti safari we had been assigned a Masai guide whose name, we were told, was "Sam" for easy communication, but who felt this name was demeaning. We soon learned that his real name was Ole Saitoti, and later that his first name was Tepilit. I returned to Seronera, park headquarters in the Serengeti, after my sons had departed and requested Ole Saitoti for my guide. He is an educated Masai, speaks several languages, is a humorous and entertaining companion and very good at finding animals. He listened sympathetically to my account of what I hoped to accomplish, and offered to be my driver and guide throughout East Africa, but the plan never came off because of the many obstacles to its realization.

We became very good friends. Ole Saitoti was the lead actor in *Man of the Serengeti*, a film produced by the National Geographic Society, and was brought to the United States for its first showing; he stayed on, lecturing with the film, entered Emerson College in Massachusetts to improve his education, and graduated from the University of Michigan with a degree in game management.

There was a great deal more to East Africa than I had seen, or than one could see on only one visit. One place I wanted to return to was Mt. Meru, with the ghost forest of lichen-shrouded trees in its crater. I also wanted to see the flamingoes on Lake Nakuru and Lake Hannington and to drive into the Aberdare Range and onto the north slopes of Mt. Kenya, which I was able to do with Jock Anderson's assistance. I also wanted to see the land and herds of animals from the air and to fly over Kilimanjaro to photograph its glaciers and crater. We found a Dutch pilot who flew me over the mountain at 20,000 feet, at a temperature way below freezing so that I could hardly operate my camera. "It's an illegal flight," the pilot said, "because we have no oxygen"; but we circled the mountain once before diving to warmer air.

For more conventional flying Jock found a pilot who would fly me around for several days. I was to meet the pilot one morning at a small air field near Nairobi, but when I arrived there no one was around except for a young girl sitting in a corner of the waiting room. When Jock arrived, he asked if I had met my pilot, and when I said I had not, he said, "there she is," pointing to the girl in the corner, and introduced me to Janet Holms, a seventeen-year-old girl with long, blond hair down to her waist. We took off in a Cessna 150, a two-seater with a small baggage compartment behind the seats. As we taxied down the runway and began to lift off, she said that the plane was grossly overloaded because of my equipment, but we became airborne without apparent difficulty. Our first destination was Amboseli on the Tanzanian border, and here we flew around look-

ing for game before checking in at the Namanga lodge. Janet refueled and we took off in the morning for Seronera. On the way we scouted around for herds of animals, and whenever I wanted to photograph, Janet would swoop down so that I could get the best possible pictures. She was an expert pilot and caught on quickly to what I wanted. As might be expected, we got to know each other quite well; she told me about her early life in Kenya in the country around Nyeri, where during the Mau Mau troubles they sent their servants home at night because they could not be trusted. I asked her how she became involved in flying, and she said it was because she wanted to do aerobatics — trick flying, rolls and loops — and asked if I would like her to give me a demonstration, which I declined. She complimented me later for not being a nervous passenger after a steep landing at Seronera that would have frightened most passengers. At Seronera we had rights to fuel on demand by order of the director of the Tanzanian National Parks in Arusha, John Owens, even if it meant the grounding of the Serengeti director's own plane. I had my heart set on Lake Natron, a shallow alkaline body of water just south of the Kenya border, famous for its colorful deposits and millions of flamingoes. Janet Holms wanted to see it, too, so we flew there on the last flight. We approached the lake from the north, where the colorful deposits were most spectacular, and flew out over the lake to the area where it was literally solid with flamingoes feeding on crustaceans. They were not alarmed by the plane until we dropped down close to the water, and then they rose all together in a great pink cloud. At the end of the lake we flew by Ol Doinyo Lengai so that I could photograph its steep sides that had deterred me from climbing, and then we returned to Seronera and the next morning back to Nairobi. Having been in Africa for four months, I left with the realization that I had come at a very favorable time to a place that was threatened with change; I was fortunate in being able to see the rich animal life in primal abundance, which in years to follow, with the

Agora and poplars, Aphrodisios, Turkey, April 1971.

exploitation of natural resources, would be greatly reduced.

In the spring of 1967 Aline and I had gone to Greece, a romantic adventure inspired by Edith Hamilton's book *The Greek Way*. We wanted to see the almond trees in bloom and the wildflowers for which Greece is famous, and I had always wanted to see the classical temple architecture that my father had admired so much. We were also influenced by Nick Metropolis, a Greek mathematician at Los Alamos. Through Nick's inspiration three other couples from Los Alamos, including the Steins, joined the expedition, making ten of us altogether. Aline and I flew ahead to Rome and drove through southern Italy and Sicily before crossing the Adriatic to Greece, where we all joined forces in Athens. In three cars we toured northern Greece and the Peloponnesus and by boat went to Ephesus and Crete. The purpose of the trip was not originally photo-

graphic but I photographed everywhere we went, as did Paul Stein. After returning home I realized that I had become so much in love with Greece that I wanted to do a book on the ancient Greek world, which would require my going back. Twice more I returned: the second time with Aline on our way home from Africa; the third time with Paul, who was equally enchanted with this country.

While in Rhodes on the last visit, I saw lichens that brightly adorned old temple stones, and Paul suggested that Iceland was a place where lichens were especially prolific. They appealed to both of us as attractive photographic subjects. Going to Iceland seemed so appealing that I immediately began to investigate travel arrangements and invite others to join Paul and me. He and his wife Carol were the first to sign up for the summer of 1972. I asked my son Jonathan and his wife if they would like to come along, and they eagerly accepted, as did Tad and Mary Jane Nichols of the Galápagos Islands adventure. Then Berndt Matthias and his wife, Joan, said they would like to come, but only for a few days; I had planned on a two-month-long visit. Berndt, a physicist with intermittent connections with Los Alamos and a friend of great charm, was a very welcome addition to the group.

I was intrigued by Iceland in large part because it is entirely volcanic in origin; Iceland is situated on the northern end of the mid-Atlantic ridge, which extends across the island from Mt. Hekla (an active volcano on the south side) in a northeasterly direction to the hot springs area near Mývatn. The beauty of the Icelandic landscape is not limited to volcanic phenomena, the mountains of igneous rock, the torrential rivers and thunderous falls, or the ice-filled glacial lakes; its vegetation is also a major attraction. The trees are dwarfed and stunted. Tundra covers much of the interior; arctic and alpine wildflowers bloom in seemingly unlimited abundance in summer. But the most striking contributor to Iceland's plant life is its mosses. Old lava flows everywhere are encased in pillowy, gray-green, spongy

masses resembling sphagnum in coarseness of structure. Sphagnum mosses, which occur in the forests of Maine, are found in a much more luxuriant form in Iceland, becoming the dominant vegetation in places. And, since there are no forests in Iceland, these mosses are not concealed. Bordering streams, below retreating glacial fronts, and on cinder deposits, mosses, fed by the mineral-rich soil, become a brilliant gold and emerald. And we found the lichens that had brought us to Iceland in the first place, decorating the older rocks everywhere with bright-colored geometric plaques.

Iceland's affinities are with the sea. Its rocky core sprang from the ocean depths in a prolonged, fiery birth. Its plant life came to it as voyagers from the distant continents. It has little mammal life of its own; what it acquired was brought there by its first human visitors little more than one thousand years ago. But its connection to the sea finds ultimate expression in the sea bird population for which the surrounding fish-rich waters provide a lasting source of food. Puffins by the hundreds of thousands nest on Iceland's cliffs, together with fulmars, glaucous gulls, and kittiwakes, whose numbers seem small only by comparison. Fiercely aggressive arctic terns colonize the low coastal plains, which they share with shearwaters and skuas. Shore birds arrive in spring in considerable numbers and varieties, largely from Europe; the small number of land birds all come from Europe. Iceland is literally a self-sufficient land, tenuously connected to Europe by a few venturous birds and to America by the fading Gulf Stream.

We used Reykjavik as our center of operations. The first trip proposed was to the region north of Mt. Hekla, a volcanically young area, and then further east to Landmannalaugar, where the Iceland Alpine Club maintained a hut, which was available for use by all visitors with preference given to club members. The area was accessible from a road up the Thjórsá River valley on a track marked by cairns, but it became increasingly indistinct as it wound into the interior, and

its location where it crossed braided watercourses was a matter of pure guess. In a marshy stream-crossing one of our two rented Landrovers became mired down and was extricated only with considerable difficulty. On a rocky stretch of the track the exhaust manifold on the vehicle I was driving broke due to extreme jolting, so that the rest of the journey was very noisy until we had it repaired after returning to civilization. The hut at Landmannalaugar, which we finally reached through seemingly impassable terrain, was equipped with bunks and running hot water from a nearby hot spring. This was a luxury we enjoyed for several days before returning to Reykjavik.

Our next expedition was along the southern coast of Iceland, where sea birds by the thousands nested on the cliffs, where the melting ice of Mýrdalsjökull created ice-filled glacial lakes and waterfalls cut deep slots in old volcanic ash deposits. In settlements at intervals along the coast lodges provided accommodations for tourists, from which we made excursions into the interior. The road ended at the outflow from Vatnajökull, Iceland's largest glacier; when attempts were made to extend the road, it was repeatedly washed out. We stayed at Kirkjubaejarklaustur near the end of the road, before retracing our way back to Reykjavik.

So far we had always returned to Reykjavik before starting out again, but our third departure was the beginning of a circumnavigation of the island and included Snaefellsnes, the peninsula where the volcano made famous by Jules Verne's fantasy about a trip to the center of the earth was located. We obtained lodgings at a very comfortable hotel in Búdhir as a base from which to explore the peninsula. After supper one evening, Paul and I went out to photograph a golden sand beach and did not return until after midnight. This was June and at this latitude the sun set after eleven o'clock and rose two hours later.

The northern coast of Iceland is deeply indented with fjords, so instead of following the coast around each headland we chose a shorter inland route to

Akureyri, and from Akureyri we continued east to Mývatn (vatn means lake), a breeding ground for water fowl; east of Mývatn, in a spectacular hot springs area where we spent two days photographing, we discovered a gyrfalcon's eyrie. The Jökulsá á Fjöllum River flows north from Vatnajökull and plunges two hundred feet into a canyon before entering the coastal plain. This is Dettifoss, the largest waterfall in Iceland, larger than Niagara. From there we drove to the north coast before continuing east to Egilsstadhir, where we spent the night. We continued on south along the east side of Iceland on a road that closely followed the coast around each headland to the town of Höfn on the most protected harbor of Iceland. Sheep are raised in the green valleys between the headlands, where many could be seen grazing with shaggy, unsheared coats hanging from them in tatters. Out from Höfn the road passed for some forty kilometers through agricultural country dissected by many streams flowing from the glacial lobes of Vatnajökull; for eighty kilometers beyond it skirted the edge of the glacier on a narrow strip of barren land, the habitat of arctic birds and alpine flowers. This coast is the bleakest, rawest, most recently liberated from the ice, yet vulnerable to engulfment again, and it was the most beautiful of Iceland's coasts we had yet seen.

On the return to Höfn suddenly without warning the Landrover became immobile except in first gear. Apparently something had gone wrong with the transmission. When we eventually got back, we telephoned the rental company and were told that another Landrover would be sent out by boat the next day. In the morning we shipped the vehicle back to Reykjavik and received the replacement, which came as promised. On the way back around Iceland we made a side trip into the interior north of Vatnajökull to a place called Askja, a desert area characterized by an unworldly, moon-like landscape. Since our new vehicle was not running well, we cut the side trip short, and as we were approaching Mývatn the rear differential gave out, an unheard-of

Lichens on river stones, south coast, Iceland, 1972.

mechanical breakdown. Jonathan disconnected the rear drive shaft so that we were able to continue on in front wheel drive. A bearing had burned out, which was replaced in Mývatn, and from then on we had no more mechanical difficulties.

We returned to Reykjavik by a route directly across the middle of Iceland between two smaller glaciers, Hofsjökull and Langjökull. At a hot spring area near Hofsjökull people were still skiing on the remnants of winter snow. The road was quite primitive and several rivers without bridges had to be forded. At one we came upon a French party in a state of near-panic with a two-wheel-drive car stuck in the middle of the river, whom we rescued by pushing them out, to their great relief and gratitude. We camped out on this cross-island

route, and at a camp near Langjökull at the outflow from Hvítárvatn we met two Icelanders who directed us to an unusual waterfall. Before returning to Reykjavik for our flight home, we made one last visit to the Thjórsá River and the cinder area on the slopes of Mt. Hekla.

The photographic result of my Iceland trip was a portfolio of twelve color prints; I failed to interest a publisher in a book on the grounds that the country of Iceland was too remote to attract public interest. My thought after leaving Iceland was that I would like to spend more time in arctic regions, and I considered visiting Greenland and Baffin Island. I was very attracted by the arctic zone and was, therefore, especially pleased when the opportunity to go to Antarctica presented itself.

In 1973 I had no projects in mind for other publications, with the possible exception of a second volume on birds (the first bird book had finally been published in 1972 by E. P. Dutton) or a more comprehensive work on America, which would involve extensive traveling throughout the United States. I was enjoying a long summer on Great Spruce Head Island in Maine and looking forward to a productive winter devoted to color printing when in August I received word from the mail boat operator, Robert Quinn, that there had been a telephone call for me from Washington. Quinn never let mysteries go unresolved, so when I asked him who called, he said it was someone from the National Endowment for the Arts and gave me a number to call. On returning the call I was asked whether I would be interested in going to Antarctica. I was taken completely by surprise. Never had I thought of Antarctica as a place I might some day see; it was a world completely beyond my expectations or imagination. Of course I said I was interested, and when I asked more about it I was told that the National Science Foundation was planning to select a group of artists — painters, photographers, and musicians — to record their impressions for an exhibition, that I was one of several

photographers being considered, and would be informed later if chosen. In the meantime I was asked to submit some work for consideration. After a long, suspenseful wait, I received a telephone call from the National Science Foundation, and I was asked where I would like to go, not just that I had been selected. Where would I like to go! I knew nothing about Antarctica; what were the choices? I could go either to the Palmer Station on the Antarctic Peninsula or to the McMurdo Base on Ross Island. I found the choice impossible, so the Foundation recommended the Antarctic Peninsula. I was given the option of joining the NSF research vessel *Hero*, which was in California for servicing, either in Tierra del Fuego or in Valparaiso on the way down. I chose Valparaiso. And then I was asked whether I would be interested in doing a book on Antarctica, to which I replied that I would, provided that I could go back for a second trip. I was assured that this would be possible. I had been chosen along with the painter Daniel Lang; the first trip to Antarctica was primarily to create an exhibition, an exhibition that was eventually put together by the Smithsonian and traveled throughout the United States.

In the fall of 1974, as the time to depart approached, I learned that the *Hero* had burned out a bearing in the gear box and had been towed into Manzanillo on the Pacific coast of Mexico for repairs. So I flew to Manzanillo and boarded the ship there. Because of the delay caused by the breakdown, the course to Tierra del Fuego was changed from the inner passage through Chilean islands to one due south across the Pacific Ocean in close proximity to Easter Island and on southeast to Cape Horn; we were to be at sea for more than a month. The new course went a thousand miles west of South America, across the most vacant area of the South Pacific Ocean. To many people such a voyage would have forecast a period of great boredom, but for me, because of my love for the sea I had acquired from summers on the Maine coast since childhood, the tropical seas, the full width of which we would cross, held

an attraction I eagerly looked forward to. I had first been introduced to them in the Galápagos Islands and enjoyed the indolence they inspired. Besides, I enjoyed shipboard life.

The crew of the *Hero* was a very convivial group, and in the informal atmosphere I was quickly made to feel quite at home. The days through the tropics followed one another with little apparent change, in a slow progression that seemed to speed up as we entered the less tranquil southern latitudes. But the monotony was only superficial, for each day was different from all that preceded it in many subtle variations of sea and sky — the colors of the waves and clouds, of the birds and the flying fish, and of the sequence of events. These variations engrossed my attention from dawn to dark.

If birds were scarce in these equatorial waters devoid of nutrients, flying fish were not, but one had to be on the lookout for them. Often I was startled by their sudden appearance, thinking as they rose before the bow that they were some species of feeding sea bird frightened by the approach of the ship. In time I learned to recognize them at a glance and was no longer fooled, and then I would watch for them and try to discover their method of flight. Flying fish live in the surface of tropical seas; they are slim and torpedo-shaped, somewhat less than a foot long, with large eyes and wide, stiff pectoral fins half the length of their bodies. Blue-gray backs the color of the sea are a perfect camouflage from above, and white bellies act as a disguise to predators from below who seek them against the sky. Escape into the atmosphere is the means they have devised for evading these predators, but in seas near islands where enemies occur in both media, where they may be snatched from the air by frigate birds or seized in the water by large, voracious fish, they live a precarious existence.

I saw flying fish emerge from the sea close aboard. Pectoral fins extended at right angles to the axis of the fish's body acted as airfoils sustaining glides of many yards before the fish plunged back into the sea. Some-

times clusters sprang up, fanning out as though in panic to escape pursuit, white sides flashing in the sun like silvered darts, before splashing down again. A whole school would break the surface of the windswept sea and remain airborne for more than fifty yards. At these times they seemed to rise over waves, keeping only slightly above the surface. Watching these remarkable aerodynamic feats through my binoculars, I thought I could detect a flutter or vibration of the pectoral fins, which would mean that flying fish were not simply passive aerodynes but had made advances in the direction of active, sustained flight and were mastering the gift of birds.

Sometimes a group was startled from the water all at once; then they were transformed from a school of fish to a flock of birds. I became obsessed with watching for their instantaneous appearance and their equally instantaneous disappearance. One landed on deck one night, and I examined its wings. It seemed to me not impossible that during the course of hundreds of thousands of years its long pectoral fins might become wings and that the fish might develop air-breathing equipment, as lungfish for quite different reasons have developed the ability to live out of water for long periods. The flying fish seemed to be moving in an evolutionary direction opposite to that of certain avian polar species. Penguins have lost the power of flight entirely; and heavy birds such as murres and puffins seem to avoid flying as much as possible, because they have to work so hard to remain airborne. Flying fish may become birds that return to the sea to breed, as penguins, having become fishlike, return to the land to breed.

The sea had seemed to change color as we moved south from temperate latitudes through the tropics and into southern waters. From the very first days of the voyage I had taken note of the color of the ocean water. It seemed to me that, unlike the North Atlantic, with which I had become familiar through many summers off the coast of Maine, the Pacific off the Mexican coast was clear and unturbid, probably because it was less

polluted by industrial wastes and river sediments. At first it had appeared to be a deep cerulean blue, a reflection of the sky. This had changed to a deep purple-blue, which made me think of the Mediterranean, or rather the Aegean of classical times, described by the Greeks as "wine-dark." The only other Pacific water I knew was the sea around the Galápagos Islands. There the water was enriched by nutrients brought from the ocean depths by the Humboldt Current and by lime from the marine life of the islands' shores. Lime turns sea water a pale, milky greenish-blue, just as colloidal minerals give glacial streams their milky-blue color. The sea around the Galápagos Islands was therefore an aquamarine, in contrast to the open ocean's purple-blue.

Now the sea seemed to have undergone another change. I noticed that the blue was darker, more ultramarine, and that it seemed to be tinged with red. The change was particularly striking in comparison with the sky near the horizon, giving the sky by contrast a greenish cast. Even as the sky darkened toward the zenith, it retained the less purple blue of normal skylight. With a gentle wind, I could study the more reflective planes on the upswept inside of the small waves, and I saw that they were in fact violet, a color which, when added to the darker blue of the other areas, gave the water its reddish cast. Still smaller facets of the wavelets reflected the sky and were greener than the bulk of the water surface. These smallest facets were generally shaped like the wings of birds, double arcs, a shape related to the dynamics of wavelets and how they are blown up by the wind. Thus, three colors combined to produce the characteristic color of the sea: the purple depths below the reflecting surface, by far the largest areas; then the lighter violet planes of semi-reflected light; and last the tiny greener wavelet facets. Taking the sea as a whole now, I began to see its true color as distinctly and strongly violet; a violet sea. It mattered not from which side of the ship I observed it; the color remained the same. At first I thought that the color

might be accounted for by reflection of skylight en-
hancing the inherent blueness of the water, but when,
in the afternoon, with clouds building up to the point
of almost complete coverage of the sky, the violet re-
mained, I felt sure that the violet color was inherent.
Where the sun shone between the clouds on the water,
lighter violet streaks were plain. During these days
I photographed the sea and the clouds in the morning
and evening and occasionally an albatross that flew near
the ship.

The only non-crew member aboard the *Hero* be-
sides myself was Bob Pitman, a young ornithologist
from San Diego. No one had ever recorded the occur-
rence of pelagic birds along the proposed route from
Mexico through the middle and south Pacific latitudes,
and Bob felt that this was an opportunity not to be
missed. He stayed on deck with his notebook and
binoculars during all daylight hours. He was good at
identification, and I learned a lot from him. A part of
his work involved shooting birds that ventured too close
to the ship, but the scientific value of this activity, for
the great majority of the birds he shot, escaped me,
since in most cases the bird had been positively identi-
fied before it was taken. They were all common species
so I failed to understand how their skins could add
greatly to the value of a collection. Those that flew near
enough to be shot could be identified; those too far away
to be identified could not be shot.

In the far South Pacific, below the roaring forties,
when we were approaching Cape Horn, flocks of
whalebirds, known also to mariners as icebirds, would
circle the *Hero* for minutes on end. The whalebirds are
small blue petrels of the genus prion. Unlike other small
petrels, the prions are delicately shaded in gray, blue,
and white and have a distinctive black line through the
eye. Because the first observers saw the whalebirds
with their pale plumage in the stormy antarctic sea,
they believed the birds had an affinity with ice and
called them icebirds. After several misses, Bob suc-
ceeded in bringing one down, but because of its camou-

flaging color he lost sight of it in the rough sea, and
despite repeated circling by the *Hero* never recovered
it. He wounded a second whalebird, which fell flutter-
ing to the surface where, by its pitiful struggles, it
attracted other members of its species. One of these
alighted beside it and was also shot, to my relief fright-
ening away the others. I saw in the bird's behavior at
most a touching concern for the welfare of a compan-
ion, at least a curiosity about its actions. The scientific
explanation is that other prions were attracted to what
appeared to be a feeding bird. When the two dead
whalebirds were brought on deck they proved bigger
than they had appeared in flight. I was then able to
examine at first hand the curious tubular nostrils that
characterize the large order to which they belong, and
the baleen-like fringes that border their bills for sift-
ing plankton from sea water. Bob said, "Aren't they
pretty?" to which my unexpressed answer was "Yes,
but how much less than the living birds." By grace
and agility, as well as by immaculate plumage, these
remarkable creatures deserve their name of swallows of
the Antarctic.

Christmas Day found us well down in the southern
latitudes. It was a blustery, cool day with the highest
seas yet — forewarnings of what lay ahead. Long ocean
swells more than a hundred feet from crest to crest
advanced from the southwest. The amplitude of these
waves was difficult to estimate and easy to exaggerate,
but from the midship deck they towered high above
me, shutting out all the sea beyond. They came in
groups of four and five with smaller waves in the
stretches between, and slid beneath the *Hero* scarcely
causing her to list as she rose on their smooth sides.

On January 1, 1975, our first landfall was the
Ildefonso Islands, sixty miles west of Cape Horn. We
passed Horn Island light in the night, entering the
Beagle Channel from the east, and after picking up a
pilot proceeded to Ushuaia, the *Hero*'s base on Tierra
del Fuego. While the *Hero* was reprovisioned and
refueled I explored the Land of Fire, first settled by

Adélie penguins and killer whale, McMurdo Sound, Antarctica, 1976.

English missionaries in 1869. Ushuaia is a typical pioneer town, with a population of 3,500, and claims the distinction of being the southernmost city in the world.

After five days in Ushuaia, where Bob Pitman departed the *Hero* and we were joined by five new scientists, we headed out through the Beagle Channel past New Island and turned southeast out into the Drake Passage, in the direction of the Antarctic Peninsula six hundred miles away.

The Drake Passage has a reputation as the stormiest and most fearful part of the southern ocean. The circumpolar current driven by perpetual westerlies is funneled through this wide strait between South America and Antarctica. Waves build to unprecedented heights. Fifty-foot waves are not uncommon, and waves one hundred feet high are not unknown. I was half hoping for rough weather so that I could photograph green water breaking over the bow of the *Hero*. I asked Captain Lenie if he had ever crossed the "Fearful Drake" when fifty-foot seas were running. He said, "Yes, and it can be scary; and when it's that bad and I can't make headway I heave the ship to." After that I did not tell him what I had secretly hoped. By morning we were eighty miles east of Horn Island. A westerly gale was blowing, kicking up much white water and

raising a considerable sea. Running in the trough, the *Hero* rolled much more than she had on the voyage south and listed as much as thirty degrees to each side on the big waves. Of the eight scientists on board — young men most of them — all but two were seasick and did not turn out for breakfast. The youngest members of the group were students working on their dissertations under professors who either had preceded them to Palmer Station or with whom they had worked before in Antarctica.

By the next afternoon we were well out in the Drake Passage. The wind had dropped, promising a calm sea on the morrow. It appeared that we were still under the influence of the summer weather pattern of Tierra del Fuego. Three of the five days of the *Hero*'s provisioning at Ushuaia had been sunny, warm, and windless.

The sun rose on January 10 over a shining sea. The polished, metallic surface was undulating to the ground swell the way a loosely stretched film is billowed by a current of air blowing beneath it. We were lifted again and again by especially large hills of water, which could best be understood as the result of a complicated system of swells — two or more — moving in different directions which interfered with or reinforced each other. These systems could be distinguished from the vantage of the icehouse. The mounds of water caused by the crossing of two swells traveled more swiftly than either swell in a direction which was the resultant vector of the directions of both systems.

An immature wandering albatross circled the ship for hours, keeping always close to the surface, where the weak up-currents of air from the swells were just sufficient to support its gliding flight. A black-browed albatross circled, too, but could maintain a greater height because of its smaller size. It frequently turned on edge in its customary manner of flight under windy conditions, one wing skimming the surface. Wilson's petrels were abundant and two larger petrels came by, both with white rumps; one was black-bellied with gray, longitudinally striped wings, and the other was

white-bellied and dark on top. Flocks of prions appeared but no cape pigeons yet. This quiet sea was the fearful Drake Passage! We were more than half way across but had not yet passed the Antarctic Convergence, where cold antarctic water meets the warmer water of the southern hemisphere and fog and floating ice occur.

My first glimpse of Antarctica was Elephant Island, one of the northernmost outposts of the South Shetland archipelago, off the port bow at 6:00 a.m. on January 11. We had crossed the Antarctic Convergence in the night and had entered a new climatic zone. From then on weather conditions would be controlled by all the vagaries and unpredictable forces originating on the Antarctic continent, which bring, even in summertime, fierce, sudden gales and days dark with driving snow, or ice fogs and whiteouts. Yesterday's calm had been replaced by wind and low, stormy clouds racing across the sky. Elephant Island lay away on our left, a huge, menacing mountain mass, all ice, snow, and rock shrouded in shifting clouds through which the sun gave glimpses of glistening glaciers. This dour, inhospitable scrap of land was the island on which Shackleton's crew found a reprieve after the sinking of the *Endurance* in 1915.

This for me was the beginning of an entirely new experience. The Antarctic is as different from Tierra del Fuego as Tierra del Fuego is from California. It is a harsh desert land of ice-encased mountains, of the flightless penguin and hardy pelagic birds, and of seals and whales. Antarctica is a land where man is at a minimum, where he never ventured and could not survive before he was able to bring with him, by means of his technology, enclaves of the temperate climate of his origin. But for all its grim and inimical character, Antarctica, with its pristine snows, unbelievable clarity of air, and blue cascading ice, is sublimely beautiful.

The atmosphere is so clear in Antarctica that one is easily deceived by distances; mountains that seem only fifty miles away may be two hundred. And in the

Ice cave, Scott Base, Ross Island, Antarctica, December 7, 1975.

absence of haze the colors of distant objects are not like those in other parts of the world. In Antarctica mountains far away look yellow rather than blue. As we entered the Neumayer Channel I saw away to the east the distant peaks of the Antarctic Peninsula and the curved top of the ice field showing yellow and salmon pink between gaps in the closer lavender mountains of the coast; and far to the south beyond the end of Neumayer Channel, showing above the tops of nearer mountains, yellow peaks looked fifty, but were in fact one hundred, miles away. Though at times the nearer parts of the scene were darkened or obscured by clouds and mists, those farthest away stood out in bright sunlight, suggesting to me as we entered the narrower reaches of the strait a secret gateway to an elysian enclave. The further into the strait we pushed, the more crowded with ice and icebergs it became, as though, in response

to our bold challenge, the incarnate forces of nature assigned to guard the passage against intrusion were mobilizing subtle means to frighten us into retreat. We pressed on undismayed.

The large icebergs that we passed close aboard were fantastically shaped by pounding waves and the melting heat of the sun. Below the waterline green grottoes gave glimpses into dim recesses beyond the reach of day, leading down to the icy heart of the iceberg. And above, under the gentler working of wind and sun, the sides were honeycombed, fluted, and sculpted into thin fins and grotesque figures suggesting unimaginable creatures. The whole iceberg was suffused with blue except for highlighted surfaces or surfaces white with a pinkish cast, where snow had lodged; and in all recesses, pockets, and grooves the color intensified to a Della Robbia blue, a condensed distillation of ocean purple.

Neumayer Channel is a narrow passage separating Wiencke from Anvers Islands and connecting Gerlache with Bismarck Strait. The north entrance to the channel is its narrowest part with perpendicular cliffs of rock rising hundreds of feet from the sea and surmounted by glaciers that extend down the gullies and ravines in the walls, appearing as hanging rivers of ice. Neumayer Channel widens to the south, where it joins Bismarck Strait, to provide a spectacular sight of the peaks of Wiencke Island. Ten miles beyond the end of Anvers Island, on the side facing Bismarck Strait, is Palmer Station, located on a spit of rock with the front of Anvers glacier less than a half mile behind it. A group of islands a mile in front of the site of Palmer, along with a longer naked spit of rock from Anvers Island, form a sheltered cove called Arthur Harbor. In this harbor the *Hero* tied up to a stone and masonry pier built out in deep water in front of the station.

Several cruises in the *Hero* had been commissioned by the scientists to support their research. On January 18 the *Hero* left Palmer Station on a northbound cruise to Deception Island, the southernmost of the South Shetland group. Deception Island is a large, flooded volcanic crater, which can be entered through a narrow passage and constitutes an excellent all-weather harbor; early in the century a Norwegian whaling station had been established there. On the way to Deception Island we stopped at Couverville Island, which is adjacent to the Antarctic Peninsula and noted for its mixed penguin colony and nesting petrels. The *Hero* anchored in Deception Island lagoon, and everyone went ashore to explore the ruins of the whaling station, which had been destroyed by a volcanic eruption and earthquake. The next day one of the ornithologists asked to be landed on the outer side of the island, where he had been told macaroni penguins had been seen — a rare occurrence this far south; I decided to go along. During the landing from a Zodiac in a choppy sea on a serrated, lava cliff, I was left hanging by my left hand in a back surge of the waves and dislocated my shoulder. Back on the *Hero* after a hot shower and a large slug of whiskey, I tried to explain the procedure for reducing a dislocated shoulder, but I forgot one of the steps so that the attempt was unsuccessful. In the meantime the Captain had radioed the British ship *Endurance*, which was nearby, for help from the ship's doctor. He was flown over in one of the *Endurance*'s helicopters and lowered onto the fantail of the *Hero*. He reduced the dislocation and gave me something to ease the pain. While arranging for my evacuation (not a simple matter in Antarctica), contact was made with the Russian base on King George Island, where there was X-ray equipment, and the Russians agreed to take care of me until the icebreaker *Glacier* picked me up on its return to Ushuaia. I was deposited with the Russians, who X-rayed my shoulder, put it in a cast, and treated me extremely well until I was finally rescued by the *Glacier* on January 28. The cast was removed on the *Glacier*, and I flew home from Tierra del Fuego with my arm in a sling.

My second trip to Antarctica was scheduled to begin in November 1975. On this trip I was being sent to the American Ross Island base on McMurdo Sound,

from which I would visit the dry valleys, photograph the penguins and whales in the sound, and fly to the South Pole. And because my first trip was cut short by injury, the National Science Foundation made arrangements for me to take passage on the U.S. Coast Guard icebreaker *Glacier* from McMurdo to Palmer Station on the peninsula — circling the Antarctic continent a distance of 2400 miles. At Palmer I would be a passenger again on the *Hero* for its last cruises to the islands and bays that I had missed on the first trip.

This time on the way to Antarctica I made arrangements to fly to New Zealand two weeks in advance of the flight from Christchurch to McMurdo so I could have time to see the South Island of New Zealand, which I did by automobile. The flight to McMurdo was set for the early morning of November 5. At 6:00 a.m. I took a taxi to the airport, where I re-sorted my baggage and put on the special antarctic clothes that had been issued to me, before boarding the New Zealand Air Force C130 for McMurdo. Flying time was expected to be seven or eight hours. Such great bulky four-engine propeller cargo planes appear quite unflyable when squatting on the runway. The view from inside is, if anything, less reassuring. As in the C141s, the passenger section is in the forward end of the cargo compartment. Passengers sit facing inward on webbed seats, attached to the side of the fusilage as a continuous band of webbing.

After three hours of flying above unbroken overcast, we left the clouds behind and could look down on a sea covered with pack ice. The plane was now south of the Antarctic Convergence, where the cold, antarctic water moving north sinks below the warm water of the South Pacific. After a while land appeared below. The plane had crossed the Antarctic coast west of Cape Adare and was flying above the Transantarctic Mountains, a landscape of triangular, black mountain peaks projecting through the vast white plain of the antarctic ice cap. Eventually the Ross Sea appeared in the distance on the left. Open water was visible as the plane approached McMurdo Sound; then it passed over a white surface with a network of black lines — cracks in the ice covering the sound. We landed on the ice runway on McMurdo Sound, a runway used by wheeled planes from September to December.

I was greeted by an official and shown to my quarters in the "Hotel," the dormitory for the scientists. My roommate was Tom Kellogg, a geologist from the University of Maine; I was to see a great deal of Kellogg and George Denton, a professor of glacial geology at the same university, during the next six weeks. McMurdo Station is located on the western side of Hut Point Peninsula, just north of Cape Armitage, the southernmost extremity of Ross Island. It is a messy complex of some hundred buildings, storage yards, muddy streets, power lines, and all kinds of military and civilian machines. McMurdo is the largest community on the continent, with a summer population of about eight hundred administration, transportation, maintenance, and communication personnel, along with the scientists for whom they are all employed.

The next morning I went to see Chris Shepard, the chief administrator for the National Science Foundation. He asked me to give him a list of all the places I wanted to see and photograph. Because it was all new to me, I had to ask advice from those who knew the area, and George Denton was the first I approached. He was very helpful, directing me to especially interesting examples of geological phenomena in the dry valley on the west side of McMurdo Sound. Transportation at McMurdo was provided by helicopters, and each NSF grantee who needed transportation was given a quota of flying time, which could be effectively increased by sharing flights with other groups. There were always individuals who wanted to fly with me, and I was often able to join the flights of others. This arrangement was especially advantageous with George Denton and his co-workers.

In addition to the penguin and marine mammal life of the sea-ice, the dry valleys on the west side of Mc-

Murdo Sound were of great interest to me. They are called "dry" because they are barren valleys from which the ice sheet has retreated, leaving behind moraine gravel and bare rock. They cut across the Transantarctic Mountains, separated by mountain ranges from which glaciers extend down towards the valley floors, creating an awesome primordial landscape. The ordinary names of the valleys — Taylor, Wright, and Victoria — suitable perhaps to their desolate character, contrast with the more romantic names for the mountains that divide them: Kukri Hill, Asgard, and Olympus. Isolated examples of some extraordinary and beautiful geological phenomena occur down in the valleys. Don Juan Pond is a body of water that never freezes, because it is a saturated solution of magnesium chloride, and in it stand grotesquely eroded monoliths deposited by the retreating ice cap. On Bull Pass between Victoria and Wright Valleys scattered granite boulders — some of enormous size — have been shaped by a process of cavernous erosion called tafoni, in which the crystals of the rock are chipped off by repeated freezing and thawing to create shell-like structures reminiscent of modern sculpture. At the upper end of Wright Valley a maze of deeply cut canyons, appropriately called The Labyrinth, was probably produced during a pluvial period in the history of the continent. And out beyond the limits of the dry valleys, Monastery Nunatak, a solitary outpost of the Transantarctic Mountains named for its architectural semblance, is being slowly ablated by the ice of the polar plateau, which scrapes from its crumbling sides the rocks that become a medial moraine as the glacier reunites after passing by. Wide where it abuts the base of the nunatak, the moraine narrows in a graceful curve out on the ice sheet, until it becomes a mere thread of stones and gravel.

It had been arranged for me to go along on a scheduled supply flight to the South Pole station. The plane, a Hercules LC 130 equipped with skis, took off from Williams Field on the Ross Ice Shelf early in the morning on December 29 for the three-hour flight. The flight crosses the Ross Ice Shelf, the Transantarctic Mountains, and the Antarctic Polar Plateau. I was invited to ride in the cockpit so that I could photograph during the flight. The windows had been specially cleaned for me. Before crossing the mountains we flew parallel to them for many miles, affording an excellent view of hanging glaciers and nunataks beyond the peaks. Everywhere ice spilled over and through the mountains, in small streams and in torrents miles wide, contributing enormous quantities of ice to the Ross Ice Shelf. As the plane approached the South Pole station, I saw a small, low-profile geodesic dome with the thin spike of a radio mast almost indistinguishable on the vast, white polar plain stretching away to the horizon.

I was warmly welcomed by the paramedic, who showed me around the station, which was much larger than my impression of it from the air. He also took me on a tour of the first station, which had been abandoned and was slowly being engulfed by the ice; on a kitchen table were unwashed dishes and partly consumed food, suggesting that it had been evacuated in haste.

On the return flight to McMurdo, as a special concession to me, the pilot flew down the Beardmore Glacier — Scott's route to the Pole — at two hundred feet above the surface. At this altitude the crevassed structure of the glacier was visible in great detail; it seemed incredible that the first polar explorers could have dragged their sledges over the two-hundred-mile length of the glacier. Near the end of the Beardmore we passed a huge snow-free monolith that looked like Gibraltar and is called The Rock by the pilots who fly the route to the Pole.

The icebreakers *Glacier* and *Burton Island* arrived in January to clear a route through the ice in McMurdo Sound for the supply ship and tanker expected that month. On January 15, after that task was completed, I joined the *Glacier* for her cruise to the Weddell Sea by way of Palmer Station. The 2400-mile course to Palmer around the Antarctic continent passed through the Ross, Amundsen, and Bellingshausen Seas. These seas

were filled with ice pack and brash ice in all stages of consolidation, through which the *Glacier* forced a passage. And icebergs, both tabular and peaked, were constantly in sight. When the going became difficult, the ship's helicopters were dispatched to reconnoiter a way out, and I went along to photograph. No land had been seen since the last view of Mt. Erebus on Ross Island until the islands of the Antarctic Peninsula were sighted on February 6. I was flown to Palmer Station and lived there for two weeks, while awaiting the return of the *Hero* from Ushuaia. Meanwhile, with Bill Fraser, in whose company excursions in a Zodiac rubber boat were permissible, I went to many of the outlying islands that I had not been able to visit on the first trip. Bill was studying antarctic avian ecology, with special emphasis on the great black-backed gull, and with him I learned a great deal about the bird life of the peninsula.

When the *Hero* returned on February 21, I moved on board for the remainder of my stay in Antarctica. Three cruises were made during the next three weeks. Most profitable for me was the third cruise south of the Antarctic Circle, on which we navigated the narrow Lamaire Channel to the Argentine Islands and on to Grandidier Channel, Adelaide Island, and Marguerite Bay. The other cruises were all to the north, one to dredge in Schollaert Channel between Anvers and Brabant Islands, returning by way of the Melchiors, a group of small, jagged islands. A narrow, navigable passage divides them, and into this the *Hero* sailed, in a foreboding atmosphere of shifting storm clouds that concealed the upper reaches of the islands, reinforced by ominous spires of black rock projecting from the water and precariously balanced and fissured cliffs of ice threatening imminent collapse. Without slackening, the ship rushed on into the gloom; her precipitous daring inspired confidence that she could successfully evade an unseen Scylla or Charybdis. During the passage the threatening atmosphere was relieved temporarily by a break in the clouds through which a shaft of light illuminated a high ice field. The ice glinted in the

sun; an eye winked open to peer at the bold intruder. Unilluminated, the islands below kept their enigmatic presence, or malign intent, and the *Hero* sailed on.

The other northern cruise was to Deception Island, where I was able to explore the inner wall of the crater opposite the abandoned whaling station. My companion did not like the looks of the slope of lava scree so I climbed it alone and discovered an unfrozen, blue lake in a hidden subsidiary crater. I decided to return by another talus across a ravine, which proved more treacherous than it first appeared. Many of the rocks resting on ice gave way at the slightest pressure as I crawled down on hands and feet, expecting at any minute to see my camera case go tumbling down the slope in an avalanche of rocks. I had several close calls but eventually got back to the lagoon without mishap.

The southern cruise marked the end of the austral summer season. The *Hero* was scheduled to depart for Ushuaia on March 9, 1976, and not to return for seven months. The party that evolved spontaneously in the evening after dinner at the station was a farewell to us by those few staying behind, who would face seven months of winter; it seemed a little sad and tinged with envy to those of us leaving Antarctica, who found the happy anticipation of a return to civilization tempered by nostalgia.

It was four years before I took such an ambitious trip again, but this last trip was the fruit of long planning. My first thoughts of going to China were inspired by my son, Jonathan, a scholar of Chinese and Oriental history. Together we had a dream of following in the footsteps of Marco Polo as an exciting adventure; we also thought of China as a possible subject for publication — an ambitious project which was ultimately reduced to realizable objectives by the restraints of historic events. We thought that the most apposite historical approach to China would be to follow Marco Polo's route, which would begin in Turkey, cross Iran into Afghanistan, and from there enter China through the Afghan corridor north of Pakistan. It was a roman-

tic, adventurous proposal fraught with difficulties but not particularly original; it had been attempted by a party that, with persistent effort, managed to reach the Chinese border by this route but was not admitted to China. In any case this approach to China became impractical after the overthrow of the Shah of Iran and the invasion of Afghanistan by Russia in 1979.

We had also tried to organize a more direct route to China through diplomatic channels. Jonathan applied to the Chinese Embassy in Canada for permission to visit China. China was then under the rule of Mao Tsetung and was not yet recognized by the United States. No reply was received, but after Mao's death in 1976 Jonathan applied again, and following the establishment of diplomatic relations with the U.S., at the beginning of 1979, he applied a third time. In April 1979 he finally received a reply from the Xinhua news agency in Peking, saying that his group would be welcomed in China for seven weeks in June. Because of a tight schedule resulting from academic obligations at the University of New Mexico, where Jonathan was a professor in the history department, he requested postponement of our visit until 1980, which was granted.

The agreement with the Xinhua news agency included guides, transportation, and accommodations for which we would pay the costs. There were four of us — Jonathan and his wife, Zoe, my youngest son, Patrick, and myself. The purpose of our visit, as our application had stated, was to photograph the Chinese landscape and historic monuments. Upon our arrival in Peking, a representative of Xinhua came to our hotel to plan our itinerary, which was very complicated because of the many places Jonathan wanted to see, scattered all over China. A tour was finally worked out to include most of the important historic and cultural centers in central China. And we were introduced to Dang Xinhua, an educated young man, fluent in English, who was to be our guide during our stay.

My first experience with the Chinese occurred on a street near the hotel when I photographed two amused nursemaids with their charges and baby carriages. My activities immediately attracted a crowd, and since I was using the new Polaroid instant camera as well as a Nikon, everyone wanted his picture taken and would grab the picture as soon as it was ejected by the camera, before I could see it myself. A policeman soon appeared, who said, "Enough of this," and dispersed the crowd.

We stayed several days in Peking visiting the Forbidden City (Imperial Palace), The Temple of Heaven, Mao's tomb in the Great Square, and the Summer Palace. We went out early in the morning to see the bicycle traffic that filled the streets with people going to work and to watch the older men performing the exercises of T'ai Chi in slow rhythms, singly and in groups. And we visited the old section of Peking in which the way of life has been less affected by modern influences. Our first journey outside the city was to the Great Wall — a major tourist attraction north of Peking. To escape the crowds of sightseers, we walked along the wall for more than a mile and marveled at its monumental construction. The wall could be seen stretching far away curving around and over the distant treeless hills, which were covered with a low vegetation like green velvet.

Our next destination was Taishan — the sacred mountain in Shandong province — and Confucius' temple, tomb, and cemetery at Qufu, where more than seventy generations of Confucius' descendants, the Kong family, are buried. There are 200,000 of them in the cemetery, in a wooded area surrounded by a moat. Some of the graves are marked by simple tombstones, or carved stone animals, whereas statues of guardians mark the graves of the more notable members of the family. On the summit of Taishan a Buddhist temple complex is the goal of pilgrims, who climb the five thousand stone steps to abase themselves and watch the sun rise over the Yellow Sea. We made the ascent and were given rooms and a meal in the primitive hostel; at four in the morning we were awakened, provided with

quilted coats to insulate us from the chilly morning air, and conducted to an overlook, from which we witnessed the break of day.

Our project was to photograph the landscape and historic monuments of China, but we discovered that many of the temples and shrines had been vandalized or destroyed by the Red Guards during the Cultural Revolution. However, we found that the activities of the people in their everyday pursuits were as interesting and captivating as their cultural achievements. Consequently we spent more time than we had originally planned walking about in the cities we visited, photographing street scenes, shops, markets, and people at work. We spent several days this way in Xian, the first major city we had visited since leaving Peking, located in the Wei River valley of central China. The loess highlands in the vicinity are the product of thousands of years' accumulation of wind-deposited soil from the Gobi Desert. The deposits are so dense and thick that cave houses have been carved into them, some even with doors and windows, facaded entrances, and electric power.

From Xian we continued on west to Lanzhou on the Yellow River and into the Gansu Corridor. Our transportation was a van similar to a station wagon with a large baggage compartment in the rear and with room for the four of us, Dang Xinhua, our driver, and frequently district representatives who served as local guides. The Gansu Corridor was the trade route west to Turkestan and Persia. It was protected by the Qilian Mountains to the south and the Great Wall on the north, which terminated in substantial fortifications at Jiayuguan. From Jiayuguan the trade route followed a line of signal towers to Dunhuang, an oasis and rest stop and the site of the Mogao Grottoes, which had been sealed by Buddhist monks during a past period of invasions and only recently rediscovered. Warnings of invasion from the west could be sent by smoke signals from the signal towers to reach Jiayuguan and the ruling dynasty in a few hours.

Dunhuang had not escaped the ravages of the Red Guards, who had destroyed a Buddhist temple situated on a lake in a hidden alcove with sand dunes rising around it. We asked permission to photograph the figures of Buddha in the Mogao Grottoes, excavated in sandstone cliffs bordering a small stream, but were refused by the bureaucratic administrator, who said that flash light would damage the paintings. In fact we used only natural light, but his true reason for refusing was to protect prior rights to publication by the Chinese. After intervention by our guide we were allowed to photograph in two of the grottoes. It was very frustrating, because of the great wealth and beauty of the displays.

Dunhuang was as far west as we got on this trip. Our next destination was Guanxian (northwest of Chengdu), famous for Dufiang Dam — a thousand-year-old irrigation system — and the Temple of the Two Kings, a place with a strong historical attraction for the Chinese themselves; while we were there we saw no Europeans or Americans — only Chinese tourists. From Guanxian we went to Chengdu in central Sichuan, a city commonly on the itinerary of western tours and known for its spicy Sichuan cuisine — the best food in China.

Chongqing was the capital of nationalist China under Chiang Kai-shek during World War II. Because of its location on the Yangtze River, Chongqing is the shipping, supply, and distribution center for central China, and we went there for a boat trip down the river through the Yangtze Gorges. We had three days before the steamship was scheduled to depart, which we profitably spent exploring the inner city and photographing on the waterfront, where boats of all types — ferries large and small, sampans, and cargo vessels — were constantly docking and departing. A recently constructed bridge that spanned the Yangtze attracted large numbers of Chinese spectators as well as us. I was photographing boys and girls leaning on the railing when it occurred to me to use the Polaroid camera and give the

Shrine, Cheung Chau, "Long Island," Hong Kong, 1981.

picture to one of my subjects. This was a mistake. A crowd quickly gathered, and I was importuned for pictures from all sides, but especially aggressively by two girls, who almost threateningly demanded to be photographed. In vain I tried to put them off, but finally I took one picture of them together and immediately pushed my way out of the crowd.

The steamer made prolonged calls at several small towns along the river so that we were able to disembark and observe and photograph the activities of the inhabitants. We left the ship at Wuhan after three days on the river and drove to Lushan; there we took a train for Hangzhou, from which we went to Huangshan (Yellow Mountain), a complex, mountainous region which is a mecca for landscape painters and for Chinese pilgrims in search of untrammeled scenery.

Before starting the climb I asked Dang if he could hire someone to carry my large camera and tripod so that I would be less encumbered for using my small camera. When I was introduced to my porter in the morning as we were starting off I was taken aback, because my helper was a small woman of undetermined age, and I wondered whether she would be able to carry all my equipment. I need not have been concerned. Accompanied by a very young daughter, she skipped up the mountain ahead of me like a mountain goat, and I had to slow her down so that I could use the larger

camera. We hiked for three days on the mountain with groups of young students, who practiced their English and French on us. On a rock ridge, while burdened with camera and tripod, two girls reached down from a ledge above and lifted me up — a manifestation of Chinese reverence for age.

One night in Shanghai was followed by two days in Suzhou — the Venice of China — built on a network of canals but without the equivalent of gondolas. The waterways, supplemented by streets for vehicular traffic and pedestrians, served for the transportation of household supplies and merchandise in sampans, both motorized and manually propelled.

We flew from Suzhou to Guilin in a cargo plane, a makeshift arrangement with seats attached to the sides of the fuselage, so that the passengers faced one another across the central space in which our baggage was heaped up. Guilin, known for its spectacular landscape of isolated mountain peaks standing on the plain as if by accident, has long been a popular place for Chinese painters, whose works have led western collectors of Chinese art to believe that the extreme geological phenomena illustrated in their paintings were typically Chinese or that the artists had indulged in aesthetic exaggeration. Neither is the case. The limestone peaks, described in geological terms as karst formation, were produced by erosion during a past pluvial period and are today, in the semitropical climate of Guilin, blanketed with vegetation. We were flown from Guilin to Canton and there visited the old deserted British section from which the Chinese were excluded in colonial times. We left China on July 27, traveling by boat down the Pearl River to Hong Kong, and returned home after a week in Macao, a Portuguese colony on the mainland of China.

Our second trip to China took place in September and October of 1981 and included the frontier districts that we had not visited in the year before, with the exception of Manchuria. Again, travel arrangements were made through the Xinhua news agency and our

guide this time was Liu, an older, more cultured man, who had been the Xinhua representative in Scandanavia and had visited Iceland and Greenland. We wanted to see some part of the Chinese coast, which was most easily accessible on the Shandong peninsula; there we first visited Qingdao on the south side, followed by Yantai, a shipping port, and Penglai lighthouse and pavilion on the north side. When we inquired about the private lives of Chinese workers — what their homes were like — we were taken to the house of a Chinese family, no doubt especially selected for its cultivated atmosphere, and were shown into all the rooms to see their cherished possessions and how they lived. And we were taken to a nursery school in which I was first enchanted by Chinese children and sensed the loving care and gentle discipline that govern childhood education.

Our next frontier was the plains of Inner Mongolia and the grasslands of the Yellow River basin. North of the Great Wall the houses of the farmers and herdsmen are built on the south-facing slopes of the low hills, with the windows and doors all on the south sides to take advantage of the southern sun — a primitive solar heating arrangement. Beyond the hill country and the Buddhist and Muslim town of Hohot, the treeless plains stretch away to the horizon; this is the land of the Mongol herdsman, whose domestic animals are sheep and goats, Bactrian camels, and smaller numbers of horses and cattle. The Mongols live in mud huts or in yurts, tent-like frames of thin wood strips covered with skins or wool cloth. Horses are their principal means of transportation, whereas camels are the beasts of burden; they are all skilled horsemen. We witnessed a roundup of horses during which they demonstrated the Mongol way of catching a horse, which, unlike the New World lasso, is accomplished with a loop of rope or rawhide attached to the end of a long pole that is dropped over the head of the pursued horse at full gallop.

Guangjuesi, "Monastery of Boundless Teaching,"

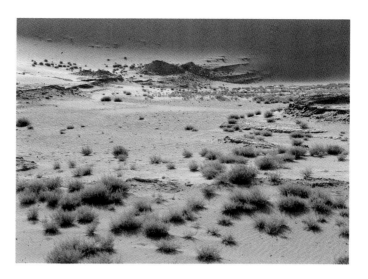

Desert vegetation, Dunhuang, Gansu Province, China, June 29, 1980.

is a Buddhist establishment consisting of many whitewashed dormitories and temples situated in hilly country near Baotou on the Yellow River. Here we were permitted to photograph the altars, shrines, and temple interiors with complete freedom. An amused, wrinkle-faced, red-robed lama of indeterminate age submitted affably to our request to photograph him, standing before red temple doors.

Xinjiang province, the northwest frontier beyond Dunhuang in Gansu, was high on the list of remote regions of China that we hoped to visit. We went there by train through the Gansu Corridor by the same route we had taken to Dunhuang the year before. Since all travel arrangements were made by Xinhua, we were always provided with first-class accommodations and train fares, and because most Chinese cannot afford first-class tickets, there were usually no other passengers in our car with the exception of army officers, whose rank in the absence of insignia on their uniforms was indicated only by the ball point pens they carried in their breast pockets. On long-distance and overnight train trips dining cars were provided for the first-class passengers. On one long train ride we and our guide were the only passengers, and the chef had so little to do that he made an effort to give us especially good

meals. One day at breakfast he said that he had a fish he would bake for us. It was a river fish of some kind, and he outdid himself; it was the best meal we had in China.

We arrived in Urumqi by a combination of train and auto transportation. The inhabitants of Urumqi and Turfan are considered minorities because they are ethnically of Turkic descent; the majority are Kazaks and Uygurs, who originally spoke Arabic and the language of Turkestan and were mostly Muslims. But Chinese cultural and economic influence was purposely introduced by the Chinese government for the assimilation of minorities and to encourage economic dependence on and unification within China.

On our travels by car we frequently stopped in villages in which a degree of entrepreneurism was evident in the activities of the villagers. We asked to visit agricultural and production communes and factories, an aspect of Chinese life that we had not seen on our first trip and a far cry from our original purpose of photographing the landscape and historic monuments. No objections were raised to this request with the result that we were taken to communes and state farms, textile mills, sugar refineries, heavy-industry factories, and steel mills. In one factory we were shown through the entire organization of the plant — from raw material to final product — and such ancillary operations as nursery schools for the children of the workers and the medical and pharmaceutical departments. In the pharmacy we saw modern medicines in one cabinet and a collection of herbs, dried insects, snakes, and toads in another.

We returned to Sichuan and climbed Emei Mountain to Qingyinke, the "Pure Sound Temple," on a stone-paved path with rest pavilions along its route. The path bridged a flowing brook in a rocky ravine on the way to the temple on the mountain top. Except for the construction of the path and the pavilions, the country was wooded and wild, without evidence of human presence. In a similar mountainous area, at the end of a well-kept path, we visited the Taoist temple Qingchengshan —"The Fifth Passage to Heaven."

The last destination was Yunnan, bordering Laos and Vietnam on the Mekong River. In Kunming, the principal city we visited, a heavy-machinery factory produced machines and steel belts for Yugoslavia, and here again we were taken to the nursery school for the children of the workers. And near Kunming we visited the house of a peasant, who belonged to the Guangwei agricultural production brigade. In the hills near Kunming, Buddhist temples that had escaped the depredations of the Red Guards were an attraction for the devout and curious Chinese themselves. The Stone Forest, a labyrinth of gray limestone pinnacles, was a unique geological phenomenon that drew many Chinese visitors. Farthest south on the Chinese mainland was the village of Jinghong, a few miles from the Mekong River, where one looks across to Laos and the people are more Indochinese than Chinese, in both dress and culture. This is the tropics, where the women sit on the ground in the market place, surrounded by their wares of tropical fruits and vegetables. They see few foreigners and turn away with shyness and embarrassment at the camera. There were also minority people at a Hani village nearby, to which we were ferried across a muddy stream on a rickety raft to be received by a group of women and children gathered to welcome us or to stare. They watched us, suspiciously perhaps, as we wandered about photographing their pigs, dogs, and chickens, which all lived together in harmony.

Our second trip to China was drawing to a close. The places we had visited and peoples we had seen complemented our experiences of the first trip; yet, even combined, they were scarcely more than a superficial introduction to China. My impressions, however, were of the almost incomprehensible richness of Chinese culture and history, made concrete by the respect and admiration I felt for the Chinese people we had met.

EPILOGUE

WALKER EVANS, whose work I have always admired, was once quoted as having announced, in I suspect a reckless, not-to-be-quoted moment, that color is vulgar, nature is trivial, and beauty is unimportant. My career has been built on the opposite beliefs. Evans' work deals exclusively with the human scene, and most of his photographs are in fact beautiful to my eyes; but then there are, paradoxically, some things in common between his work and mine.

As the photographer of the social scene records human emotions and behavior, normal and abnormal, man's relationship to his fellow men and to the environment, and the impact of his activities on his surroundings — how he alters them to his advantage and disadvantage, and how he copes with the situations he creates — so the photographer of the non-human world is concerned with the interrelationships between other living things and between them and the physical environment. The study of these relationships is ecology. Ecology in its broadest sense includes man, too, and in its most comprehensive meaning ecology is the study of life.

During my career as a photographer I discovered that color was essential to my pursuit of beauty in nature. Walker Evans was not alone in his criticism of color photography, particularly in its early years. When color film became available in the forties it was not highly regarded by those photographers who practiced photography as an art. Ansel Adams felt that color methods restricted interpretive freedom by greatly increasing the literal quality of the finished product.

In color photography one was simply copying nature, whereas in black and white the hues of the subject could be rendered in almost any desired tone of gray, thus allowing a wide range of personal interpretation. However, Adams, like many, failed to see that color manipulation can have an interpretive power like the control of tonal values in black and white photography. I believe that when photographers reject the significance of color, they are denying one of our most precious biological attributes — color vision — that we share with relatively few other animal species.

As I became interested in photography in the realm of nature, I began to appreciate the complexity of the relationships that drew my attention; and these I saw were more clearly illustrated in color than in tones of gray. The first objects of nature that attracted me, as might be expected, were the most colorful ones. Of the birds they were those with the brightest plumage, while among other subjects they were the flowers, lichens, and autumn leaves. Gradually the more subtle hues began to draw my attention — the colors of earth, of decaying wood, of bark, and then the strange colored reflections one sees when one looks for them. To be aware of these relationships of light and color requires an education of perception, of training oneself to see; not that in my case the process was a purely conscious one, for if it had been the results would have been stiff and contrived, lacking in spontaneity, as in fact they almost always were when I did make a conscious effort. Rather, the things I began to see were the result of continuously observing the fine structure of nature.

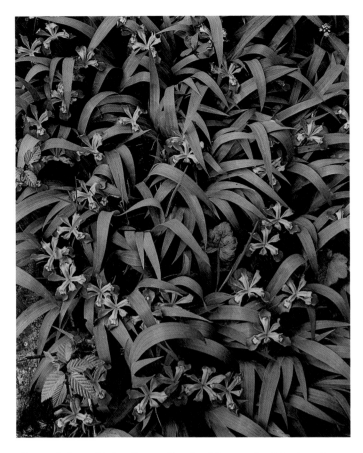

Crested dwarf iris, Great Smoky Mountains National Park, Tennessee, 1968.

It was this complexity in nature that I found most irresistible and that, at first in a very fumbling way, I tried to capture meaningfully on film. I focused on details, and when on occasion I made pictures of the same subject in both color and black and white, it was usually the color photograph that carried the message because it contained the information that attracted my attention in the first place. I began to see the effect of available light on my subjects, either from a clear blue or from an overcast sky, and I began to recognize that direct sunlight was often a disadvantage, producing spotty and distracting patterns. But all sorts of wonderful effects are produced by the interaction of sunlight and skylight with the environment, by a complex of reflection and absorption.

One of the most interesting and compelling subjects for me is water in its numerous forms and manifesta-

tions. As is well known, it reflects the sky, thus giving us the blue sea on a clear day. In rills and puddles it also reflects the sky, giving some marvelous effects in surroundings of quite different color. These small bodies of water reflect light that has already been reflected from some other source in which partial absorption has taken place. Thus the green vegetation beside a pool is reflected by a ruffled surface, giving an emerald cast to the water, or autumn leaves may turn it gold. If the water is moving, the ripples, as they face in various directions, reflect the light from different sources, producing patterns of color. But not only water reflects light; leaves and rocks reflect the sky, too — the upper surfaces of the former, becoming at times in shaded locations as blue as the sky itself, leaving the undersides still a yellow green. The black oxides that form on sandstone in the West, called desert varnish, reflect the sky, too, almost perfectly in shaded alcoves, at which times they shine like windows in the cliff.

Fresh snow is a nearly perfect diffuse reflector, as we have all experienced in the glare from a sunlit winter landscape and in the blueness of shadows illuminated only by the sky. On sunlit snow the blue from the sky is overwhelmed by the intensity of the direct sunlight. Some physiologists insist that snow shadows appear blue owing to a mechanism of visual perception by which one sees the complementary color following stimulation by a strong colored light. Since sunlight is slightly yellow, shadows on snow would by this mechanism appear blue by contrast. No doubt this does happen, but it is also a fact that shadows on snow are illuminated by blue skylight and should appear blue like shaded areas in summer landscapes on bright days. On overcast days snow may appear slightly bluish but is always perceived as neutral white. The blueness of ice and the interior of clean snow banks, described by Thoreau, is an example of the same phenomenon of differential scattering that makes the sky blue.

All these effects can be recorded on color film and can be enhanced or diminished in the print as the

photographer chooses. To those who are not used to observing them they often seem, on reproduction, unreal or false; I have been criticized for the distorted and artificial colors in my photographs. Some people claim that they have never seen anything like them, although they have been to the same places, and therefore they maintain that what I have done is to falsify nature. However, the colors in my photographs are always present in the scene itself, although I sometimes emphasize or reduce them in the printing process. To do this is no more than to do what the black and white photographer does with neutral tonal values during the steps of negative development and printing.

I recall an incident when a painter friend saw my exhibition of Glen Canyon photographs and asked me how I could justify representing rocks in those gaudy colors. "What color are rocks?" I asked. "Rock color," he said. Though he lived in the Southwest, he was a New Englander and was unable to free himself from his early-life gray-stones impressions — the "color of antiquity" as Thoreau described the lichened rocks of Concord. He could not contemplate the Utah sandstones of more recent antiquity being different in color from the ancient granites of Massachusetts. Thoreau, I am sure, would have been more open-minded.

My brother Fairfield's observations on the color in my photographs were more perceptive. In 1960 he wrote an article for *The Nation* in which he discussed the relationship of painting to photography as an art medium and included a critical review of my color photographs, which were then being exhibited at the George Eastman House in Rochester under the title *The Seasons*. In the article he called my photographs an expression of the immediacy of experience, saying: "They are not like other color photographs. There are no eccentric angles familiar to the movies, snapshots or advertising, and the color is like a revelation. The color of photographs usually looks added: it floats in a film above the surface; it is a dressing-up. . . . But Porter's colors, with all the clear transparency of dyes, have

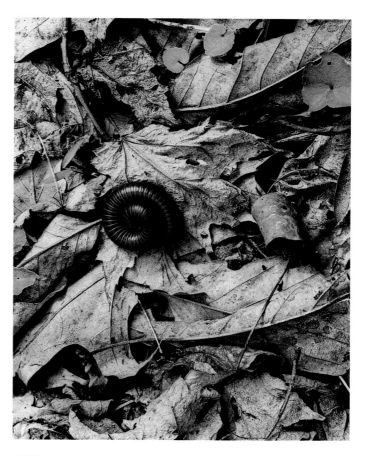

Millipede, Laurel Falls Trail, Great Smoky Mountains National Park, Tennessee, May 10, 1968.

substance as well. They are not on top. . . . His range of colors contributes to their namelessness. . . . These photographs make wonder the natural condition of the human mind. Have you ever seen before the redness of grass, the blueness of leaves, the orange cliffs of autumn, the two circles of sunflower blossoms, or a kerosene lamp against the sun in a window? Or that where a tree has fallen, it seems to have fallen with intention? There is no subject and background, every corner is equally alive."

The total picture is in the end what counts. All the parts should combine to produce an integrated whole with greatest economy and least irrelevance. The more clutter the viewer has to dig through to get the message, the less the photograph will appeal to him and the less conviction it will carry. Nevertheless, and perhaps somewhat paradoxically, I believe that intricacy of

detail and complexity of subject need not contradict harmony nor an inherent simplicity of the whole. A large percentage of the subjects I photograph are complex, but the many parts and interrelationships within these photographs add up to a simple concept. That one cannot lay down elementary rules, and that when one does he is almost certainly caught in a contradiction, is a measure of the creative potential of an art medium. In the end the evaluation of any medium of expression eventually comes back to a judgment of the work of the individual artist who uses it, and not of the intrinsic nature of the process.

The essential quality of a photograph is the emotional impact that it carries, which is a measure of the author's success in translating into photographic terms his own emotional response to the subject. The more keenly the photographer feels his relationship with the world about him, whatever this world may be, whether it is what we commonly call the natural world or whether it is the world of human society and its products, and the more attuned he is to the most subtle manifestations of its complexity and variety, the more possibility there will be that his interpretation of his experiences will carry conviction. If his vision has become clouded because he has fallen into the rut of formulization, not all the skill at his command will convey to his audience more than superficial feeling. Sensitivity cannot be faked by trick or device; it has no substitute, and any attempt to replace it with mechanical contrivances is certain to be apparent to the more discerning critics. Not all photographs have to be inspired to be worth making, but the best, rare photographs are the result of a force at least very close to inspiration. Formulized work becomes impersonal, and all the individuality of authorship tends to disappear. It unquestionably has its uses, but it is not art.

I have had years to experience in my own work, and observe in the work of others, that the rare photograph, the work of art, is the conscious product of personality, the expression of individuality, of vision and understanding of truth. But before all else a work of art is the creation of love, love for the subject first and for the medium second. Love is the fundamental necessity underlying the need to create, underlying the emotion that gives it form, and from which grows the finished product that is presented to the world. Love is the general criterion by which the rare photograph is judged. It must contain it to be not less than the best of which the photographer is capable.

In my life my chosen subject has been nature and my chosen medium color photography. My devotion to the natural world was the inevitable consequence of childhood environment and family influence; my sense of wonder was first aroused by the physical and biological mysteries of science, and when I became interested in photography the subjects that occupied my attention were those primarily connected with the natural scene. At the same time, nature became intimately associated with my perception of beauty. This feeling has persisted throughout my life, although with maturity my appreciation for what is beautiful has vastly expanded. And so the aspects of nature that I perceive as beautiful in the conventional sense as well as in a phenomenal sense are what I attempt to record photographically.

PLATES

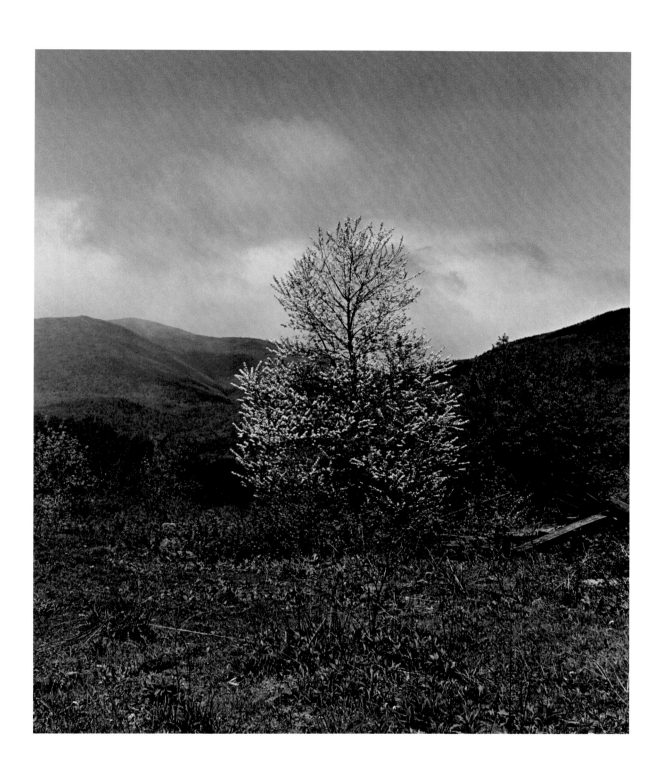

1. WHITEFACE INTERVALE, NEW HAMPSHIRE, 1936

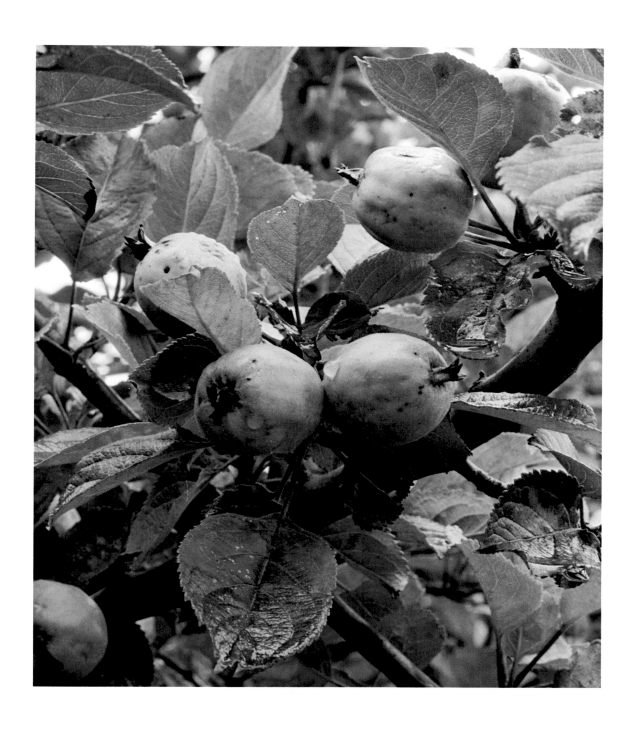

2. APPLES, GREAT SPRUCE HEAD ISLAND, MAINE, 1936

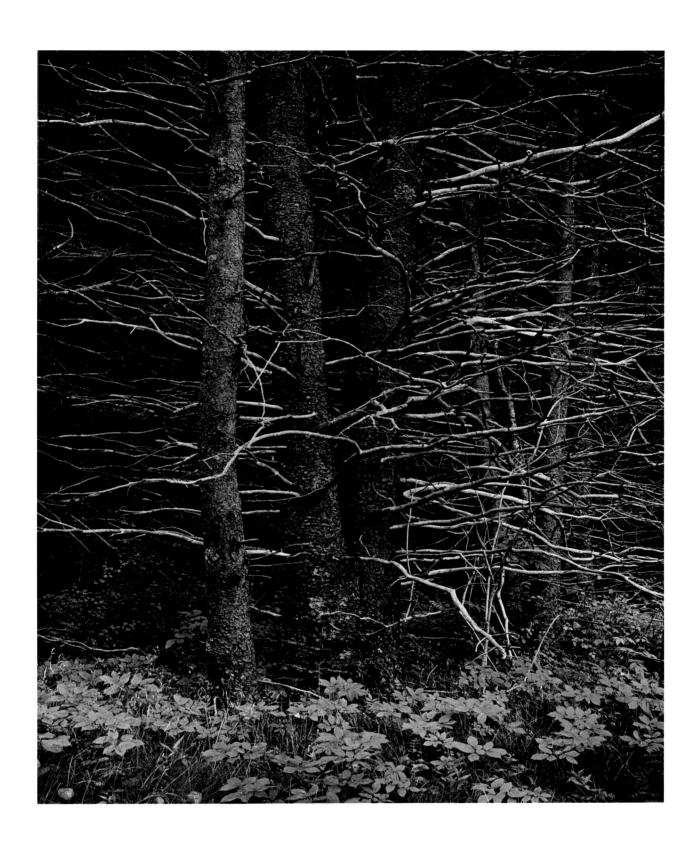

3. SPRUCE TREES, GREAT SPRUCE HEAD ISLAND, MAINE, 1940

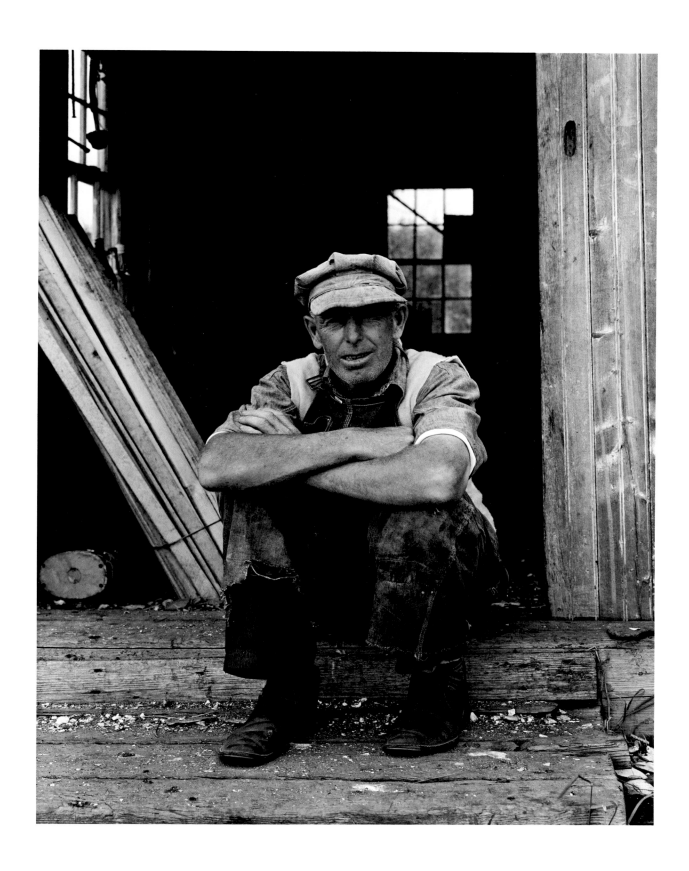

4. EARL BROWN, EAGLE ISLAND, MAINE, 1939

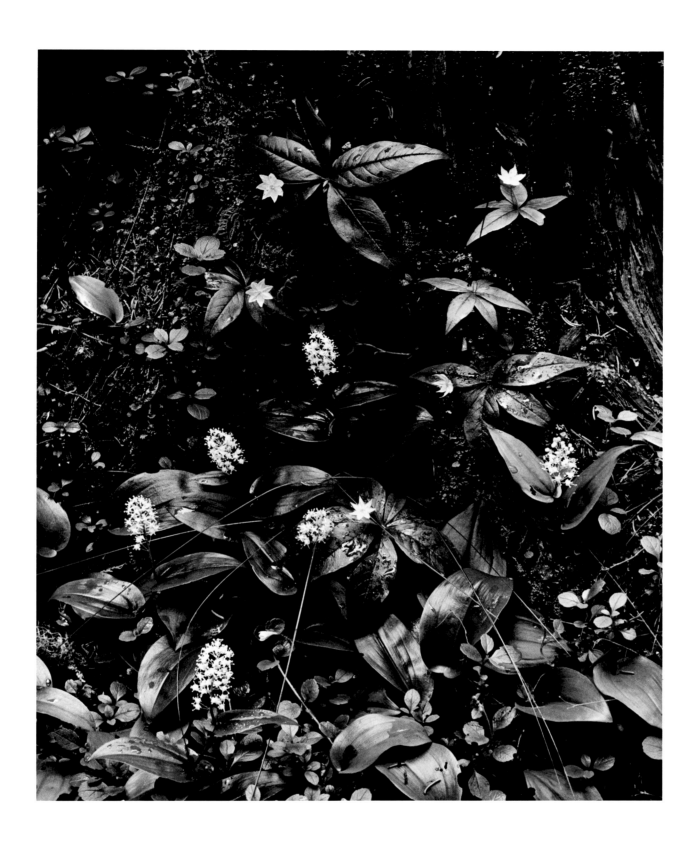

5. MAIANTHEMUM AND STARFLOWER, GREAT SPRUCE HEAD ISLAND, MAINE, 1938

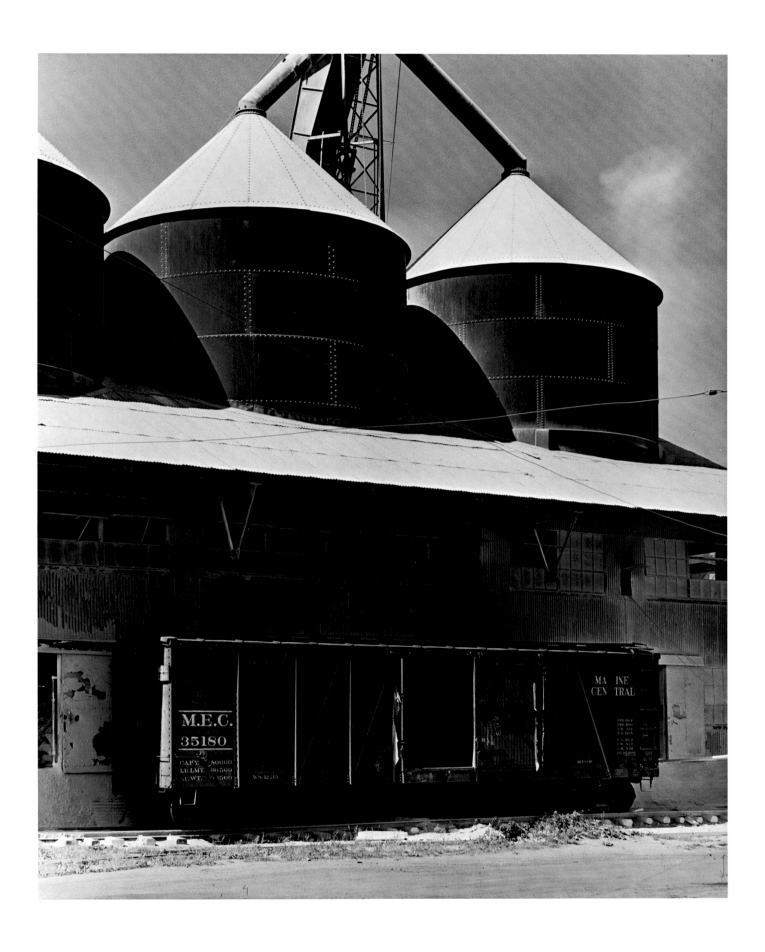

6. GRAIN ELEVATORS, ROCKLAND, MAINE, 1937

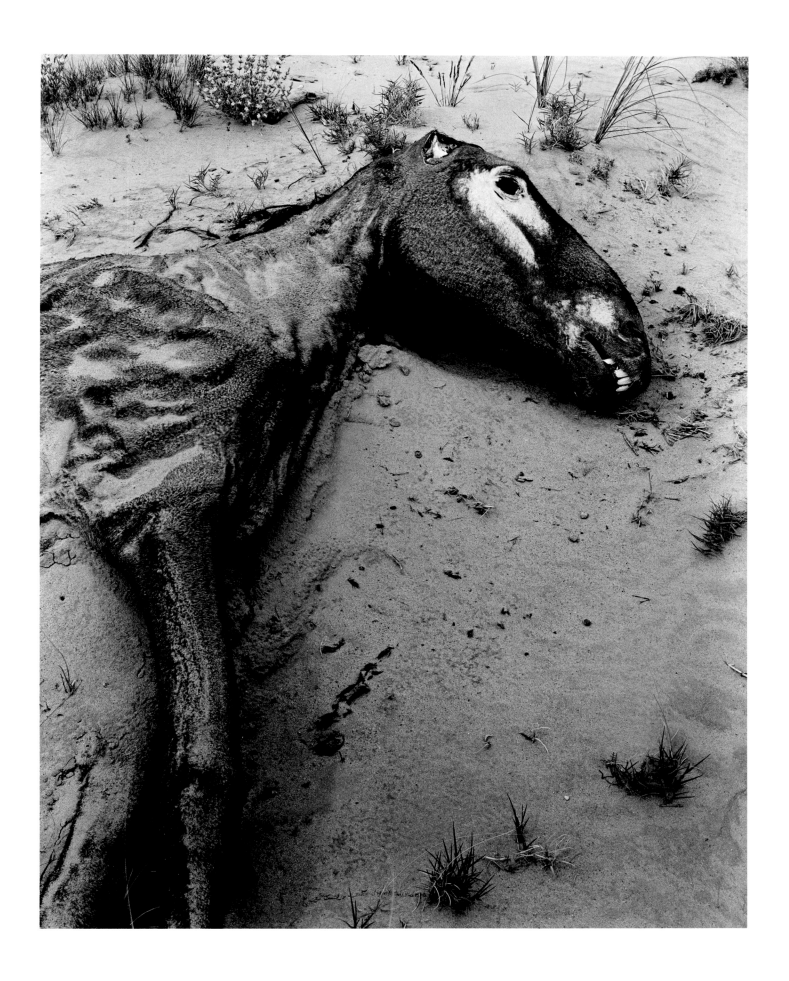

7. DEAD HORSE, ARIZONA, 1940

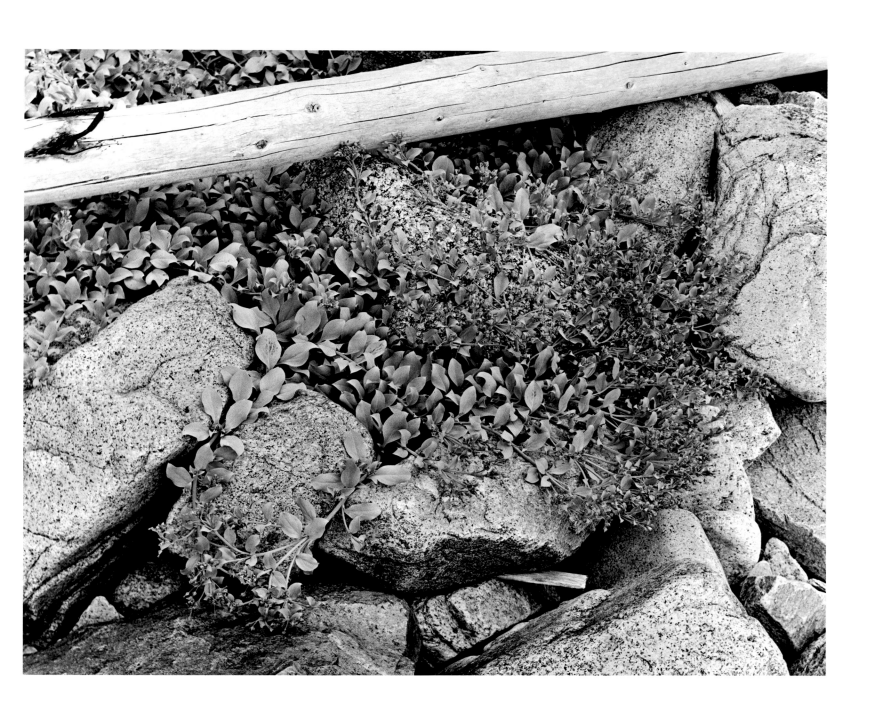

8. MERTENSIA MARITIMA, GREAT SPRUCE HEAD ISLAND, MAINE, 1937

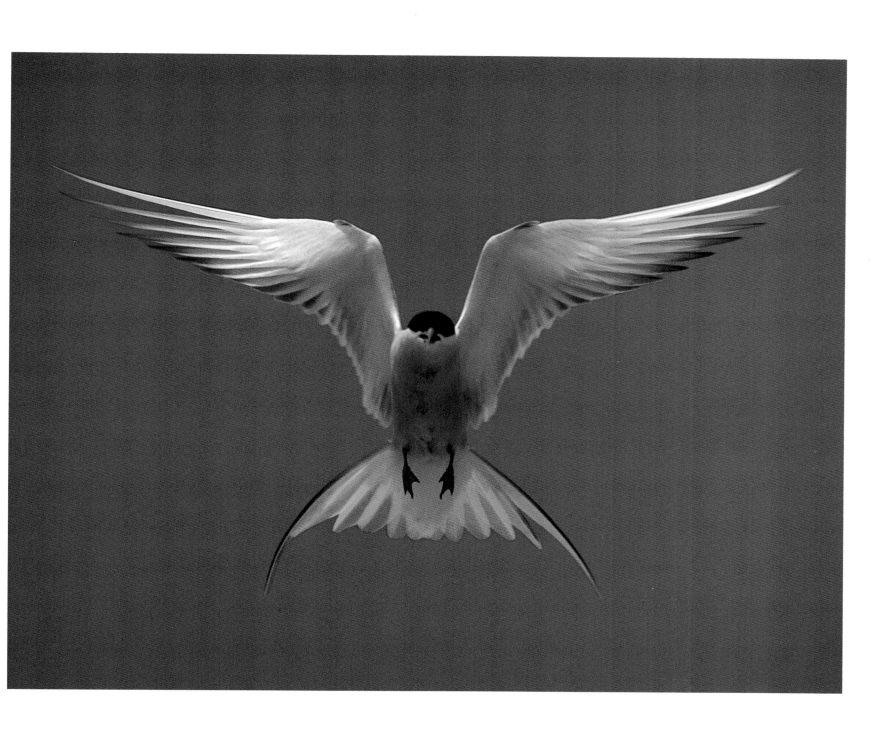

9. ARCTIC TERN, MATINICUS ROCK, MAINE, 1976

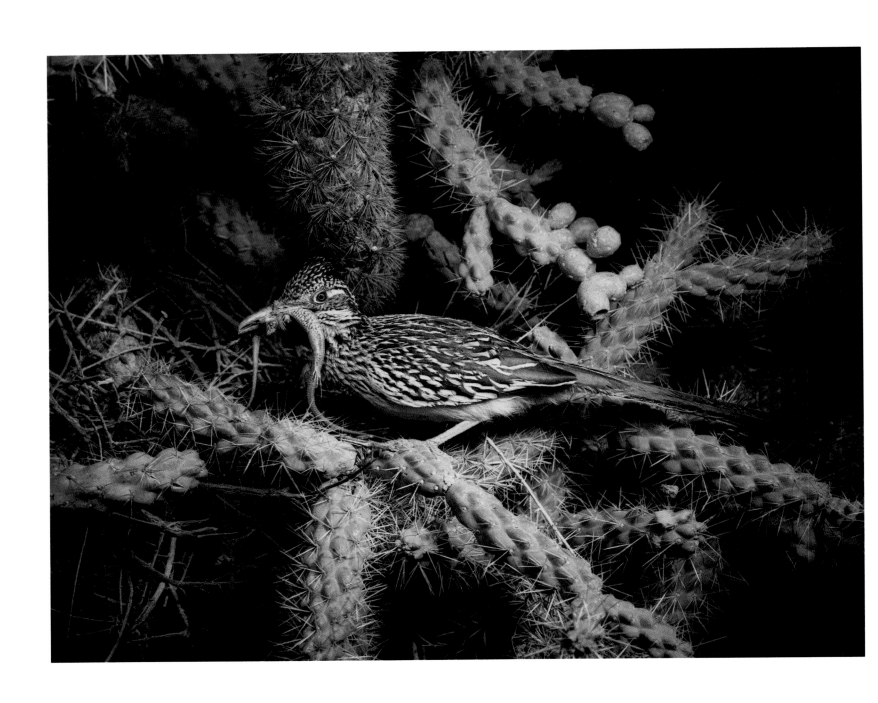

10. ROADRUNNER, SAN XAVIER INDIAN RESERVATION, ARIZONA, MAY 2, 1952

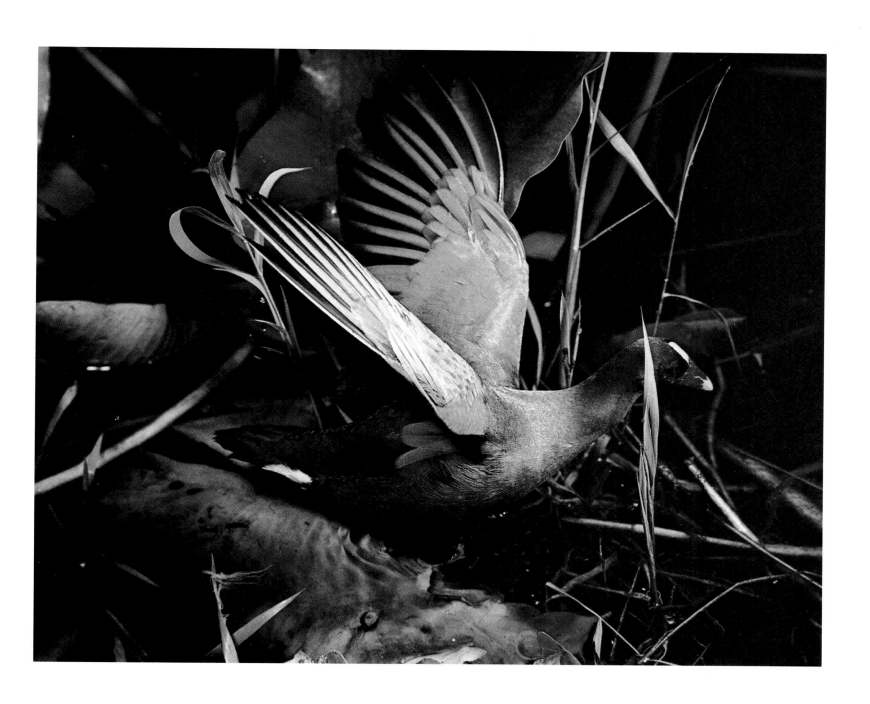

11. PURPLE GALLINULE, EVERGLADES NATIONAL PARK, FLORIDA, MARCH 2, 1954

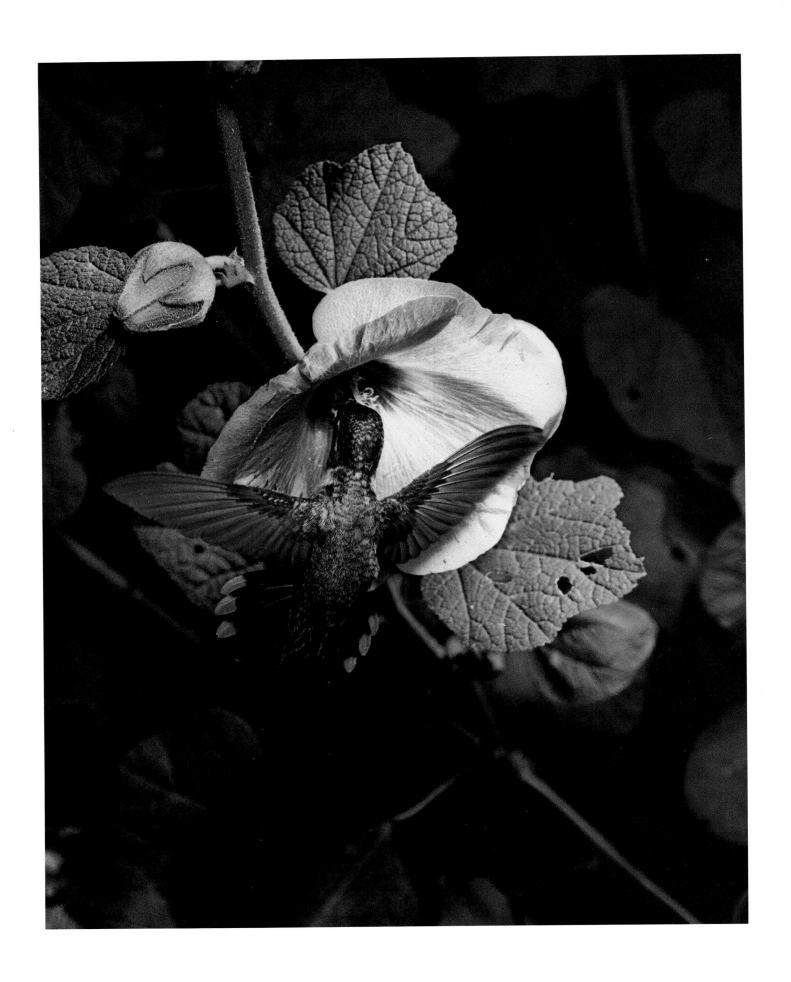

12. RUFOUS HUMMINGBIRD, TESUQUE, NEW MEXICO, AUGUST 4, 1956

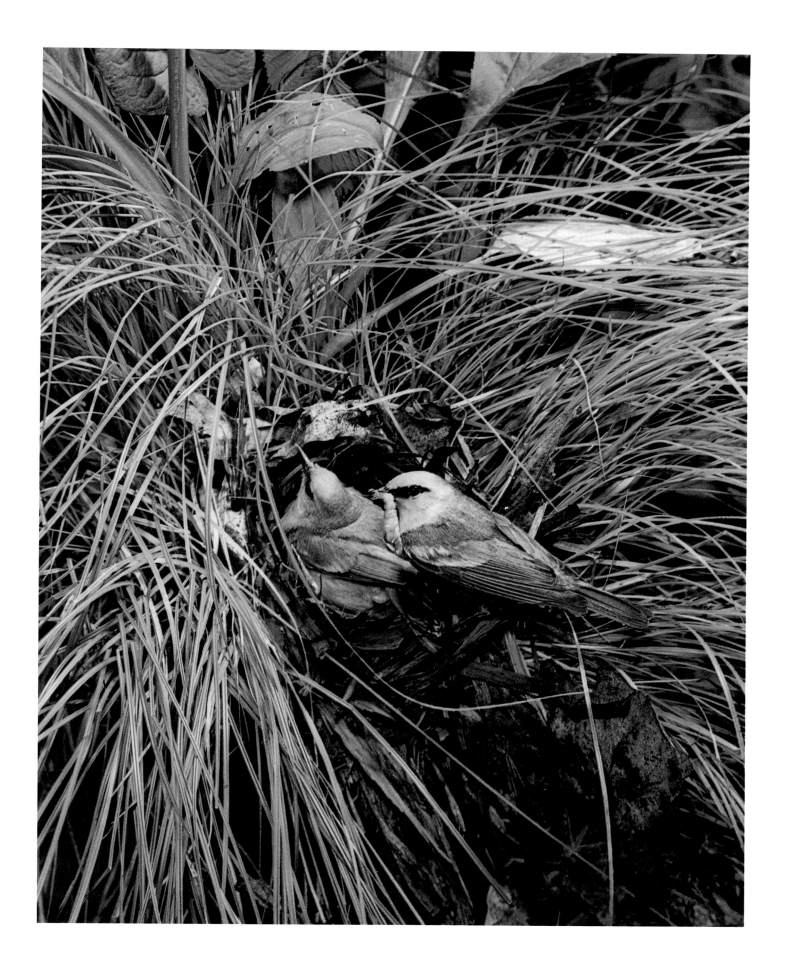

13. BLUE-WINGED WARBLERS, JACKSON, MICHIGAN, JUNE 1955

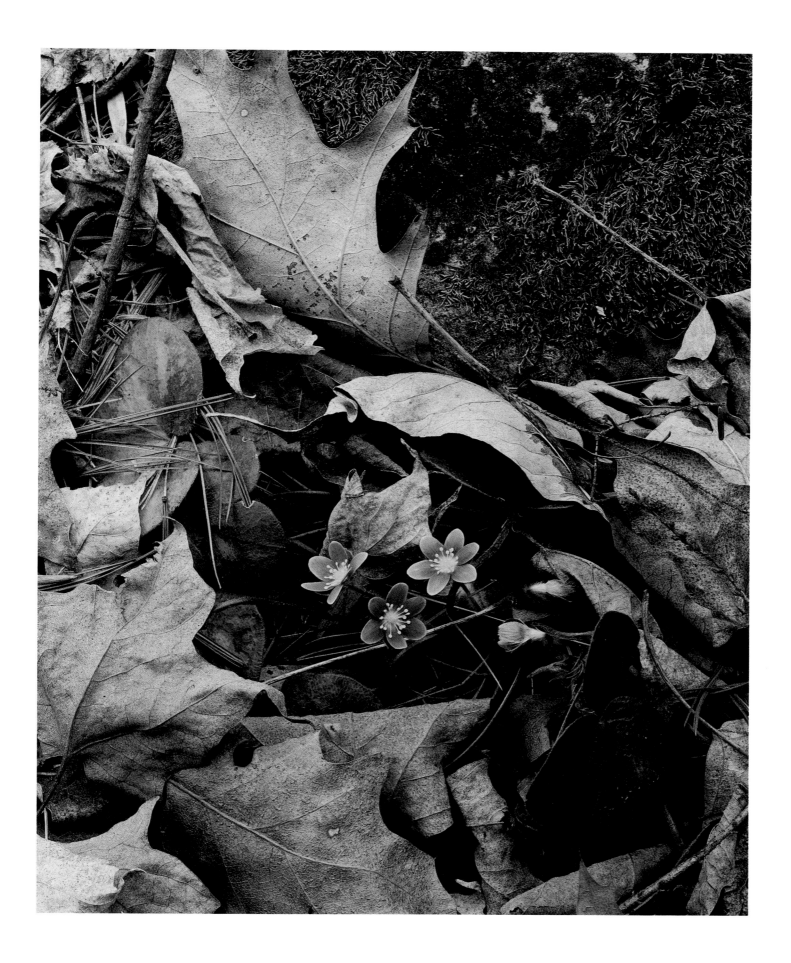

14. HEPATICAS, NEAR SHEFFIELD, MASSACHUSETTS, APRIL 17, 1957

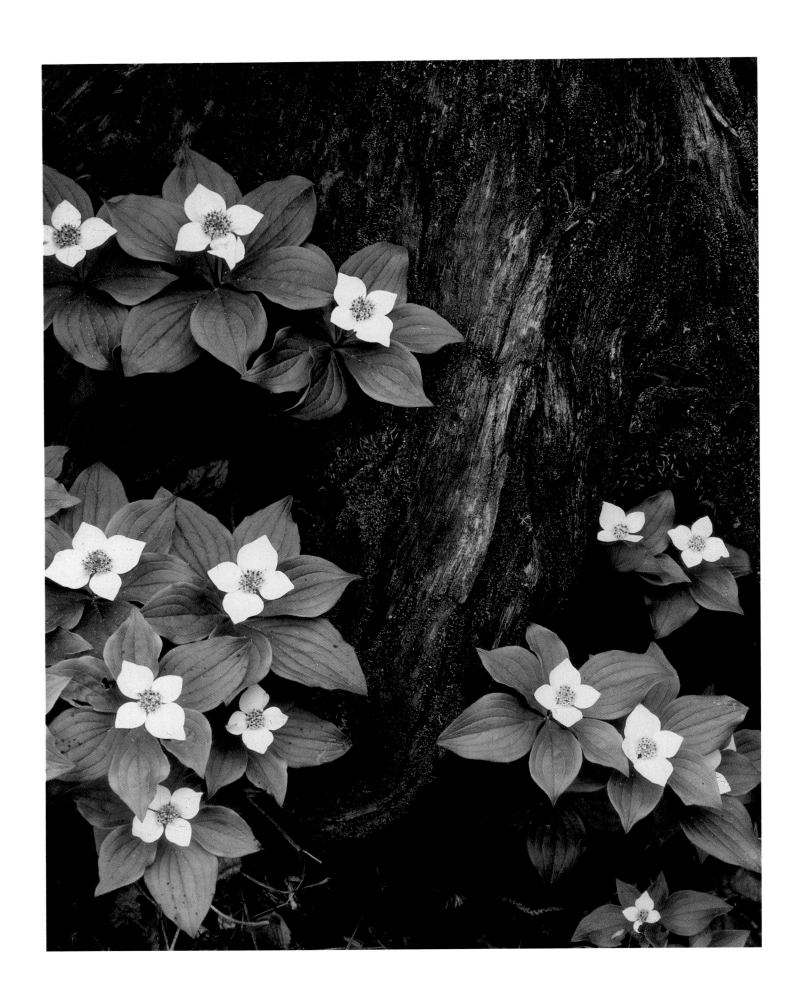

15. BUNCHBERRY FLOWERS, SILVER LAKE, NEW HAMPSHIRE, JUNE 5, 1953

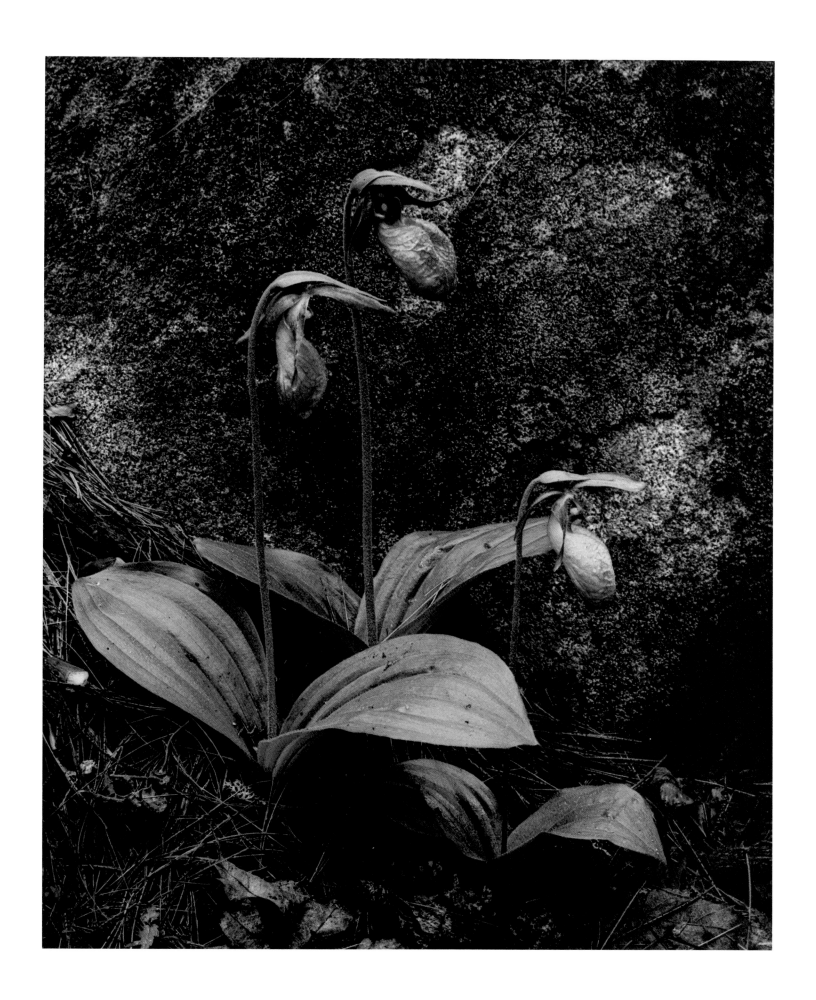

16. LADY'S-SLIPPER, TAMWORTH, NEW HAMPSHIRE, MAY 27, 1953

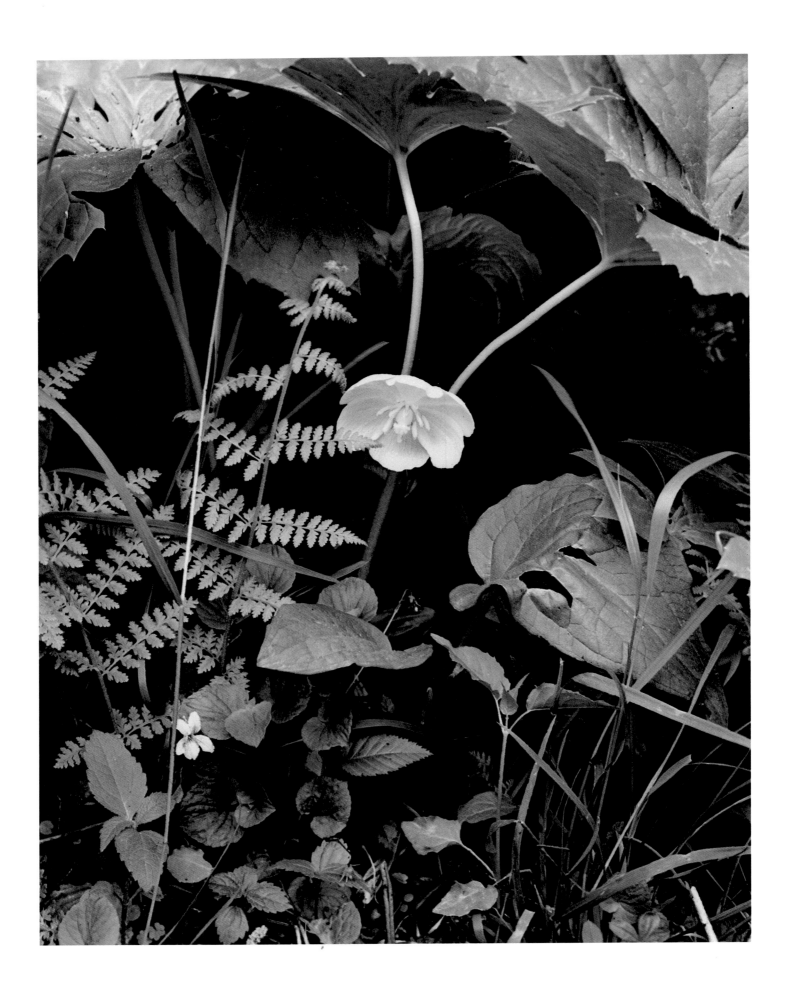

17. MAY APPLE, NEAR HARRISBURG, PENNSYLVANIA, MAY 13, 1957

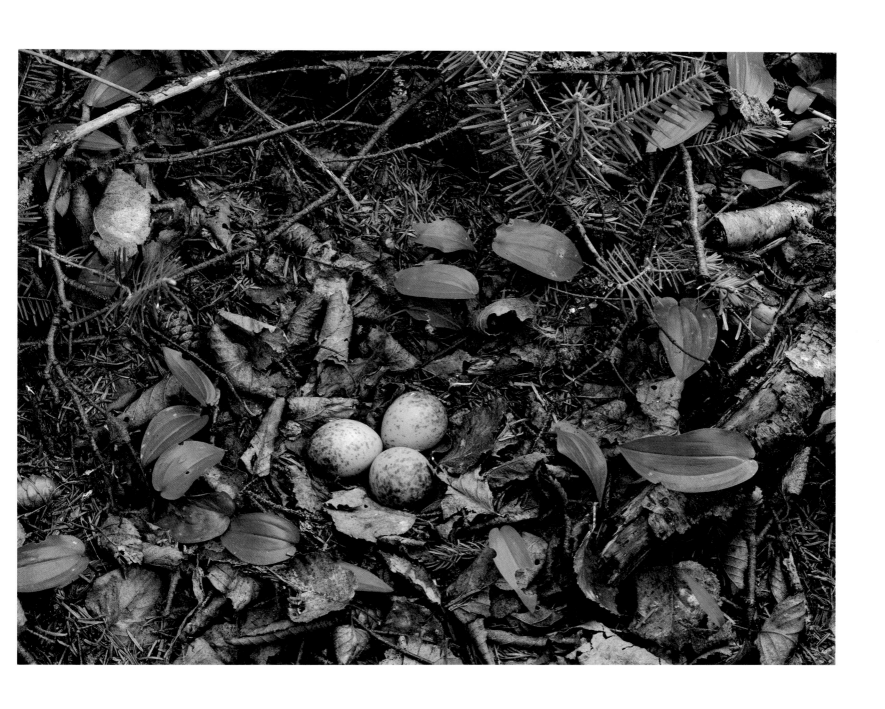

18. WOODCOCK'S NEST, GREAT SPRUCE HEAD ISLAND, MAINE, JUNE 5, 1949

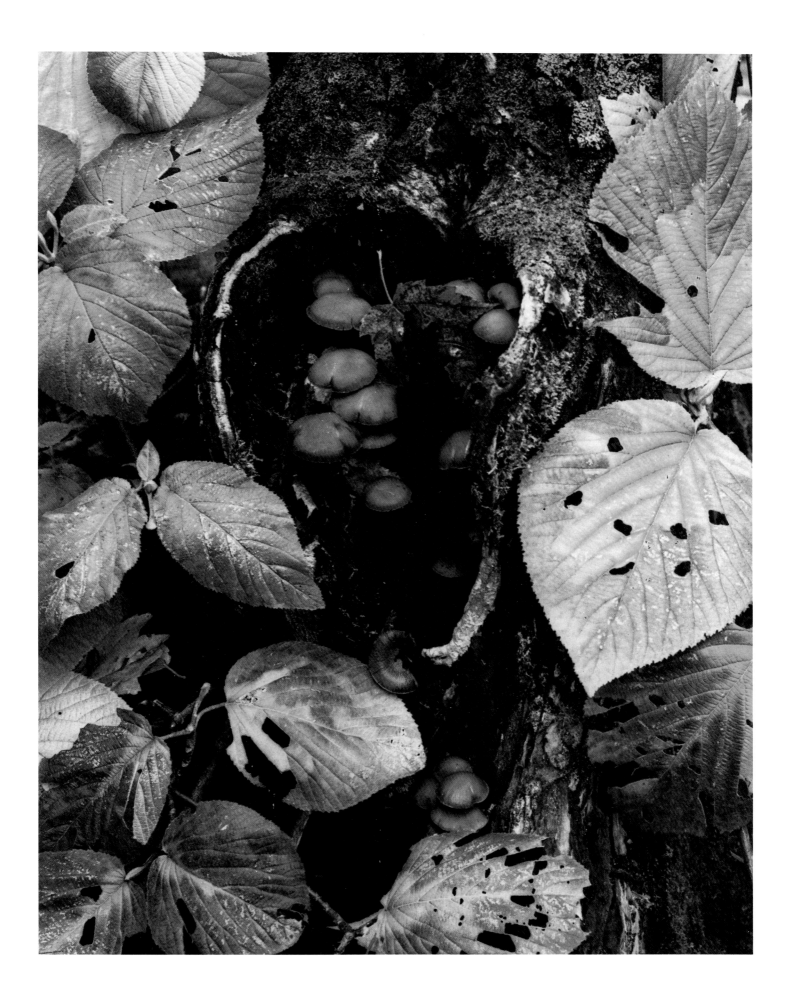

19. MUSHROOMS AND STUMP WITH HOBBLEBUSH LEAVES, NEW HAMPSHIRE, 1952

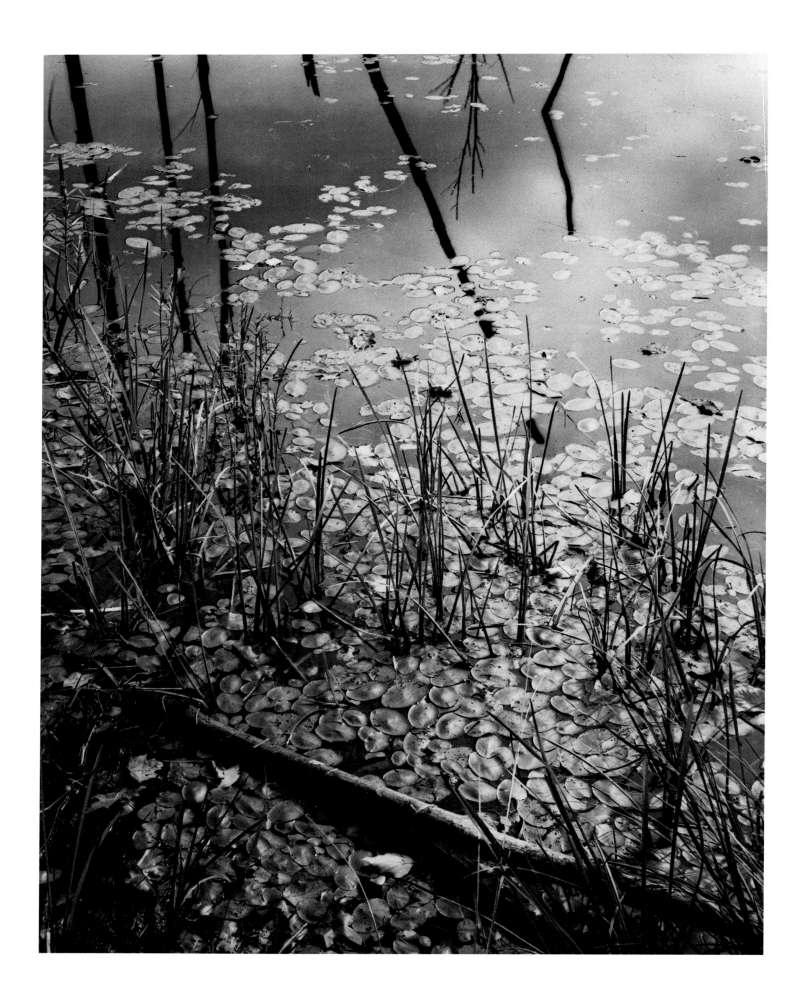

20. POND WITH MARSH GRASS AND LILY PADS, MADISON, NEW HAMPSHIRE, OCTOBER 1, 1952

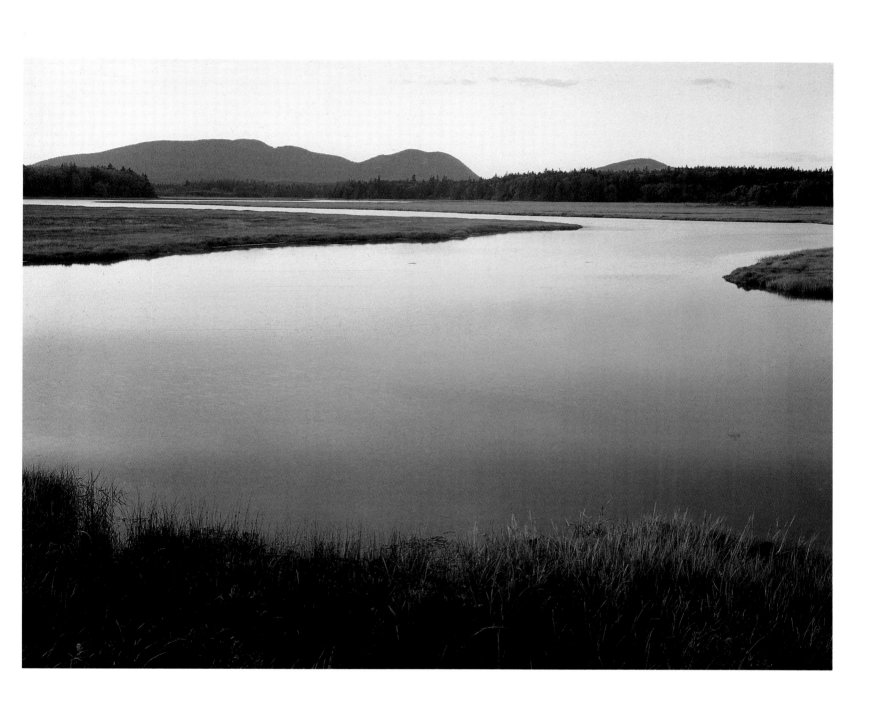

21. TIDAL MARSH, MT. DESERT ISLAND, MAINE, AUGUST 4, 1965

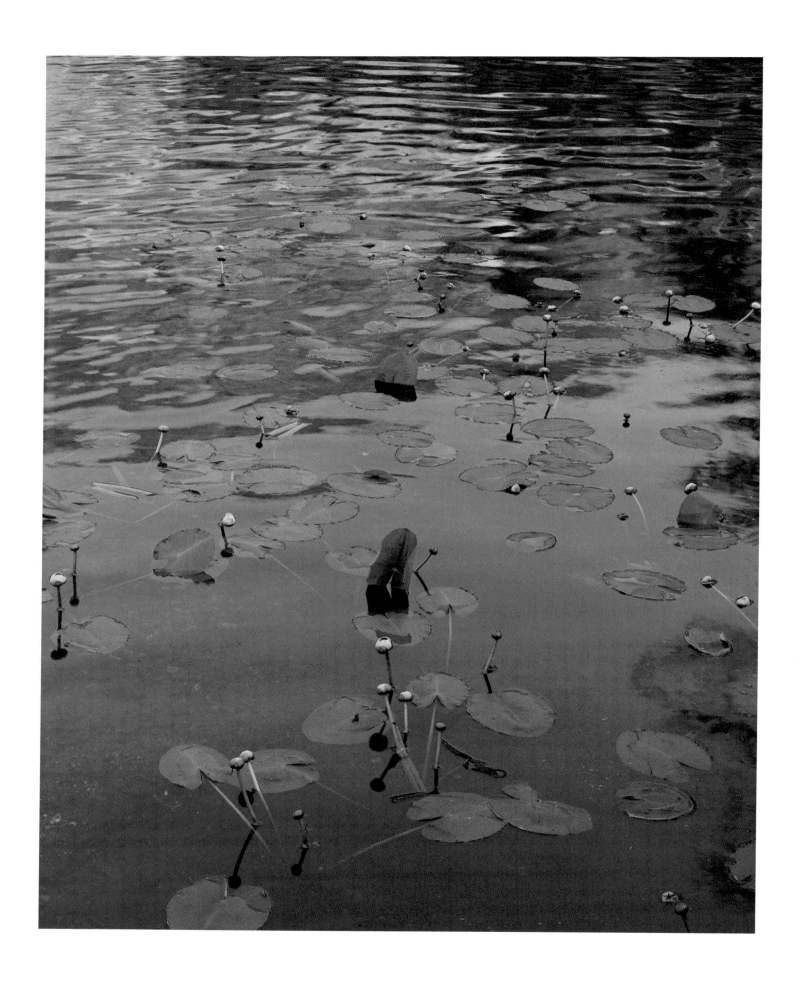

22. WATER LILIES, ROCKY CREEK, OZARK MOUNTAINS, MISSOURI, MAY 20, 1978

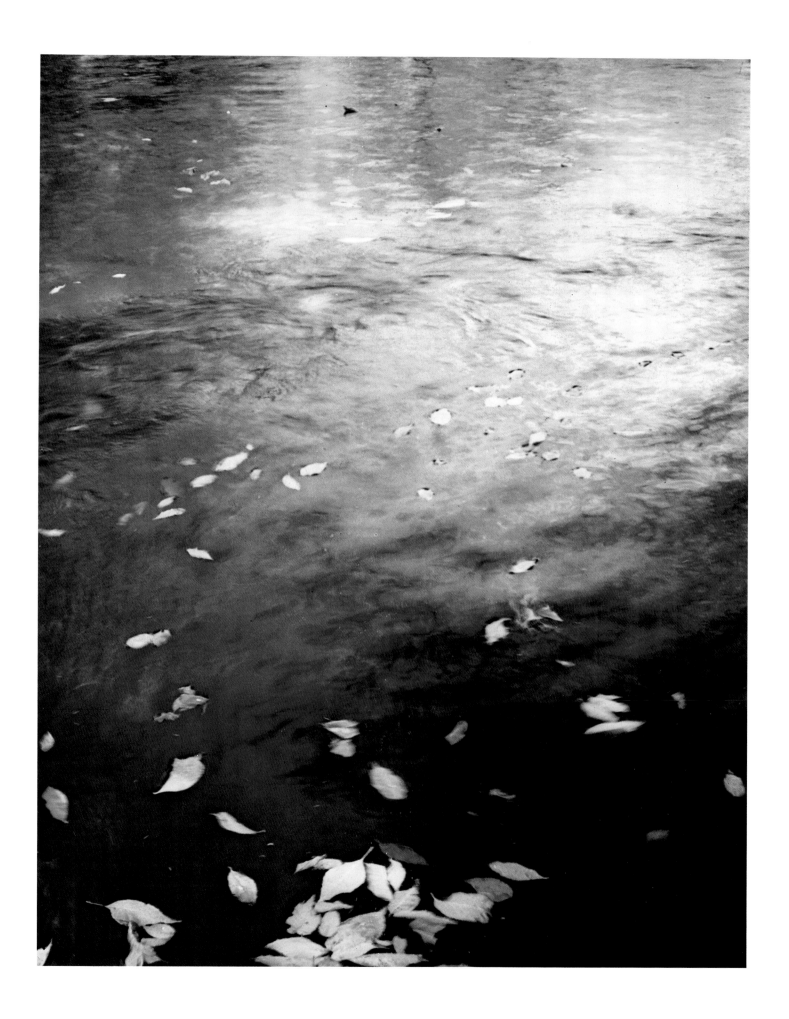

23. POOL IN A BROOK, POND BROOK, NEW HAMPSHIRE, 1953

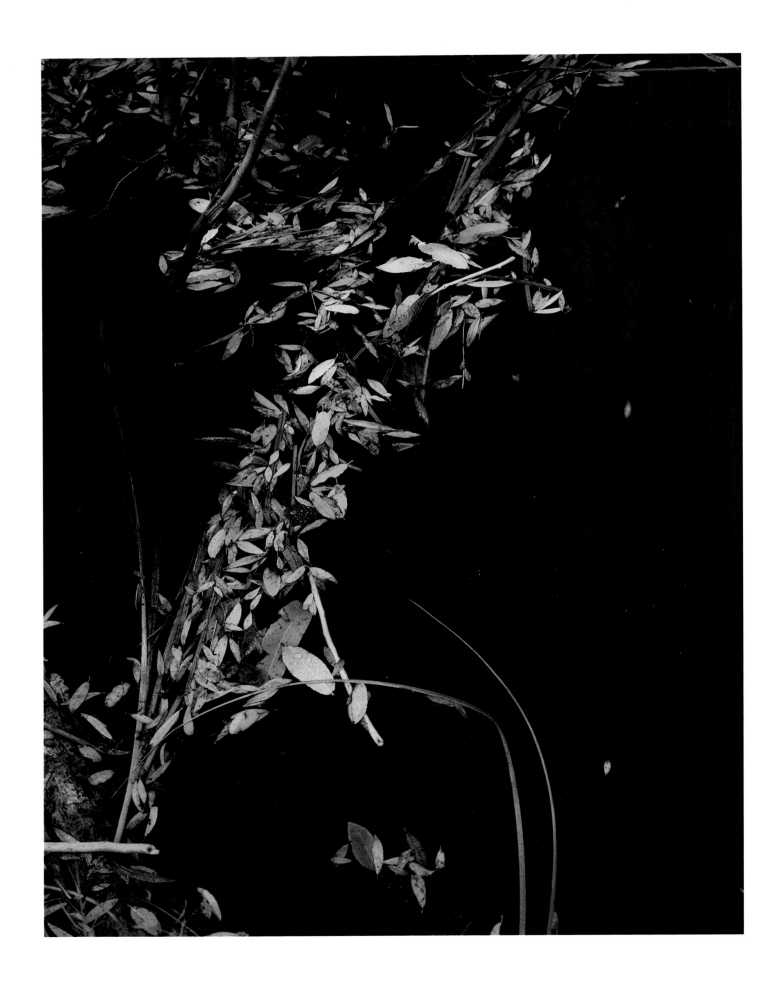

24. FLOATING LEAVES AND REFLECTIONS, ASPEN, COLORADO, OCTOBER 3, 1951

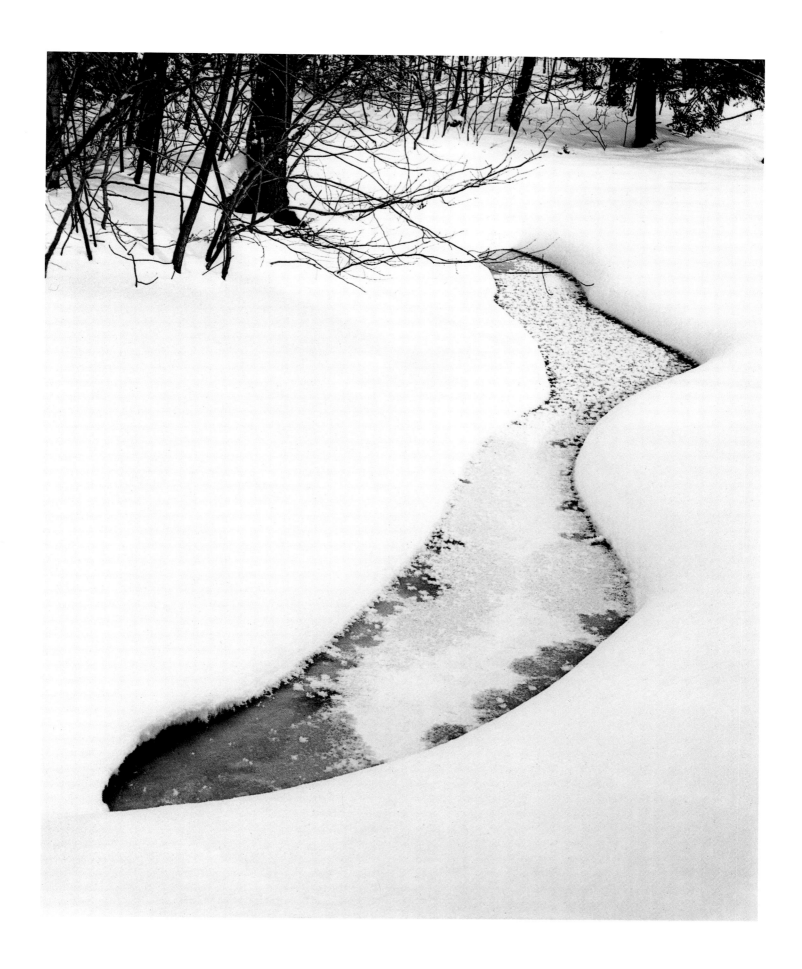

25. FROZEN POOL, ADIRONDACK MOUNTAINS, NEW YORK, 1965

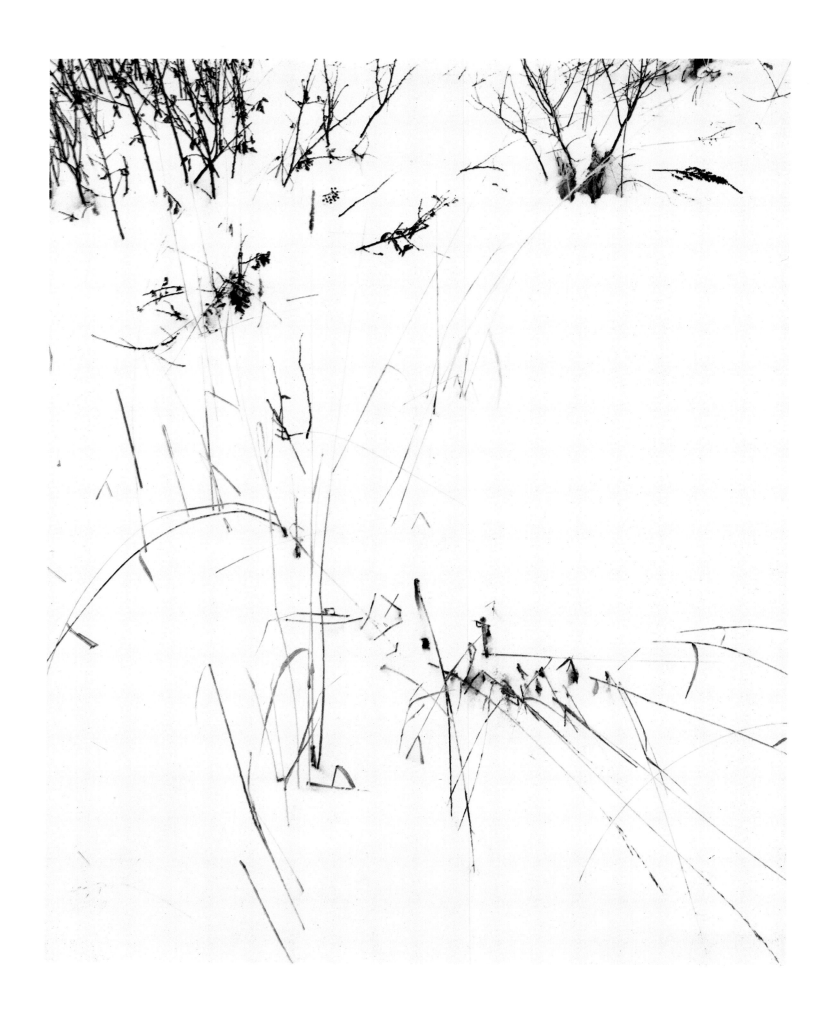

26. GRASS IN SNOW, SHELBURNE PASS, VERMONT, FEBRUARY 1957

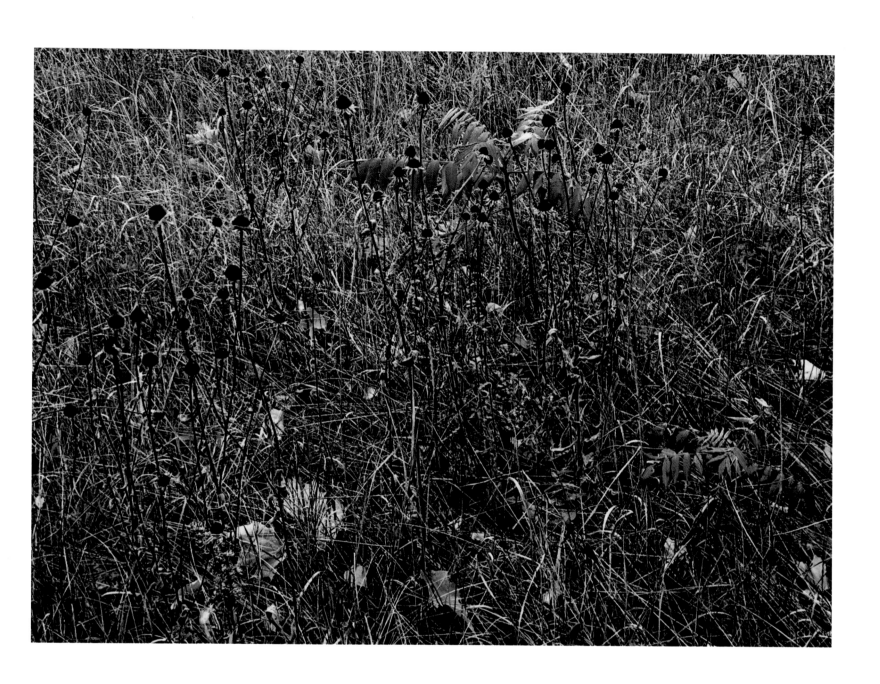

27. BLACK-EYED SUSANS AND SUMAC IN GRASS, PASSACONAWAY ROAD, NEW HAMPSHIRE, OCTOBER 4, 1956

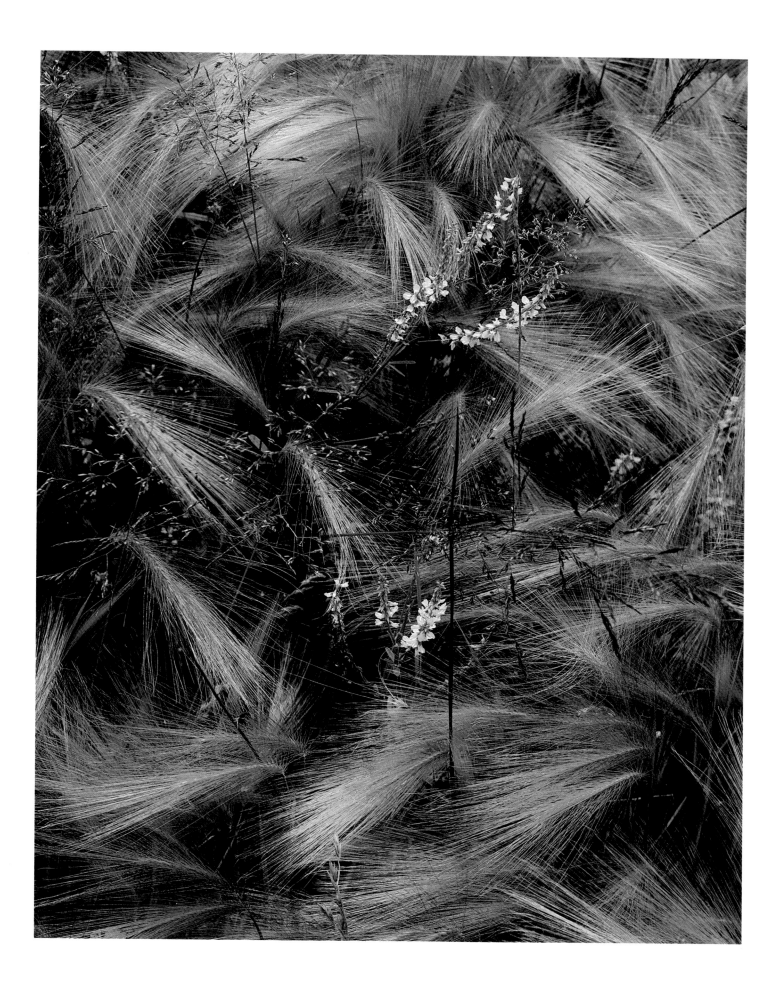

28. FOXTAIL GRASS, LAKE CITY, COLORADO, AUGUST 1957

29. RASPBERRY LEAVES IN GRASS, GREAT SPRUCE HEAD ISLAND, MAINE, 1964

30. APPLES, GREAT SPRUCE HEAD ISLAND, MAINE, 1942

31. YELLOW LEAVES AND ASTERS, SANGRE DE CRISTO MOUNTAINS, NEW MEXICO, SEPTEMBER 20, 1950

32. PEELING BIRCH BARK, GREAT SPRUCE HEAD ISLAND, MAINE, JUNE 24, 1969

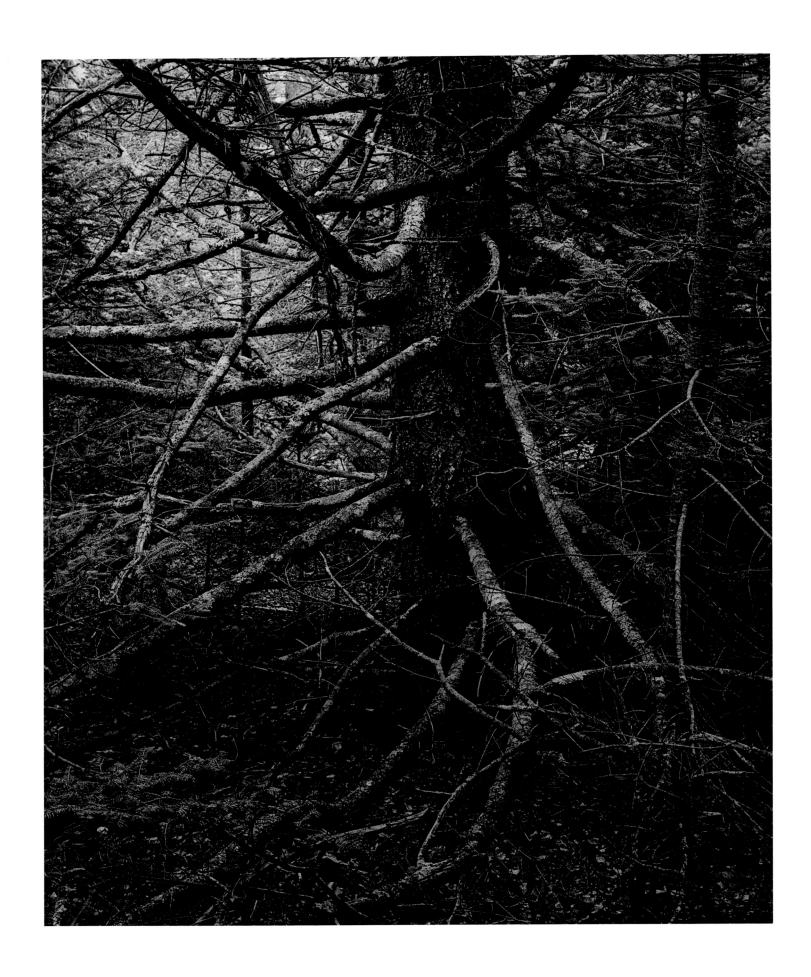

33. SPRUCE TREE WITH LOWER DEAD BRANCHES, GREAT SPRUCE HEAD ISLAND, MAINE, JULY 14, 1963

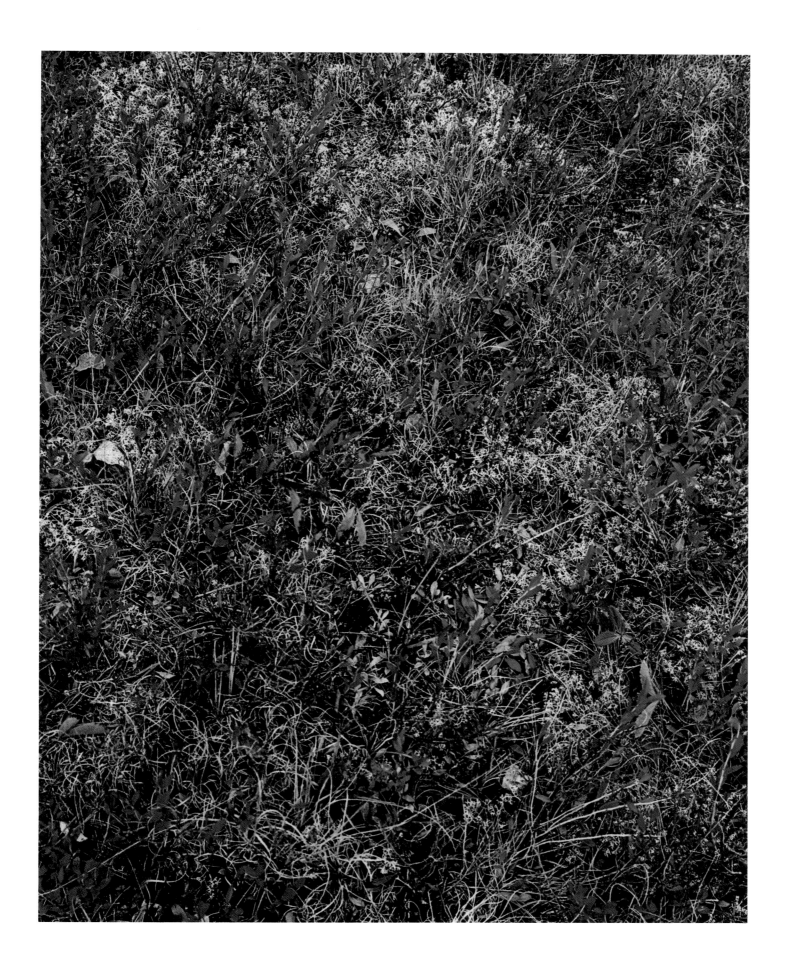

34. BLUEBERRY BUSHES, NEAR KEENE VALLEY, ADIRONDACK PARK, NEW YORK, OCTOBER 1963

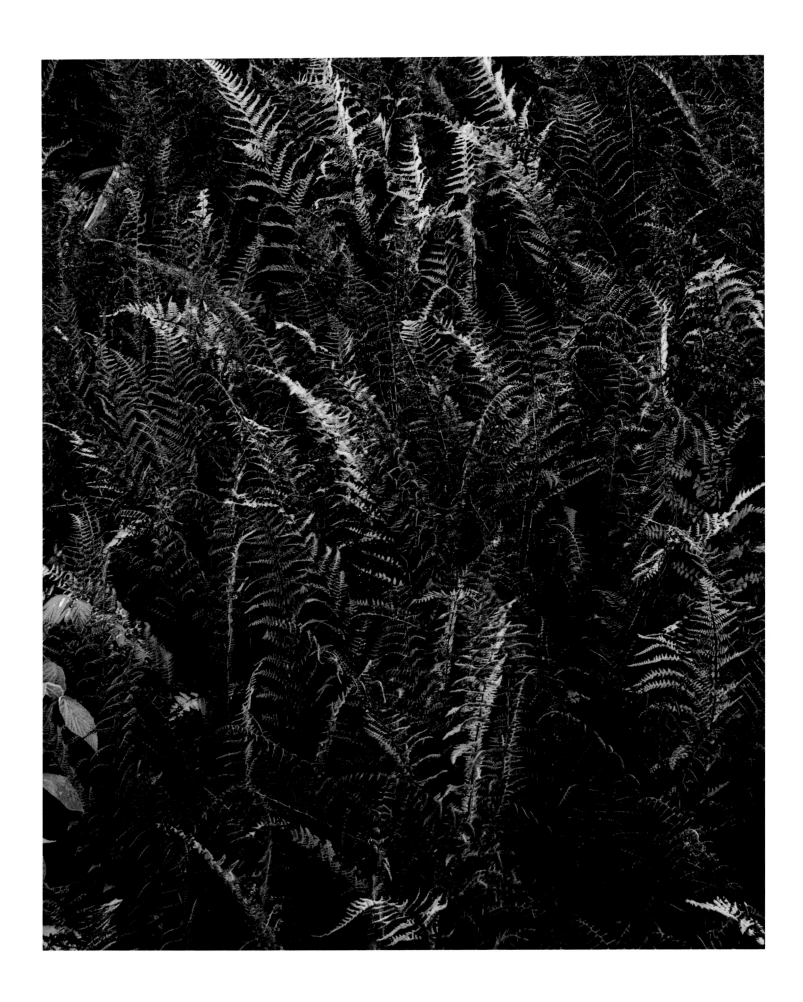

35. HAY FERN, CHOCORUA, NEW HAMPSHIRE, OCTOBER 13, 1953

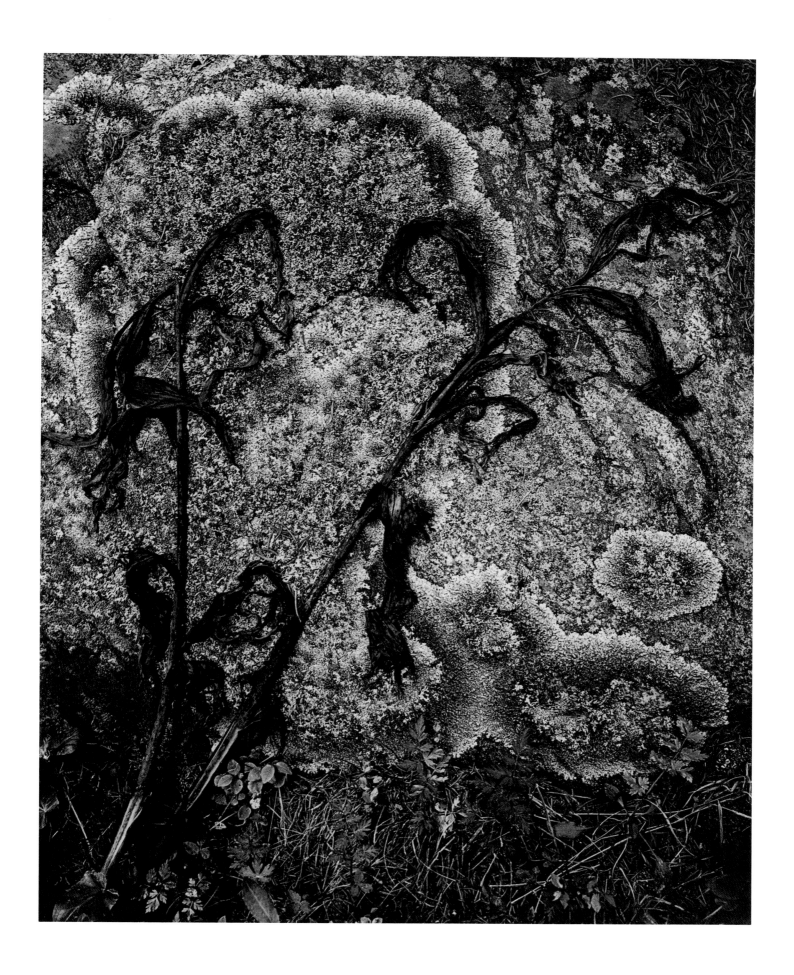

36. ROCK, LICHEN, DEAD HELLEBORE, SANTA FE BASIN, NEW MEXICO, SEPTEMBER 18, 1960

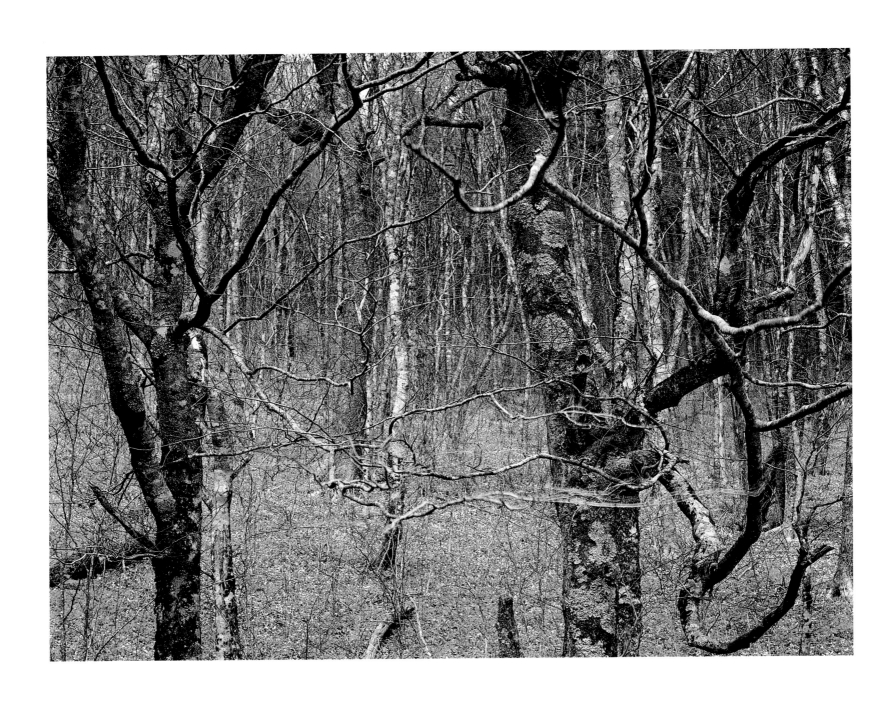

37. BEECH GROVE, GREAT SMOKY MOUNTAINS NATIONAL PARK, APRIL 26, 1968

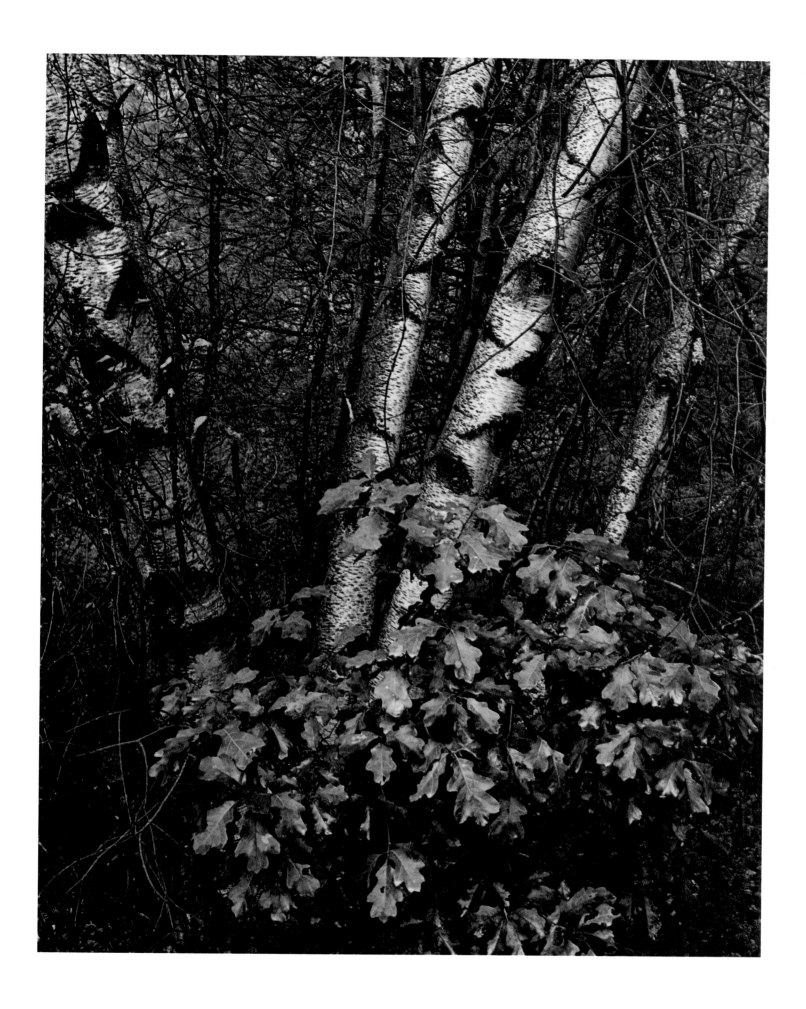

38. OAK LEAVES AND BIRCHES, PASSACONAWAY, NEW HAMPSHIRE, OCTOBER 7, 1956

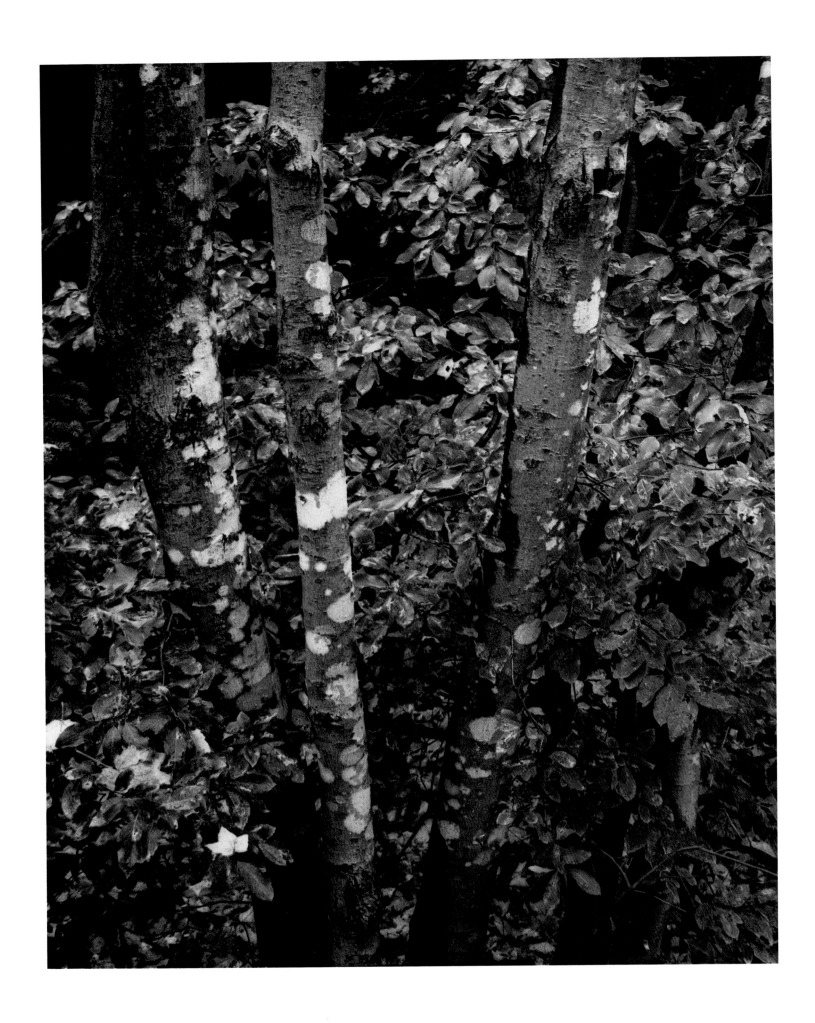

39. BLUEBERRY LEAVES AND MAPLE TRUNKS, PASSACONAWAY, NEW HAMPSHIRE, JULY 10, 1952

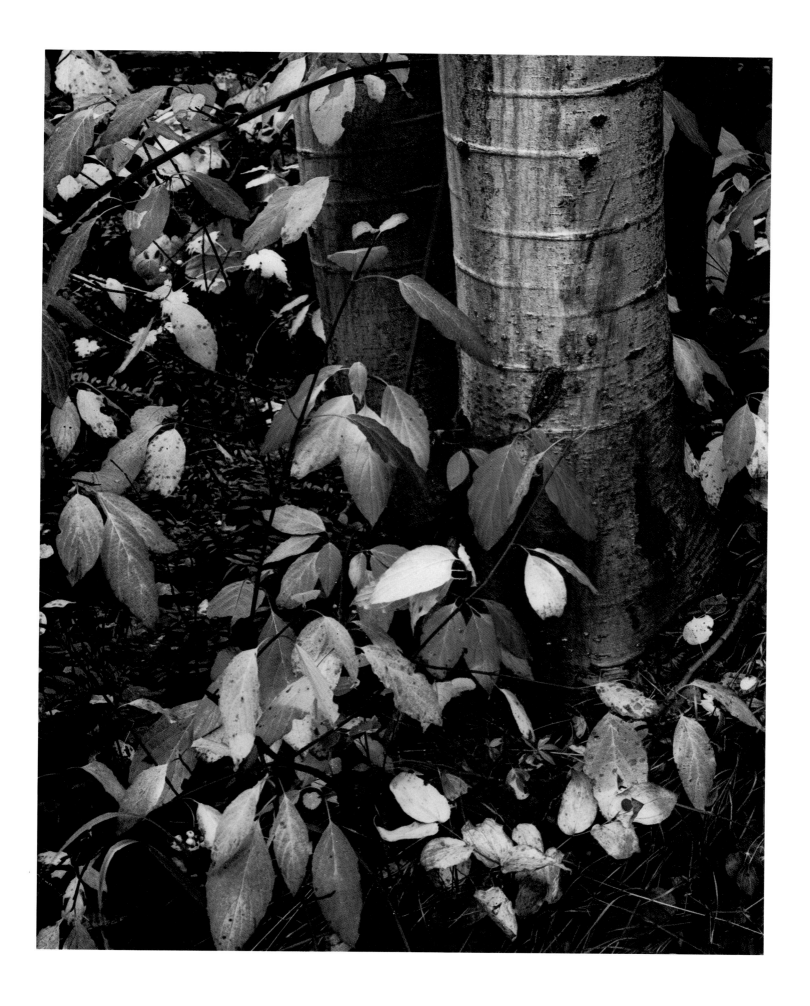

40. BANEBERRY LEAVES AND ASPEN TRUNKS, ASPEN, COLORADO, OCTOBER 3, 1951

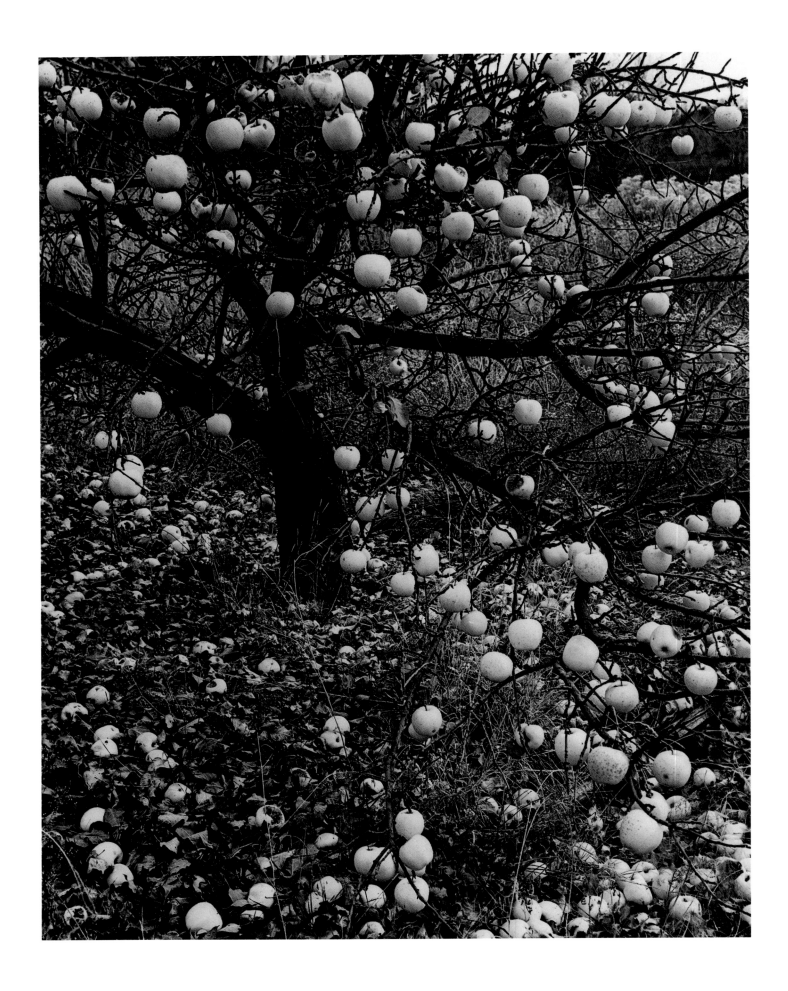

41. FROZEN APPLES, TESUQUE, NEW MEXICO, NOVEMBER 21, 1966

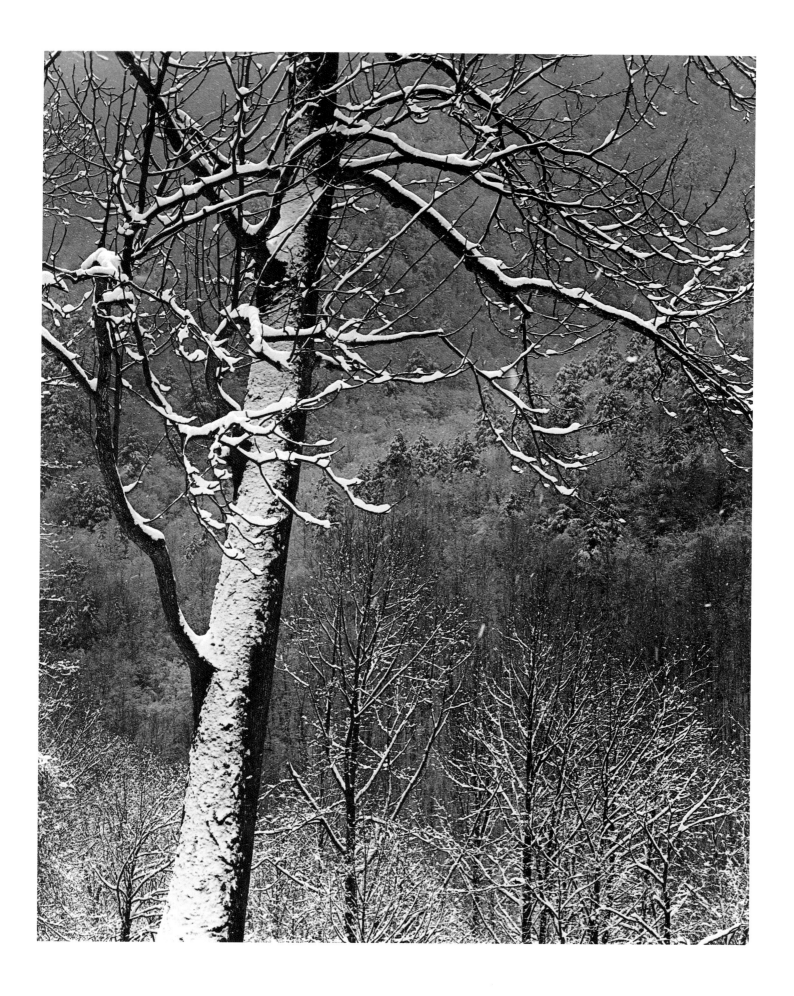

42. TREE AND MOUNTAIN VALLEY, GREAT SMOKY MOUNTAINS NATIONAL PARK, TENNESSEE, MARCH 11, 1969

43. RED TREE NEAR CADES COVE, GREAT SMOKY MOUNTAINS NATIONAL PARK, TENNESSEE, OCTOBER 7, 1967

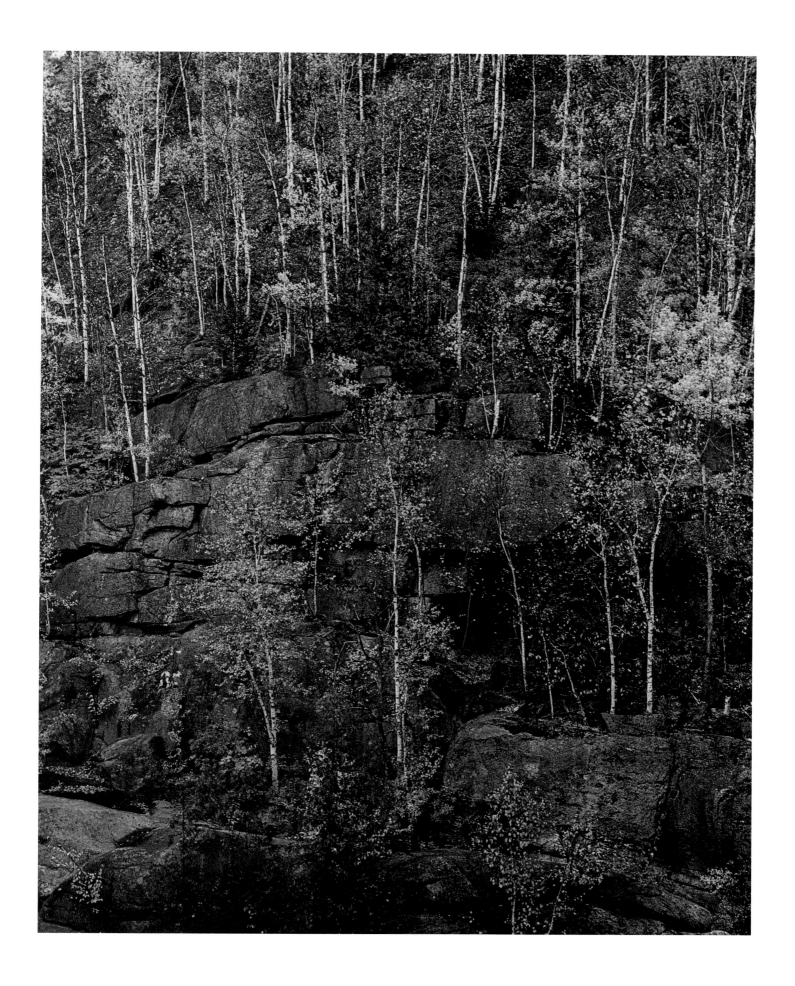

44. BIRCH TREES ON CLIFF, NEAR KEENE VALLEY, ADIRONDACK PARK, NEW YORK, 1963

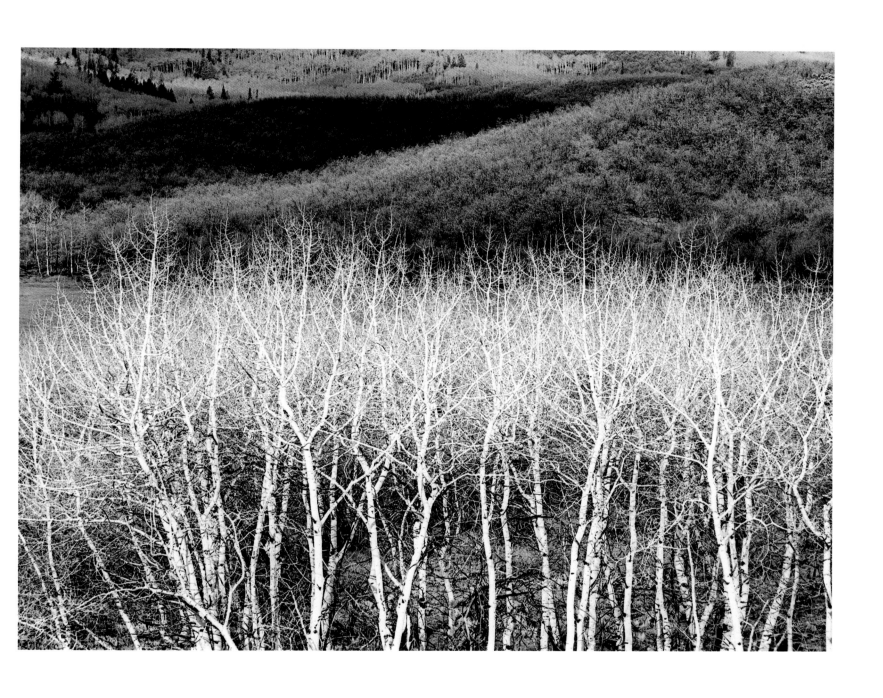

45. WHITE ASPENS AND HILLSIDE, NEAR STEAMBOAT SPRINGS, COLORADO, MAY 28, 1975

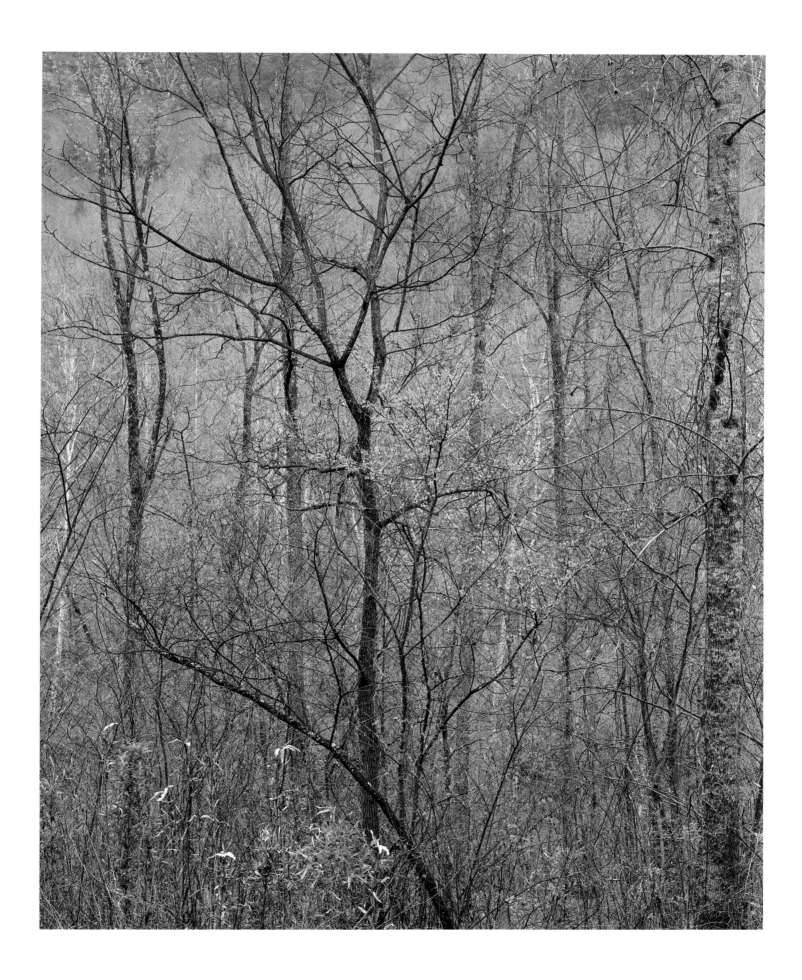

46. REDBUD TREE IN BOTTOM LAND, RED RIVER GORGE, KENTUCKY, APRIL 17, 1968

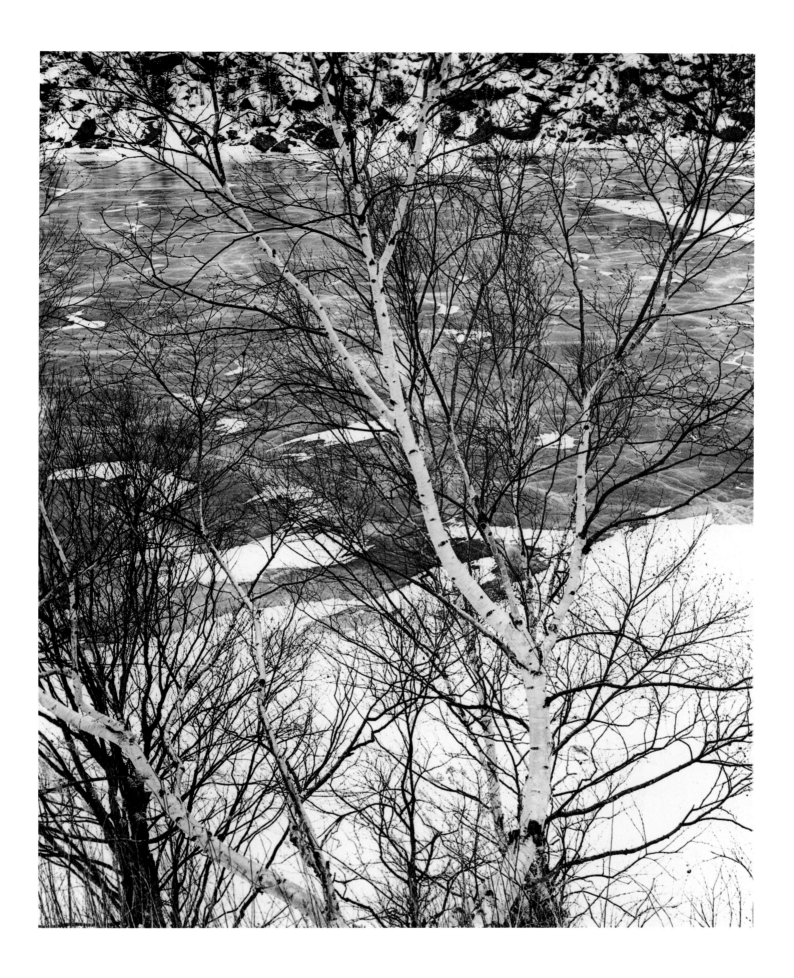

47. CHAPEL POND, ADIRONDACK PARK, NEW YORK, 1965

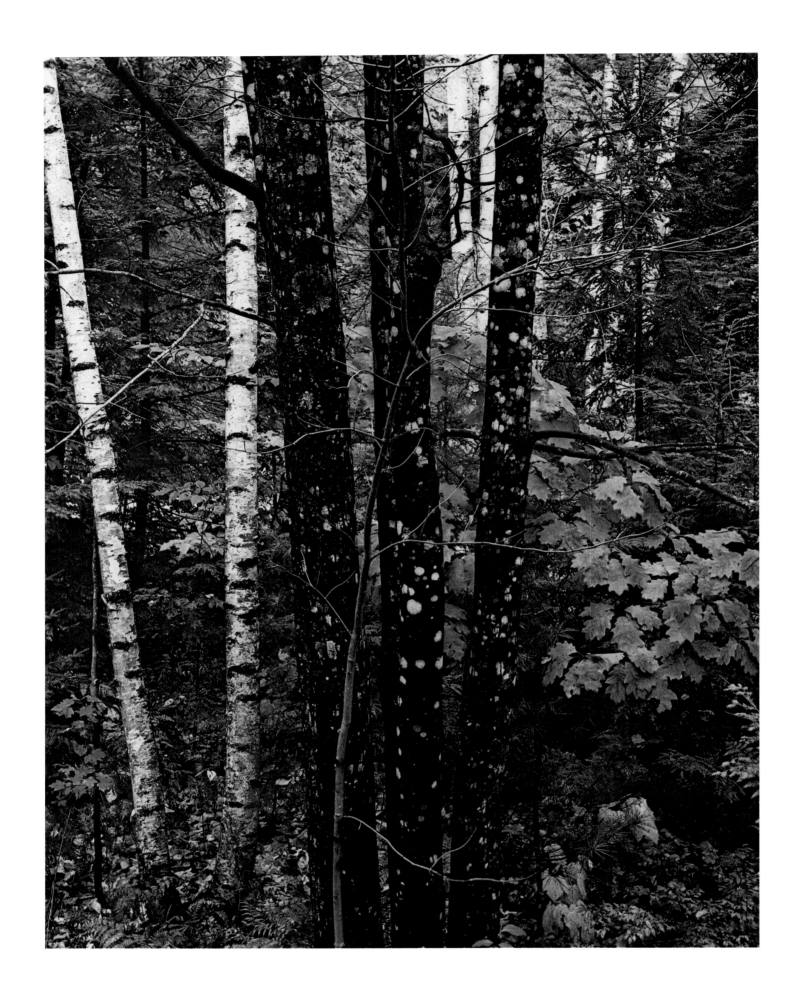

48. MAPLE AND BIRCH TRUNKS AND OAK LEAVES, PASSACONAWAY, NEW HAMPSHIRE, OCTOBER 7, 1956

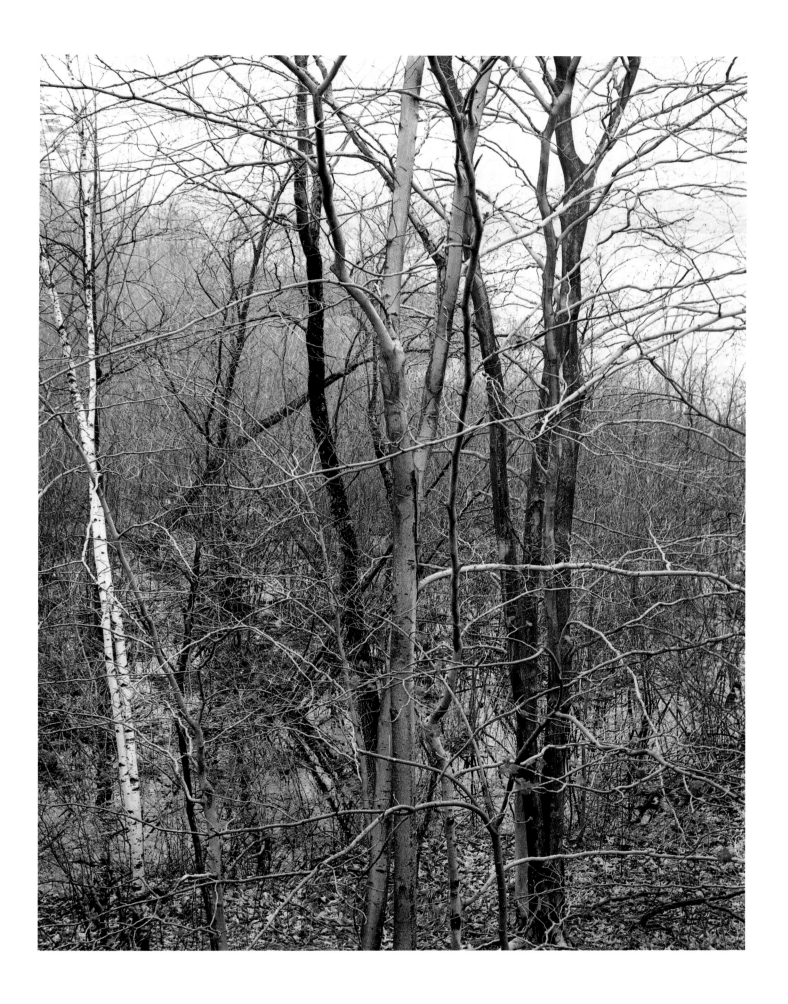

49. TREES AND POND, NEAR SHERBORN, MASSACHUSETTS, APRIL 1957

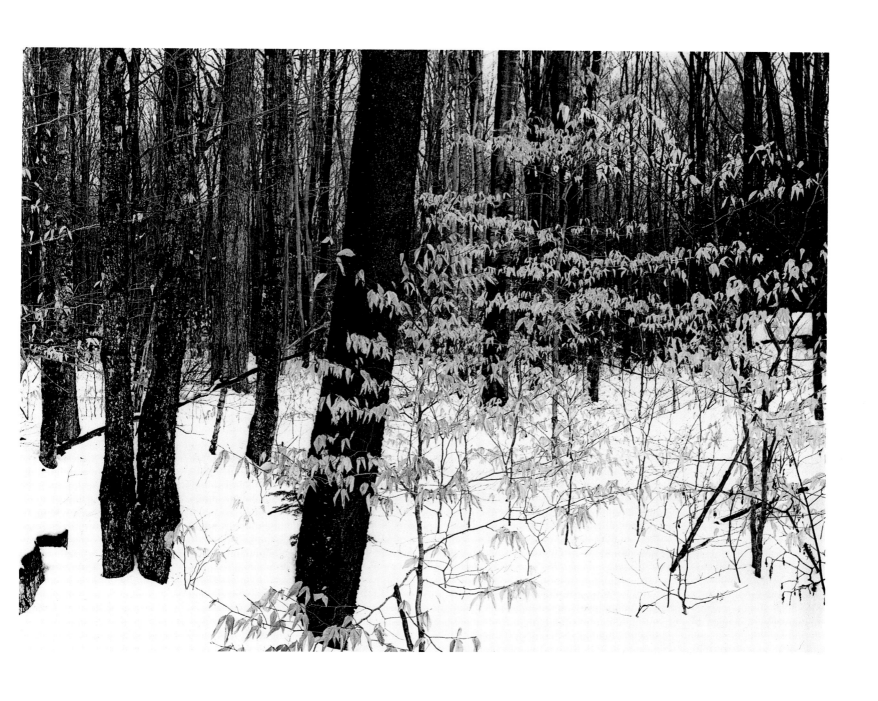

50. BEECH LEAVES AND TREE TRUNKS IN SNOW, ADIRONDACK MOUNTAINS, NEW YORK, 1965

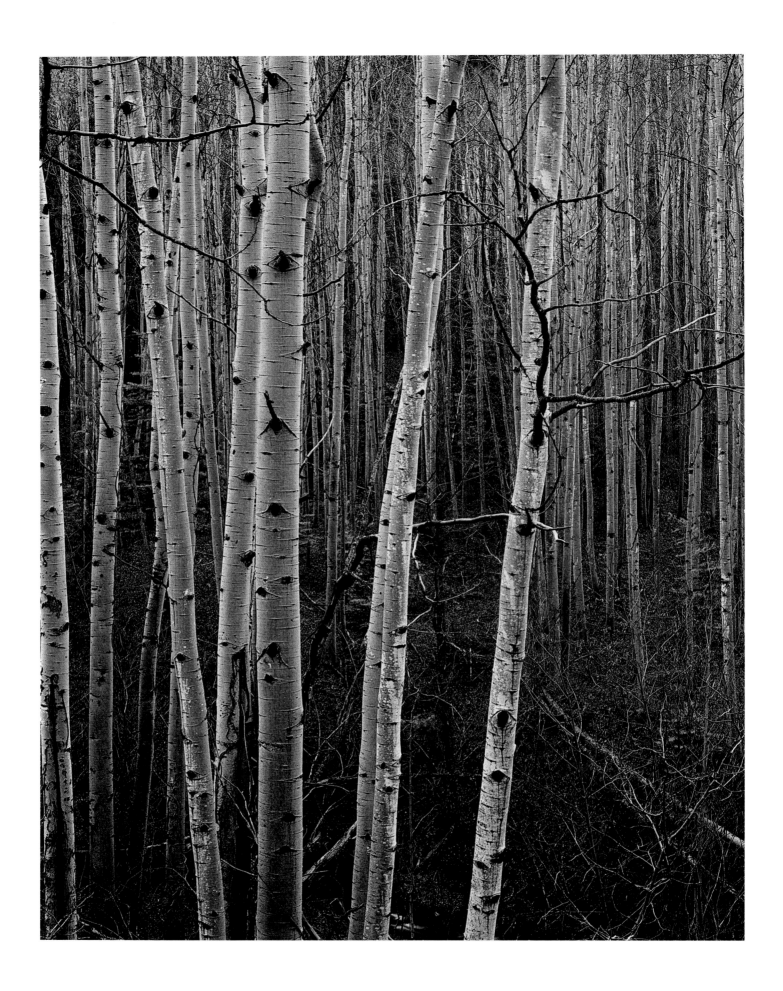

51. BARE ASPENS, PACHECO CANYON, NEW MEXICO, JUNE 1, 1957

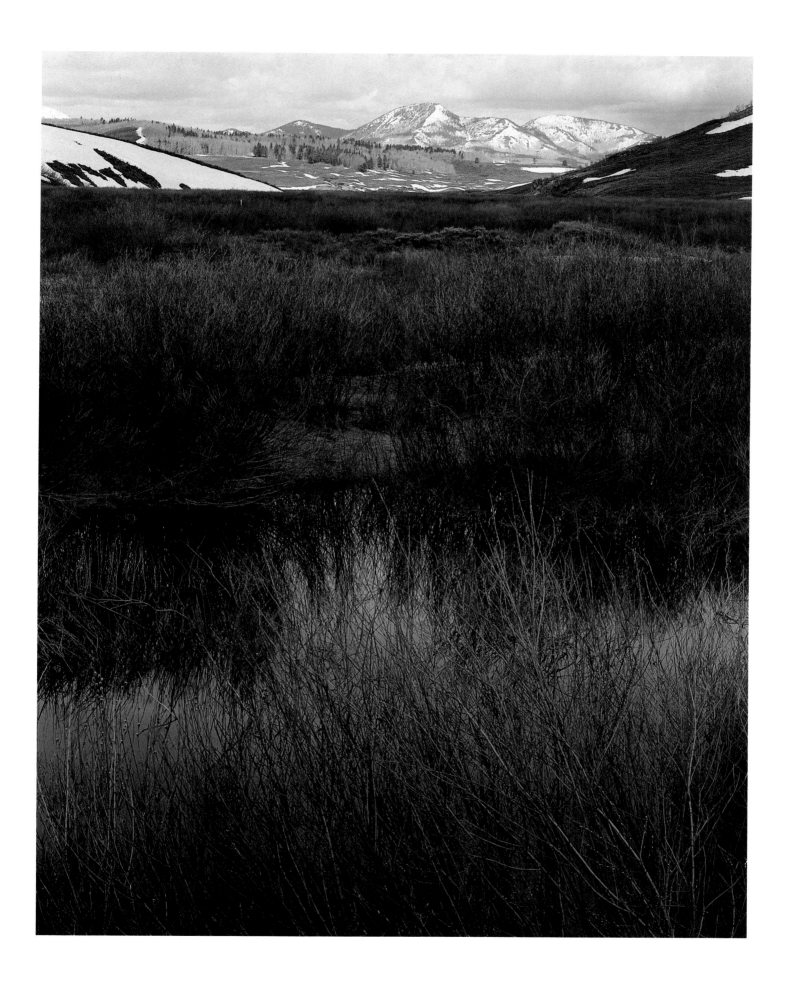

52. WILLOWS, HAHNS PEAK ROAD, COLORADO, MAY 27, 1975

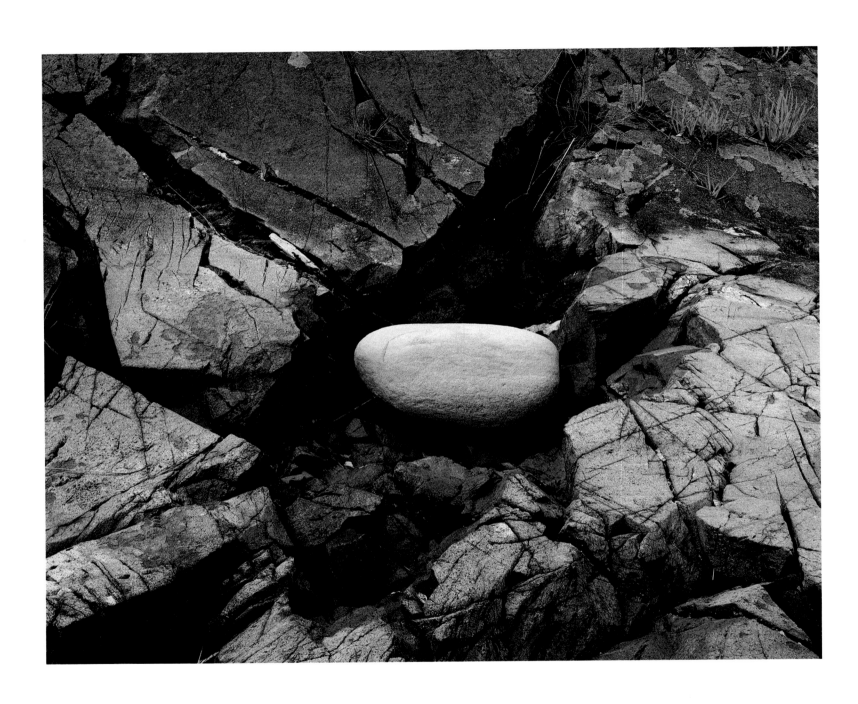

53. ERRATIC BOULDER, BARRED ISLANDS, MAINE, 1983

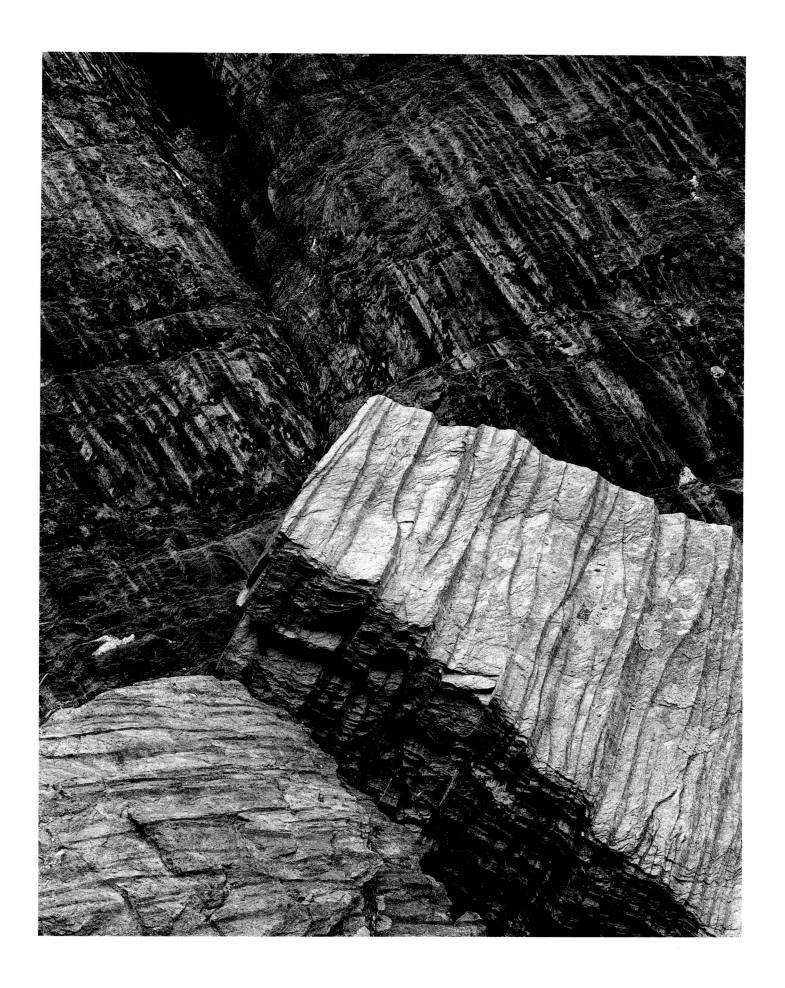

54. FOLDED SCHIST, LITTLE SPRUCE HEAD ISLAND, MAINE, JULY 27, 1969

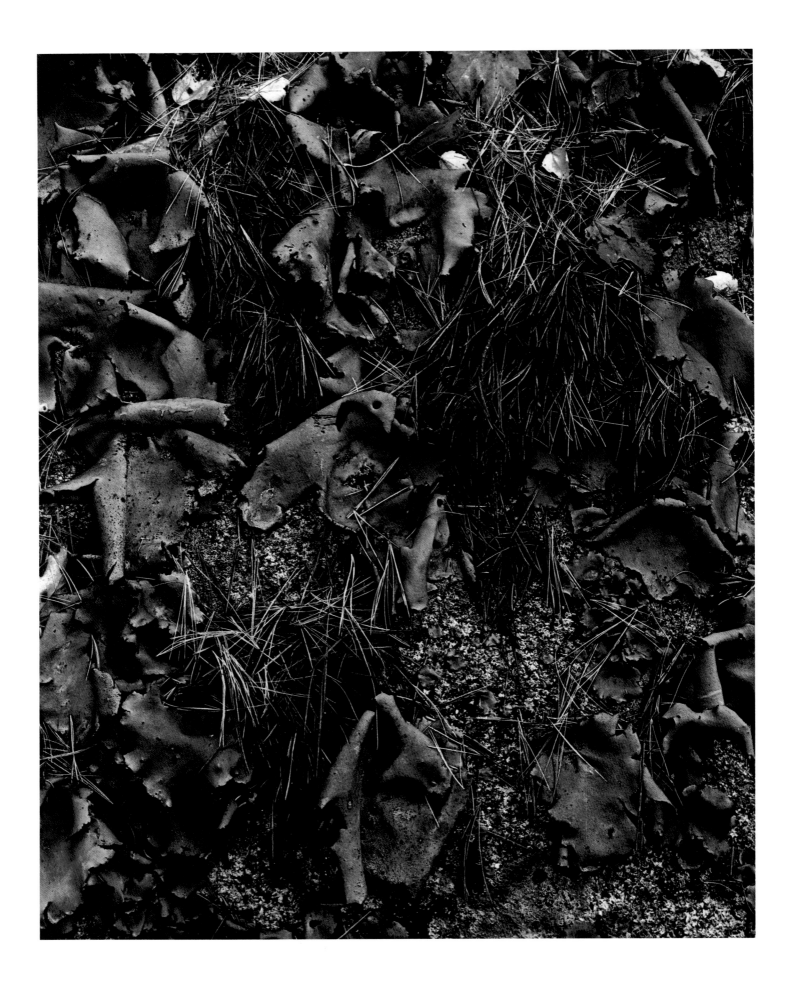

55. LICHENS AND PINE NEEDLES ON BOULDER, MADISON, NEW HAMPSHIRE, OCTOBER 12, 1953

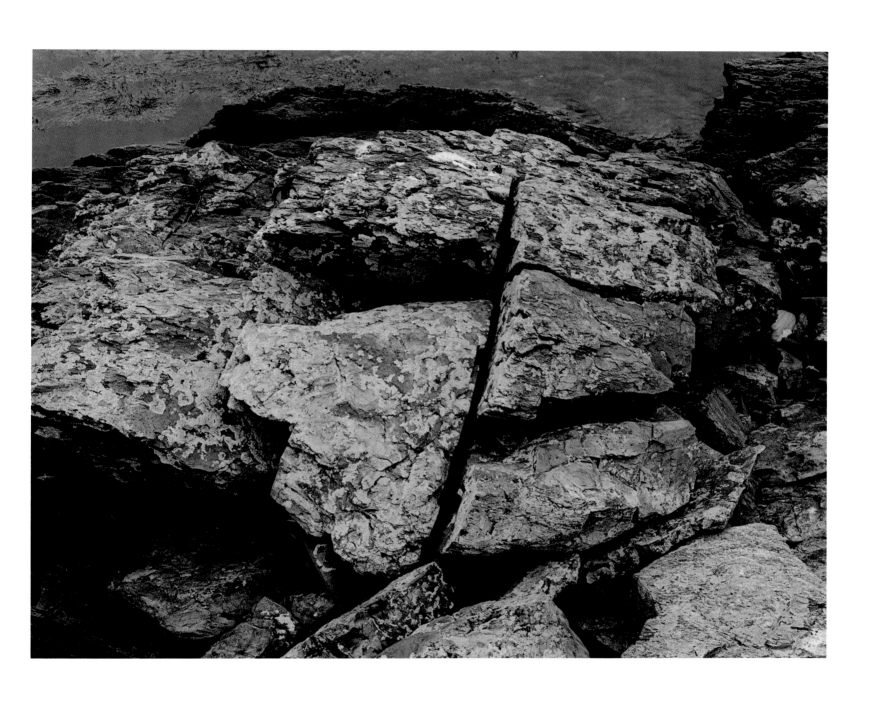

56. LICHENS ON ROCKS, CHAIN LINKS, MAINE, JULY 21, 1963

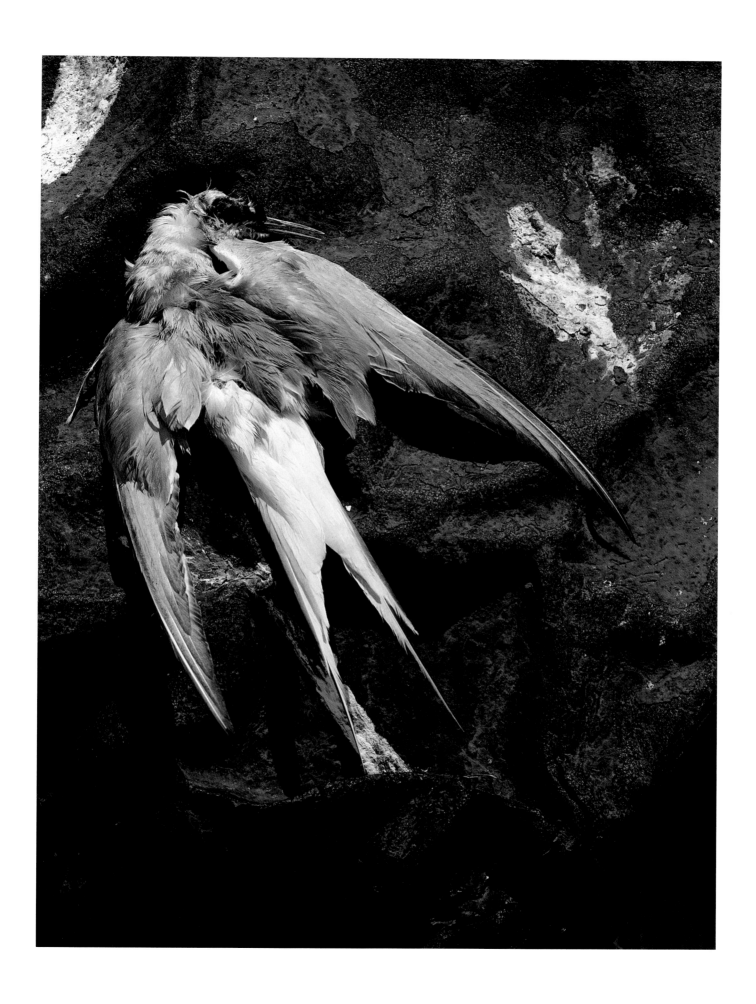

57. DEAD ARCTIC TERN, MATINICUS ROCK, MAINE, AUGUST 6, 1949

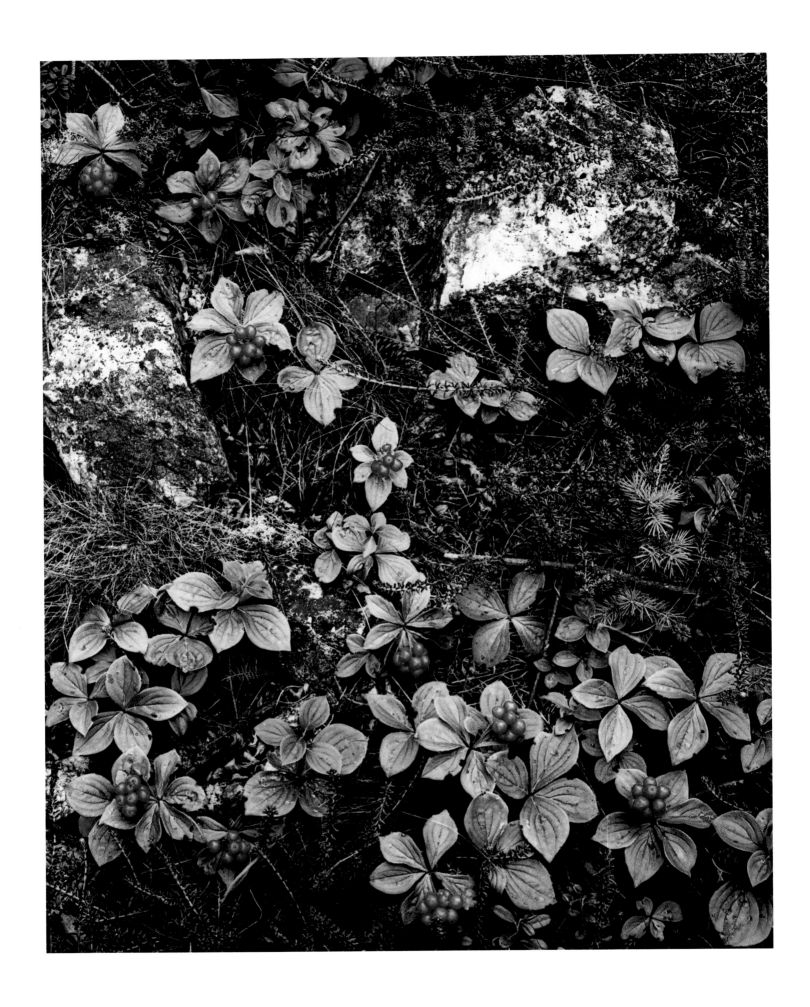

58. BUNCHBERRIES AND CROWBERRY, GREAT SPRUCE HEAD ISLAND, MAINE, AUGUST 2, 1954

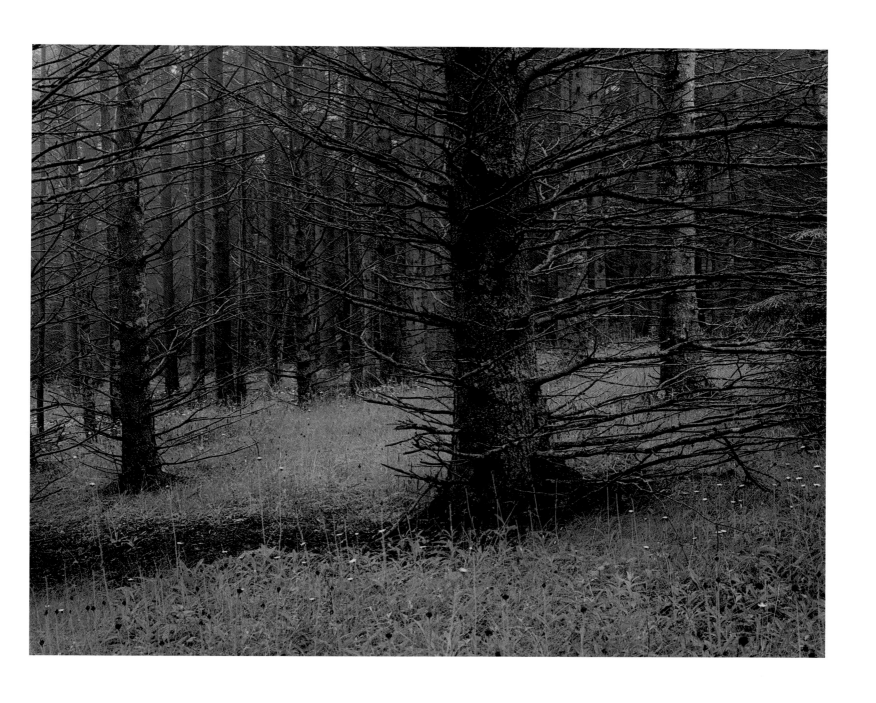

59. SPRUCE TREES IN FOG AND HAWKWEED, GREAT SPRUCE HEAD ISLAND, MAINE, JULY 4, 1964

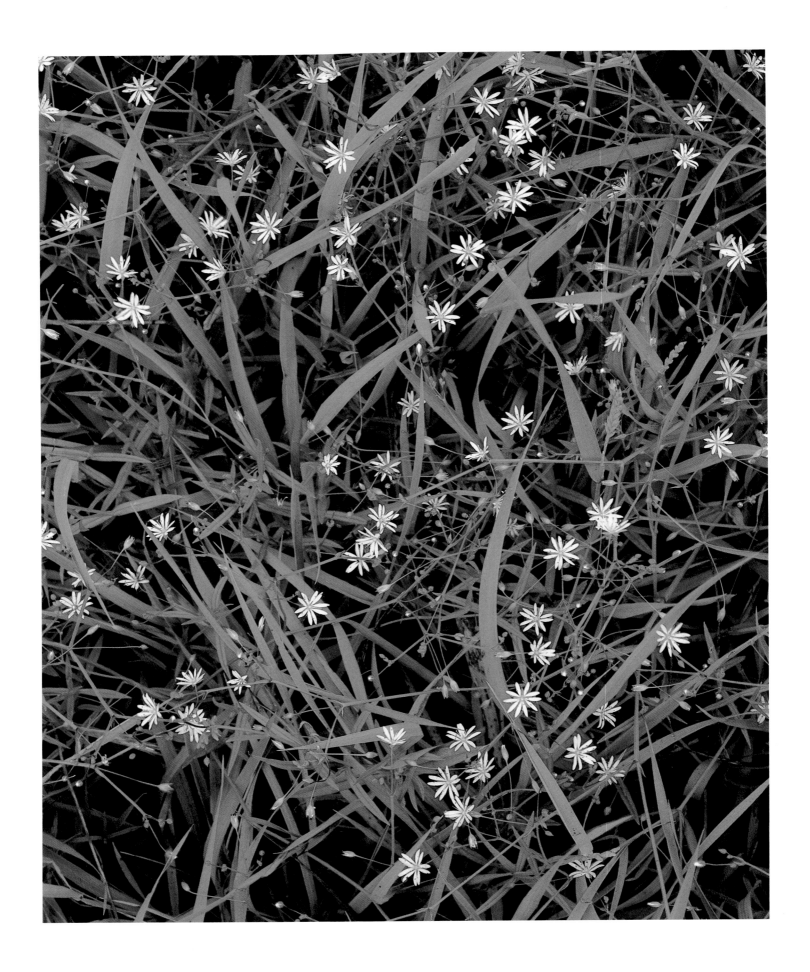

60. CHICKWEED, GREAT SPRUCE HEAD ISLAND, MAINE, JUNE 25, 1981

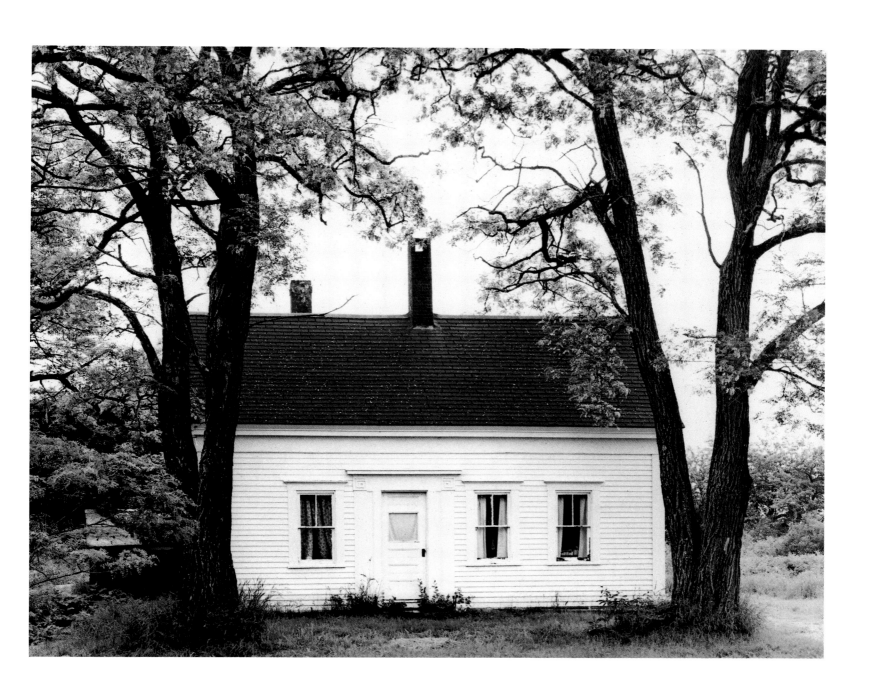

61. WHITE HOUSE WITH TWO LOCUST TREES, NEAR CASTINE, MAINE, JUNE 28, 1978

62. ERRATIC BOULDERS AND ROSES, CHAIN LINKS, MAINE, JUNE 19, 1982

63. LOBSTER POT BUOYS, EATON COVE, MAINE, AUGUST 17, 1974

64. HOUSES AND HARBOR, STONINGTON, MAINE, AUGUST 27, 1974

65. ROSE PETALS ON BEACH, GREAT SPRUCE HEAD ISLAND, MAINE, JULY 1, 1971

66. GRAVEL SEA WALL, SCHOODIC POINT, MAINE, AUGUST 17, 1974

67. MOSS, WATERFALL, CINDERS, NEAR MT. HEKLA, ICELAND, JUNE 26, 1972

68. ABANDONED FARM, SOUTH COAST, ICELAND, 1972

69. TARN WITH COTTON GRASS, FJORDHARHEIDHI, ICELAND, JULY 29, 1972

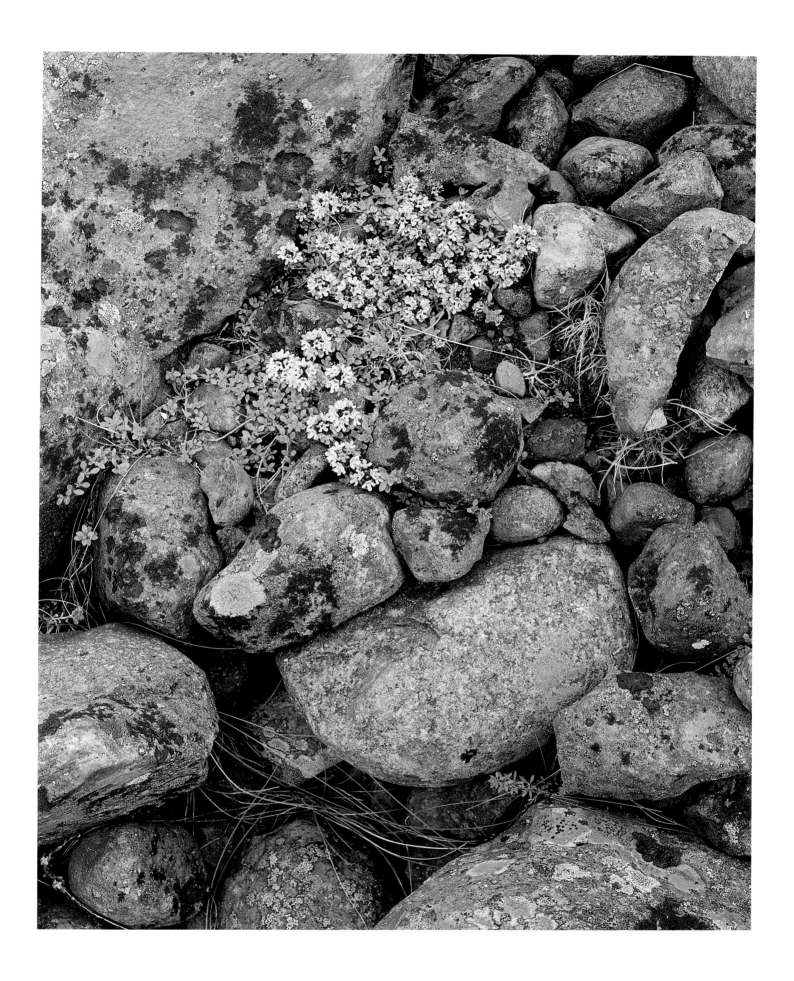

70. FLOWERING HEATH AND ROUND STONES, SOUTH COAST, ICELAND, JULY 31, 1972

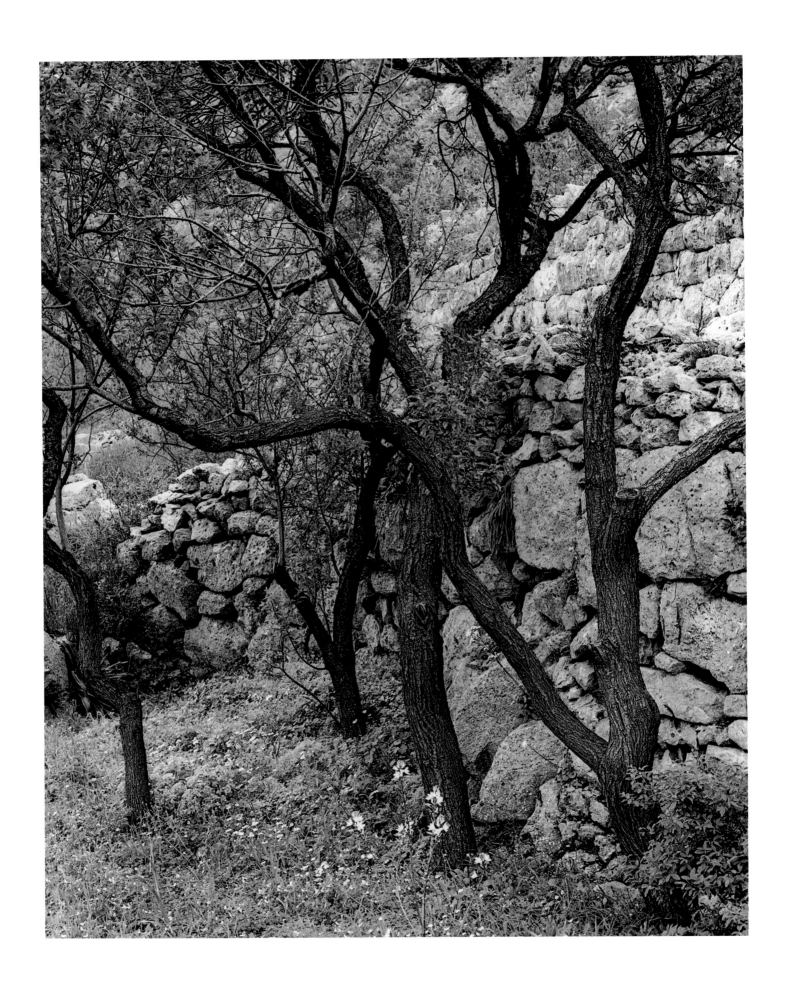

71. ALMOND TREES AND WALL, LATO, CRETE, MARCH 27, 1971

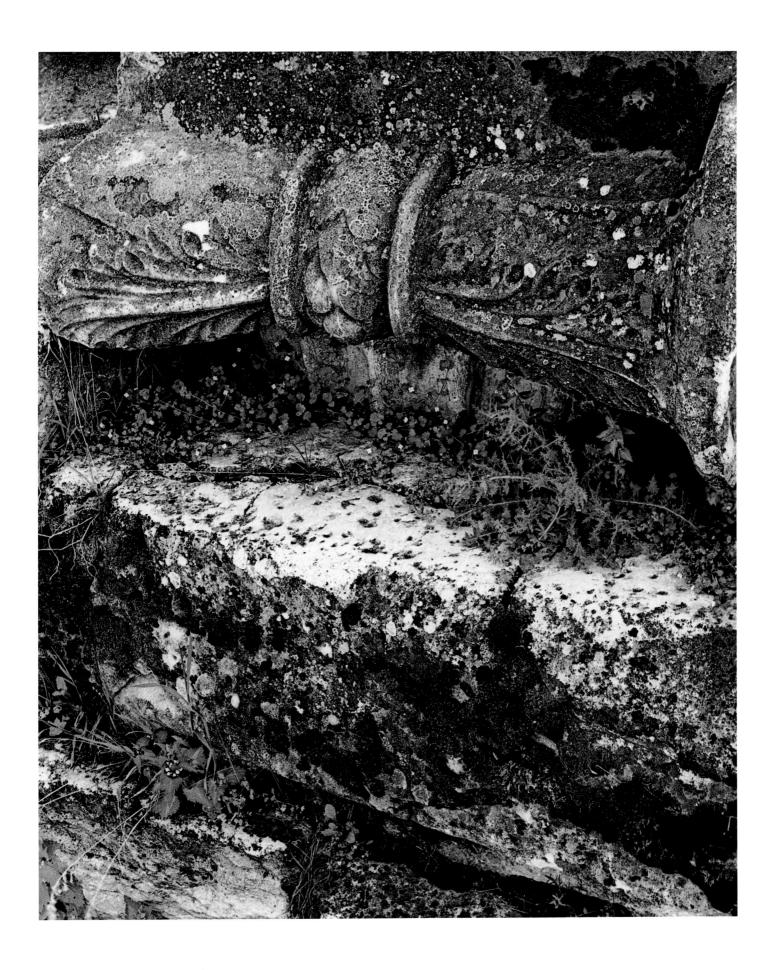

72. LICHENS ON IONIC CAPITAL, TEMPLE OF APHRODISIOS, TURKEY, APRIL 5, 1971

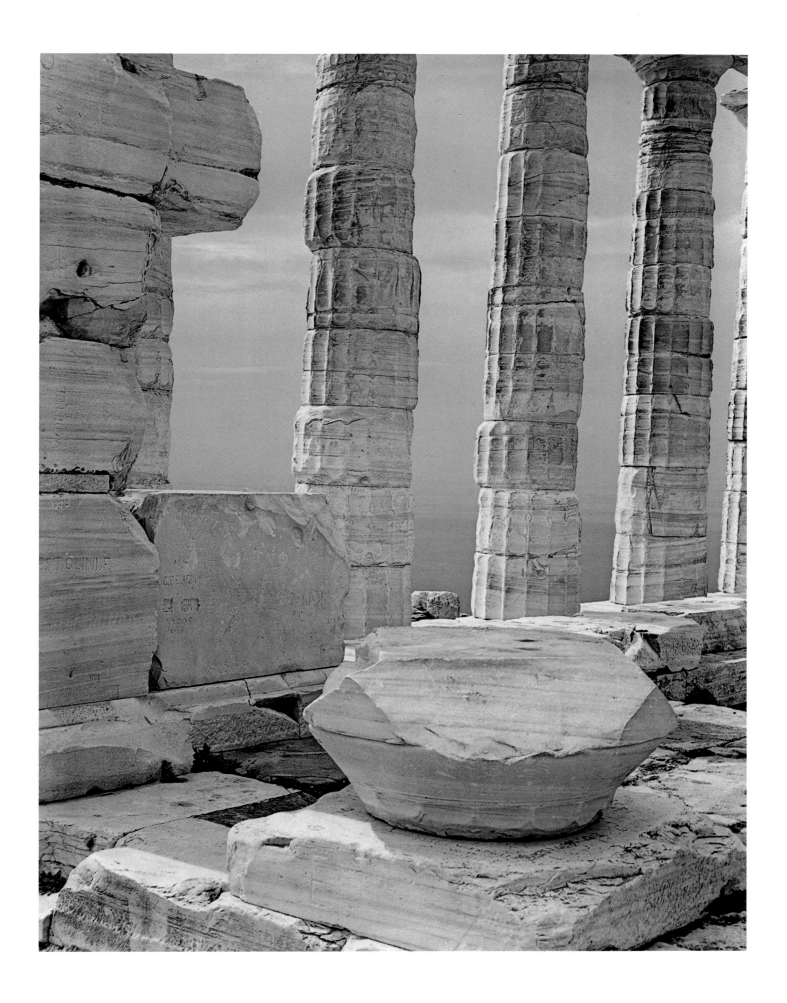

73. SOUNION, GREECE, MARCH 7, 1970

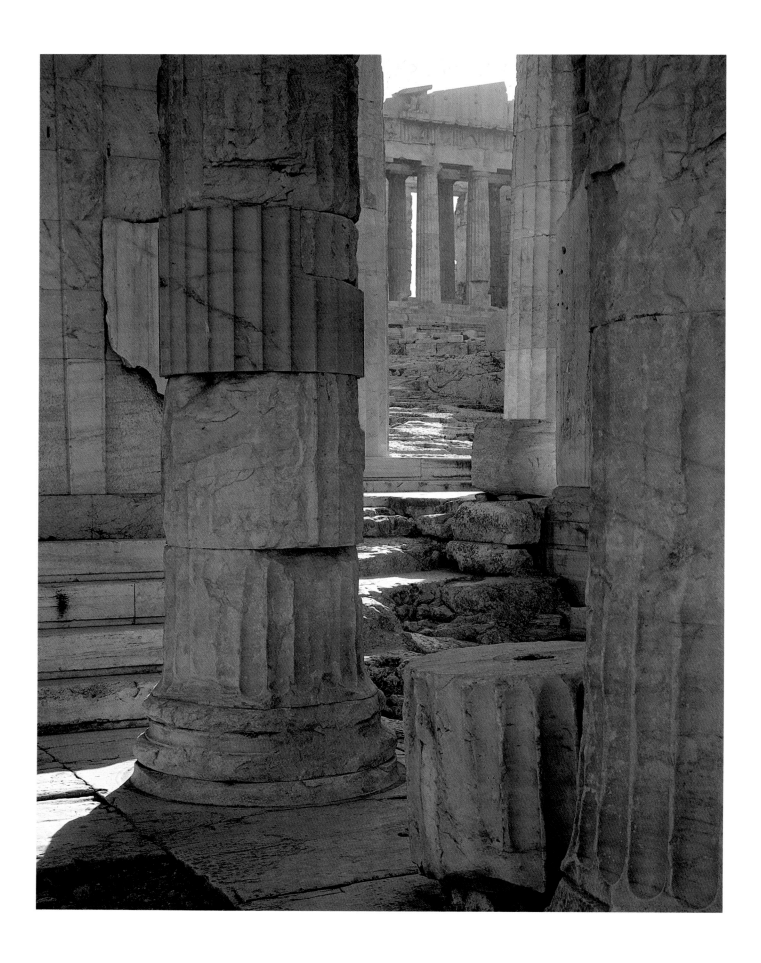

74. PROPYLAEA, ACROPOLIS, ATHENS, GREECE, 1970

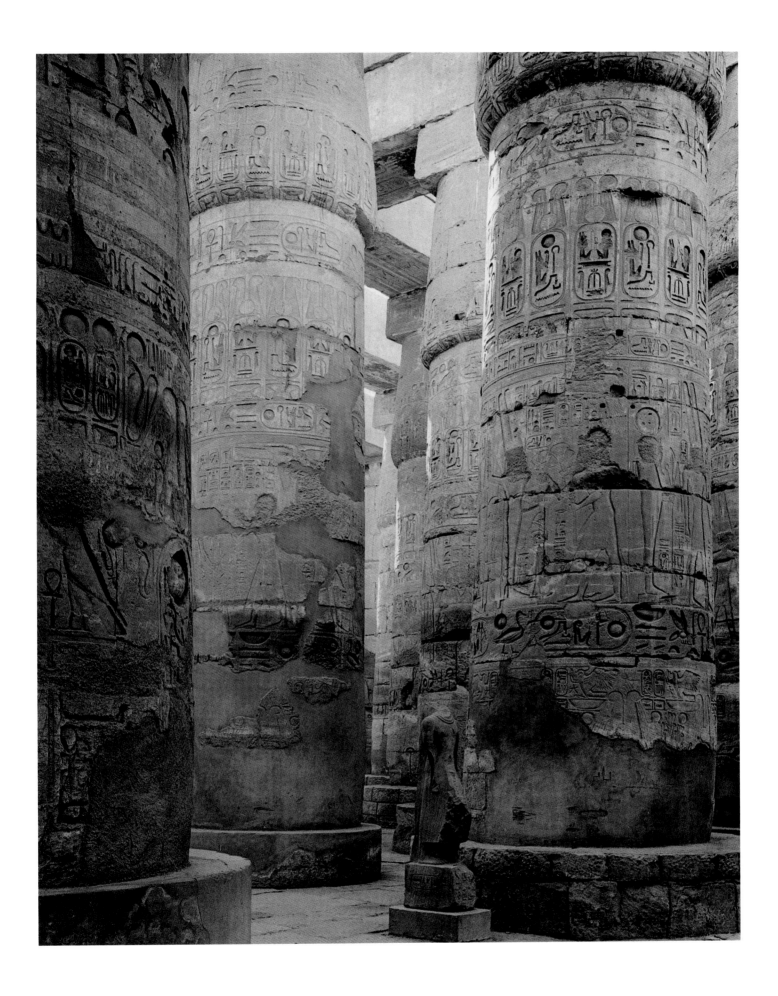

75. COLUMNS IN HYPOSTYLE, TEMPLE OF AMEN, KARNAK, LUXOR, EGYPT, JANUARY 25, 1973

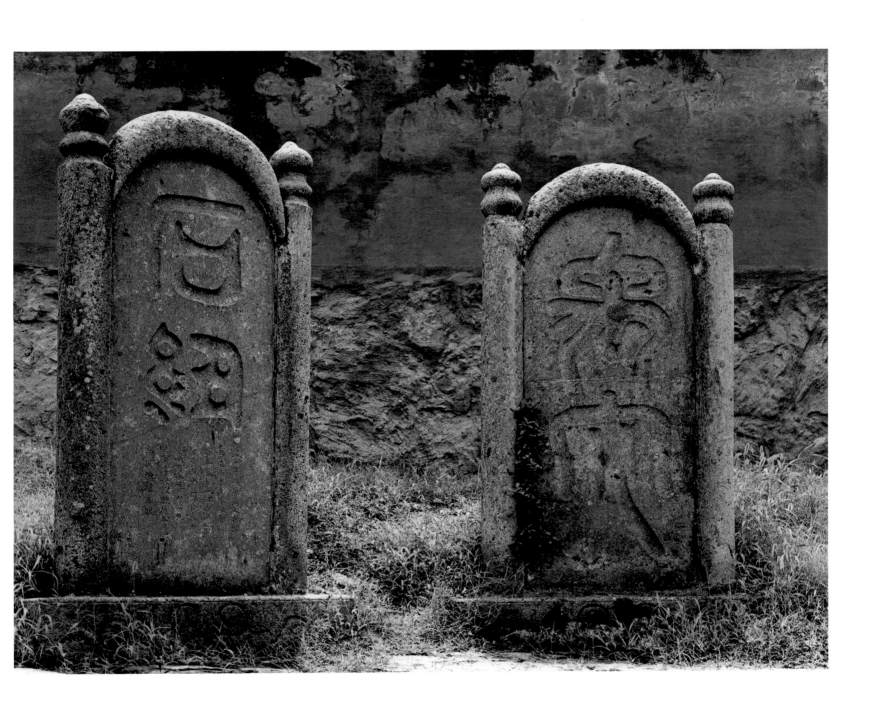

76. TEMPLE OF YU THE GREAT, SHAOXING, CHINA, JULY 15, 1980

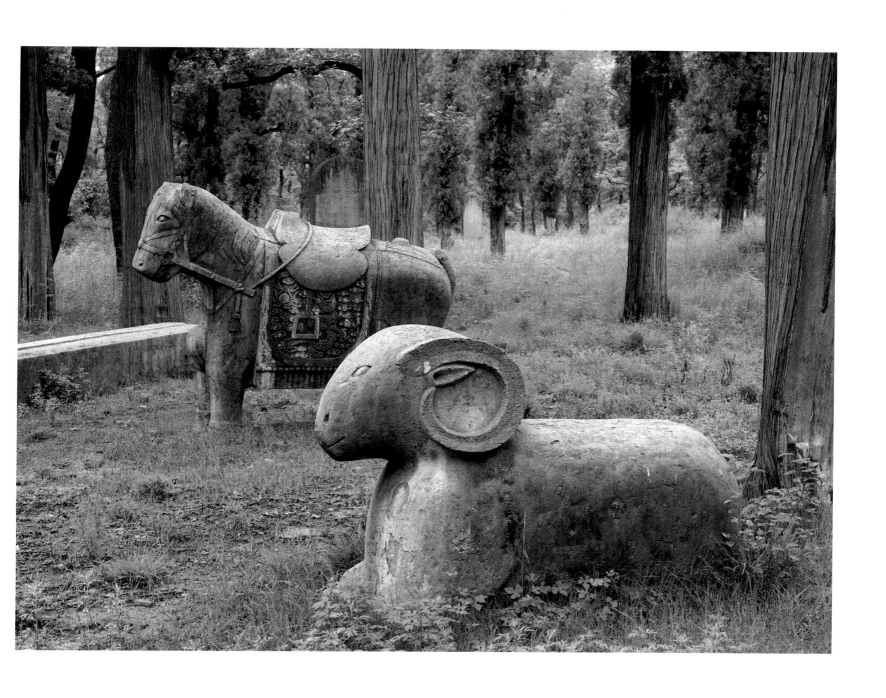

77. CONFUCIUS GRAVEYARD, QUFU, CHINA, 1980

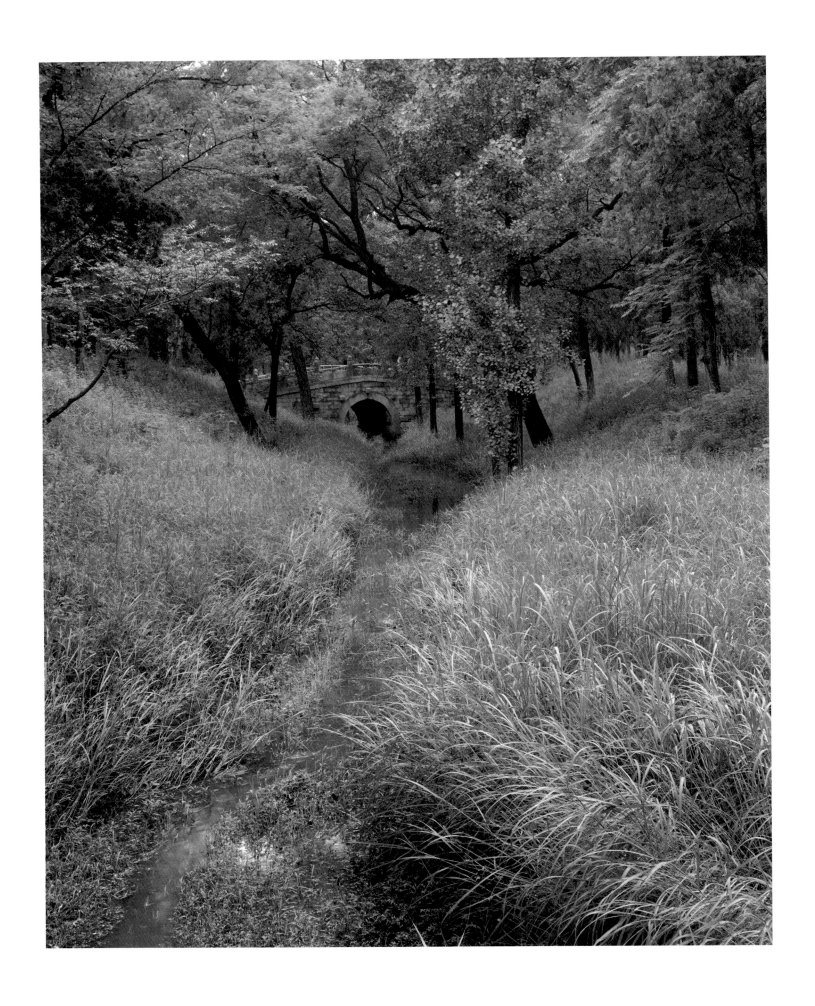

78. OLD MOAT, CONFUCIUS GRAVEYARD, QUFU, CHINA, 1980

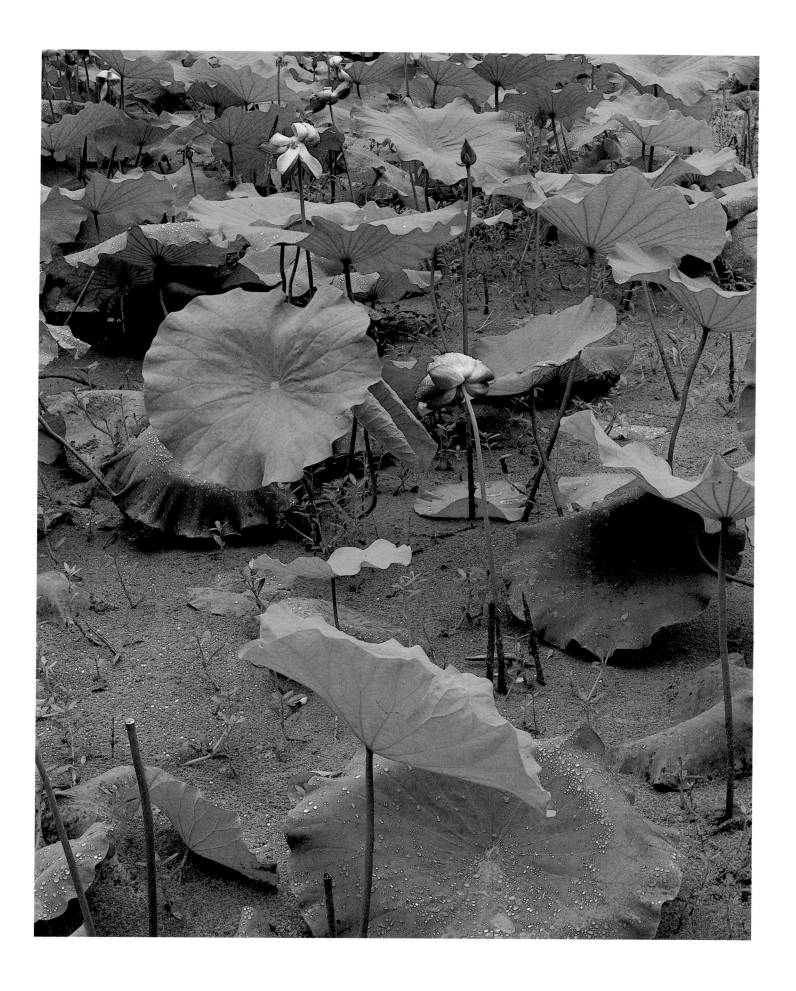

79. LOTUS BLOSSOMS AND AZOLLA, WEST LAKE, HANGZHOU, ZHEJIANG, CHINA, 1980

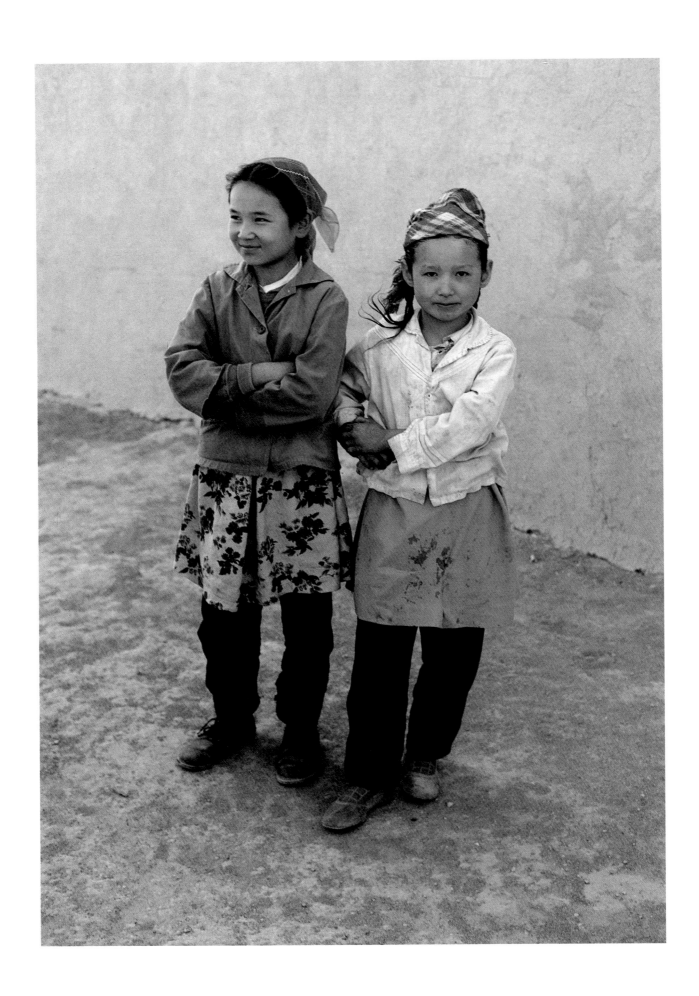

80. UYGUR GIRLS, TURFAN, CHINA, 1981

81. GRAFFITI ON WALL, MACAO, 1985

82. PLASTERED WALL, MACAO, 1980

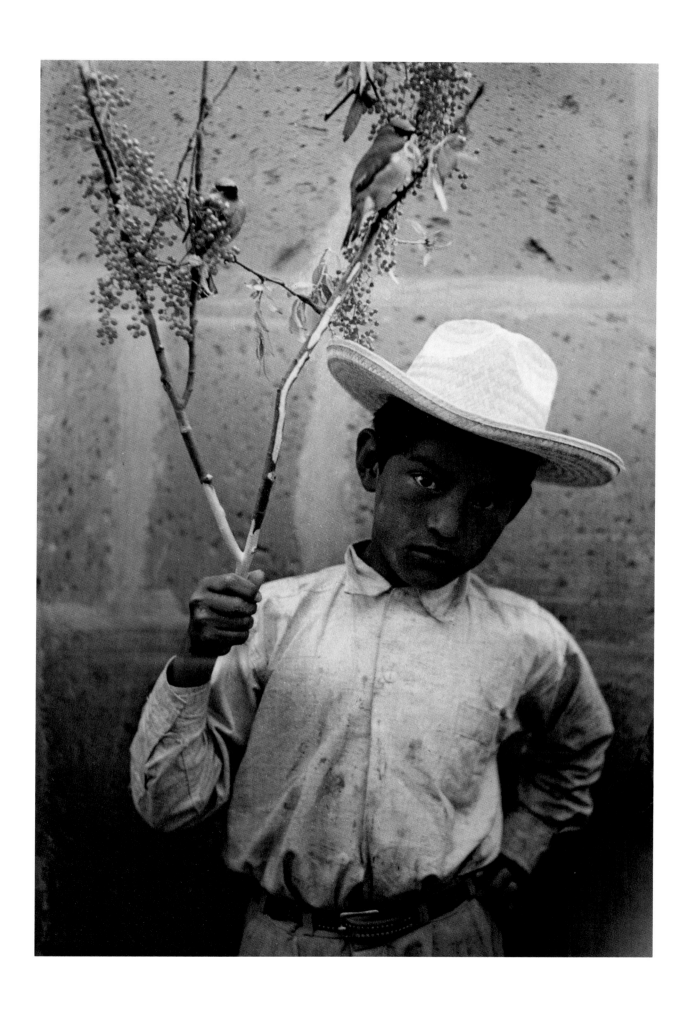

83. BOY WITH BIRDS, MORELIA, MEXICO, 1956

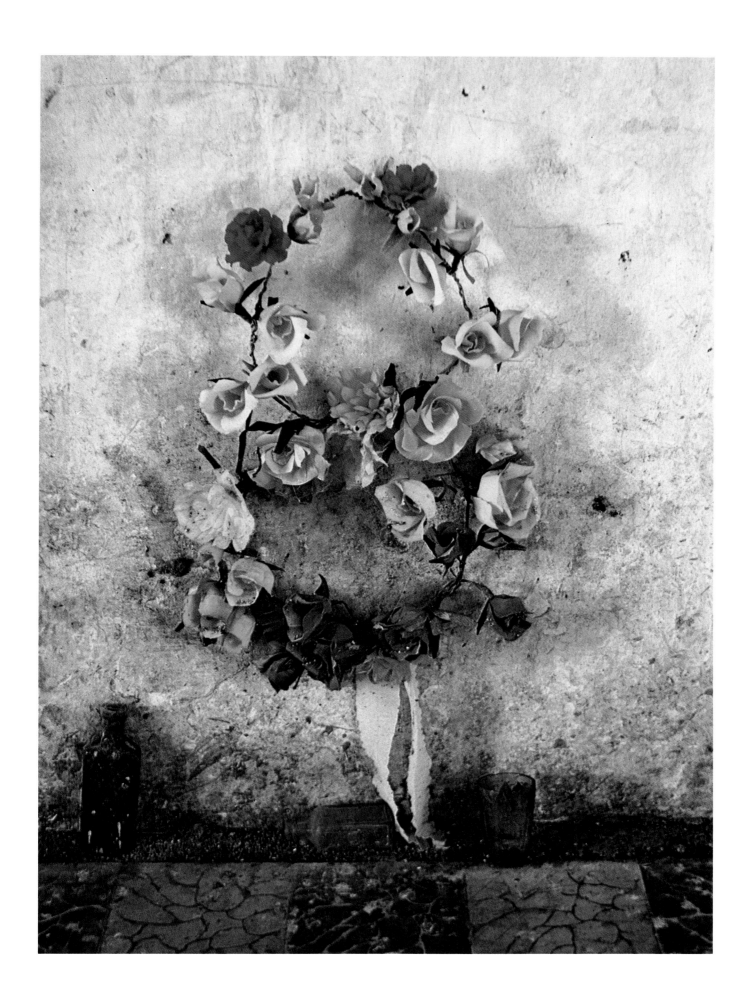

84. ORANGE WREATH, CHURCH OF XOCHEL, YUCATÁN, MEXICO, 1956

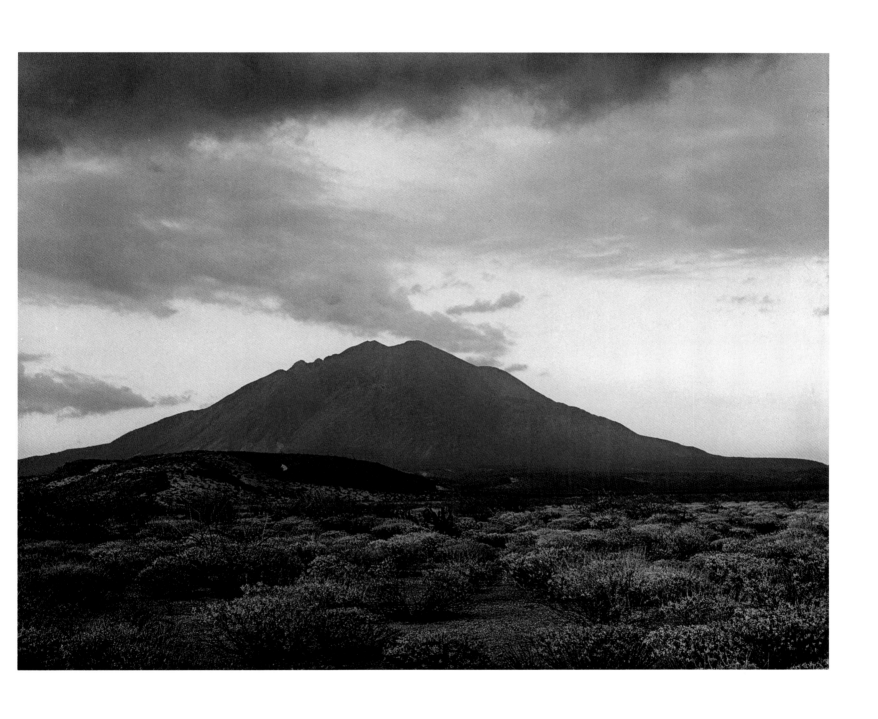

85. VOLCANIC PEAK, BAJA CALIFORNIA, 1966

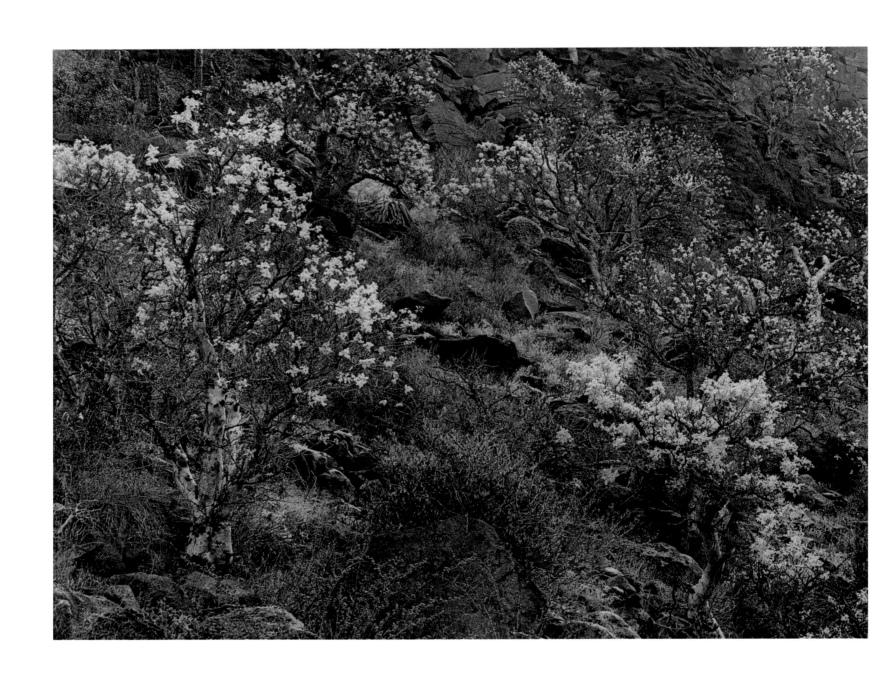

86. ELEPHANT TREES ON HILLSIDE, NEAR ROSARITO, BAJA CALIFORNIA, AUGUST 6, 1966

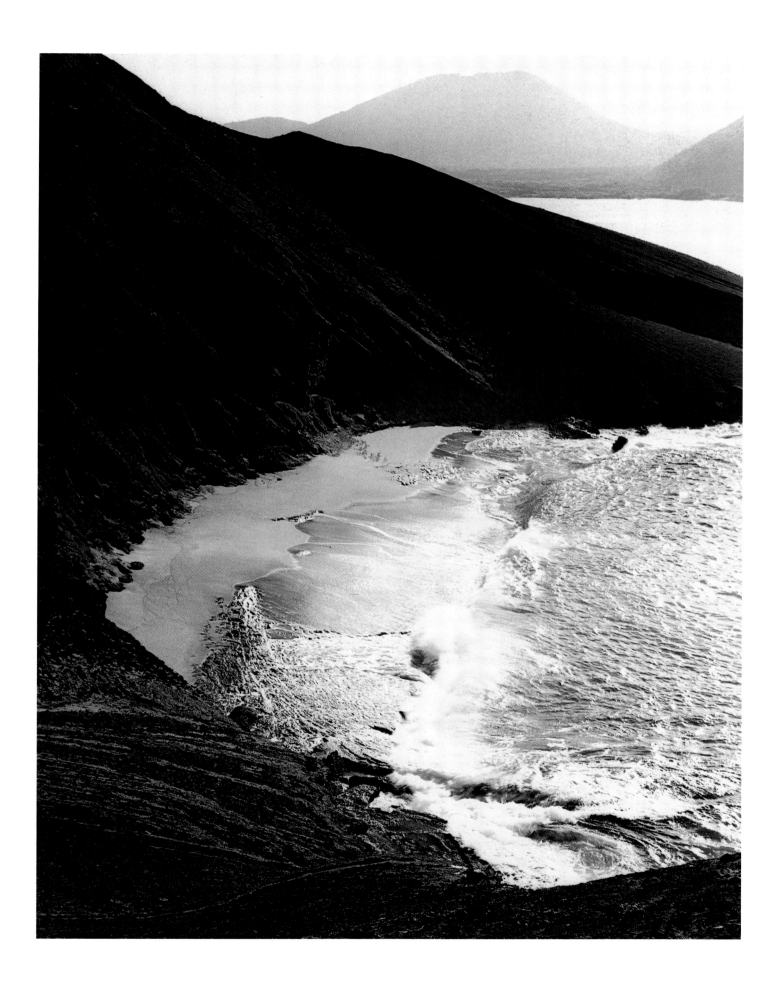

87. BARTOLOMÉ ISLAND, GALÁPAGOS ISLANDS, 1966

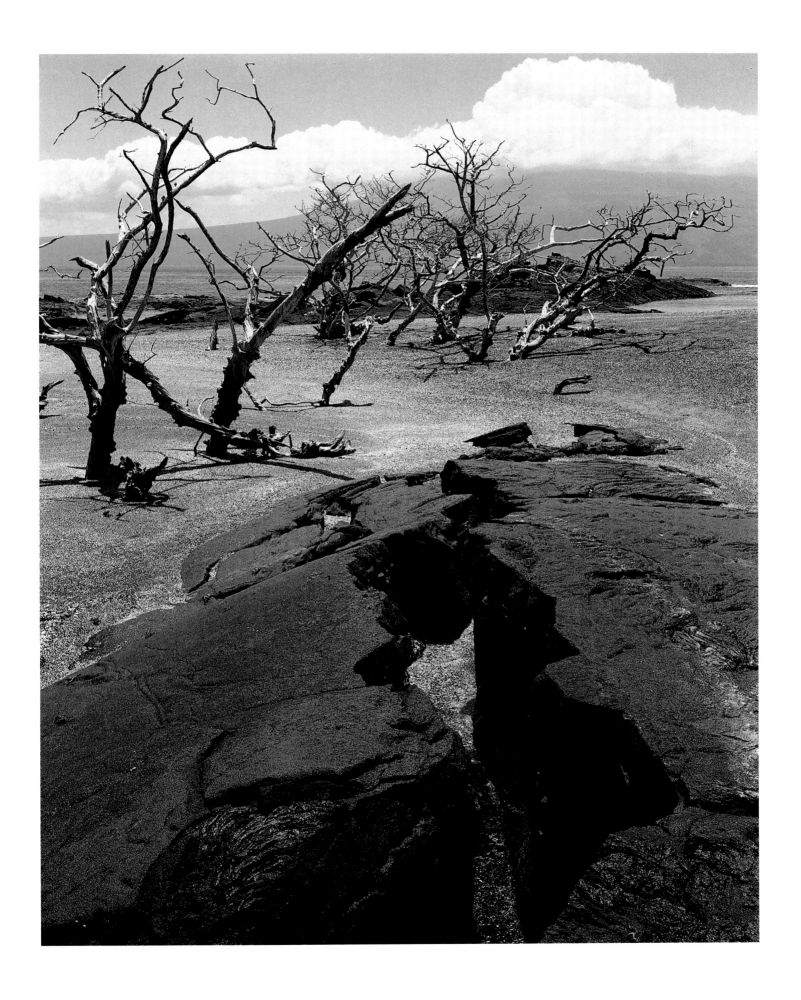

88. DEAD MANGROVE AND LAVA, ESPINOSA POINT, GALÁPAGOS ISLANDS, APRIL 7, 1966

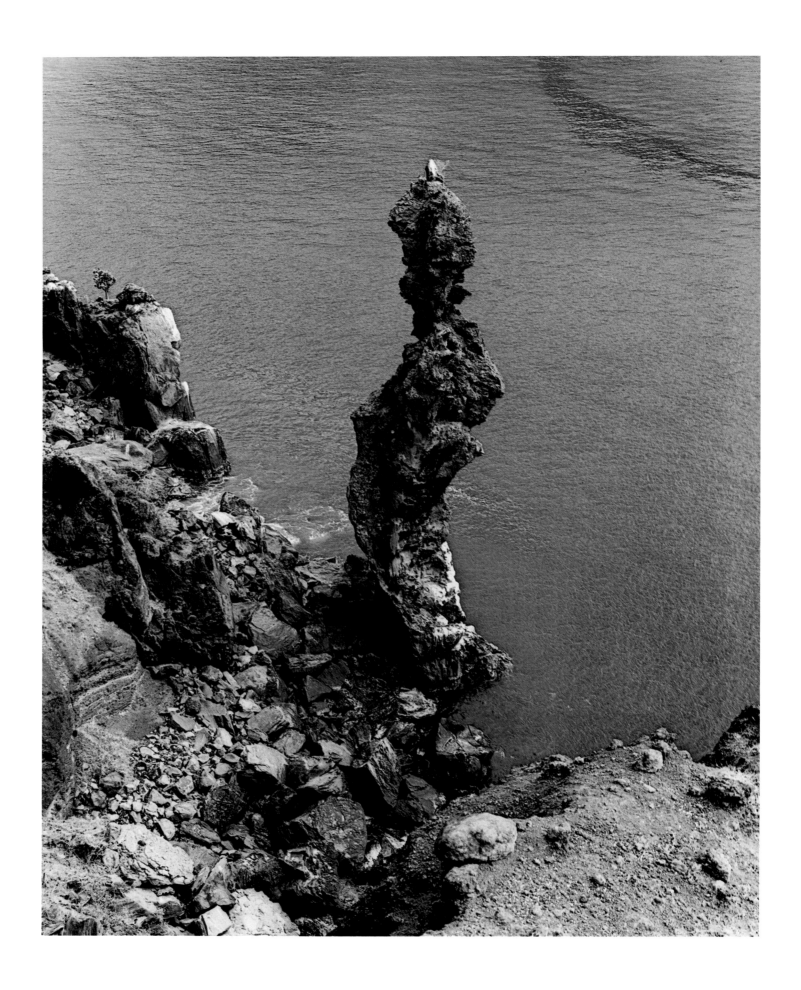

89. PINNACLE ROCK, BUCCANEER COVE, GALÁPAGOS ISLANDS, MAY 10, 1966

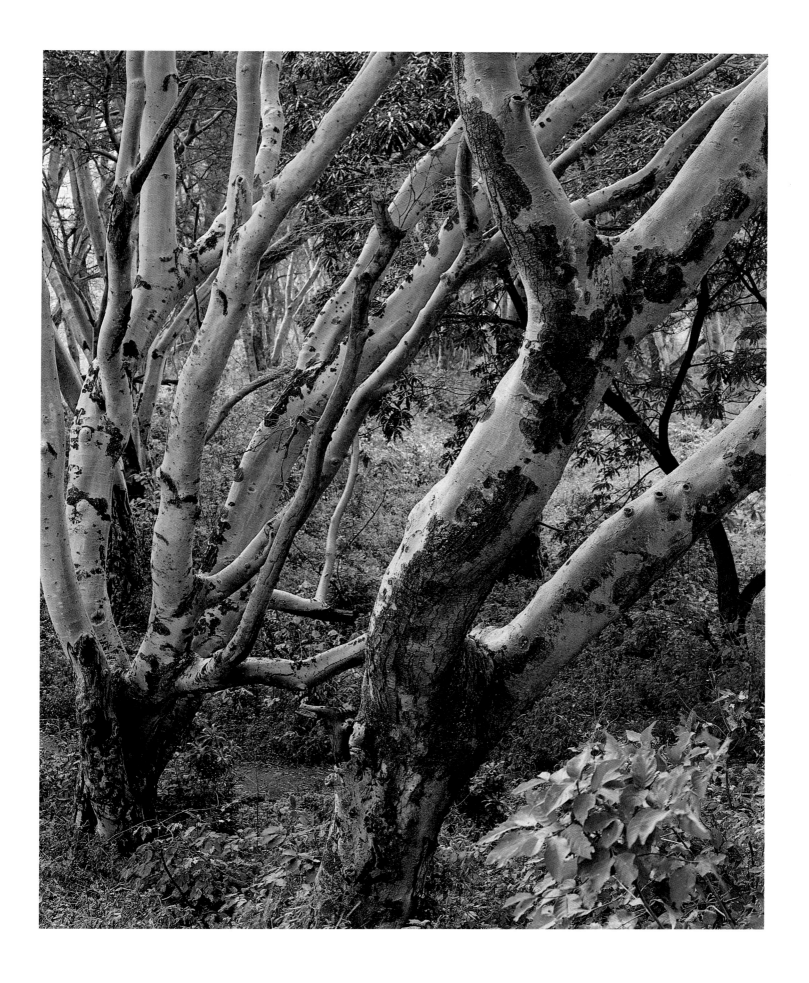

90. YELLOW-BARK ACACIAS, NGORONGORO CRATER, TANZANIA, JULY 15, 1970

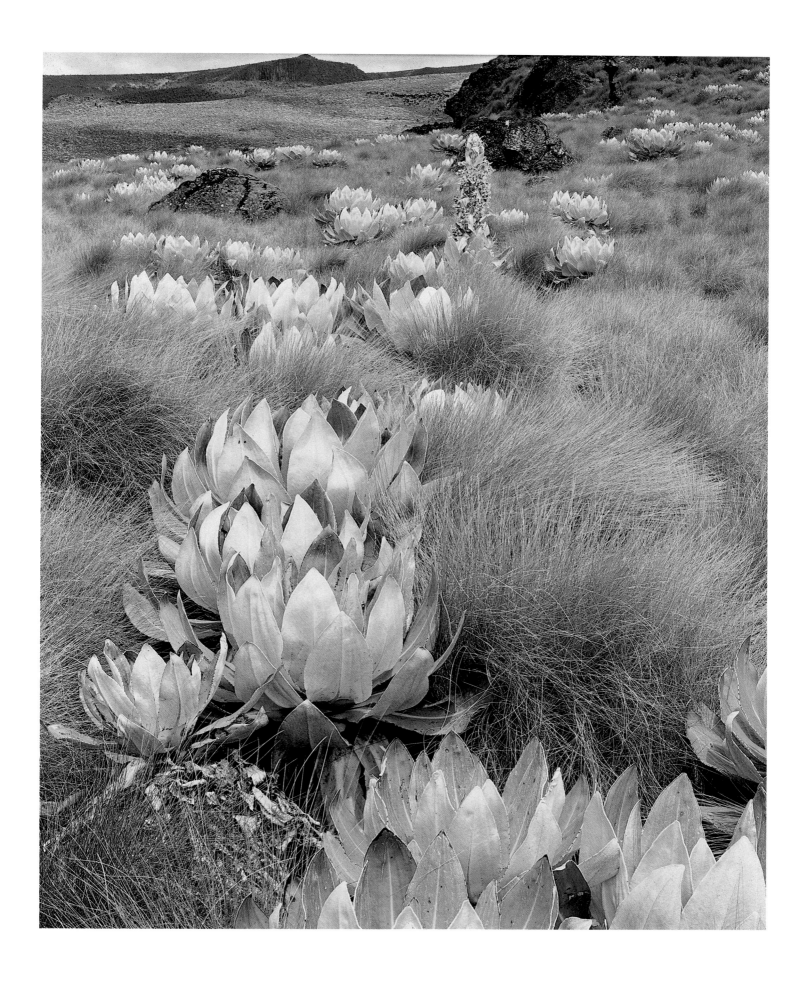

91. CABBAGE GROUNDSEL AND GRASS, MT. KENYA, KENYA, FEBRUARY 12, 1970

92. GIANT LOBELIA SEEDLING, UPPER TELEKI VALLEY, MT. KENYA, KENYA, FEBRUARY 14, 1970

93. STRANGLER FIG ROOTS, EVERGLADES NATIONAL PARK, FLORIDA, MARCH 7, 1954

94. CLOUDS FROM RIM, ALCEDO VOLCANO, GALÁPAGOS ISLANDS, MAY 4, 1966

95. VIEW FROM MONASTERY NUNATAK, DRY VALLEYS, ANTARCTICA, DECEMBER 31, 1975

96. VIEW DOWN BEACON VALLEY, ANTARCTICA, DECEMBER 28, 1975

97. THE LABYRINTH, WRIGHT VALLEY, ANTARCTICA, JANUARY 1976

98. COUVERVILLE ISLAND, ANTARCTICA, JANUARY 1975

99. CRABEATER SEAL, PALMER STATION, ANTARCTICA, 1976

100. SPONGE RAISED BY ANCHOR ICE, BLACK ISLAND, MCMURDO SOUND, ANTARCTICA, DECEMBER 17, 1975

IOI. EVENING REFLECTIONS ON SEA, SCHOLLAERT CHANNEL, ANTARCTICA, 1976

102. SUNSET CLOUDS, TESUQUE, NEW MEXICO, SUMMER 1960

103. CLOUDS, CHIRICAHUA MOUNTAINS, ARIZONA, 1959

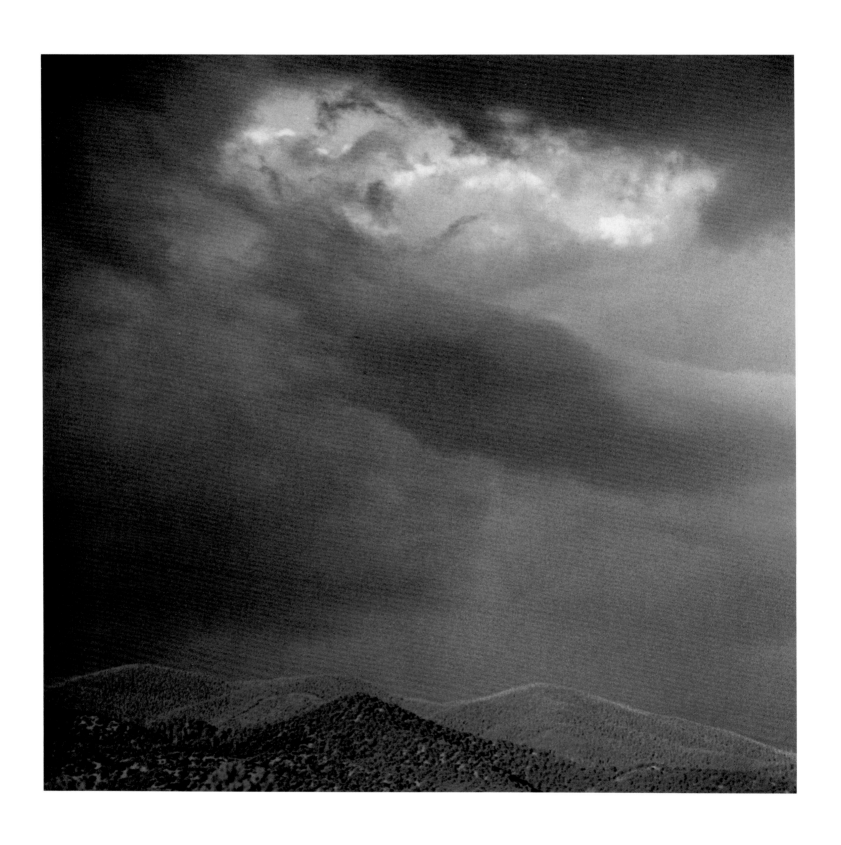

104. SANGRE DE CRISTO MOUNTAINS AT SUNSET, TESUQUE, NEW MEXICO, JULY 1958

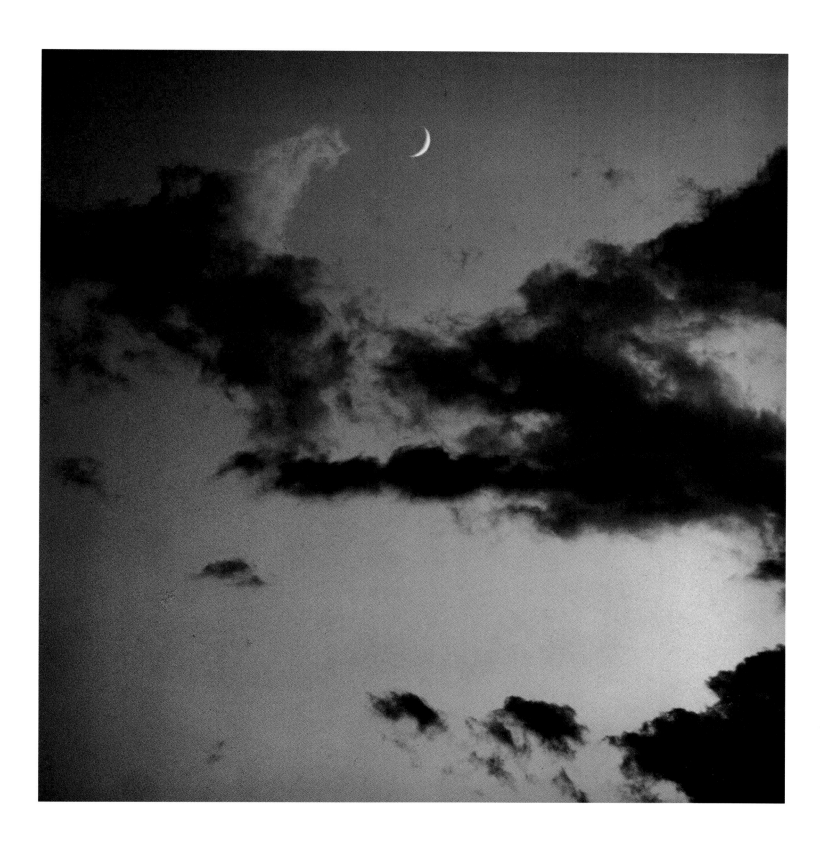

105. CLOUD FORMATIONS AND MOON AFTER SUNSET, TESUQUE, NEW MEXICO, JULY 1958

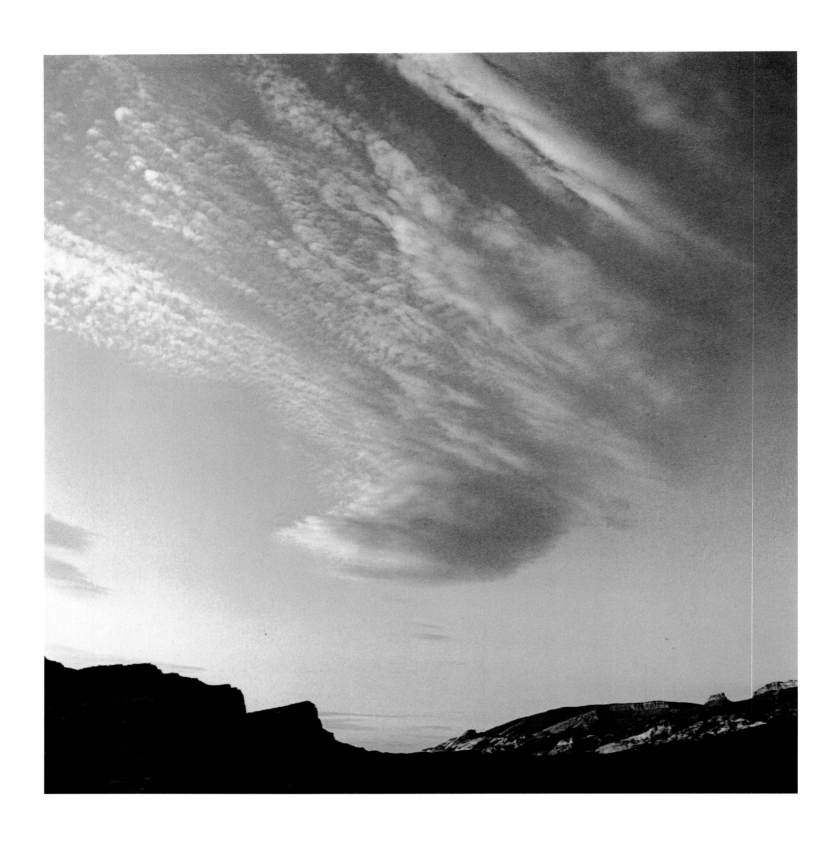

106. SUNRISE CLOUDS, WATERPOCKET FOLD, UTAH, AUGUST 20, 1963

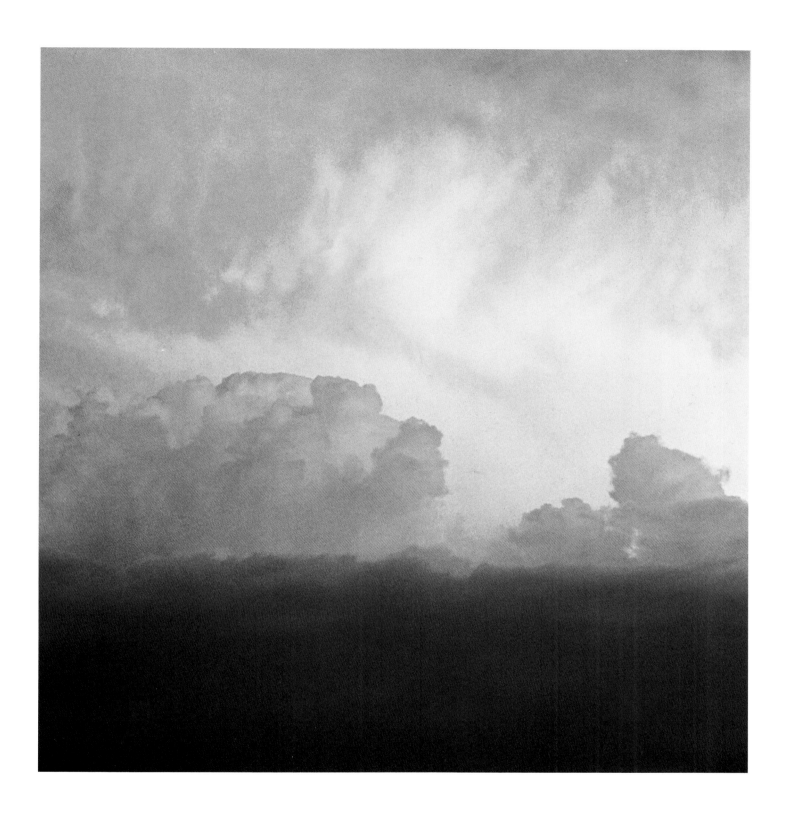

107. CLOUDS, WATERPOCKET FOLD, UTAH, AUGUST 1963

108. BROWN STONES WITH RED LICHEN, NEAR SAN IGNACIO, BAJA CALIFORNIA, AUGUST 10, 1966

109. PYROCLASTIC LAVAS, HÍTARDALUR, SNAEFELLSNES, ICELAND, JULY 10, 1972

110. HARD INCLUSIONS IN SANDSTONE, GRAY'S ARCH TRAIL, RED RIVER GORGE, KENTUCKY, APRIL 18, 1968

III. BLUE VITRIFIED LAVA, CRATERS OF THE MOON, IDAHO, JULY 2, 1975

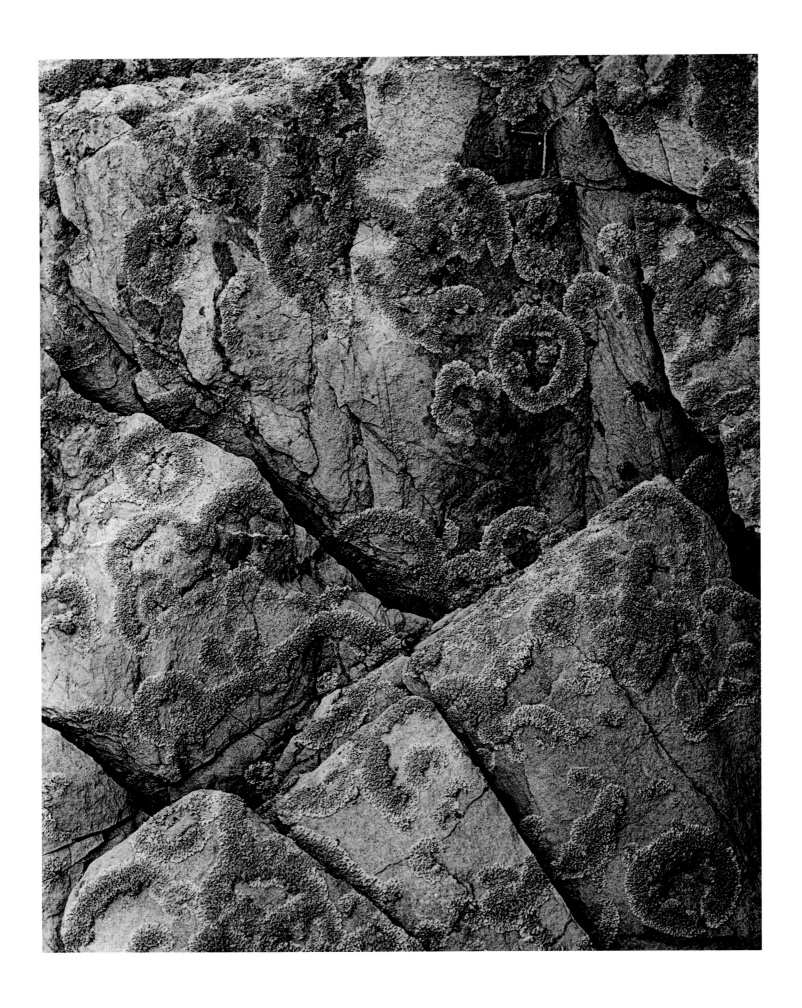

112. LICHENS ON BROWN ROCK, SUGAR LOAF, BARRED ISLANDS, MAINE, JUNE 23, 1969

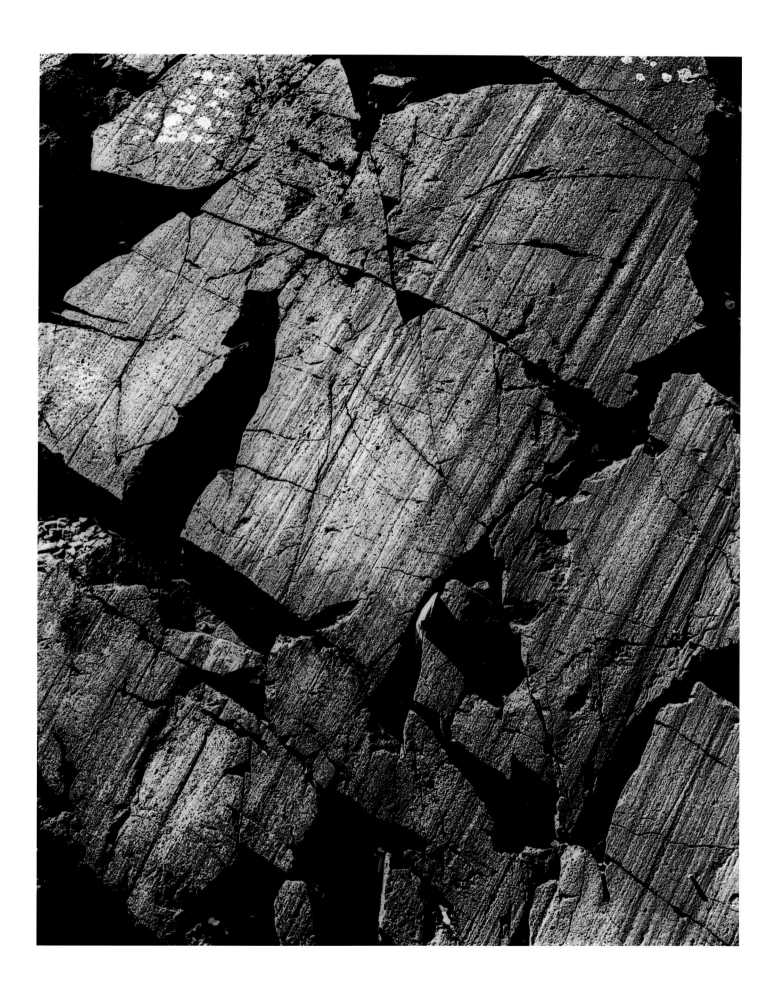

113. GLACIER-SCRATCHED ROCK, GREAT SPRUCE HEAD ISLAND, MAINE, JULY 21, 1971

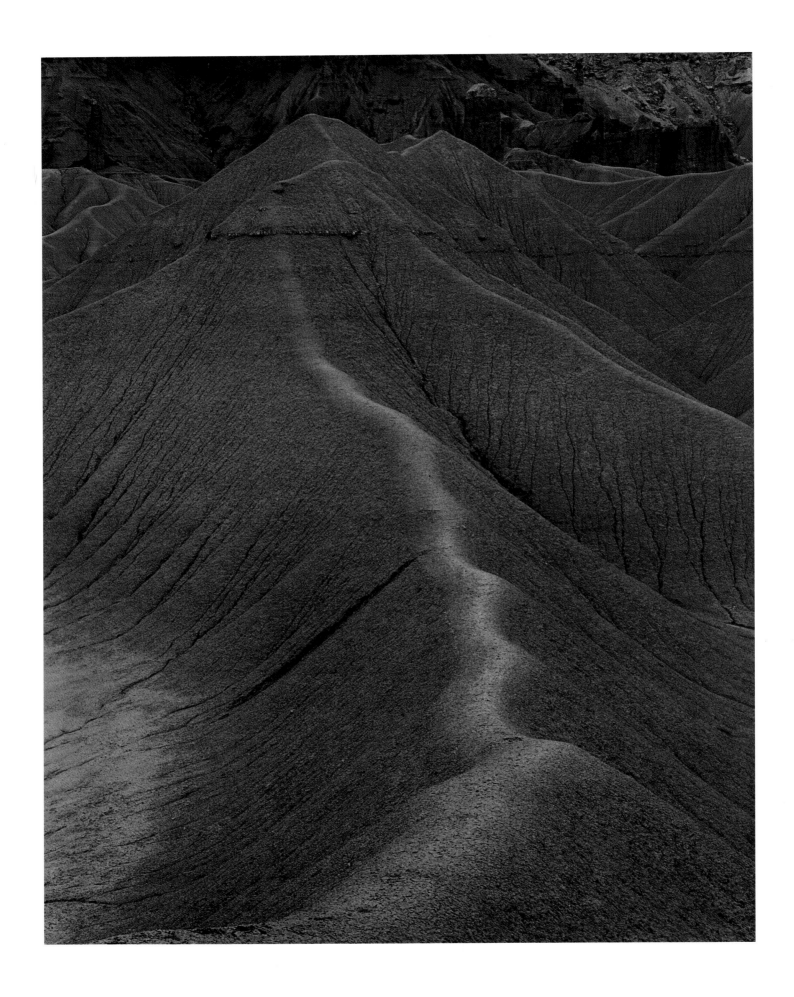

114. GRAY ERODED BENTONITE, NEAR HANKSVILLE, UTAH, AUGUST 17, 1963

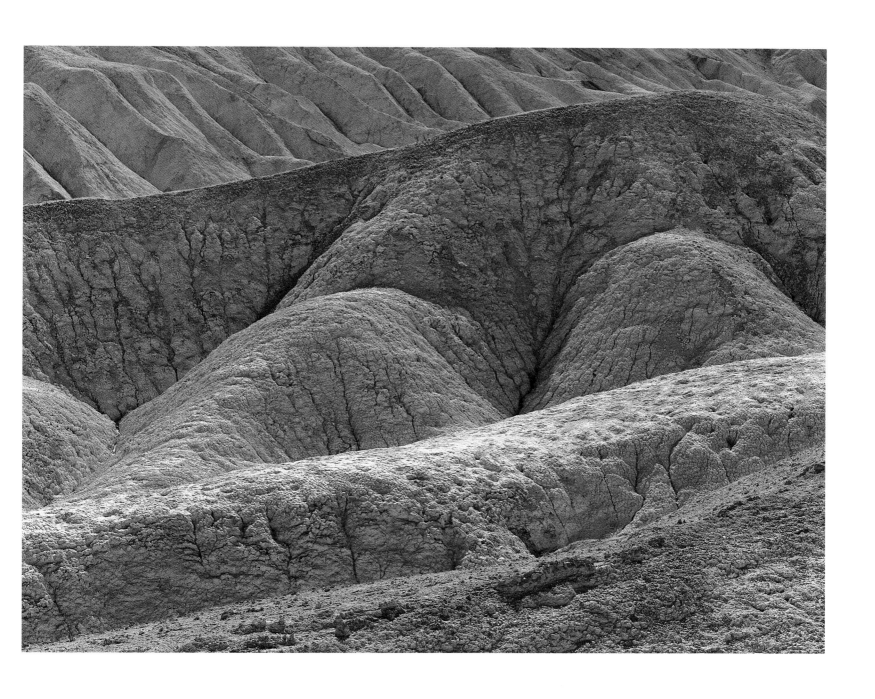

115. DEATH VALLEY, CALIFORNIA, 1974

116. DEPOSITS OF VOLCANIC ASH, TRES VIRGENES CANYON, BAJA CALIFORNIA, MARCH 2, 1964

117. SANDSTONE BOULDERS NEAR CAPITOL REEF, UTAH, JUNE 16, 1975

118. RED BOULDERS, MULEY TANKS, WATERPOCKET FOLD, UTAH, AUGUST 22, 1963

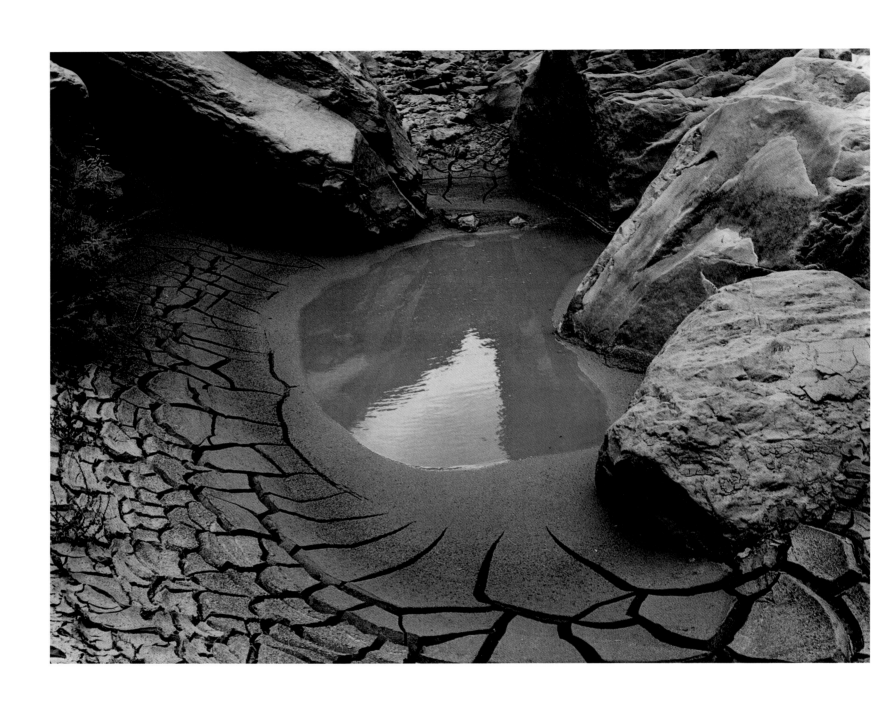

119. MUD CRACKS AND POOL, HOUSE ROCK CANYON, MARBLE CANYON, ARIZONA, JUNE 13, 1967

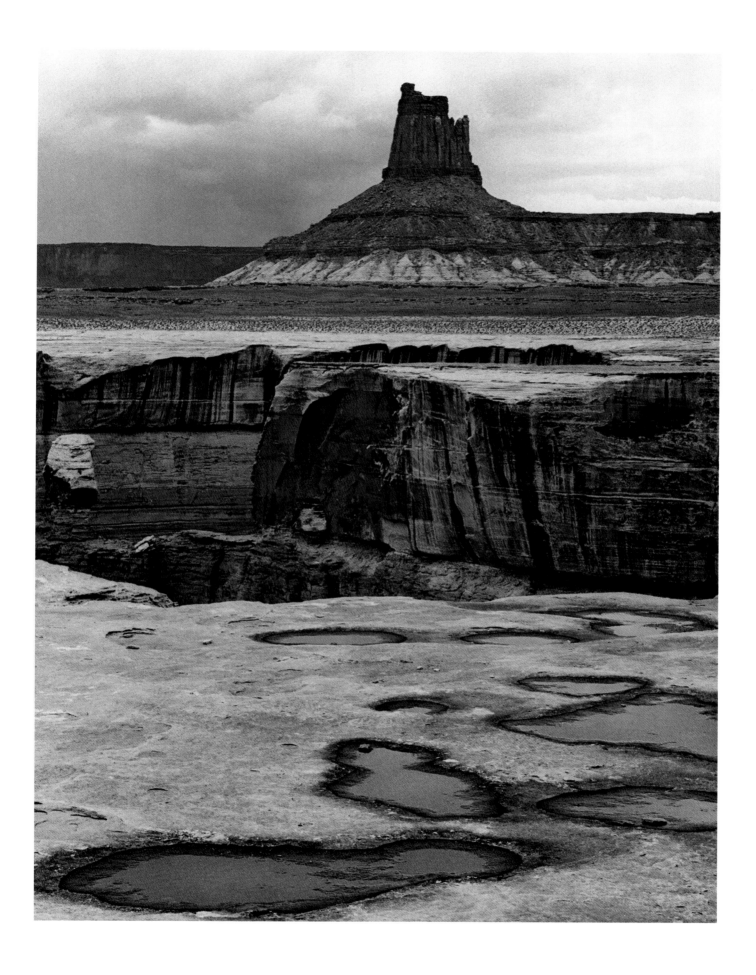

120. STORM OVER GREEN RIVER, CANYONLANDS NATIONAL PARK, UTAH, APRIL 30, 1973

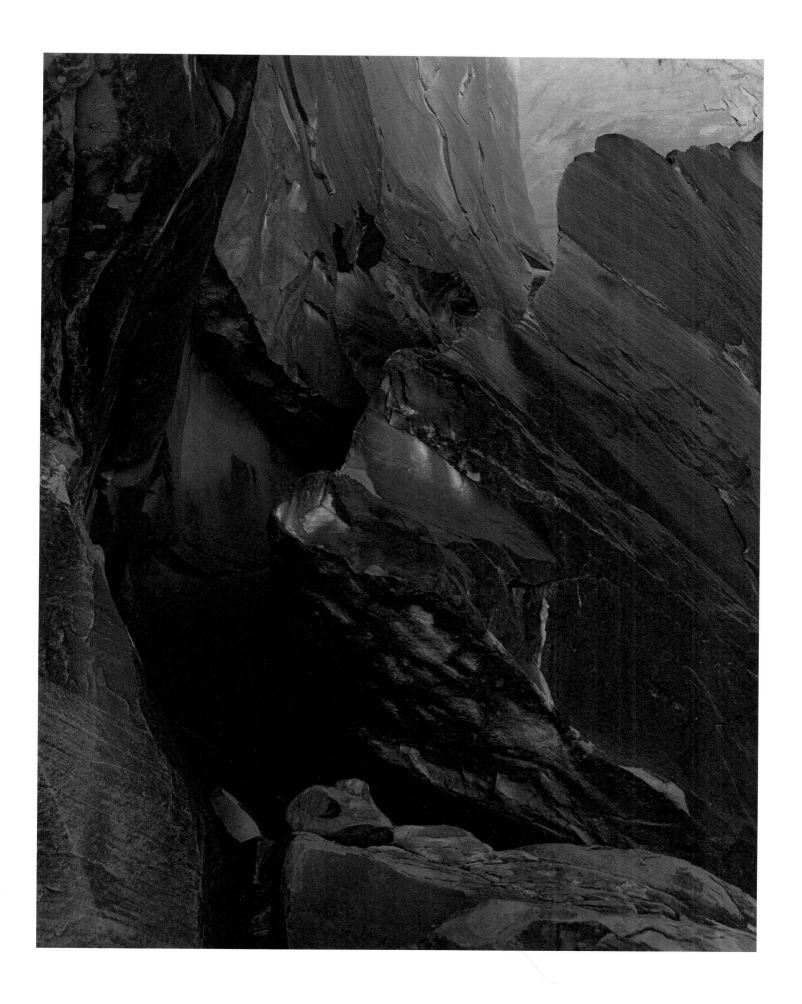

121. CLIFF, MOONLIGHT CREEK, SAN JUAN RIVER, UTAH, MAY 23, 1962

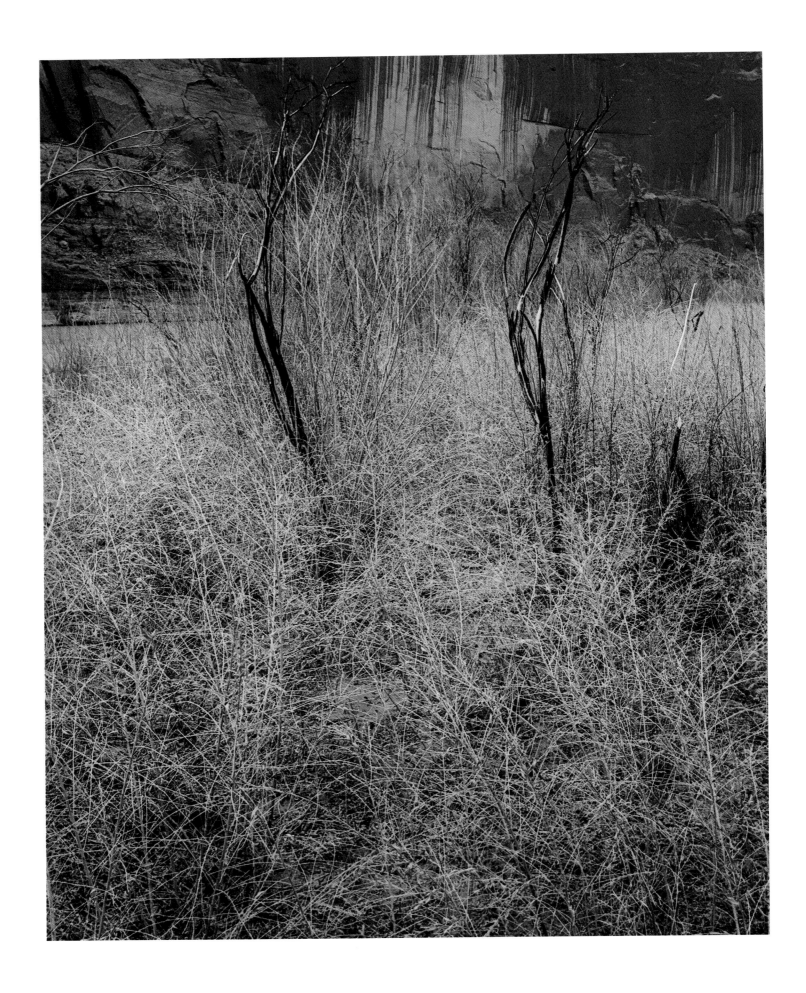

122. WEEDS AND BURNED WILLOWS, OLYMPIA BAR, GLEN CANYON, UTAH, APRIL 8, 1963

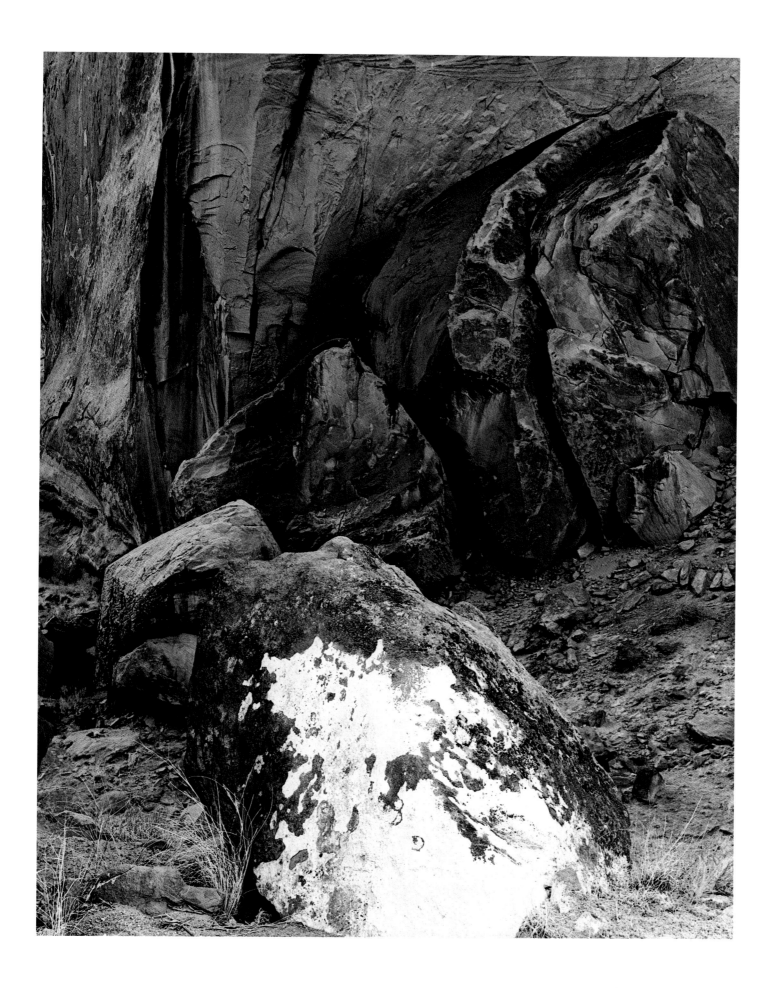

123. BOULDERS AT FOOT OF BROKEN BOW ARCH, WILLOW CANYON, UTAH, AUGUST 11, 1971

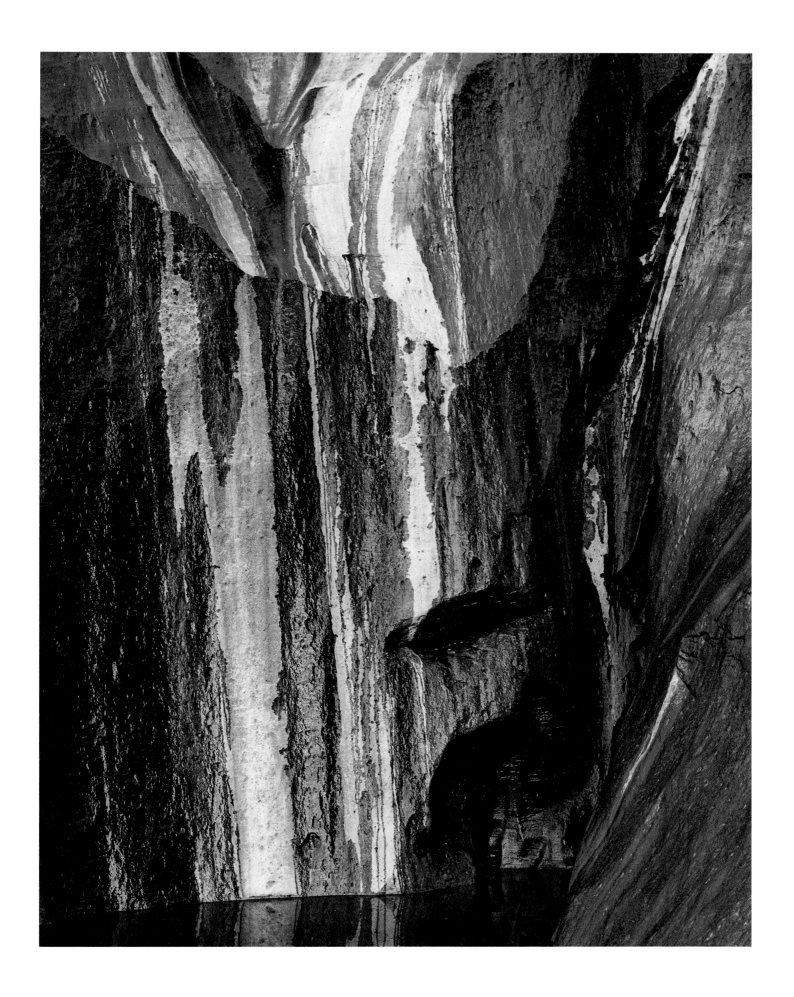

124. WATER-STREAKED WALL, WARM SPRING CANYON, LAKE POWELL, UTAH, SEPTEMBER 24, 1965

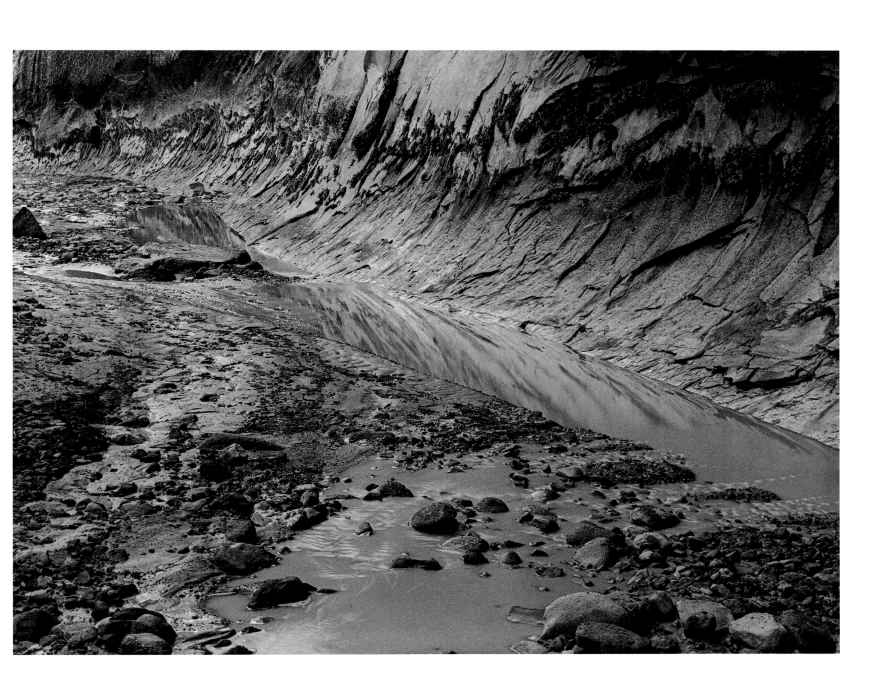

125. BLUE REFLECTIONS, WILLOW CANYON, UTAH, AUGUST 12, 1971

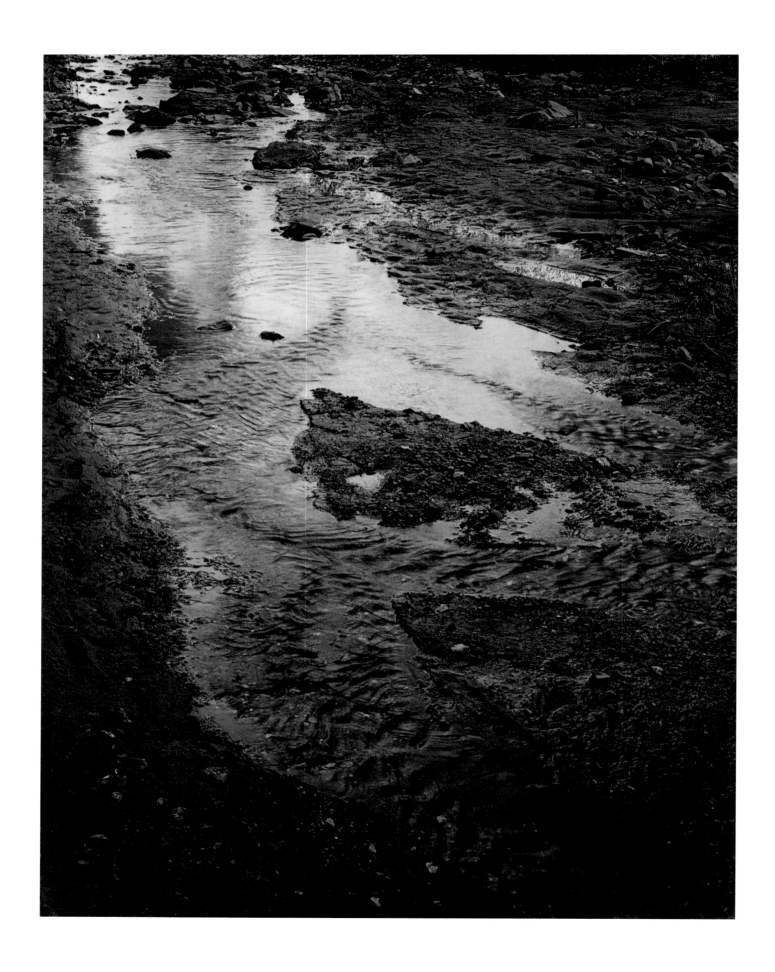

126. GREEN REFLECTIONS IN STREAM, MOQUI CREEK, GLEN CANYON, UTAH, SEPTEMBER 2, 1962

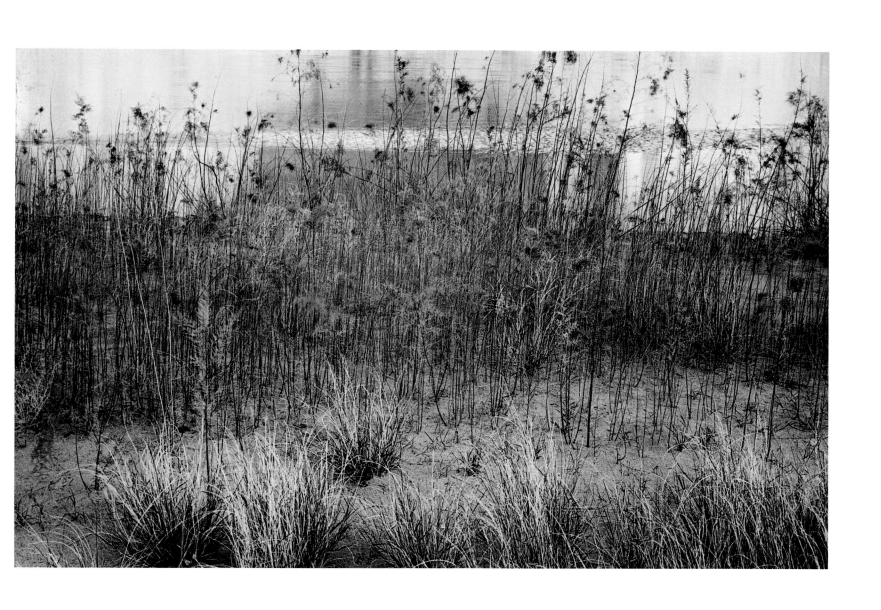

127. TAMARISK AND GRASS, GLEN CANYON, UTAH, 1961

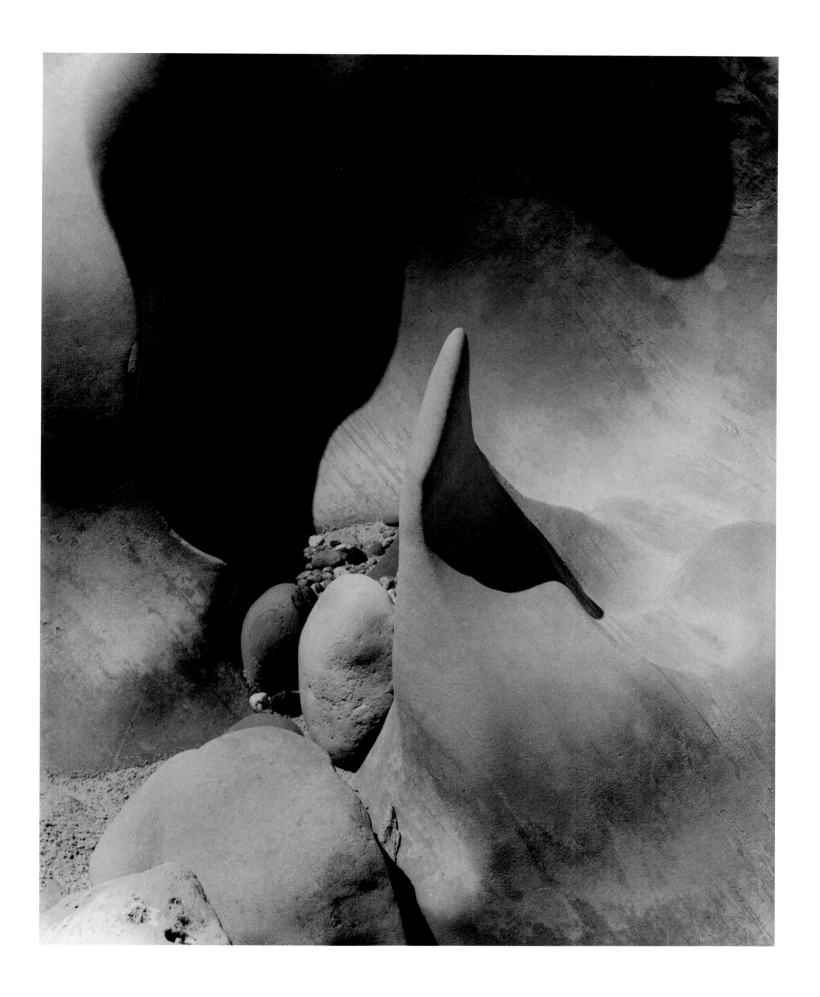

128. SCULPTURED ROCK, HOUSE ROCK CANYON, MARBLE CANYON, ARIZONA, JUNE 13, 1967

CHECKLIST OF THE EXHIBITION

ALL PRINTS are from the collection of Eliot Porter unless otherwise noted, and all catalogue numbers refer to his master numbering system. In the given dimensions height precedes width.

FRONTISPIECE. *Gray's Arch, Red River Gorge, Kentucky,*
April 16, 1968
Dye-transfer print
15⅞ x 12⅜ in.
68–142

1. *Whiteface Intervale, New Hampshire, 1936*
Gelatin silver print
8⅞₆ x 6¹⁵⁄₁₆ in.
BW 36–9

2. *Apples, Great Spruce Head Island, Maine, 1936*
Gelatin silver print
7 x 6 in.
BW 36–30

3. *Spruce trees, Great Spruce Head Island, Maine, 1940*
Gelatin silver print
8¼ x 6⅝ in.
BW 40–52
Collection, The Museum of Modern Art, New York;
Gift of the photographer

4. *Earl Brown, Eagle Island, Maine, 1939*
Gelatin silver print
8⅞₆ x 6⁹⁄₁₆ in.
BW 810–39–7

5. *Maianthemum and starflower, Great Spruce Head Island,*
Maine, 1938
Gelatin silver print
8¼ x 6⅝ in.
BW 38–58
Collection, The Museum of Modern Art, New York;
Gift of the photographer

6. *Grain elevators, Rockland, Maine, 1937*
Gelatin silver print
9³⁄₁₆ x 7¼ in.
BW 37–28

7. *Dead horse, Arizona, 1940*
Gelatin silver print
9⁷⁄₁₆ x 7½ in.
BW 810–40–108

8. *Mertensia maritima, Great Spruce Head Island, Maine, 1937*
Gelatin silver print
8¼ x 6⁹⁄₁₆ in.
BW 37–21

9. *Arctic tern, Matinicus Rock, Maine, 1976*
Dye-transfer print
10⅜ x 12¹¹⁄₁₆ in.
2–2–5–6

10. *Roadrunner, San Xavier Indian Reservation, Arizona,*
May 2, 1952
Dye-transfer print
8¼ x 10⁹⁄₁₆ in.
12–1–2–24

11. *Purple gallinule, Everglades National Park, Florida,*
March 2, 1954
Dye-transfer print
8½ x 10³⁄₁₆ in.
7–2–3–19

12. *Rufous hummingbird, Tesuque, New Mexico, August 4, 1956*
Dye-transfer print
10⅛ x 7¹³⁄₁₆ in.
14–3–4–5

13. *Blue-winged warblers, Jackson, Michigan, June 1955*
Dye-transfer print
10¾ x 8⅝₆ in.
15–13–23–22

14. *Hepaticas, near Sheffield, Massachusetts, April 17, 1957*
Dye-transfer print
10½ x 8⁵⁄₁₆ in.
57–42C

15. *Bunchberry flowers, Silver Lake, New Hampshire, June 5, 1953*
Dye-transfer print
10⅞ x 8½ in.
53–165

16. *Lady's-slipper, Tamworth, New Hampshire, May 27, 1953*
Dye-transfer print
10¾ x 8⁷⁄₁₆ in.
53–136

17. *May apple, near Harrisburg, Pennsylvania, May 13, 1957*
Dye-transfer print
10⁹⁄₁₆ x 8⅛ in.
57–132

18. *Woodcock's nest, Great Spruce Head Island, Maine, June 5, 1949*
Dye-transfer print
8¼ x 10⅜ in.
8–3–3–1

19. *Mushrooms and stump with hobblebush leaves, New Hampshire, 1952*
Dye-transfer print
10¹³⁄₁₆ x 8⁷⁄₁₆ in.
52–107

20. *Pond with marsh grass and lily pads, Madison, New Hampshire, October 1, 1952*
Dye-transfer print
10⁷⁄₁₆ x 8⁷⁄₁₆ in.
59–92

21. *Tidal marsh, Mt. Desert Island, Maine, August 4, 1965*
Dye-transfer print
7⅝ x 10 in.
65–476

22. *Water lilies, Rocky Creek, Ozark Mountains, Missouri, May 20, 1978*
Dye-transfer print
10¼ x 8⅛ in.
78–67

23. *Pool in a brook, Pond Brook, New Hampshire, 1953*
Dye-transfer print
10¹¹⁄₁₆ x 8⁵⁄₁₆ in.
53–308

24. *Floating leaves and reflections, Aspen, Colorado, October 3, 1951*
Dye-transfer print
10¾ x 8³⁄₁₆ in.
51–63

25. *Frozen pool, Adirondack Mountains, New York, 1965*
Dye-transfer print
9¹⁵⁄₁₆ x 8³⁄₁₆ in.
65–1

26. *Grass in snow, Shelburne Pass, Vermont, February 1957*
Dye-transfer print
10¹³⁄₁₆ x 8⁷⁄₁₆ in.
57–13

27. *Black-eyed Susans and sumac in grass, Passaconaway Road, New Hampshire, October 4, 1956*
Dye-transfer print
8⁷⁄₁₆ x 10⁹⁄₁₆ in.
56–313

28. *Foxtail grass, Lake City, Colorado, August 1957*
Dye-transfer print
10⅝ x 8⅛ in.
57–204

29. *Raspberry leaves in grass, Great Spruce Head Island, Maine, 1964*
Dye-transfer print
10⁷⁄₁₆ x 8³⁄₁₆ in.
64–685

30. *Apples, Great Spruce Head Island, Maine, 1942*
Dye-transfer print
16¹⁄₁₆ x 12³⁄₁₆ in.
42–8

31. *Yellow leaves and asters, Sangre de Cristo Mountains, New Mexico, September 20, 1950*
Dye-transfer print
10¾ x 8⁵⁄₁₆ in.
50–32

32. *Peeling birch bark, Great Spruce Head Island, Maine, June 24, 1969*
Dye-transfer print
10½ x 8³⁄₁₆ in.
69–302

33. *Spruce tree with lower dead branches, Great Spruce Head Island, Maine, July 14, 1963*
Dye-transfer print
10⅜ x 8⅜ in.
63–177

34. *Blueberry bushes, near Keene Valley, Adirondack Park, New York,*
 October 1963
 Dye-transfer print
 10½ x 8³⁄₁₆ in.
 63 – 517

35. *Hay fern, Chocorua, New Hampshire, October 13, 1953*
 Dye-transfer print
 10¹¹⁄₁₆ x 8⅝ in.
 53 – 336

36. *Rock, lichen, dead hellebore, Santa Fe Basin, New Mexico,*
 September 18, 1960
 Dye-transfer print
 10⁵⁄₁₆ x 8¹⁄₁₆ in.
 60 – 576

37. *Beech grove, Great Smoky Mountains National Park,*
 April 26, 1968
 Dye-transfer print
 8⁵⁄₁₆ x 10½ in.
 68 – 286

38. *Oak leaves and birches, Passaconaway, New Hampshire,*
 October 7, 1956
 Dye-transfer print
 10⅞ x 8⁷⁄₁₆ in.
 56 – 337

39. *Blueberry leaves and maple trunks, Passaconaway, New*
 Hampshire, July 10, 1952
 Dye-transfer print
 10¹¹⁄₁₆ x 8⅜ in.
 52 – 133

40. *Baneberry leaves and aspen trunks, Aspen, Colorado,*
 October 3, 1951
 Dye-transfer print
 10¾ x 8⅛ in.
 51 – 67

41. *Frozen apples, Tesuque, New Mexico, November 21, 1966*
 Dye-transfer print
 10½ x 8¹⁄₁₆ in.
 66 – 3199

42. *Tree and mountain valley, Great Smoky Mountains National*
 Park, Tennessee, March 11, 1969
 Dye-transfer print
 10⅝ x 8¼ in.
 69 – 5

43. *Red tree near Cades Cove, Great Smoky Mountains National Park,*
 Tennessee, October 7, 1967
 Dye-transfer print
 10⁵⁄₁₆ x 8 in.
 67 – 1268

44. *Birch trees on cliff, near Keene Valley, Adirondack Park,*
 New York, 1963
 Dye-transfer print
 10½ x 8⅛ in.
 63 – 519

45. *White aspens and hillside, near Steamboat Springs, Colorado,*
 May 28, 1975
 Dye-transfer print
 8¹⁄₁₆ x 10⅜ in.
 75 – 231

46. *Redbud tree in bottom land, Red River Gorge, Kentucky,*
 April 17, 1968
 Dye-transfer print
 10¼ x 8⅛ in.
 68 – 144

47. *Chapel Pond, Adirondack Park, New York, 1965*
 Dye-transfer print
 16 x 12¾ in.
 65 – 40

48. *Maple and birch trunks and oak leaves, Passaconaway, New*
 Hampshire, October 7, 1956
 Dye-transfer print
 13⅜ x 10⅝ in.
 56 – 340

49. *Trees and pond, near Sherborn, Massachusetts, April 1957*
 Dye-transfer print
 10¹¹⁄₁₆ x 8⁵⁄₁₆ in.
 57 – 177

50. *Beech leaves and tree trunks in snow, Adirondack Mountains,*
 New York, 1965
 Dye-transfer print
 12⅞ x 15¹⁵⁄₁₆ in.
 65 – 84

51. *Bare aspens, Pacheco Canyon, New Mexico, June 1, 1957*
 Dye-transfer print
 10¾ x 8³⁄₁₆ in.
 57 – 150

52. *Willows, Hahns Peak Road, Colorado, May 27, 1975*
 Dye-transfer print
 10 x 7¾ in.
 75 – 221

53. *Erratic boulder, Barred Islands, Maine, 1983*
Dye-transfer print
8¹/₁₆ x 10³/₁₆ in.
83−63

54. *Folded schist, Little Spruce Head Island, Maine, July 27, 1969*
Dye-transfer print
10½ x 8³/₁₆ in.
69−401

55. *Lichens and pine needles on boulder, Madison, New Hampshire, October 12, 1953*
Dye-transfer print
10¹/₁₆ x 8¹/₁₆ in.
53−322

56. *Lichens on rocks, Chain Links, Maine, July 21, 1963*
Dye-transfer print
8³/₈ x 10⁷/₁₆ in.
63−204

57. *Dead arctic tern, Matinicus Rock, Maine, August 6, 1949*
Dye-transfer print
9⁵/₈ x 7⁹/₁₆ in.
49−20

58. *Bunchberries and crowberry, Great Spruce Head Island, Maine, August 2, 1954*
Dye-transfer print
10⁹/₁₆ x 8¹/₈ in.
54−205

59. *Spruce trees in fog and hawkweed, Great Spruce Head Island, Maine, July 4, 1964*
Dye-transfer print
8¹/₈ x 10⁵/₁₆ in.
64−676

60. *Chickweed, Great Spruce Head Island, Maine, June 25, 1981*
Dye-transfer print
10¹/₈ x 8¹/₈ in.
81−52

61. *White house with two locust trees, near Castine, Maine, June 28, 1978*
Dye-transfer print
8⁵/₁₆ x 10⁷/₁₆ in.
78−196

62. *Erratic boulders and roses, Chain Links, Maine, June 19, 1982*
Dye-transfer print
10³/₁₆ x 8¹/₈ in.
82−15

63. *Lobster pot buoys, Eaton Cove, Maine, August 17, 1974*
Dye-transfer print
8 x 10½ in.
74−341

64. *Houses and harbor, Stonington, Maine, August 27, 1974*
Dye-transfer print
7¹⁵/₁₆ x 10½ in.
74−403

65. *Rose petals on beach, Great Spruce Head Island, Maine, July 1, 1971*
Dye-transfer print
7⁷/₈ x 10⁷/₁₆ in.
71−276

66. *Gravel sea wall, Schoodic Point, Maine, August 17, 1974*
Dye-transfer print
7¹⁵/₁₆ x 10½ in.
74−337

67. *Moss, waterfall, cinders, near Mt. Hekla, Iceland, June 26, 1972*
Dye-transfer print
10⁵/₈ x 8¹/₁₆ in.
72−81

68. *Abandoned farm, south coast, Iceland, 1972*
Dye-transfer print
8¹/₁₆ x 10⁵/₈ in.
72−336

69. *Tarn with cotton grass, Fjordharheidhi, Iceland, July 29, 1972*
Dye-transfer print
8 x 10⁵/₈ in.
72−287

70. *Flowering heath and round stones, south coast, Iceland, July 31, 1972*
Dye-transfer print
10½ x 8¹/₈ in.
72−314

71. *Almond trees and wall, Lato, Crete, March 27, 1971*
Dye-transfer print
10¼ x 7¹⁵/₁₆ in.
71−113

72. *Lichens on Ionic capital, Temple of Aphrodisios, Turkey, April 5, 1971*
Dye-transfer print
9¹⁵/₁₆ x 7¾ in.
71−198

73. *Sounion, Greece, March 7, 1970*
Dye-transfer print
10⁵/₁₆ x 7⁷/₈ in.
70−259

74. *Propylaea, Acropolis, Athens, Greece, 1970*
Dye-transfer print
10 x 7⅞ in.
70–247

75. *Columns in hypostyle, Temple of Amen, Karnak, Luxor, Egypt, January 25, 1973*
Dye-transfer print
10½ x 8⅛ in.
73–66

76. *Temple of Yu the Great, Shaoxing, China, July 15, 1980*
Dye-transfer print
7¹³⁄₁₆ x 10¼ in.
80–169

77. *Confucius graveyard, Qufu, China, 1980*
Dye-transfer print
7⅞ x 10¼ in.
80–29

78. *Old moat, Confucius graveyard, Qufu, China, 1980*
Dye-transfer print
10⅛ x 8⅛ in.
80–41

79. *Lotus blossoms and azolla, West Lake, Hangzhou, Zhejiang, China, 1980*
Dye-transfer print
8⅛ x 10³⁄₁₆ in.
80–156

80. *Uygur girls, Turfan, China, 1981*
Dye-transfer print
12½ x 8⅞ in.
Roll 28, No. 23

81. *Graffiti on wall, Macao, 1985*
Dye-transfer print
13¹⁄₁₆ x 8¹⁵⁄₁₆ in.
Roll 16, No. 36

82. *Plastered wall, Macao, 1980*
Dye-transfer print
13 x 8⅞ in.
Roll 56, No. 30

83. *Boy with birds, Morelia, Mexico, 1956*
Dye-transfer print
10¹³⁄₁₆ x 7⁵⁄₁₆ in.
Roll 19, No. 13

84. *Orange wreath, Church of Xochel, Yucatán, Mexico, 1956*
Dye-transfer print
9¹⁵⁄₁₆ x 7⅛ in.
Roll 27, No. 22

85. *Volcanic peak, Baja California, 1966*
Dye-transfer print
8¹⁄₁₆ x 10½ in.
66–3067

86. *Elephant trees on hillside, near Rosarito, Baja California, August 6, 1966*
Dye-transfer print
8⅛ x 10⁷⁄₁₆ in.
66–3025

87. *Bartolomé Island, Galápagos Islands, 1966*
Dye-transfer print
10⁷⁄₁₆ x 8¹⁄₁₆ in.
66–45

88. *Dead mangrove and lava, Espinosa Point, Galápagos Islands, April 7, 1966*
Dye-transfer print
10½ x 8 in.
66–179

89. *Pinnacle rock, Buccaneer Cove, Galápagos Islands, May 10, 1966*
Dye-transfer print
10⁵⁄₁₆ x 8⅛ in.
66–354

90. *Yellow-bark acacias, Ngorongoro Crater, Tanzania, July 15, 1970*
Dye-transfer print
10⁹⁄₁₆ x 8⅛ in.
70–811

91. *Cabbage groundsel and grass, Mt. Kenya, Kenya, February 12, 1970*
Dye-transfer print
10½ x 8³⁄₁₆ in.
70–10

92. *Giant lobelia seedling, Upper Teleki Valley, Mt. Kenya, Kenya, February 14, 1970*
Dye-transfer print
10½ x 8⅛ in.
70–45

93. *Strangler fig roots, Everglades National Park, Florida, March 7, 1954*
Dye-transfer print
10¾ x 8⁷⁄₁₆ in.
54–49

94. *Clouds from rim, Alcedo Volcano, Galápagos Islands, May 4, 1966*
Dye-transfer print
12³⁄₁₆ x 15¾ in.
66–298

95. *View from Monastery Nunatak, dry valleys, Antarctica,*
December 31, 1975
Dye-transfer print
12⁵⁄₁₆ x 15¾ in.
75-997

96. *View down Beacon Valley, Antarctica, December 28, 1975*
Dye-transfer print
12¼ x 15⅝ in.
75-985

97. *The Labyrinth, Wright Valley, Antarctica, January 1976*
Dye-transfer print
13¹⁄₁₆ x 8¾ in.
Roll 21, No. 14

98. *Couverville Island, Antarctica, January 1975*
Dye-transfer print
8¹¹⁄₁₆ x 13 in.
Roll 32, No. 16

99. *Crabeater seal, Palmer Station, Antarctica, 1976*
Dye-transfer print
6¹⁵⁄₁₆ x 10⁷⁄₁₆ in.
Roll 76, No. 37

100. *Sponge raised by anchor ice, Black Island, McMurdo Sound,*
Antarctica, December 17, 1975
Dye-transfer print
10⁹⁄₁₆ x 8¹⁄₁₆ in.
75-901

101. *Evening reflections on sea, Schollaert Channel, Antarctica, 1976*
Dye-transfer print
9¾ x 10¹⁵⁄₁₆ in.
76-548

102. *Sunset clouds, Tesuque, New Mexico, Summer 1960*
Dye-transfer print
8⅝ x 8½ in.
60-506

103. *Clouds, Chiricahua Mountains, Arizona, 1959*
Dye-transfer print
8⁷⁄₁₆ x 8⅜ in.
59-45

104. *Sangre de Cristo Mountains at sunset, Tesuque, New Mexico,*
July 1958
Dye-transfer print
8⅝ x 8⁷⁄₁₆ in.
58-406

105. *Cloud formations and moon after sunset, Tesuque, New Mexico,*
July 1958
Dye-transfer print
8½ x 8⁵⁄₁₆ in.
58-416

106. *Sunrise clouds, Waterpocket Fold, Utah, August 20, 1963*
Dye-transfer print
8⁹⁄₁₆ x 8½ in.
63-414

107. *Clouds, Waterpocket Fold, Utah, August 1963*
Dye-transfer print
8¼ x 8½ in.
63-396

108. *Brown stones with red lichen, near San Ignacio, Baja California,*
August 10, 1966
Dye-transfer print
10½ x 8⅛ in.
66-3055

109. *Pyroclastic lavas, Hítardalur, Snaefellsnes, Iceland, July 10, 1972*
Dye-transfer print
10½ x 8⅛ in.
72-176

110. *Hard inclusions in sandstone, Gray's Arch Trail, Red River Gorge,*
Kentucky, April 18, 1968
Dye-transfer print
10⅜ x 8⅛ in.
68-166

111. *Blue vitrified lava, Craters of the Moon, Idaho, July 2, 1975*
Dye-transfer print
10½ x 8¹⁄₁₆ in.
75-374

112. *Lichens on brown rock, Sugar Loaf, Barred Islands, Maine,*
June 23, 1969
Dye-transfer print
10½ x 8¼ in.
69-295

113. *Glacier-scratched rock, Great Spruce Head Island, Maine,*
July 21, 1971
Dye-transfer print
10⁹⁄₁₆ x 8 in.
71-318

114. *Gray eroded bentonite, near Hanksville, Utah, August 17, 1963*
Dye-transfer print
10½ x 8¼ in.
63-281

115. *Death Valley, California, 1974*
Dye-transfer print
7¹⁵/₁₆ x 10⁷/₁₆ in.
74–196

116. *Deposits of volcanic ash, Tres Virgenes Canyon, Baja California, March 2, 1964*
Dye-transfer print
10³/₁₆ x 7⅞ in.
64–91

117. *Sandstone boulders near Capitol Reef, Utah, June 16, 1975*
Dye-transfer print
10⅜ x 8⅛ in.
75–293

118. *Red boulders, Muley Tanks, Waterpocket Fold, Utah, August 22, 1963*
Dye-transfer print
8 x 10⁵/₁₆ in.
63–311

119. *Mud cracks and pool, House Rock Canyon, Marble Canyon, Arizona, June 13, 1967*
Dye-transfer print
8⅛ x 10⁷/₁₆ in.
67–480

120. *Storm over Green River, Canyonlands National Park, Utah, April 30, 1973*
Dye-transfer print
10⁷/₁₆ x 8⅛ in.
73–365

121. *Cliff, Moonlight Creek, San Juan River, Utah, May 23, 1962*
Dye-transfer print
12¹⁵/₁₆ x 10⁵/₁₆ in.
62–29

122. *Weeds and burned willows, Olympia Bar, Glen Canyon, Utah, April 8, 1963*
Dye-transfer print
10⁵/₁₆ x 8³/₁₆ in.
63–3

123. *Boulders at foot of Broken Bow Arch, Willow Canyon, Utah, August 11, 1971*
Dye-transfer print
10½ x 8¹/₁₆ in.
71–342

124. *Water-streaked wall, Warm Spring Canyon, Lake Powell, Utah, September 24, 1965*
Dye-transfer print
10³/₁₆ x 7⅞ in.
65–556

125. *Blue reflections, Willow Canyon, Utah, August 12, 1971*
Dye-transfer print
8⅛ x 10⅝ in.
71–348

126. *Green reflections in stream, Moqui Creek, Glen Canyon, Utah, September 2, 1962*
Dye-transfer print
15¹⁵/₁₆ x 12½ in.
62–182

127. *Tamarisk and grass, Glen Canyon, Utah, 1961*
Dye-transfer print
10½ x 15⅜ in.
61–808

128. *Sculptured rock, House Rock Canyon, Marble Canyon, Arizona, June 13, 1967*
Dye-transfer print
10⁷/₁₆ x 8¹/₁₆ in.
67–483

BIBLIOGRAPHY

This bibliography is intended to serve as a selective look at Eliot Porter's career as author and photographer. Nancy Barrett's chronology, partially reproduced in *Intimate Landscapes: Photographs by Eliot Porter* (New York: Metropolitan Museum of Art, 1979), covers Porter's career through 1979 and serves as the basis for this bibliography, revised and enlarged to cover the period through 1986. A complete chronological bibliography is on file at the Amon Carter Museum Library, Fort Worth.

The bibliography is arranged chronologically to show the development of Porter's career as a photographer and writer. Publications by Porter are followed by works illustrated by or about him. An asterisk (*) indicates that a Porter illustration appears in the item cited. All his one-person exhibitions are included, as well as selected group exhibitions. Selected reviews of publications and exhibitions are also included. The portfolio section serves as a record of each portfolio's contents. Dates, numbers, or titles in brackets are ascribed by me based on research in Porter's records and in other museums and libraries.

I would like to extend my thanks to the many librarians and archivists who supplied the most minute details to help complete this bibliography.

Milan R. Hughston
Associate Librarian
Amon Carter Museum

EXHIBITIONS

One-person Exhibitions

February 24 – March 8, 1936
New York. Delphic Studios. *Exhibition of Photographs by Eliot Porter.* 37 prints.

December 29, 1938 – January 18, 1939
New York. An American Place. *Eliot Porter — Exhibition of Photographs.* 29 prints.
REVIEWS: *New York Sun*, December 31, 1938; *New York Times*, January 1, 1939; *Art News* 37 (January 7, 1939): 14.

November 1939
Boston. New England Museum of Natural History. [*Photographs by Eliot Porter*].
REVIEW: *Boston Herald*, November 12, 1939.

November 6 – 25, 1939
Chicago. The Georgia Lingafelt Book Shop. *An Exhibition of Photographs by Eliot Porter.* 29 prints.
REVIEW: *Chicago Tribune*, November 17, 1939.

March 15 – 30, 1940
Santa Fe. Museum of New Mexico. *Exhibition of Photographs by Eliot Porter.* 17 prints.
REVIEW: *Santa Fe New Mexican*, March 16, 1940.

February 23 – March 14, 1942
Chicago. Katherine Kuh Gallery. *Photographs by Eliot Porter.*
REVIEWS: *Chicago Daily News*, February 28, 1942; *Chicago Sun*, February 28, 1942.

May 30 – June 30, 1942
New York. New York Zoological Society. Head and Horns Gallery. [*Photographs by Eliot Porter*]. 80 prints.
REVIEW: *New York Times*, May 31, 1942.

March 9 – April 18, 1943
New York. Museum of Modern Art. *Birds in Color: Flashlight Photographs by Eliot Porter.* Organized and circulated by the Museum of Modern Art to: Chicago. Museum of Natural History (July 28 – October 13, 1943); Boston. Orchestral Hall (October 27 – November 11, 1944). 54 prints.
REVIEWS: *Bulletin of The Museum of Modern Art* 10 (April 1943): 6-7; *New York Times*, March 14, 1943.

October 9 – 23, 1943
Denton, Texas. North Texas State Teacher's College. [*Photographs by Eliot Porter*].

March 1944
New York. National Audubon Society. [*Photographs by Eliot Porter*].

October 4 – 25, 1946
Charlottesville, Va. University of Virginia. *Leaders in Photography: Eliot Porter.* Organized and circulated by the Museum of Modern Art to: Albion, Mich. Albion College (February 7 – 29, 1947); St. Louis. Washington University (April 19 – May 10, 1947); Westerville, Ohio. Otterbein College (November 17 – December 8, 1947); Athens, Ohio. Ohio University (January 1 – 22, 1948); Lakeville, Conn. Hotchkiss School (April 19 – May 10, 1948); Philadelphia. N. W. Ayer & Son (July 1 – August 12, 1948); Utica, N.Y. Munson-Williams-Proctor Institute (October 10 – 31, 1948); New Brunswick, N.J. Rutgers University (October 28 – November 18, 1949). 15 prints.

October 1950
Santa Fe. Art Alliance. [*Photographs by Eliot Porter*]. 30 prints.
REVIEW: *Santa Fe New Mexican*, September 1, 1950.

[December 1950–February 1951]
Boston. Orchestra Hall. *Eliot Porter Exhibition of Bird Photography*. 34 prints.

May 1951
Washington, D.C. Audubon Society. National Museum. [*Photographs by Eliot Porter*].

November–December 1951
Rochester, N.Y. George Eastman House. [*Photographs by Eliot Porter*].
REVIEW: *Rochester Times*, November 30, 1951.

March 17–31, 1952
Santa Fe. Art Alliance. *Eliot Porter Photographs*.
REVIEW: *Santa Fe New Mexican*, March 16, 1952.

May 21–June 10, 1952
Cambridge, Mass. Massachusetts Institute of Technology. [*Exhibition of Color Photographs*]. [57 prints].

October 1–22, 1953
New York. American Museum of Natural History. *Birds in Color: Photographs by Eliot Porter*. Circulated by the Smithsonian Institution Traveling Exhibition Service to: Louisville, Ky. J. B. Speed Art Museum (November 2–30, 1953; Birmingham, Ala. Museum of Art (December 13, 1953–January 10, 1954); Pittsburgh. Carnegie Institute Art Museum (January 24–February 14, 1954); Exeter, N.H. Lamont Art Gallery (March 1–22, 1954); Buffalo. Museum of Science (April 4–25, 1954); Williamstown, Mass. Lawrence Art Museum (May 9–30, 1954); Wheeling, W. Va. Oglebay Institute (June 13–July 18, 1954); Columbus, Ohio. Ohio State Archaeological and Historical Society (September 12–October 10, 1954); Bloomfield Hills, Mich. Cranbrook Institute of Science (October 24–November 15, 1954); Manchester, N.H. Currier Gallery of Art (November 28–December 20, 1954); Attleboro, Mass. Attleboro Museum (January 3–23, 1955); Canton, N.Y. Ellsworth Museum (February 6–28, 1955); Houston. Museum of Natural History (April 17–May 8, 1955); Elizabeth City, N.C. Museum of Natural History (July 1–September 5, 1955); Staten Island, N.Y. Staten Island Museum (February 19–March 11, 1956); Philadelphia. Academy of Natural Sciences (March 25–April 15, 1956); Annapolis, Md. St. John's College Book Store (April 27–May 13, 1956); Huntington, W. Va. Huntington Galleries (June 5–30, 1956); San Diego. Museum of Natural History (June 15–August 18, 1957). 50 prints.

March 21–April 17, 1955
New York. Limelight Gallery. [*Photographs by Eliot Porter*]. 60 prints.
REVIEW: *New York Times*, March 27, 1955.

July 15–August 17, 1958
Santa Fe. Museum of New Mexico. Museum of Fine Arts. [*Photographs by Eliot Porter*].

February 1–10, 1959
Albuquerque. University of New Mexico. [*Photographs by Eliot Porter*]. 36 prints.

August 1–September 8, 1959
Santa Fe. Centerline General Store. *The Seasons: A Photographic Essay*. Organized and circulated by Porter to: Baltimore. Museum of Art ([October] 1959); Kansas City, Mo. Nelson-Atkins Museum of Art (February 6–March 27, 1960). 73 prints.

August 12–October 1, 1960
Rochester, N.Y. George Eastman House. *The Seasons: Color Photographs by Eliot Porter Accompanied by Quotes from Henry David Thoreau*. Organized by George Eastman House and circulated by the Smithsonian Institution Traveling Exhibition Service to: Urbana, Ill. University of Illinois (November 1–23, 1960); Princeton, N.J. [Princeton University Art Museum] (December 6–31, 1960); Manchester, N.H. Currier Gallery of Art (January 15–February 5, 1961); Philadelphia. University of Pennsylvania (February 18–March 12, 1961); Ruston, La. Louisiana Polytechnic Institute (March 24–April 16, 1961); Chicago. University of Illinois (May 1–31, 1961); Oakland, Calif. Oakland Public Museum (September 1–24, 1961); Logan, Utah. Utah State University (October 7–31, 1961); Los Angeles. Great Savings and Loan Association (November 15–December 17, 1961); St. Cloud, Minn. St. Cloud State College (January 21–February 10, 1962); Baltimore. Morgan State College (February 22–March 14, 1962); Lafayette, Ind. Purdue University (March 24–April 15, 1962); Geneseo, N.Y. [State University of New York] (May 1–27, 1962); Oshkosh, Wis. University of Wisconsin (June 8–30, 1962); Athens, Ga. University of Georgia (September 15–October 14, 1962); Washington, D.C. Sierra Club (December 1–31, 1962); Columbus, Ohio. Ohio State University (March 23–April 15, 1963); Bowling Green, Ohio. Bowling Green State University (May 1–26, 1963); Columbia, Mo. University of Missouri (July 15–August 15, 1963); Cleveland. Institute of Art (October 5–27, 1963); Newark, Del. University of Delaware (November 16–December 15, 1963); Allentown, Pa. Muhlenberg College (January 1–26, 1964); Windsor, Conn. Loomis School (February 8–29, 1964); Chicago. Art Institute of Chicago (December 14, 1964–January 26, 1965). 76 prints.
REVIEW: *Image* 9 (June 1960): 102–103.

November 1960
Albuquerque. Sandia Base. [*Photographs by Eliot Porter*]. 40 prints.

March 26–April 25, 1965
San Francisco. M. H. deYoung Memorial Museum. [*Photographs by Eliot Porter*]. 50 prints.
REVIEW: *San Francisco Observer* 1 (April 8, 1965): 10–11.

October 1965
Brunswick, Maine. Bowdoin College Museum of Art. *Maine and the West*. 60 prints.

October 8–10, 1965
Squaw Valley, Calif. *Eyes West: Color; The Third West Coast Conference for Artists and Designers*. [Sponsored by The University of California at Berkeley Extension].

February 1967
> Santa Fe. St. John's College. *Recent Photographs by Eliot Porter.*

August 5 – September 4, 1967
> New York. Time and Life Exhibition Center. Sierra Club. *America's Wilderness: A Heritage to Preserve.*

November 1967
> New York. Sierra Club Gallery. *Eliot Porter Photographs.* REVIEW: *New York Times,* November 12, 1967.

December 11, 1967 – January 14, 1968
> Philadelphia. Art Alliance Gallery. *Eliot Porter Color Photography.*

June 26 – August 30, 1968
> New York. Sierra Club Gallery. *Eliot Porter's Color Photographs of the Galapagos Islands.* 40 prints.

January 7 – February 1, 1969
> San Francisco. Focus Gallery. *Eliot Porter Color Photographs: Thirty-Five Unpublished Pictures of Baja California and the Galapagos Islands.* 50 prints.

[February] 1969
> Milwaukee. Public Museum. *Broadleaf Deciduous Installation Exhibit.* 20 prints, permanent display.

December 26 – 31, 1969
> Medford, Mass. Tufts University. [*Photographs by Eliot Porter*].

January 4 – 30, 1970
> Las Vegas, N. Mex. New Mexico Highlands University. [*Photographs by Eliot Porter*]. 56 prints.

February 7 – March 7, 1970
> Phoenix. Phoenix College. [*Photographs by Eliot Porter*]. 57 prints.

March 15 – April 15, 1970
> St. Petersburg, Fla. Museum of Fine Arts. *Eliot Porter: Nature's Photographer.* 75 prints.

October 1970
> Asheville, N.C. Asheville Art Museum. [*Photographs by Eliot Porter*]. 40 prints.

February 3 – 28, 1971
> Princeton, N.J. Princeton University Art Museum. *Photographs by Eliot Porter.*

May 13 – June 13, 1971
> Milwaukee. Bathhouse Gallery. [*Photographs by Eliot Porter*]. 35 prints.

September 30 – October 24, 1971
> New York. Neikrug Galleries. *Dye Transfer Photographs by Dr. Eliot Porter.* 30 prints. REVIEWS: *Village Voice,* October 21, 1971; *New York Times,* October 17, 1971.

December 4 – 19, 1971
> Santa Fe. St. John's College. *Eliot Porter Photographs of Classical Greece and Asia Minor.* 36 prints.

February 25 – March 12, 1972
> Middletown, Conn. Wesleyan University. Davison Art Center. *Eliot Porter — Eastern Pictures.*

September 5 – October 15, 1972
> Birmingham, Mich. 831 Gallery. [*Photographs by Eliot Porter*].

November 1972
> Logan, Utah. Utah State University. [*Photographs by Eliot Porter*].

March – May 1973
> Boston. Museum of Science. Washburn Gallery. [*Photographs by Eliot Porter*]. 91 prints.

March 20 – April 15, 1973
> Albuquerque. University of New Mexico Art Museum. *Eliot Porter Retrospective.* Organized by Beaumont Newhall and circulated by the University of New Mexico Art Museum to: Fort Worth. Amon Carter Museum (July 5 – September 4, 1973); Wichita, Kans. Wichita Art Museum (October 7 – November 11, 1973); Roswell, N. Mex. Museum and Art Center (February 24 – April 4, 1974); Los Angeles. Municipal Art Gallery (May 7 – June 9, 1974); San Antonio. Witte Memorial Museum (June 22 – August 8, 1974); Pensacola, Fla. Art Center (March 30 – April 28, 1975). 240 prints. REVIEW: *Albuquerque Journal,* March 18, 1973.

March 13 – 22, 1974
> University Park, Pa. Pennsylvania State University. [*Photographs by Eliot Porter*]. 60 prints.

May 1975
> Boston. Harcus Krakow Rosen Sonnabend Gallery. [*Photographs by Eliot Porter*].

June 3 – July 5, 1975
> Dallas. Afterimage Gallery. [*Photographs by Eliot Porter*]. 36 prints.

February – March 1976
> Salt Lake City. Edison Street Gallery. [*Photographs by Eliot Porter*]. 35 prints.

September 22 – October 20, 1976
> Santa Monica, Calif. Santa Monica College. *Eliot Porter Retrospective.* Circulated by the Western Association of Art Museums Traveling Exhibition Service to: Ashland, Oreg. Southern Oregon State College (November 22 – December 10, 1976); Santa Barbara, Calif. University of California (January 4 – February 6, 1977); Yakima, Wash. Yakima Valley College (April 3 – May 1, 1977); Charlotte, N.C. University of North Carolina (June 19 – July 18, 1977); Great Falls, Mont. Paris Gibson Art Center (August 15 – September 7, 1977); Miles City, Mont. Custer County Art Center (September 15 – October 7, 1977); Butte, Mont. Arts Center (October 15 – November 15, 1977); Idyllwild, Calif. Desert Sun (January 15 – February 15, 1978); Corvallis, Oreg. Oregon State University (March 3 – 24, 1978); Fairbanks, Alaska. Alaska Association for the Arts (April 15 – May 15, 1978). 75 prints.

October 4 – 29, 1976
> Santa Fe. State Capitol, Governor's Gallery. [*Photographs by Eliot Porter*]. 21 prints.

November 12 – December 31, 1976
> Ithaca, N.Y. Stills Photographic Gallery. [*Photographs by Eliot Porter*]. 40 prints.

May 24 – June 18, 1977
> Houston. Cronin Gallery. *Eliot Porter Dye-Transfer Prints.* 50 prints.

March 9–April 9, 1978
South Yarra, Australia. Photographers' Workshop and Gallery. [*Photographs by Eliot Porter*]. 62 prints.

April 1978
Ithaca, N.Y. New York Laboratory of Ornithology. *Dye-Transfer Photographs of Birds by Eliot Porter.* 49 prints.

January 9–February 10, 1979
Birmingham, Mich. Halstead Gallery. *Eliot Porter: Color Dye Transfer Prints.* 54 prints.

January 26–March 10, 1979
Newport Beach, Calif. Susan Spiritus Gallery. [*Dye-Transfer Photographs by Eliot Porter*].
REVIEW: *Artweek*, February 17, 1979, pp. 11–12.

March 14–April 21, 1979
Berkeley, Calif. Cody's Books. [*Photographs by Eliot Porter*]. [45] prints.

[May 19–June 19], 1979
Carlisle, Pa. Dickinson College. Boyd Lee Spahr Library, Special Collections Room. [*Photographs of Antarctica by Eliot Porter*]. 25 prints.

May 29–June 23, 1979
San Francisco. Focus Gallery. *Egypt: Tombs, Temples, Pyramids and Other Ancient Monuments.* [37] prints.

July 15–September 30, 1979
Orono, Maine. University of Maine. Lobby, Hauck Auditorium. *Photographs of Maine by Eliot Porter.* [100] prints.

November 14, 1979–January 20, 1980
New York. Metropolitan Museum of Art. *Intimate Landscapes.* 55 prints.
REVIEWS: *New York Times*, December 16, 1979; *Newsweek* 95 (January 7, 1980): 60–61; *Art News* 79 (March 1980): 179.

November 17–December 29, 1979
New York. Daniel Wolf, Inc. *Eliot Porter: Wildlife.* 46 prints.

January 4–March 2, 1980
Rockland, Maine. William A. Farnsworth Library and Art Museum. *Eliot Porter.* 46 prints.

March 4–May 10, 1980
New Orleans. A Gallery for Fine Photography. *Eliot Porter.* [31] prints.

[May] 1980
St. Louis. Kemp Gallery. [*Photographs by Eliot Porter*]. 21 prints.

December 10, 1980–January 18, 1981
Amarillo, Texas. Art Center. *Eliot Porter: Visual Explorations.* Circulated to: Lubbock, Texas. Texas Tech University. Museum (January 25–February 20, 1981); Oklahoma City. Art Center (February 28–March 29, 1981); Tyler, Texas. Museum of Art (May 9–June 28, 1981); Lufkin, Texas. Arts Center (July 5–30, 1981); Houston. University of Houston. Sarah Campbell Blaffer Gallery (August 23–October 11, 1981); Austin, Texas. Laguna Gloria Art Museum (October 22–December 3, 1981); Dallas. Museum of Natural History (December 15, 1981–February 15, 1982). [50] prints.

May 3–30, 1981
Santa Fe. Santa Fe Gallery of Photography. *The New York of Eliot Porter.* 44 prints.

REVIEWS: *Albuquerque Journal*, May 9, 1981; *Art in America* 69 (December 1981): 153.

October 9–18, 1981
Santa Fe. Sweeney Center. *1981 Festival of the Arts: Eliot Porter Retrospective.* 83 prints.

November 10–December 5, 1981
Baltimore. G. H. Dalsheimer Gallery. *Eliot Porter.* 28 prints.

December 1–20, 1981
Grand Forks, N. Dak. University of North Dakota. Art Galleries. *Eliot Porter: Photographs.*

May 24–July 30, 1982
Santa Fe. School of American Research. *Eliot Porter's Images of China.* [59] prints.
REVIEW: *Albuquerque Journal*, June 20, 1982.

August 17–October 1, 1982
Southwest Harbor, Maine. Wendell Gilley Museum. [*Photographs by Eliot Porter*]. 25 prints.

September 12–October 17, 1982
Cincinnati. Images: A Gallery for Fine Photographs. *Color Photographs by Eliot Porter.* [34] prints.

August 27–September 28, 1982
Santa Fe. Scheinbaum & Russek. *Eliot Porter: Macao.* 30 prints.

January–February 1983
Batavia, Ill. Fermi National Accelerator Laboratory. *Eliot Porter: The Antarctic and Iceland.* 62 prints

[January–May] 1983
Denver. Denver Art Museum. [*Photographs from Intimate Landscapes*]. 55 prints.

March 4–April 4, 1983
Houston. Kauffman Galleries. [*Photographs by Eliot Porter*].

July 8–October 2, 1983
Santa Fe. Museum of New Mexico. Museum of Fine Arts. *Eliot Porter.* 67 prints.

August 9–October 2, 1983
Houston. Museum of Fine Arts. *Eliot Porter: Intimate Landscapes.* Circulated to: Tyler, Texas. Museum of Art (April 19–June 29, 1986); Baton Rouge, La. Louisiana Arts and Science Center (July 14–September 14, 1986); Nashville, Tenn. Cheekwood Fine Arts Center (November 16, 1986–January 4, 1987). 55 prints.
REVIEW: *Houston Post*, August 28, 1983.

October 1983
Baltimore. G. H. Dalsheimer Gallery. [*Photographs of China by Eliot Porter*]. 13 prints.

October 7–November 1983
Carmel, Calif. Photography West Gallery. *Eliot Porter.* 25 prints.

November 1–December 3, 1983
New York. Daniel Wolf, Inc. *Eliot Porter: Color Photographs of China.* 24 prints.

July 1–30, 1984
Arles, France. Musée Réattu. XVe Rencontres Internationales de la Photographie. *Eliot Porter.* 42 prints.

October 6–11, 1984

Salt Lake City. University of Utah. Museum of Natural History. *Eliot Porter.* [12] prints.

December 17, 1984–January 16, 1985

Denver. Ginny Williams/Photographs, Inc. *The Southwest.*

February 4–March 7, 1985

Daytona Beach, Fla. Daytona Beach Community College. Gallery of Fine Arts. *Eliot Porter — Photographs.* 40 prints.

June 29–August 10, 1985

Santa Fe. Scheinbaum & Russek. *The Southwest.*
REVIEW: *Albuquerque Tribune,* July 12, 1985.

July 20–August 4, 1985

Manchester, Vt. Southern Vermont Art Center. *Eliot Furness Porter: Photographs.* 30 prints.

August 4–9, 1985

Santa Fe. College of Santa Fe. Gallery of Fine Arts. *Sante Fe Photography Adventure.* 10 prints.

November 1985

Portland, Oreg. Nature Conservancy, Globe Scope Conference. [*Photographs of Costa Rica by Eliot Porter*]. 13 prints.

December 5, 1985–January 18, 1986

Newport Beach, Calif. Susan Spiritus Gallery. *Eliot Porter's Southwest.* 51 prints.

January 11–March 1986

Albuquerque. Museum of Natural History. *Eliot Porter's Southwest.* 60 prints.

April 22–May 31, 1986

New York. Witkin Gallery. *Eliot Porter: Black and White Photographs of the Southwest.* 24 prints.
REVIEW: *New York Times,* May 16, 1986.

September 11–October 10, 1986

Tulsa, Okla. Tulsa Photography Collective. *Eliot Porter: Landscapes of the American West.* 49 prints.

October 7–November 1986

Santa Fe. Randall Davey Audubon Center. [*Photographs by Eliot Porter*]. 35 prints.

Group Exhibitions

April 13–28, 1938

New York. American Museum of Natural History. Pictorial Photographers of America. *Fifth International Salon of Photography.* [1] print.

May 1–December 31, 1939

New York. American Museum of Natural History. Pictorial Photographers of America. *Sixth International Salon of Photography. Centennial Exhibition of Photography 1839–1939.* 2 prints.

December 1939–January 1940

New York. Museum of Modern Art. *Sixty Photographs.* Checklist in *Bulletin of The Museum of Modern Art* 8 (December 1939–January 1940): 4–7. 1 print.

February 5–18, 1940

Boston. New England Museum of Natural History. *First Annual Boston International Salon of Nature Photography.* 5 prints.

March 6–29, 1940

New York. American Museum of Natural History. Pictorial Photographers of America. *Seventh International Salon of Photography.* 4 prints.

December 1940–January 1941

New York. Museum of Modern Art. *Sixty Photographs.* 1 print.

n.d. [1940]

San Francisco. Museum of Art. *A Pageant of Photography.* [1] print.

October 29, 1941–February 1, 1942

New York. Museum of Modern Art. *Image of Freedom.* 1 print.

May 1–14, 1942

Springfield, Ill. Illinois State Museum. *Illinois Bird Art.*

July 31–August 31, 1944

New York. American Contemporary Art Gallery. *Photography Today.* 4 prints.

January 28–February 28, 1946

Chicago. Natural History Museum. Nature Camera Club of Chicago. *First Chicago International Exhibition of Nature Photography.* 2 prints, won honorable mention.

September 15–October 15, 1946

Los Angeles. County Museum of History, Science, and Art. *Los Angeles International Color Photography Exhibition.* 1 print.

December 16–31, 1946

Santa Fe. Museum of New Mexico. Museum of Fine Arts. *The Camera's Eye.*
REVIEW: "Camera Exhibit at Art Museum Monday." *Santa Fe New Mexican,* December 14, 1946.

March 20–April 1, 1950

London. Central Hall, Westminster. *The Second Country Life International Exhibition of Wildlife Photography.* 13 prints, awarded silver plaque for 8 color prints.

February 1951

Chicago. Museum of Natural History. Nature Camera Club of Chicago. *Sixth Chicago International Exhibition of Nature Photography.* 4 prints. 1 first prize, 3 honorable mention.

December 9, 1951–January 6, 1952

Santa Fe. Museum of New Mexico. Museum of Fine Arts. *5th Exhibition: Graphic Arts in New Mexico.* 2 prints.

February 1–29, 1952

Chicago. Museum of Natural History. Nature Camera Club of Chicago. *Seventh Chicago International Exhibition of Nature Photography.* 4 prints. Won honorable mention.

May 20–September 20, 1952

New York. Museum of Modern Art. *Diogenes with a Camera.* 21 prints.
REVIEW: *New York World-Sun,* May 22, 1952.

June 6–August 31, 1953

Colorado Springs, Colo. Fine Arts Center. *The West.* [10] prints.

n.d. [1955]

Yosemite Valley, Calif. LeConte Lodge. *This Is the American Earth.* Organized by Nancy Newhall and Ansel Adams and circulated by Smithsonian Institution Traveling Exhibition Service to: Boston. Museum of Science (April 1–June 30,

1956); Rochester, N.Y. Museum of Arts and Sciences (August 1 – September 16, 1956); New York. Lenscraft Studios (October 5 – 26, 1956); Urbana, Ill. University of Illinois. Architecture Building (December 12, 1956 – January 3, 1957); Columbia, S.C. University of South Carolina (January 17 – February 10, 1957); East Lansing, Mich. Michigan State University. Art Department (February 24 – March 17, 1957); Birmingham, Mich. Cranbrook Institute of Science (April 1 – 22, 1957); Albany, N.Y. New York State Museum (May 5 – 26, 1957).
> REVIEW: *Modern Photography* 19 (November 1955): 86.

June 17 – July 14, 1956
> Santa Fe. Museum of New Mexico. Museum of Fine Arts. *First New Mexico Photographers Exhibition.* 2 prints. Won 1st and 3rd prizes.

April 4 – May 19, 1957
> New York. Limelight Gallery. *Madonnas and Marketplaces: Mexico in Color.* 83 prints by Porter and Ellen Auerbach.
> REVIEW: *New York Times*, April 14, 1957.

June 15 – August 15, 1957
> Santa Fe. Centerline General Store. *Mexican Baroque Church Art by Eliot Porter and Ellen Auerbach.* 60 prints by Porter and Auerbach.
> REVIEW: *Santa Fe New Mexican*, June 16, 1957.

September 19 – October 31, 1957
> West Berlin, Germany. Kongresshalle. *American Spirit.* Organized by Nancy Newhall and circulated by the United States Information Agency to: Essen, West Germany. Amerika Haus (April 12 – 28, 1958); Munich, West Germany. Amerika-Haus (August 16 – 24, 1958). 5 prints.

n.d. [1957]
> *I Hear America Singing.* Selected by Nancy Newhall and circulated in Europe and the Middle East by the United States Information Agency. 3 prints.

February 1 – 23, 1958
> Chicago. Museum of Natural History. Chicago Nature Camera Club. *Thirteenth Chicago International Exhibition of Nature Photography.* 4 prints. Won honorable mention.

February 17 – March 28, 1958
> Roswell, N. Mex. Roswell Museum and Art Center. *Mexican Church Art.* Prints by Porter and Ellen Auerbach.

[December] 1958
> Santa Fe. Museum of New Mexico. Museum of Fine Arts. *1958 New Mexico Photographers Annual Exhibition.* 1 print.

November 10, 1959 – February 10, 1960
> Rochester, N.Y. George Eastman House. *Photography at Mid-Century.* [2] prints.

November 29 – December 1959
> Santa Fe. Museum of New Mexico. Museum of Fine Arts. *1959 New Mexico Photographers Annual Exhibition.* 4 prints. Won first prize, color category.

May 20 – September 4, 1960
> New York. Metropolitan Museum of Art. *Photography in the Fine Arts II.* [1] print.

February 16 – April 10, 1960
> New York. Museum of Modern Art. *The Sense of Abstraction in Contemporary Photography.* 4 prints.

April 1 – 30, 1961
> Boston. Museum of Fine Arts. *Photography at Mid-Century.* [2] prints.

June 1961
> Minneapolis. Minneapolis Institute of Fine Arts. *Photography in the Fine Arts III.* 2 prints.

January 12 – February 27, 1962
> Sante Fe. Museum of New Mexico. Museum of Fine Arts. *An Exhibition of Photographs: Laura Gilpin, Eliot Porter, Todd Webb.*
> REVIEW: *Sante Fe New Mexican*, January 14, 1962.

January 28 – March 18, 1962
> Lincoln, Mass. DeCordova Museum. *Photography U.S.A. National Invitational Exhibition.*

February 5 – 26, 1963
> Springfield, Mass. George Walter Vincent Smith Art Museum. *Spectrum.* Organized by Nathan Lyons and circulated by the American Federation of Arts to: Emporia, Kans. Kansas State Teachers Collége (March 12 – April 2, 1963); Eugene, Oreg. University of Oregon (April 16 – May 7, 1963); Atlanta. Atlanta Public Library (July 2 – August 2, 1963); Wayne, N.J. Paterson State College (September 20 – October 10, 1963); Urbana, Ill. University of Illinois. Krannert Art Museum (October 25 – November 15, 1963); Pottstown, Pa. Hill School (November 29 – December 10, 1963); Pittsburgh. Carnegie Institute. Art Museum (January 9 – 30, 1964).

May 8 – 29, 1963
> Tucson. Tucson Art Center. *Photographers from the Southwest.* 10 prints.

May 16 – September 30, 1963
> New York. Metropolitan Museum of Art. *Photography in the Fine Arts IV.* 2 prints.

September 24 – November 28, 1963
> New York. Museum of Modern Art. *The Photographer and the American Landscape.* 9 prints.

September – October 1964
> Taos, N. Mex. Manchester Gallery. *Eliot Porter Photographs. Aline Porter Paintings. Stephen Porter Sculpture.*
> REVIEW: *Santa Fe New Mexican*, September 27, 1964.

May 20 – June 16, 1965
> New York. Eastman Kodak Pavilion, World's Fair. *Selections from Photography in the Fine Arts Collection.*

October 13 – November 28, 1965
> New Haven, Conn. Yale University Art Gallery. *Photography in America 1850 – 1965.* 3 prints.

February 22 – March 20, 1966
> Lincoln, Nebr. University of Nebraska. Sheldon Memorial Art Gallery. *American Photography: The Sixties.* 3 prints.

April 15 – May 13, 1966
> Philadelphia. Philadelphia College of Art. *An Exhibition of Work by The John Simon Guggenheim Memorial Foundation Fellows in Photography.* 1 print.

December 14, 1966–February 12, 1967
New York. Museum of Modern Art. *From the McAlpin Collection*. 2 prints.
REVIEW: *New York Times*, December 25, 1966.

December 10, 1967–January 28, 1968
Lincoln, Mass. DeCordova Museum. *Photography U.S.A. '67.*

May 24–September 1, 1968
Philadelphia. Philadelphia Museum of Art. *Selections from the Dorothy Norman Collection.* [1] print.

March 1969
Kansas City, Mo. Nelson-Atkins Museum of Art. Sales and Rental Gallery. [*Photographs Available for Purchase*]. 10 prints.

April 1–June 30, 1969
Cambridge, Mass. Harvard University. Widener Library. [*Harvard Alumni Photographers*].

May 6–June 24, 1969
Waterville, Maine. Colby College Art Museum. [*Photographs by Eliot Porter, Paintings by Fairfield Porter*]. 48 prints.

March 14–September 30, 1970
Osaka, Japan. Expo '70. Universal Eye Gallery, Kodak Pavilion. [*Group Exhibition of Photographs*]. [1] print.

May 9–30, 1971
Minneapolis. University of Minnesota. Bell Museum of Natural History. *First Annual American Natural History Art Show.* 5 prints.

September 29–November 10, 1973
Fullerton, Calif. Muckenthaler Cultural Center. *Through One's Eyes.* Circulated by Western Association of Art Museums Traveling Exhibition Service to: New Castle, Wyo. Butler Gallery (February 1–22, 1974); Lander, Wyo. Fremont County Pioneer Museum (July 29–August 12, 1974); Rock Springs, Wyo. Carnegie Public Library. Fine Arts Center (August 19–30, 1974); Ashland, Oreg. Southern Oregon State College (September 15–October 15, 1974); Dillon, Mont. Western Montana College (November 1–30, 1974); McAllen, Texas. International Museum (February 1–28, 1975); Longview, Wash. Lower Columbia College (March 15–April 15, 1975); Beaumont, Texas. Art Museum (May 15–June 15, 1975); Bowling Green, Ky. Western Kentucky University (September 15–October 19, 1975). 8 prints.

November 13, 1973–February 3, 1974
New York. Metropolitan Museum of Art. *Landscape/Cityscape.* 4 prints.

November 14, 1974–February 16, 1975
New York. International Center of Photography. *The Eye of the Beholder.*

November 20, 1974–January 12, 1975
New York. Whitney Museum of American Art. *Photography in America.* 4 prints.

September 29–October 27, 1975
Wellesley, Mass. Wellesley College Museum. Jewett Art Center. *Color Photography Now.* [17] prints.

November 12, 1975–February 15, 1976
London. Victoria and Albert Museum. *The Land: Twentieth Century Landscape Photographs.* Circulated by the Victoria and Albert Museum to: Edinburgh, Scotland. National

Gallery of Modern Art (March 6–April 11, 1976); Belfast, Northern Ireland. Ulster Museum (April 24–June 6, 1976); Cardiff, Wales. National Museum of Wales (June 19–August 1, 1976). 4 prints.

January 31–February 29, 1976
St. Louis. 59th Street Gallery. *Antarctica.* Circulated by Smithsonian Institution Traveling Exhibition Service to: Blacksburg, Va. Virginia Polytechnic Institute (October 2–31, 1976); Philadelphia. Natural History Museum of the Academy of Natural Sciences (November 20–December 19, 1976); Tulsa, Okla. Philbrook Art Center (January 8–February 6, 1977); Tampa, Fla. Florida Center for the Arts (February 26–March 26, 1977); Orono, Maine. University of Maine (April 15–May 4, 1977); Boston. Boston University. School for the Arts (June 3–July 2, 1977); Flushing, N.Y. Queens Museum (July 22–August 20, 1977); De Kalb, Ill. Northern Illinois University (September 9–October 8, 1977); College Station, Texas. Texas A&M University. Rudder Center Exhibit Hall (November 15–21, 1977); Christchurch, New Zealand. Canterbury Museum (December 17, 1977–January 15, 1978); Los Angeles. California Museum of Science and Industry (February 18–March 19, 1978); Logan, Kans. Hansen Memorial Museum Association (May 27–June 25, 1978); Louisville, Ky. Junior Art Gallery (July 15–August 13, 1978); Fort Dodge, Iowa. Blanden Art Gallery (September 2–October 1, 1978); Columbus, Ohio. Ohio State University. Institute of Polar Studies (October 21–November 19, 1978); Chattanooga, Tenn. Hunter Museum of Art (December 9, 1978–January 7, 1979); Tucson. University of Arizona. Center for Creative Photography (January 27–February 25, 1979). 45 prints, [with 14 paintings by Daniel Lang].

April 1–30, 1976
St. Louis. University of Missouri. Gallery 210. *Aspects of American Photography 1976.* 4 prints.

December 2, 1976–January 3, 1977
Tacoma, Wash. Silver Image Gallery. *Photographs by Eliot Porter and Paul Caponigro.* 40 prints.

May 22–June 4, 1977
Santa Fe. Elaine Horwitch Galleries. *5 Santa Fe Photographers.*
REVIEW: *Santa Fe Reporter*, May 19, 1977.

September 5–October 8, 1977
Bloomington, Ind. Indiana University Art Museum. *Contemporary Color Photography.* 6 prints.

September 9–October 15, 1977
Boulder, Colo. University of Colorado. Fine Arts Department. *The Great West: Real/Ideal.* Circulated by the Smithsonian Institution Traveling Exhibition Service to: New York. International Center of Photography (July 13–September 3, 1978); North Adams, Mass. North Adams State College (September 23–October 22, 1978); Houston. Sharpview Nursing Center (November 11–December 10, 1978); Columbus, Ohio. Gallery of Fine Arts (December 30, 1978–January 28, 1979); Buffalo. Erie Savings Bank (February 17–March 18, 1979); Vermillion, S. Dak. University of South Dakota. W. H. Over Museum (April 7–May 6, 1979); Rochester, N.Y.

Lincoln First Bank (October 20–November 18, 1979); Wichita, Kans. Wichita State University (January 26–February 24, 1980); Wausau, Wis. Woodson Art Museum (March 15–April 3, 1980); Billings, Mont. Yellowstone Art Center (May 3–June 1, 1980); Bowling Green, Ky. Western Kentucky University. Ivan Wilson Center for Fine Arts (June 21–July 20, 1980); Saskatoon, Saskatchewan, Canada. Mendel Art Gallery (August 9–September 7, 1980); Cedar Falls, Iowa. University of Northern Iowa (September 27–October 26, 1980); Rockville, Md. Montgomery College (November 15–December 14, 1980); Havre, Mont. Northern Montana State College (January 10–February 8, 1981); Lubbock, Texas. Texas Tech University. Museum (February 28–March 29, 1981); Wenatchee, Wash. Wenatchee Valley College (April 18–May 17, 1981); Chattanooga, Tenn. Hunter Museum of Art (June 6–July 5, 1981); Wichita Falls, Texas. Museum and Art Center (July 25–August 23, 1981); Ardmore, Okla. Charles E. Goddard Center (September 12–October 11, 1981); Miami, Fla. Miami Dade Community College (October 31–December 6, 1981). 12 prints.

REVIEW: *Denver Post*, April 23, 1978.

May 2–27, 1978
New York. Zabriskie Gallery. *Alfred Stieglitz and "An American Place."*

May 18–July 16, 1978
New York. Metropolitan Museum of Art. *The Art of Seeing: Photographs from the Alfred Stieglitz Collection.* 3 prints.

July 28–October 2, 1978
New York. Museum of Modern Art. *Mirrors and Windows: American Photography Since 1960.* Circulated by the Museum of Modern Art to: Cleveland. Museum of Art (November 13, 1978–January 1, 1979); Minneapolis. Walker Art Center (January 29–March 11, 1979); Louisville, Ky. J. B. Speed Art Museum (April 1–May 15, 1979); San Francisco. Museum of Modern Art (May 29–July 29, 1979); Richmond, Va. Museum of Fine Arts (November 12–December 23, 1979); Milwaukee. Art Center (January 10–March 2, 1980); Paris, France. Musée d'Art Moderne de la Ville de Paris (November 5, 1980–January 4, 1981); Humlebaek, Denmark. Louisiana Museum (January 16–February 27, 1981); Hovikodden, Norway. Sonja Henie-Niels Instad Foundation (March 16–April 20, 1981); Madrid, Spain. Fundacion Juan March (May 22–July 1, 1981); Dublin, Ireland. Trinity College. Douglas Hyde Gallery (September 20–October 1, 1981); Turin, Italy. Mole Antonelliana (November 21, 1981–January 24, 1982). 1 print.

REVIEWS: *New York Times Magazine*, July 23, 1978; *Time* 112 (August 7, 1978): 83–84; *Newsweek* (August 14, 1978): 69–72.

August 12–September 10, 1978
Seattle. Silver Image Gallery. *Andre Kertesz and Eliot Porter.* 65 prints.

September 30–October 28, 1978
Washington, D.C. Sander Gallery. *Mexican Church Interiors: Color Dye-Transfers by Eliot Porter and Ellen Auerbach.*

January 31–[] 1979
Chicago. Art Institute of Chicago. *Discovering America.* 4 prints.

April 1–July 29, 1979
Albuquerque. University of New Mexico. Art Museum. *History of Photography in New Mexico.* Circulated to: Tyler, Texas. Museum of Art (September 15–October 28, 1979); Roswell, N. Mex. Museum of Art (November 18, 1979–January 6, 1980). 2 prints.

April 18–May 20, 1979
Amarillo, Texas. Amarillo Art Center. *Approaches to Photography: A Historical Survey.* 1 print.

June 17–September 16, 1979
Venice, Italy. *Venezia '79/La Fotografia.*

October 17–November 24, 1979
New York. Witkin Gallery. *The Photographic Portfolio: An Exhibition from Limited Editions.* 11 prints.

March 15–May 4, 1980
Chicago. Art Institute of Chicago. *Color Photographs by Marie Cosindas and Eliot Porter.* 96 prints.
REVIEWS: *Chicago Sun-Times*, March 23, 1980; *Chicago Tribune*, April 15, 1980; *American Photographer* 5 (August 1980): 9.

May 23–July 6, 1980
New York. International Center of Photography. *Photography of the Fifties: An American Perspective.* Circulated to: Tucson. University of Arizona. Center for Creative Photography (September 28–November 13, 1980); Minneapolis. Institute of Arts (December 14, 1980–February 28, 1981); Long Beach, Calif. California State University. Art Galleries (March 30–May 3, 1981); Wilmington, Del. Delaware Art Museum (August 7–September 13, 1981). 2 prints.

June 1–August 31, 1980
Lincoln, Mass. DeCordova Museum. *Aspects of the 70's.* 2 prints.

September 12–28, 1980
Cologne, West Germany. Kunsthalle. Photokina. *The Imaginary Photo Museum.* 2 prints.

September 19–October 31, 1980
Oklahoma City. Cowboy Hall of Fame. [*Photographs by Eliot Porter*]. 40 prints.

January 24–February 22, 1981
Houston. University of Houston. Sarah Campbell Blaffer Gallery. *New Mexico Photographers.* 1 print.

January 24–February 20, 1981
Santa Fe. Graphics Santa Fe. *An Exhibition of Dye-Transfer Prints by Eliot Porter, Jim Bones, Peter Vogel.* 16 prints.

February 28–May 17, 1981
Southampton, N.Y. Parrish Art Museum. *Alive at the Parrish.* 1 print.

May 2–July 5, 1981
Oakland, Calif. Oakland Museum. *American Photographers and the National Parks.* Organized and circulated by the National Park Foundation to: Washington, D.C. Corcoran Gallery of Art (September 19–November 15, 1982); New York. New York Public Library (December 7, 1981–February 3, 1982); Chicago. Chicago Historical Society (February 28–April 4, 1982); Fort Worth. Amon Carter Museum (May 27–July 11, 1982); Pittsburgh. Carnegie Institute. Museum of Art

(July 24–September 26, 1982); Minneapolis. Institute of Arts (October 17–December 5, 1982); Denver. Denver Art Museum (January 8–March 6, 1983); Los Angeles. County Museum of Art (April 7–June 26, 1983). 10 prints.

May 14–June 15, 1981
Cambridge, Mass. American Academy of Arts and Sciences. *The Life of the Mind: Focus on the Visual Arts.* 3 prints.

July 5–September 30, 1981
Arles, France. Musée Réattu. XIIe Rencontres Internationales de la Photographie. *Eleven Santa Fe Photographers.* Circulated to: Paris, France. American Center in Paris. Center for Media Art (October 1–31, 1981). [10] prints.

November 1981
New York. Association of International Photography Art Dealers. *Fourteen Photographers from Santa Fe.* 2 prints.

November 3–28, 1981
San Francisco. Focus Gallery. *Master Photographers: A Sentimental Celebration.* 2 prints.

April 5–May 22, 1982
Santa Fe. Scheinbaum & Russek. *Eliot Porter/Paul Caponigro: Maine/New Mexico.* 27 prints.

April 10–June 6, 1982
Washington, D.C. Corcoran Gallery of Art. *Color as Form.* Circulated to: Rochester, N.Y. International Museum of Photography at George Eastman House (July 2–September 5, 1982). 2 prints.

April 24–June 6, 1982
Chicago. Art Institute of Chicago. *A History of Photography from Chicago Collections.* 4 prints.

July 1–September 1982
Santa Fe. Museum of New Mexico. Museum of Fine Arts. *Masterworks on Paper.* 1 print.

July 4–31, 1982
Rockport, Maine. Maine Photographic Workshop. The Workshop Gallery. [*Eliot Porter/Paul Caponigro*]. 30 prints.

October 4–30, 1982
Santa Fe. Santa Fe Center for Photography. *The Second Annual Benefit Show.* 1 print.

December 4, 1982–January 6, 1983
New York. Terry Dintenfass Gallery. *Stieglitz: A Memoir/Biography.* 5 prints.

February 1–28, 1983
Redding, Calif. Redding Museum and Art Center. *Dyed Images: Recent Work in Dye Transfer.* Circulated by the Art Museum Association of America to: Juneau, Alaska. State Museum (April 7–May 1, 1983); Anchorage, Alaska. Visual Arts Center of Alaska (May 7–31, 1983); Fairbanks, Alaska. Alaska Association for the Arts (June 6–30, 1983); Fort Lauderdale, Fla. Museum of Art (September 1–30, 1983); Las Vegas, Nev. Charleston Heights Art Center (October 16–November 11, 1983); El Paso, Texas. Museum of Art (December 1–30, 1983); Tacoma, Wash. University of Puget Sound. Art Department (February 10–22, 1984); Blacksburg, Va. Virginia Polytechnic Institute (March 22–April 19, 1984); Gainesville, Fla. University of Florida (May 6–June 7, 1984); Florida (May 6–June 7, 1984); Oakland, Calif. Kaiser Center

Oakland, Calif. Kaiser Center (June 21–July 19, 1984); Montgomery, Ala. Museum of Art (August 10–September 10, 1984); Des Moines, Iowa. Polk County Heritage Gallery (October 29–November 23, 1984). 8 prints.

January 18–February 7, 1984
Boston. Boston University Art Gallery. *New Work by Photographic Resource Center Major Lecturers.* 15 prints.

May 3–June 10, 1984
Santa Barbara, Calif. Museum of Art. *101 Photographs: Selections from the Steinman Collection.* 2 prints.

September 14–October 14, 1984
Santa Fe. Santuario de Guadalupe. *Arts/New Mexico.* Organized by Arts/New Mexico and circulated to: Washington, D.C. Organization of American States. Museum of Modern Art of Latin America (November 1–30, 1984). 1 print.

October 10–31, 1984
Wilmington, N.C. Front Street Gallery. *The Florida Document.* Organized and circulated by the Southeast Center for Photographic Studies to: Pensacola, Fla. Pensacola Junior College. Visual Arts Gallery (November 15–December 14, 1984); Jensen Beach, Fla. Florida Institute of Technology (January 14–February 22, 1985); Daytona Beach, Fla. Gallery of Fine Arts (March 11–April 5, 1985); Clearwater, Fla. Performing Arts Center and Theatre (May 3–July 11, 1985); North Miami, Fla. Museum and Art Center (July 15–August 2, 1985); Bradenton, Fla. Manatee Junior College (September 16–October 11, 1985); Orlando, Fla. University of Central Florida (October 28–November 22, 1985); Tallahassee, Fla. Society of the Four Arts (December 9, 1985–January 3, 1986); Rochester, N.Y. Rochester Institute of Technology (January 20–February 14, 1986); De Land, Fla. Stetson University. Gallery of Art (March 3–28, 1986); Palatka, Fla. Florida School of the Arts (April 14–May 9, 1986); Fort Myers, Fla. Edison Community College (May 26–June 20, 1986); Cocoa, Fla. Brevard Art Center (July 7–August 1, 1986); Jacksonville, Fla. Florida Junior College at Jacksonville (August 18–September 12, 1986); New Smyrna Beach, Fla. Atlantic Center for the Arts (September 24–October 24, 1986); Spokane, Wash. Spokane Falls Community College (November 16–December 5, 1986). 1 print.

November 15, 1984–January 7, 1985
Bronx, N.Y. Wave Hill. *Flower as Image in 20th-Century Photography.* 2 prints.

November 20–December 29, 1984
Paris, France. Paris Art Center. *Straight Color Photography.* [10] prints.

December 4, 1984–March 17, 1985
New York. Metropolitan Museum of Art. *Photographs from the Museum's Collection.* 1 print.

March 1–14, 1985
Santa Fe. Elaine Horwitch Galleries. *Contemporary Approaches in Photography.* [6] prints.

May 8–June 7, 1985
Ithaca, N.Y. The Upstairs Gallery. *Photographs by Eliot Porter and Sculpture by Stephen Porter.* 20 prints.

June 4–July 13, 1985
> Los Angeles. G. Ray Hawkins Gallery. *Portfolios: Exhibition*.

June 5–26, 1985
> St. Paul, Minn. Film in the Cities. *Eliot Porter and Richard Misrach: Landscape and Color*. 20 prints.

September 12–November 17, 1985
> Santa Fe. Museum of New Mexico. Museum of Fine Arts. *Artist as Subject: The Photographic Portraits of Georgia O'Keeffe*. 1 print.

March 4–May 4, 1986
> New York. Metropolitan Museum of Art. *Advocating Photography: The David Hunter McAlpin Fund*. 4 prints.

April 14–May 18, 1986
> Delaware, Ohio. Ohio Wesleyan University. Humphreys Art Hall. *Looking at the American Land: Contrasting Realities*. 15 prints.

April 26–June 21, 1986
> Ridgefield, Conn. Aldrich Museum of Contemporary Art. *Views & Visions: Recent American Landscape Photography*. 1 print.

June 1, 1986–January 4, 1987
> Santa Fe. Museum of New Mexico. Museum of Fine Arts. *Inspirations: The Churches of New Mexico in Art*. 2 prints.

June 20–August 31, 1986
> Linz, Austria. Stadtmuseum. Polarities, Incorporated. *Imagining Antarctica*. Circulated to: Worcester, Mass. Grove Street Gallery (September 19–October 19, 1986); Old Westbury, N.Y. State University of New York (November–December 1986). 4 prints.

August 30–October 26, 1986
> Hanover, N.H. Dartmouth College. Hood Museum of Art. *In Spite of Everything, Yes*. 6 prints.

October 31–December 14, 1986
> Fort Worth. Amon Carter Museum. *New Landscapes*. 1 print.

November 6–December 13, 1986
> Tokyo, Japan. Photo Gallery International. *Retrospective: Eliot Porter and Beaumont Newhall*. 30 prints.

November 7–December 12, 1986
> Grand Rapids, Mich. Calvin College. Center Art Gallery. *The Expression of Creative Discovery in Contemporary Photography*. 15 prints.

November 14–30, 1986
> Santa Fe. Museum of New Mexico. Museum of Fine Arts. *Beaumont Newhall and Eliot Porter*. [20] prints. REVIEW: *Santa Fe Reporter*, November 12, 1986.

PUBLICATIONS

By Eliot Porter

[Brief statement in checklist of *Exhibition of Photographs by Eliot Porter*, New York, Delphic Studios, 1936].

* "Mushrooms." *U.S. Camera Magazine* no. 1 (January–February 1939): 50. 1 illus.

* "Photographing Birds." *U. S. Camera Magazine* no. 3 (March–April 1939): 18–21. 10 illus.

* "Some Problems of Bird Photography." *New England Naturalist* 5 (December 1939): 5–9. 5 illus.

* "Chemistry, Medicine, Law and Photography: The Autobiography of a Photographer." *U.S. Camera Magazine* no. 8 (February–March 1940): 26–29. 7 illus.

* "Making Bird Studies." *Photo Technique* 2 (March 1940): 7–9. 4 illus.

* "Color Photography of Birds." *Journal of the Biological Photographic Association* 10 (December 1941): 54–62. 3 illus.

* "A Preface to Bird Photography." *American Annual of Photography 1946* 60 (1945): 48–56. 7 illus.

"A Few Words in Appreciation of Alfred Stieglitz." In *Stieglitz Memorial Portfolio, 1864–1946*, edited by Dorothy S. Norman. New York: Twice A Year Press, 1947, pp. 35–36.

"On Bird Photography." *Concert Bulletin of The Boston Symphony Orchestra, Seventieth Season, 1950–1951*, pp. 263–264.

* "Photographing Birds — In Color." *U.S. Camera* 17 (July 1954): 50–53. 5 illus.

* "Color Camera Afield." *U.S. Camera* 18 (June 1955): 68–71. 4 illus.

* "The Rare Photograph." *U.S. Camera* 19 (November 1956): 69. 1 illus.

* "Arctic Tern." *Pacific Discovery* 16 (September–October 1963): 16–17. 1 illus.

"Save the Land." *St. Louis Post-Dispatch*, December 1, 1963.

The Place No One Knew: Glen Canyon on the Colorado. San Francisco: Sierra Club, 1963. 72 illus.
> REVIEWS: *New York Times Book Review*, June 9, 1963; *Christian Science Monitor*, July 11, 1963; *Natural History* 73 (February 1964): 7; *Utah Historical Quarterly* 32 (Spring 1964): 169–171; *Atlantic* 213 (May 1964): 134; *Aperture* 11, no. 2 (1964): 82–83.

* "An Explanation." *Harvard Medical Alumni Bulletin* 39 (Spring 1965): 20–25. 3 illus.

* "Summers in Penobscot Country." *Natural History* 75 (August–September 1966): 34–43. 8 illus.

* *Forever Wild: The Adirondacks*. Blue Mountain Lake, N.Y., and New York: The Adirondack Museum and Harper & Row, 1966. 80 illus.
> REVIEWS: *Albuquerque Tribune*, December 10, 1966; *Popular Photography* 61 (December 1967): 146–147.

* *Summer Island: Penobscot Country*. San Francisco: Sierra Club, 1966. 96 illus.
> REVIEWS: *Christian Science Monitor*, December 1, 1966; *New York Times Book Review*, December 4, 1966; *New York Times*, July 23, 1967.

"The Artist and Nature." In *Man in Nature and the Nature of Man*. Program of Fifth Combined Plan Conference. New York: Columbia University School of Engineering and Applied Science, 1967.

* "The Red River Gorge — One Final Look: A Portfolio of Photographs by Eliot Porter." *Audubon* 70 (September 1968): 58–70. 17 illus.

* *Galapagos: The Flow of Wildness*. 2 vols. San Francisco: Sierra Club, 1968. 138 illus.
> REVIEWS: *Times Literary Supplement*, December 19, 1968;

Natural History 78 (January 1969): 62; *Scientific American* 220 (February 1969): 130; *Audubon* 71 (May 1969): 91.

* "Wings." *Audubon* 71 (May 1969): 57. 1 illus.

"Lament for a Lost Eden." *American Heritage* 20 (October 1969): 60–61.

* "The Colorado's Canyons Today." *Audubon* 71 (November 1969): 77–79. 1 illus.

* "To Conserve Our Natural Heritage for the Good of Mankind." *Harvard Medical Alumni Bulletin* 44 (March–April 1970): 6–12. 4 illus.

* *Appalachian Wilderness: The Great Smoky Mountains.* New York: E. P. Dutton and Company, 1970. 45 illus.
 R E V I E W S : *New York Times Book Review*, December 6, 1970.

"On Bird Photography." *Audubon* 74 (May 1972): 29.

* *Birds of North America: A Personal Selection.* New York: E. P. Dutton and Company, 1972. 75 illus.

"The Greater Crime: Gullible Legislators." *New York Times*, November 24, 1973.

* "Birds of Summer Island." In *This Good Earth: The View from Audubon Magazine*, edited by Les Line. New York: Crown, 1974, pp. 114–123. 7 illus.

"Nature Photography." *Bulletin of The New England Camera Club Council* 34 (Fall 1977): 5–6.

* *Moments of Discovery: Adventures with American Birds.* New York: E. P. Dutton and Company, 1977. 64 illus.
 R E V I E W S : *Santa Fe New Mexican*, October 30, 1977; *New York Times Book Review*, January 15, 1978; *Field & Stream* 82 (January 1978): 88.

"Nature Photography." *Bulletin of The New England Camera Club Council* 34 (Winter 1978): 5.

"Nature Photography." *Bulletin of The New England Camera Club Council* 34 (Spring 1978): 16.

* "Denizens of an Upland Pasture." *Blair and Ketchum's Country Journal* 5 (August 1978): 51–55. 4 illus.

* *Antarctica.* New York: E. P. Dutton and Company, 1978. 87 illus.
 R E V I E W S : *New York Times Book Review*, December 3, 1978; *Newsweek* 92 (December 11, 1978): 95; *Field & Stream* 83 (December 1978): 54; *Economist* 270 (February 3, 1979): 98; *Modern Photography* 45 (July 1981): 32.

* *Intimate Landscapes: Photographs by Eliot Porter.* New York: Metropolitan Museum of Art, 1979. 55 illus.
 R E V I E W S : *New York Times Book Review*, November 25, 1979; *Christian Science Monitor*, December 3, 1979; *Popular Photography* 87 (October 1980): 201; *Art in America* 69 (December 1981): 31.

* "[Statement]." In *Landscape: Theory.* New York: Lustrum Press, 1980, pp. 113–127. 9 illus.

* "Portfolio: Nature in Focus." *Dialogue* 53 (1981): 42–47. 6 illus.

* "Photographer's Perspective." In *Let's Save Antarctica!*, by James N. Barnes. Richmond, Australia: Greenhouse Publications, 1982, p. [5]. 22 illus.

* *All Under Heaven: The Chinese World.* Text by Jonathan Porter. New York: Pantheon Books, 1983. 127 illus.
 R E V I E W S : *Natural History* 92 (November 1983): 100–104; *Modern Photography* 48 (February 1984): 40–42.

"Letters: The State Should Not Kill." *Santa Fe New Mexican*, March 11, 1984.

"My Brother Fairfield." In *Fairfield Porter*, Exhibition catalogue, Arts Club of Chicago, 1984.

* *Eliot Porter's Southwest.* New York: Holt, Rinehart and Winston, 1985. 90 illus.
 R E V I E W S : *Santa Fe New Mexican*, November 14, 1985; *New York Times Book Review*, December 8, 1985; *American Photographer* 16 (April 1986): 71.

* *Maine.* Boston: New York Graphic Society, 1986. 86 illus.

Illustrated by Eliot Porter

* "Nestling Birds." *Life* 14 (May 17, 1943): 58–62. 8 illus.

* Murphy, Robert C., and Dean Amadon. *Land Birds of America.* New York: McGraw-Hill Book Co., 1953. 104 illus.

* Rand, Austin L. *American Water and Game Birds.* New York: E. P. Dutton and Company, 1956. 7 illus.

* Sherman, Charles L., ed. *Nature's Wonders in Full Color.* Garden City, New York: Hanover House, 1956. 28 illus.

* Peattie, Donald C. "Our Tribes of Birds." *Holiday* 24 (July 1958): 60–67. 5 illus.

* Gilliard, E. Thomas. *Living Birds of the World.* Garden City, New York: Hanover House, 1958. 35 illus.

* Newberry, Cyril. *The Beauty of Birds.* Garden City, New York: Hanover House, 1958. 5 illus.

* Klots, Alexander, and Elsie Klots. *Living Insects of the World.* New York: Doubleday and Co., 1959. 7 illus.

* Sanderson, Ivan T. *The Continent We Live On.* London: Hamish Hamilton, 1959. 21 illus.

* "*In Wildness Is the Preservation of the World,*" from Henry David Thoreau. San Francisco: Sierra Club, 1962. 72 illus.
 R E V I E W S : *Christian Science Monitor*, November 29, 1962; *Natural History* 72 (May 1963): 7; *Aperture* 11, no. 2 (1964): 82–83.

* Phillips, Allan, Joe Marshall, and Gale Monson. *The Birds of Arizona.* Tucson: University of Arizona Press, 1964. 51 illus.

* Wetmore, Alexander. *Song and Garden Birds of North America.* Washington, D.C.: National Geographic Society, 1964. 77 illus.

* "Mirroring the Magic of Old Mexico." *New York Times*, May 9, 1965. 5 illus.

* Wetmore, Alexander. *Water, Prey, and Game Birds of North America.* Washington, D.C.: National Geographic Society, 1965. 10 illus.

* Krutch, Joseph Wood. *Baja California and the Geography of Hope.* San Francisco: Sierra Club, 1967. 73 illus.

* Munroe, Joe. "For All the Generations: The Sierra Club." *Infinity* 16 (September 1967): 8. 7 illus.

* "The Geography of Hope: Baja California." *American West* 5 (January 1968): 38–48. 6 illus.

* Eichler, Arturo. "A Tolerable Planet." *Americas* 20 (November–December 1968): 30. 5 illus.

* "The Enchanted Islands: Selections from Loren Eiseley, Herman Melville, Charles Darwin and Others. Photographs by Eliot Porter." *Americas* 21 (March 1969): 20–29. 12 illus.

* "*Down the Colorado* by John Wesley Powell with Text and Photographs by Eliot Porter." *American Heritage* 20 (October 1969): 52–60. 7 illus.
* "Powell's River: A Colorado Portfolio by Eliot Porter." *Audubon* 71 (November 1969): 64–76. 12 illus.
* Powell, John Wesley. *Down the Colorado: Diary of the First Trip Through the Grand Canyon, 1869.* New York and London: E. P. Dutton and Company and Allen and Unwin, 1969. 44 illus.
* Worth, C. Brooke. "The Last Days of Polyphemus." *Audubon* 72 (March 1970): 22–30. 19 illus.
* "Smokies Spring: A Portfolio by Eliot Porter." *Audubon* 72 (May 1970): 32–39. 9 illus.
* "The Birds of Summer Island: A Portfolio by Eliot Porter." *Audubon* 74 (May 1972): 20–28. 10 illus.
* Matthiessen, Peter, and Eliot Porter. *The Tree Where Man Was Born.* New York and London: E. P. Dutton and Collins, 1972. 92 illus.
 REVIEWS: *New York Times*, October 17, 1972; *Santa Fe New Mexican*, October 22, 1972; *New York Times*, November 26, 1972; *Atlantic* 230 (November 1972): 125–126; *Natural History* 81 (December 1972): 92–97; *New York Review of Books* 19 (January 25, 1973): 19; *Christian Science Monitor*, April 18, 1973.
* "Great Caldron Mountains: Essay by Peter Matthiessen, Photographs by Eliot Porter." *Audubon* 74 (November 1972): 4–21. 8 illus.
* Matthiessen, Peter. "African Profile: I; Under the Great Sky." *Reader's Digest* 102 (January 1973): 197–209. 16 illus.
* "Rocks, Shells and Birds: Maine Island Photographs by Eliot Porter." In *The Wild Places: A Photographic Celebration of Unspoiled America.* New York: Harper & Row, 1973, pp. 117–121. 5 illus.
* Speight, Carol. "Mountain Greening: Spring Comes to Carolina Hills." *South Carolina Wildlife* 21 (March–April 1974): 20–33. 8 illus.
* Soucie, Gary. "Congaree: Great Trees or Coffee Tables?" *Audubon* 77 (July 1975): 60–80. 9 illus.
* "Eliot Porter: Smokies Portfolio." *Living Wilderness* 39 (October–December 1975): 20–28. 9 illus.
* "Icelandic Landscape." *Living Wilderness* 40 (July–September 1976): 22–35. 12 illus.
* "Moments of Discovery: Adventures with American Birds—A Collection of Color Photographs." *Bulletin of The New England Camera Club Council* 34 (Spring 1978): 8–9.
* "Cold Splendor of Antarctica: A Color Portfolio by Eliot Porter." *Life* n.s.1 (October 1978): 96–106. 9 illus.
* Davies, Brian. *Seal Song.* New York: Viking Press, 1978. 32 illus.
 REVIEW: *Atlantic Monthly* 242 (December 1978): 99.
* "Schatzsuche am Ende der Welt." *Bunte* no. 5 (January 1979): 58–69. 6 illus.
* "Eliot Porter: Images of Antarctica." *Living Wilderness* 43 (June 1979): 22–31. 10 illus.
* Morris, John G. "Keys to the Wilderness." *Quest* 3 (October 1979): 44–50. 6 illus.
* Rosen, Eric. "White Continent." *Omni* 2 (December 1979): 60–65. 7 illus.

* "Eliot Porter: A Special Portfolio of Maine Photographs by a Modern Master, Adapted from *Summer Island.*" *Down East* 27 (August 1980): 72–81. 7 illus.
* Levi, Peter. *The Greek World.* New York: E. P. Dutton, 1980. 83 illus.
 REVIEWS: *British Journal of Photography* 128 (October 2, 1981): 1021; *New York Review of Books* 28 (October 8, 1981): 39; *New York Times*, November 30, 1980; *Art in America* 69 (December 1981): 31.
* Stegner, Wallace, and Page Stegner. *American Places.* New York: E. P. Dutton, 1981. 89 illus.
* Barnes, James N. *Let's Save Antarctica!* Richmond, Australia: Greenhouse Publications, 1982. 22 illus.
* "[Excerpts from *All Under Heaven*]." *Nikon World* 16 (Fall 1983): 3–9. 6 illus.
* Porter, Jonathan. "China's Landscape: Image of Her Culture." *Asia* 6 (November–December 1983): 32–37. 7 illus.
* King, S. K. "Focus New Mexico." *New Mexico Magazine* 63 (March 1984): 20. 5 illus.
* Roth, Evelyn. "Eliot Porter: Searching for the Essence of Oriental Spirituality." *American Photographer* 12 (May 1984): 52–59. 5 illus.
* Tallent, Elizabeth. "Gardens: Ancient Acres." *Architectural Digest* 42 (September 1985): 168–175, 232–233. 10 illus.
* "Eliot Porter: New Mexico in Black and White." *New Mexico Magazine* 64 (March 1986): 40–51. 11 illus.
* Detjen, Jim. "Living on the Bottom of the Earth." [Philadelphia] *Inquirer* magazine, June 22, 1986. 8 illus.

About Eliot Porter

* *U.S. Camera* no. 1 (Autumn 1938): 2. 1 illus., p. 11.
Stieglitz, Alfred. "Eliot Porter . . ." In checklist of exhibition at An American Place, 1938–1939.
* Norman, Dorothy. "Jonathan." *Twice a Year* 2 (Spring–Summer 1939): 5–6. 1 illus.
McKittrick, Margaret. "Santa Fe Camera Angles." *Santa Fe New Mexican*, February 17, 1940.
"Photographers Hear Talk on Bird Pictures." *Santa Fe New Mexican*, May 2, 1940.
"Guggenheim Award Won by 4 Illinoisans." *Chicago Daily News*, March 24, 1941.
* "Photographer at Large." *Audubon* 48 (January–February 1946): 58–59. 1 illus.
Porter, Fairfield. "Eliot Porter." *The Nation* 190 (January 1960): 39–40.
* Elkort, Martin. "New Mexico's Tiny Jungle World: Brilliant Nature Color Photo Portfolio by Eliot Porter." *New Mexico Magazine* 38 (February 1960): 18–23. 10 illus.
* Bright, Robert. "About the Arts." *Santa Fe New Mexican*, October 22, 1961. 1 illus.
* Caulfield, Patricia. "Eliot Porter." *Modern Photography* 28 (February 1964): 52–57, 92. 3 illus.
Caulfield, Patricia. "Return to the Classic Scene." *Modern Photography* 30 (October 1966): 54.

* MacGregor, John. "Eliot Porter Captures Nature's Poetry on Color Film." *Santa Fe New Mexican*, December 18, 1966. 4 illus.

* Caulfield, Patricia. "Eliot Porter: How He Works." *Modern Photography* 31 (September 1967): 66–69. 2 illus.

Hundertmark, C. A. "N. M. Man Trained as Doctor Now a Noted Photographer." *Albuquerque Tribune*, November 24, 1967.

* Caulfield, Patricia. "The Art and Technique of Eliot Porter: An Interview." *Natural History* 76 (December 1967): 26–31, 92–94. 5 illus.

Deschin, Jacob. "Eliot Porter: Medication to Conservation." *Popular Photography* 61 (December 1967): 70.

* Cox, Peter W. "Photography: Eliot Porter's Vision." [Topsham] *Maine Times*, December 13, 1968. 2 illus.

"Porter Brothers Among Those Honored at Colby." [Waterville, Maine] *Morning Sentinel*, June 2, 1969.

Dunning, Bill. "Eliot Porter Home Between Safaris." *Santa Fe New Mexican*, September 7, 1969.

"Outstanding-Son-of-Maine Award Goes to Dr. Eliot Porter at Dinner Here." *Bangor Daily News*, October 23, 1969.

* Adams, Ansel. "Eliot Porter, Master of Nature's Color." *Modern Photography* 33 (October 1969): 92–97. 3 illus.

Webster, Bayard. "Eliot Porter Finds Battle for Wilderness Endless." *New York Times*, November 16, 1969.

"Porter, Eliot (Furness)." *Contemporary Authors*, vols. 5–8. Detroit: Gale Research Co., 1969, pp. 906–907.

* Marshall, Patricia. "He Teaches Birds." *Ameryka* 133 (February 1970): 29. 2 illus.

* Weiss, Margaret. "Eliot Porter: Conservationist with a Camera." *Saturday Review* 54 (October 2, 1971): 58–59. 3 illus.

* "A Quest for Beauty." *Art and Man* 2 (January 1972): 12. 1 illus.

Crawford, James. "Noted Bird Photographer Urges Ecological Stability." *Rocky Mountain News*, March 2, 1972.

Macrae, John, III. "Peter Matthiessen and Eliot Porter." *Book-of-the-Month Club News* (October 1972): 5.

Orent, Joel. "Dr. Eliot Porter, Santa Fe, New Mexico." *New England Sierran* 3 (October 1972): n.p.

* "Reflections in Nature: Eliot Porter [on] How to Capture Light and Color in Wilderness Photography." *Backpacker* 1 (Summer 1973): 52–55. 4 illus.

* "Eliot Porter." *Camera* 53 (June 1974): 14–23. 9 illus.

Kozloff, Max. "Photography: The Coming to Age of Color." *Artforum* 13 (January 1975): 30–35.

* "Eliot Porter." *Camera* 54 (November 1975): 39. 1 illus.

"Santa Feans Selected for Arts Awards." *Santa Fe New Mexican*, September 12, 1976.

"Porter, Eliot (Furness)." *Current Biography* 37 (November 1976): 20–22.

Garland, Bill. "Eliot Porter . . . Poet with a Camera." *Santa Fe New Mexican*, December 19, 1976.

Beerer, Pamela. "Eliot Porter: His Photography Style 'Simply Is.'" *Albuquerque Journal*, June 19, 1977.

* Caulfield, Patricia. "Eliot Porter on 35mm: An Interview with Patricia Caulfield." *Popular Photography* 81 (September 1977): 108. 9 illus.

* Hendrickson, Paul. "Giving Nature His Best Shot: Photographer Eliot Porter Captures the Moment." *Los Angeles Times*, October 21, 1977. 4 illus.

* Landman, Jonathan. "Eliot Porter: In Wildness Is the Preservation of the World." *Senior Scholastic* 110 (December 1, 1977): 2–5. 3 illus.

Hill, Paul, and Tom Cooper. "*Camera* Interview: Eliot Porter." *Camera* 57 (January 1978): 33–37.

Otte, Ed. "Eliot Porter: 'Riding the Crest of the Wave.'" *Santa Fe New Mexican*, October 15, 1978.

* "Eliot Porter." *New Mexico Craft* 1 (Winter 1978/1979): 14–20. 5 illus.

* Naef, Weston J. "Eliot Porter." In *The Collection of Alfred Stieglitz: Fifty Pioneers of Modern Photography*. New York: Metropolitan Museum of Art and The Viking Press, 1978, pp. 242–250. 2 illus.

Deane, James G. "After Word." *Living Wilderness* 43 (June 1979): 47.

* Raether, Keith. "Eliot Porter: Preserving His Vision of the World." *Albuquerque Tribune*, October 10, 1979. 1 illus.

* Neary, John. "For Master Photographer Eliot Porter, Nature Is His Art and His Life." *People* 12 (December 10, 1979): 67–71. 1 illus.

* Coke, Van Deren. *Photography in New Mexico*. Albuquerque, New Mexico: University of New Mexico Press, 1979, pp. 33–34. 1 illus.

Hill, Paul, and Thomas Cooper. *Dialogue with Photography*. New York: Farrar, Straus, Giroux, 1979, pp. 237–252.

* Naef, Weston J. "Afterword." In *Intimate Landscapes*, by Eliot Porter, pp. 126–134. 1 illus.

* Harwood, Michael. "A Conversation with Eliot Porter." *Harvard Magazine* 82 (July–August 1980): 30–40. 9 illus.

* Robbins, Cathy. "Photography China." *Impact* [*Albuquerque Journal* magazine], December 16, 1980, pp. 4–7, 13. 2 illus.

Lisle, Laurie. *Portrait of an Artist: A Biography of Georgia O'Keeffe*. New York: Seaview Books, 1980, pp. 288–289, 300, 301–302.

* Teensma, Hans. "Above the Horizon: A Portfolio by Eliot Porter." *Rocky Mountain Magazine* 3 (March–April 1981): 48–53. 5 illus.

* McNamee, Thomas. "Prior Knowledge: Photographs by Eliot Porter." *Camera Arts* 1 (May–June 1981): 78–85. 7 illus.

Filler, Martin, and Babs Simpson. "The Priceless Luxury of the Simple Life." *House and Garden* 153 (July 1981): 66–73.

* Neary, John. "Eliot Porter." *American Photographer* 7 (December 1981): 44–47. 7 illus.

Johnstone, Mark. "Landscape: Perceiving the Land as Image." *Untitled* 24 (1981): 5–6.

* Cahn, Robert. "Evolving Together: Photography and the National Park Idea." In *American Photographers and the National Parks*. New York: Viking Press, 1981, pp. 134–136. 10 illus.

* "The Modern Innovators: Eliot Porter's Beloved Nature." In *Life Library of Photography: Color*. Alexandria, Va.: Time-Life Books, 1981, pp. 148–155. 8 illus.

* Mays, Buddy. "Nature Photographer Eliot Porter: His Photos and Philosophy." *Westways* [*Dallas Times-Herald* magazine], January 31, 1982. 7 illus.

* Hausman, Gerald. "The Black Widow Webbing [a poem], for Eliot Porter." *New Mexico Wildlife Magazine* 27 (May–June 1982): 14–15. 1 illus.

* Persson, Hasse. "Eliot Porter." *Foto* 44 (June 1982): 43–49. 5 illus.

* Murphy, Joy. "Eliot Porter: Living by Lunar Time." *New Mexico Magazine* 60 (September 1982): 60–67. 3 illus.

* Steinorth, Karl. "Einblicke in die Natur." *Photo* 120 (October 1982): 78–87. 10 illus.

* Steinorth, Karl. "Eliot Porter: Ein Wissen Schaftler als Fotograf." *Bild der Wissenschaft* 10 (October 1982): 104–112. 4 illus.

* Hulbert, Elizabeth. "Eliot Porter: Master of Color." *Islander Magazine* 2 (Autumn 1982): 8–9. 1 illus.

* Asbury, Dana. "How They Work: 3 Master Printers and Their Assistants." *Popular Photography* 89 (December 1982): 79–87. 1 illus.

* "Porter, Eliot." In *Contemporary Photographers*. New York: St. Martin's Press, 1982, pp. 603–605. 2 illus.

* Newhall, Beaumont. *The History of Photography*. Revised and enlarged 5th edition. New York: Museum of Modern Art, 1982, pp. 279, 292. 1 illus.

Plett, Nicole. "Nature Artist's Forte." *Santa Fe New Mexican*, March 24, 1983.

* Browne, Turner, and Elaine Partnow. *Macmillan Biographical Encyclopedia of Photographic Artists & Innovators*. New York: Macmillan, 1983, pp. 488–489. 1 illus.

* Netherton, John, and Mike Coleman. "Outside Shots with Eliot Porter." *Lens Magazine* 9 (January–February 1984): 8–9. 3 illus.

* Bell, David. "Eliot Porter in Black and White." *Impact* [*Albuquerque Journal* magazine], September 4, 1984, pp. 4–11, 15. 9 illus.

* Evans, Karen. "Living Color: The Life of Photographer Eliot Porter." *Boston Globe*, December 12, 1984. [3] illus.

* Evans, Karen. "Photography: Eliot Porter." *Artlines* 5 (December–January 1984/1985): 18–19. 2 illus.

Clergue, Lucien. "Eliot Porter." In catalogue of XVe Rencontres Internationales de la Photographie, Arles, France, n.p.

* "Porter, Eliot." *International Center of Photography Encyclopedia of Photography*. New York: Crown Publishers, 1984, p. 403. 1 illus.

* Rosenblum, Naomi. *A World History of Photography*. New York: Abbeville Press, 1984, pp. 582–583. 1 illus.

* Evans, Karen. "Living Color: The Life of Photographer Eliot Porter." *Empire Magazine* [*Denver Post* magazine], January 13, 1985, pp. 5–7, 11. 3 illus.

Adams, Ansel. *Ansel Adams: An Autobiography*. Boston: New York Graphic Society, 1985, pp. 175, 204, 216.

* "Masters of Color: The Subtle Hues of Nature." In *The Kodak Library of Creative Photography: Mastering Color*. [Alexandria, Va.]: Time-Life Books, 1985, pp. 50–52. 4 illus.

* "Porter, Eliot Furness." In *Encyclopédie internationale des photographes de 1839 à nos jours*, compiled by Michèle Auer and Michel Auer. Geneva: Editions Camera Obscura, 1985, vol. 2, n.p. 1 illus.

* "The Personal Style of . . . Eliot Porter." In *The New Joy of Photography*. Reading, Mass.: Addison-Wesley, 1985, pp. 70–75. 8 illus.

* Murphy, Joy W. "Eliot Porter: Focused on Nature." *Southwest Art* 16 (July 1986): 68–75. 13 illus.

* Cameron, Franklin. "Meet the Masters: Eliot Porter." *Petersen's Photographic* 15 (September 1986): 26–28. 2 illus.

* Sudborough, Harrison. "Eliot Porter, Audubon Share Nest of Honors." *Santa Fe New Mexican*, October 3, 1986. 2 illus.

* Hester, Nolan. "Eliot Porter Close-Up." *Impact* [*Albuquerque Journal* magazine], October 7, 1986. 5 illus.

Yu, Winifred. "Great Books." *American Photographer* 17 (December 1986): 72–75.

"Porter, Eliot Furness." *Who's Who in America*. 44th ed. Wilmette, Ill.: Marquis Who's Who, Inc., 1986, p. 2240.

"Porter, Eliot Furness." *Who's Who in American Art*. 17th ed. New York: R. R. Bowker Co., 1986, p. 808.

* Pyne, Stephen J. *The Ice: A Journey to Antarctica*. Iowa City: University of Iowa Press, 1986, pp. 197–200. 2 illus.

PORTFOLIOS

1953

American Birds: 10 Photographs in Color

New York: McGraw-Hill Book Company, 1953. 3 pages of text by Eliot Porter.

1. Black-Chinned Hummingbird, Juvenile; at Trumpet Flower. Alcalde, New Mexico, August 1951
2. Red-Shafted Flicker, Male with Young; at Nest in Apple Tree. Tesuque, New Mexico, June 1950
3. Alder Flycatcher; at Nest in Raspberry Bush. Great Spruce Head Island, Maine, July 1940
4. Barn Swallow, Female and Young; at Nest in Cow Barn. Great Spruce Head Island, Maine, July 1949
5. Florida Jay; at Nest in Palmetto 2 Feet High. Central Florida, May 1946
6. Western Bluebird, Male; at Nest Hold in Apple Tree. Tesuque, New Mexico, May 1948
7. Ruby-Crowned Kinglet, Male; at Nest in Colorado Blue Spruce Which Has Been Lowered from Tree Top to Ground Level. Sangre de Cristo Mountains, New Mexico, July 1951
8. Northern Parula Warbler, Male; at Nest in Usnea Lichen 20 Feet High, Photographed from Erected Platform. Great Spruce Head Island, Maine, June 1945
9. Scarlet Tanager, Male; at Nest 30 Feet High in Oak Tree, Photographed from Blind on Platform Built in Tree. Battle Creek, Michigan, June 1947
10. Western Blue Grosbeaks, Male and Female; at Nest in Seedling Wild Plum Tree, About 30 Inches High. Tesuque Indian Pueblo, New Mexico, July 1951

1964

The Seasons

PORTFOLIO ONE. 12 dye-transfer prints. San Francisco: Sierra Club, 1964. 1 page of text by Eliot Porter. Edition: 105; 100 for sale.

1. Maple Blossoms in a Woodland Pool. May 1961, New Hampshire
2. Rhodora. May 1953, New Hampshire
3. Aspens in Early Spring. June 1957, New Mexico
4. Eroded Rock. July 1953, New Mexico
5. Foxtail Grass. August 1957, Colorado
6. Weeds in Rock Cracks. August 1955, Maine
7. Ponderosa Pine. August 1960, New Mexico
8. Spruce Trees and River. September 1959, Colorado
9. Yellow Aspens. September 1951, Colorado
10. Cypress Swamp. February 1954, Florida
11. Snow and Grass. September 1959, Colorado
12. Snow on Sand Dunes. September 1959, Colorado

1972

Iceland

PORTFOLIO TWO. 12 dye-transfer prints. San Francisco: Sierra Club, 1972. 1 page of text by Eliot Porter. Edition: 110; 100 for sale.

1. Tarn and Cotton Grass — Fjordharheidhi
2. Pinks on Glacial Moraine — South Coast
3. Small Stream in Cinders — Skeljafell
4. White Flowers in Black Ash Cliff — Breidhidalur
5. Ice in Glacial Lake — Fjallsarlon, South Coast
6. Lichens on River Stones — South Coast
7. Fractured Obsidian — Landmannalaugar
8. Steam Vent — Landmannalaugar
9. Sea-Weed at Low Tide — Hellnar, Snaefellsnes
10. Wind-Eroded Volcanic Ash — Kleifarvatn
11. Abandoned Farm — South Coast
12. River Canyon Junction — Oxnadalsheidhi

1977

Birds in Flight

8 dye-transfer prints. Santa Fe and New York: Bell Editions, 1977. 9 text pages. Edition: 20, plus 6 artist's copies.

1. Osprey (Pandion Haliaetus Carolinensis). Penobscot Bay, Maine
2. Barn Swallow (Hirundo Rustica Erythrogaster). Great Spruce Head Island, Maine
3. Chipping Sparrow (Spizella Passerina Passerina). Great Spruce Head Island, Maine
4. Parula Warbler (Parula Americana). Great Spruce Head Island, Maine
5. Wood Ibis (Mycteria Americana). Corkscrew Swamp, Florida
6. Arctic Tern (Sterna Paradisaea). Matinicus Rock, Maine
7. Blue-Throated Hummingbird (Lampornis Clemenciae). Chiricahua Mountains, Arizona
8. Snowy Egret (Leucophoyx Thula Thula). Everglades National Park, Florida

1979

Intimate Landscapes

10 dye-transfer prints. New York: Daniel Wolf Press, Inc., 1979. Edition: 250.

1. Redbud Trees in Bottomland. Near Red River Gorge, Kentucky. April 17, 1968
2. Colorful Trees. Newfound Gap Road, Great Smoky Mountains National Park, Tennessee. October, 1967
3. Foxtail Grass. Lake City, Colorado. August, 1957
4. Shadbush. Near Hillsborough, New Hampshire. April 28, 1957
5. Columbine Leaves. Great Spruce Head Island, Maine. July 27, 1974
6. Frostbitten Apples. Tesuque, New Mexico. November 21, 1966
7. Trunks of Maple and Birch with Oak Leaves. Passaconaway Road, New Hampshire. October 7, 1956
8. Stones & Cracked Mud. Black Place, New Mexico. June 9, 1977
9. Rock-Eroded Stream Bed. Coyote Gulch, Utah. August 14, 1971
10. River Edge at Sunset. Below Piute Rapids, San Juan River, Colorado. May 24, 1962

1980

Glen Canyon

10 [dye-transfer] prints. New York: Daniel Wolf Press, Inc., 1980. Edition: 250.

1. Coyote Gulch. Escalante River. August 17, 1971
2. Cliff. Moonlight Creek, San Juan River. May 23, 1962
3. Reflections in Pool. Indian Creek, Escalante River. September 22, 1965
4. Redbud in Bloom. Hidden Passage, Glen Canyon. April 10, 1963
5. Green Reflections in Stream. Moqui Creek, Glen Canyon. September 2, 1962
6. Amphitheater. Davis Gulch, Escalante Basin. May 12, 1965
7. Escalante River Outwash. Glen Canyon. September 2, 1962
8. Tamarisk & Grass, River's Edge. Glen Canyon. August, 1961
9. Waterslide from Above. Long Canyon. September 21, 1965
10. Dungeon Canyon. Glen Canyon. August 29, 1961

1981

In Wildness

10 dye-transfer prints. New York: Daniel Wolf Press, Inc., 1981. Edition: 300.

1. Red Osier. Near Great Barrington, Massachusetts. April 18, 1957
2. Path in Woods. Great Spruce Head Island, Maine. 1981
3. Hawkweed in Meadow. Great Spruce Head Island, Maine. 1968
4. Tidal Marsh. Mount Desert Island, Maine. August 4, 1965
5. Maple Leaves and Pine Needles. Tamworth, New Hampshire. October 3, 1956

6. Sunflower and Sandune. Colorado. 1959
7. Sculptured Rock. Marble Canyon, Arizona. 1967
8. Maple Sapling and Rock. Passaconaway, New Hampshire. 1953
9. Pool in a Brook. Pond Brook, near Whiteface, New Hampshire. October 1953
10. Sunset Behind Las Tres Virgenes Volcano. Near Mezquilal, Baja California. August 12, 1966

1982

Santa Fe Center for Photography: Portfolio I

Santa Fe: Santa Fe Center for Photography, 1982. 5 prints. Edition: 16; 10 for sale.

1. Mary Peck. "Bandelier National Monument, 1977"
2. Bernard Plossu. "Santa Clara Pueblo, 1978"
3. Eliot Porter. "Landscape, New Mexico, 1960"
4. David Scheinbaum. "Church, Canada de los Alamos, 1980"
5. Susan Steffy. "Squash on Black, 1979"

1984

China

7 laser dye-transfer prints. Introduction by Jonathan Porter. New York: DEP Editions, Inc., 1984. Edition: 50, plus 10 artist's proofs, 1–x.

1. The Kong Forest, Confucius' Family Cemetery, Qufu, Shandong
2. Ferry, Chongqing, Sichwan
3. Imperial Palace, Peking
4. Lotus and Azolla, West Lake, Hangzhou, Zhejiang
5. Yuantong Monastery, Kunming, Yunnan
6. Black Dragon Falls, Lushan, Jiangxi
7. Bamboo Grove near Hangzhou, Zhejiang

INDEX

Text edited by Terry Reece Hackford and Ann Mason.

Designed by Eleanor Morris Caponigro.

Production coordinated by Amanda Freymann and Eleanor Morris Caponigro.

Composition by Finn Typographic Service Inc.

Duotone negatives by Robert Hennessey.

Separations and printing by Acme Printing Company.

Binding by Horowitz/Rae.